Climbing Rock

Vertical Explorations across North America

Protect America's Climbing

Access Fund is the national nonprofit advocacy organization that protects and conserves America's outdoor climbing areas. Founded in 1991, Access Fund represents millions of climbers in all forms of climbing: rock climbing, ice climbing, mountaineering, and bouldering. Today, 1 in 5 climbing areas in the United States are threatened. Whether private land lost to development, public land managers over-regulating climbing, or climber impacts degrading the environment, the list of threats is long and constantly evolving. No one loves our climbing landscapes and the experiences they offer quite the same way that climbers do, but we must be willing to fight for them. A portion of the proceeds of this book will be donated to help Access Fund conserve the climbing environment through their policy and advocacy, education, and stewardship and conservation work. To learn more, please visit www.accessfund.org

Cover: *Moonlight Buttress (5.12+), pitch 6*
Ethan Pringle putting the crux pitch to rest during his onsight of this classic Zion testpiece. Six of the 10 pitches on this sustained, magnificent route are rated 5.12.

First published in the United States of America in 2019
by Rizzoli International Publications, Inc.
300 Park Avenue South
New York, NY 10010
www.rizzoliusa.com

Foreword: Peter Croft
Photography: François Lebeau

Publisher: Charles Miers
Editorial Direction: Martynka Wawrzyniak
Design: Jaysen Henderson
Production Manager: Barbara Sadick
Managing Editor: Lynn Scrabis

2019 2020 2021 2022/ 10 9 8 7 6 5 4 3 2 1

Distributed in the U.S. trade by Random House, New York

Printed in China

ISBN: 9780847866113

Library of Congress Control Number: 2019931036

Visit us online:
Facebook.com/RizzoliNewYork
Twitter: @Rizzoli_Books
Instagram.com/RizzoliBooks
Pinterest.com/RizzoliBooks
Youtube.com/user/RizzoliNY
Issuu.com/Rizzoli

Climbing Rock

Vertical Explorations across North America

Text:

Jesse Lynch

Photography:

François Lebeau

Edited by:

Martynka Wawrzyniak

New York · Paris · London · Milan

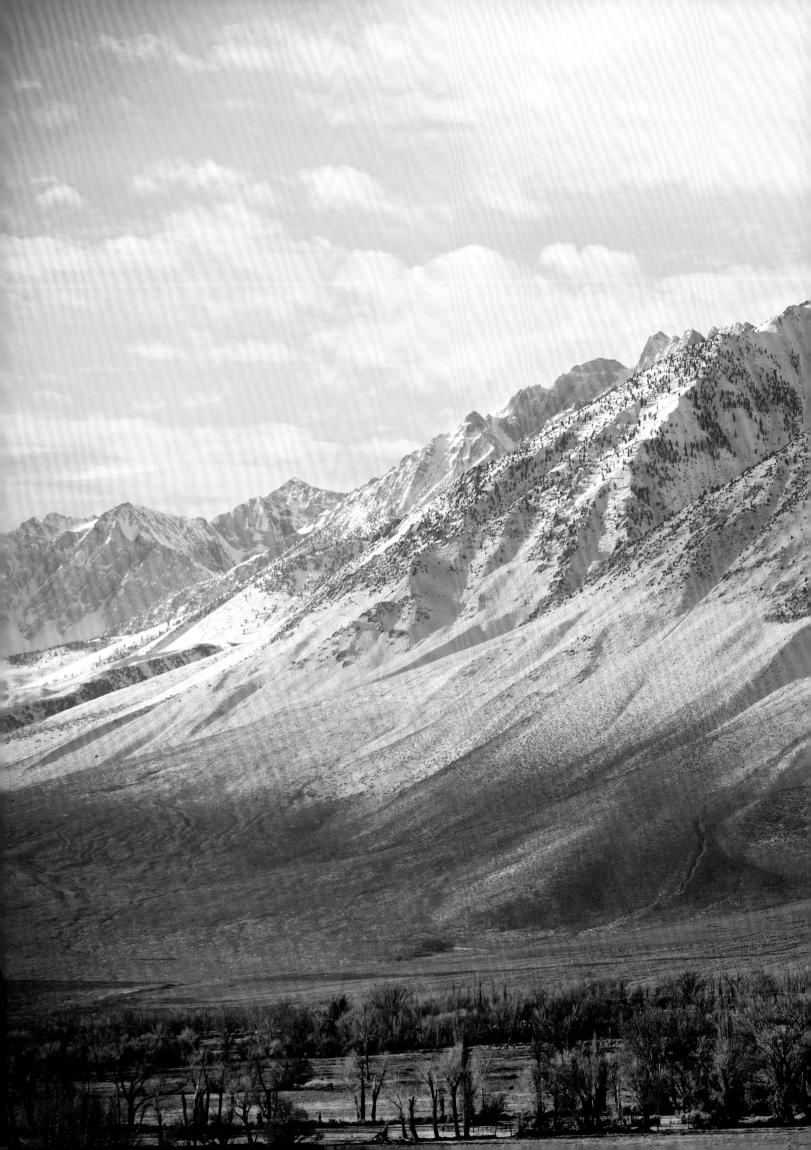

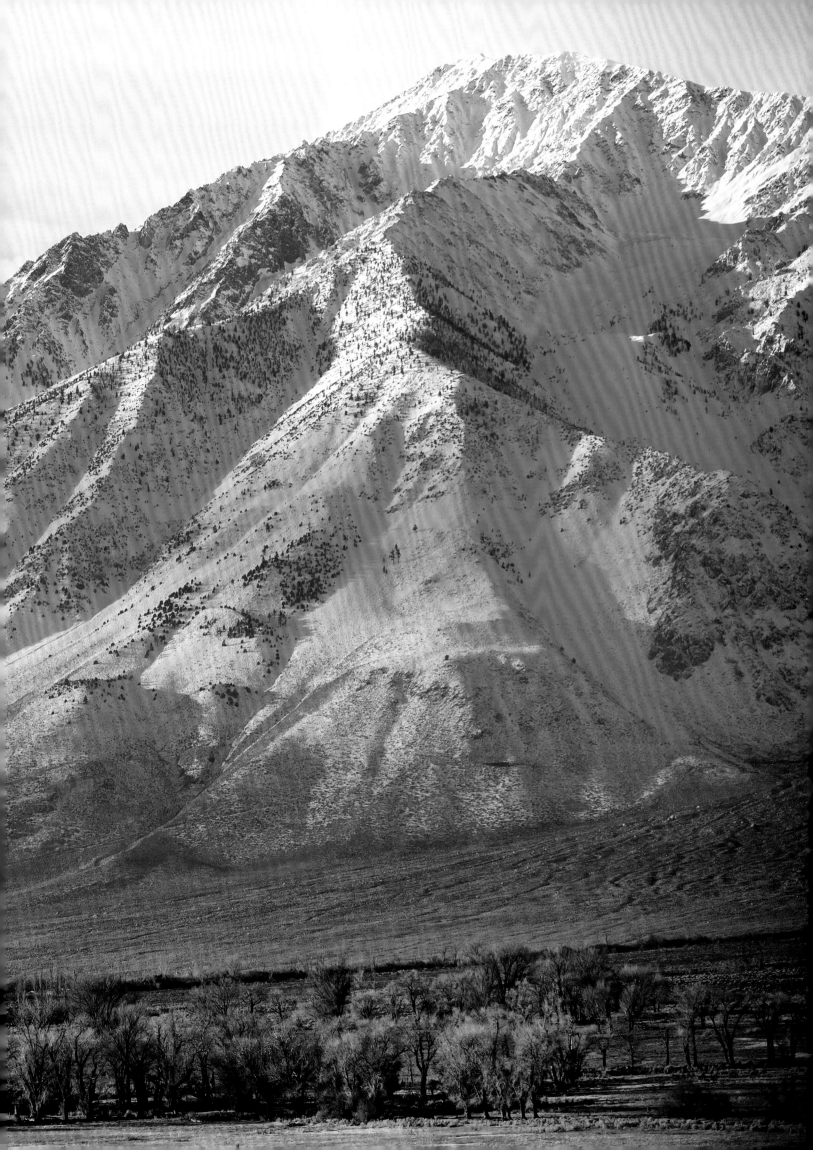

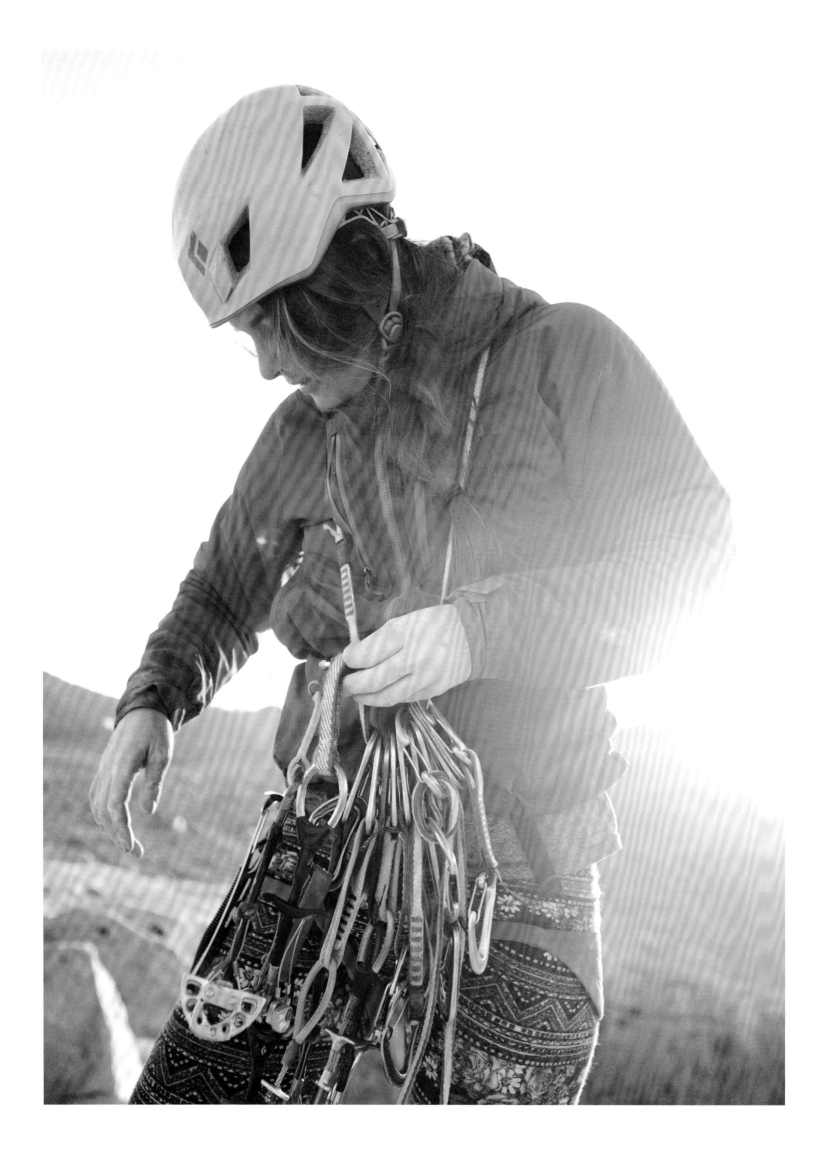

CONTENTS

17 Spring

83 Summer

137 Fall

205 Winter

Previous
The glorious snowcapped skyline of the High Sierra, California—one of the premier alpine climbing destinations in North America.

Left
Alix Morris sorts the rack and enjoys the calm of the summit on a summer evening in the High Sierra.

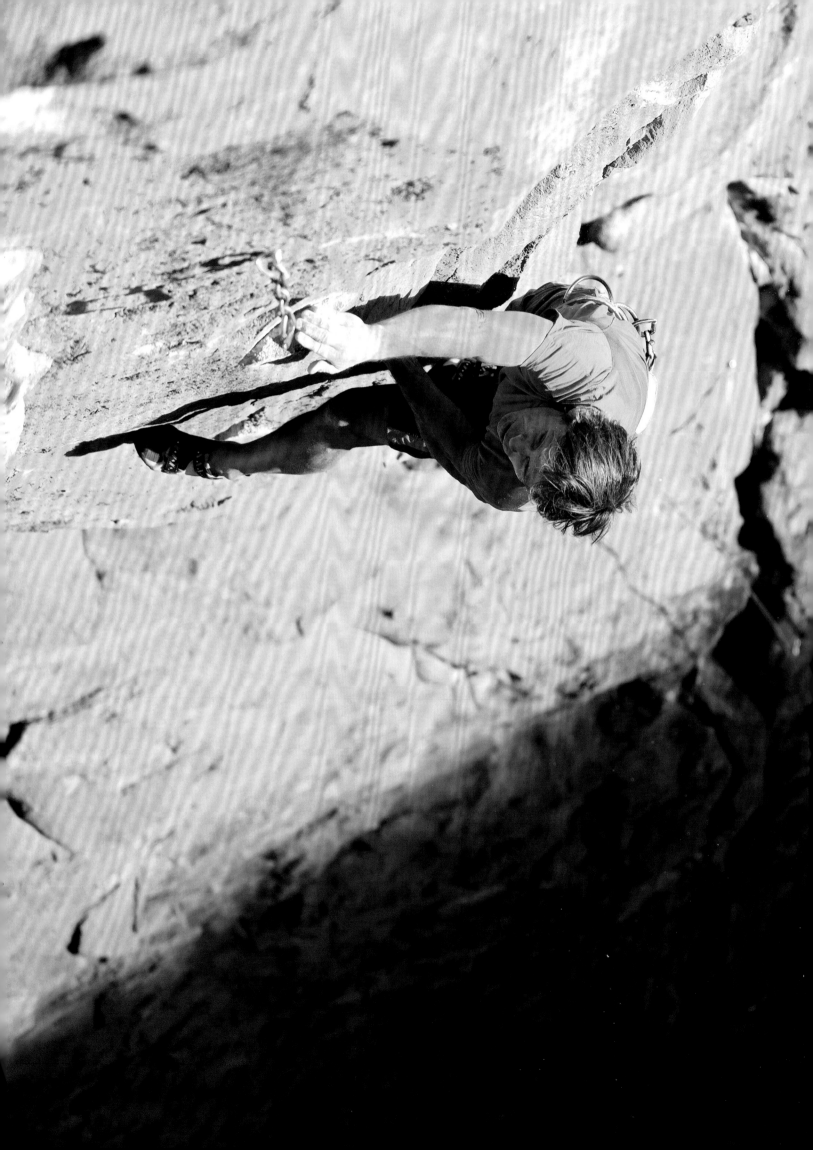

FOREWORD

By Peter Croft

I cringe every time I hear climbing described as a sport. If competition, winning, and "crushing" are necessary components of sport, they don't define the climbing I know. And if comparing myself to others in such a diverse and changeable environment feels fairly foolish, then the very idea of conquering a mountain or crushing a climb seems the pinnacle of crazy-dom. To see the world I've chosen—a world that has punished and rewarded me with adventures of a lifetime—painted in such one-dimensional monotones is flat-out nonsensical. One might just as well describe life as merely the propagation of the species but, while that process is truly extraordinary and the primary act boatloads of fun, life is clearly far, far more than that.

Moreover, if sport is defined by a myriad of rules, climbing instead has just one commandment: Respect the Environment. In other words, take care of the rock kingdoms we dream of and make pilgrimages to. Beyond that, just don't do anything stupid. That, of course, is wide open to interpretation.

Obviously, my old-school-nicity is showing here. After all, climbing is about to become an Olympic sport. For some, perhaps, this will be the future, revealing to the world exactly how incredible climbing is and, by extension, how incredible we, as climbers, are. Maybe, but it will also be the slowest event by a very large margin, making a snail-sport such as curling look like a hot-rod race. The winning brilliance of what we do lies not in the watching but in the doing. The warp-speed excitement happens in our heads.

Climbing, certainly in broad sense, is not about winning. Picture an ice-cold bivy below a 1,000-foot wall where the night turns white granite black and impossibly blank, impossibly tall—impossible for a being as puny as you. The darkness gives birth to nightmares and makes dragons real. And when sleep simply won't come, an echo from childhood—what if this time the night never ends? Then, when a sliver of light on the horizon turns to warm orange on the wall's summit, the dark dreams flee and there's an inner flood of hope, a hope I'm sure our cavemen ancestors jumped up for and celebrated. What we do on the rock and in the mountains returns us to a primitive past, a past in which we reach so desperately for something we can't even define. Although we might be too shy to voice it, our efforts become a quest, forged in the fire of risk, injury and gut-wrenching toil, and made noble by an absence of tangible reward.

Perhaps nothing illustrates the multi-dimensional diversity of climbing like a year-long road trip. It is the dirtbag's version of *Star Trek*'s mission to explore strange new worlds and to boldly just go. And I can't think of another path or vocation that allows all of us, from freshly baptized, clumsy newbies to genetically engineered mutants, to visit some of the most hallowed arenas that the planet has to offer. In layman's terms, can you imagine a no-talent baseball player being allowed to pitch a few balls in Wrigley Field? Or a first-

Left **Corona (5.13b)**
Peter Croft flowing through the choreography of one of his bolted lines in the Owens River Gorge.

time driver hopping into the Indy 500 on a whim? In what alternate first-time driver hopping into the Indy 500 on a whim? In what alternate reality would a tennis bumblie like myself get to play at Wimbledon?

The same awe strikes all of us as we stare up at El Cap for the first time and even the most unpoetic soul gets the "vibe" when grabbing that first handhold on the Captain's flanks. Everyone who makes the decision to get out on the road and find out firsthand what Canyonlands is like will get to do so, at times, in the company of the vagabond elite who have arrived from the four corners of the globe. And yes, the whole lot of them will get what they came for in the crazy perfection of the splitter cracks and the perfect craziness of the otherworldly towers. But they'll also be blown away by the desert sunrises, where the cosmic brush painting the pinks and oranges of the landscape sweeps those spooky pastels right up into the sky.

In my view, still images capture the moment and essence of climbing better than any other medium. Words fall short and video inevitably goes on too long, capturing more than enough of the stops and starts and slo-mo pace. This is why in movies like *Cliffhanger*, climbing is mere window dressing. The main course is all about exterminating bad guys and, of course, really big explosions. In our own adventures, experiences are distilled into penultimate moments—triumphant skin-of-our-teeth dynos, the fluid elegance of entering a flow state or even just a hard-won belay ledge where the clouds part and the god rays of sunset bathe you and your partner in palpable glory.

Nothing is what it is except by comparison and contrast. Consider the comfortable warmth of a day at home—nothing really, just a number on a thermostat. After a frosty dawn, however, the simple warmth of the sun becomes a rapturous event to me, the meteorological equivalent of hot-baked blackberry pie. Or hiking up through thick evergreen forest for hours to finally break through treeline into the alpine and above the clouds, literally stopping you in your tracks. On a moonless night a bigwall appears as an even bigger chunk of empty space, a black starless hole of anti-matter. At daybreak, though, the cliff comes to multi-hued life and we can trace buttresses and corners, crack systems and water streaks.

The pictures in this book captures those contrasts—the differences and the diversity that light and shadow bestow on us.

I've been lucky enough to have visited most of the areas featured in this book. Some I've even taken up residence in. Exploring the pages, I've time traveled back and forth acrossthe continent, the images having a similar flashback effect that some smells and aromas trigger from childhood. When I was a kid I loved going to the zoo, which entailed catching a bus into the city. Waiting at the stop for the correct one I'd imagine the monkeys, lizards and penguins I'd see, all the while engulfed in clouds of bus exhaust. The association of

that foul cloud with my favorite destination turned the pollutant into a perfume. I've lost the taste for seeing animals in cages but I still catch myself breathing deep whenever a bus goes by. The images in this book do a similar job of transporting us back to time and place. The shot of the sun-bleached meadow under El Cap reminds a bunch of us of victory celebrations there, a bag of Doritos in one hand and a pint of Ben and Jerry's in the other. Looking at the atmospheric shots of the Bugaboos, we can feel the hard frost and hear the crunch of footsteps on the glacier. And speaking for myself, the image of dark rain clouds over Squamish whisks me back to a rain-soaked bivy cave at the Chief, waking up to the wrong end of a skunk aimed at my face.

François's art carries us around the continent but also into what it means to be possessed by the vertical (and overhanging) world. The action is juxtaposed with vivid scenery, the tight focus of bleeding fingertips, cramped hands and wincing face zooms us into the climbers' inner world and then back out again to take in the vast panorama. The blood spilt and efforts made are evident, but so are the overpowering reasons for these epic battles. That same imagination that makes El Cap seem twice as big or a curling wave of limestone utterly blank can also be harnessed into believing the most wonderful absurdities. And whether the hurling of our life force is a transcendent success or glorious failure, these magnificent arenas truly inspire us to be better than who we are.

Beyond the heart-pumping, heat-of-the-moment action shots are the reasons why climbing is more than a sport. And that is because it is so much more than just pulling down on stone. Because of the way in which we interact with our environment, destinations become far more than a tourist stop. The locales it introduces us to helps to connect us with the planet on a visceral level. The effort invested and the fear we wrestle with helps to pull the landscapes right into who we are and they become home regardless of where we actually live. The very nature of what we do inevitably draws us to the spectacular—and to appreciate what is precious. Perhaps the kinship that is born and bred in the wild places is why climbers have always played an important role in protecting that wildness. No doubt the images in this book will fire you up to try harder and to go further, to be pure soul food for the feeding of dreams. What we also need is to use some of that fire to ensure that future generations have that opportunity, too.

Right
Peter Croft profile against the volcanic tuff of Owens River Gorge—a home crag where he put up many first ascents.

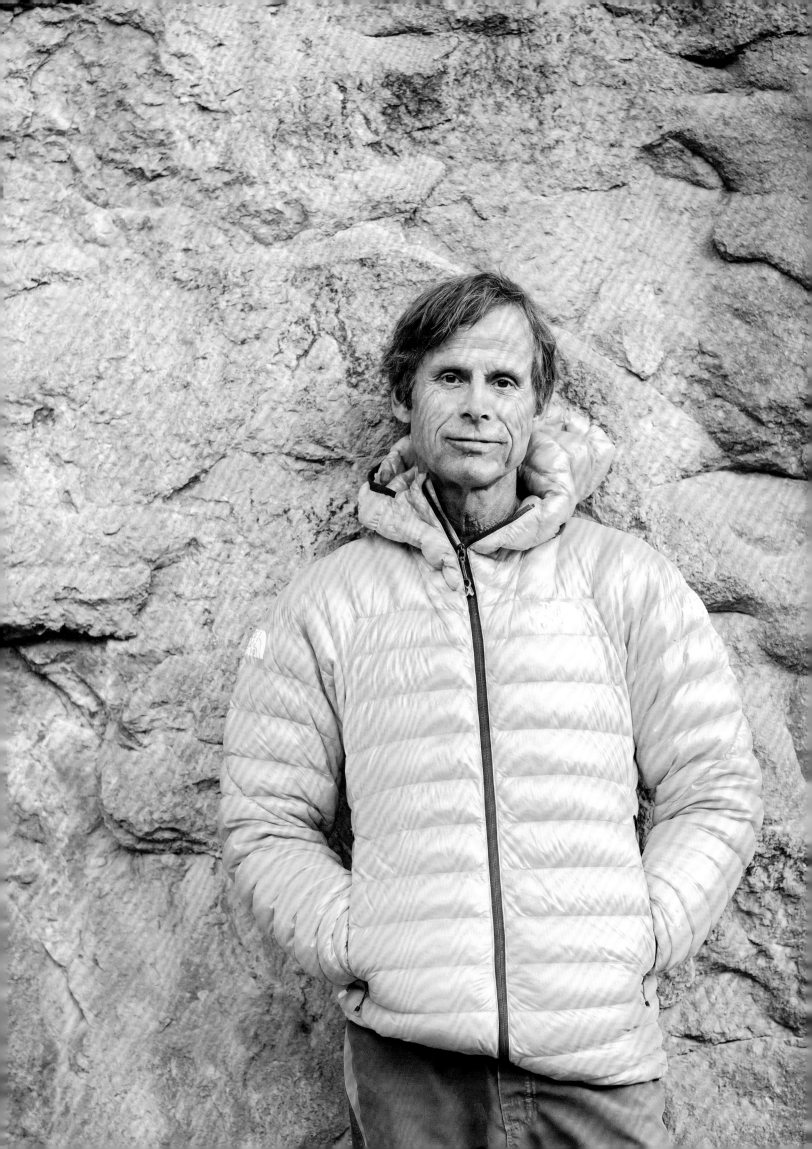

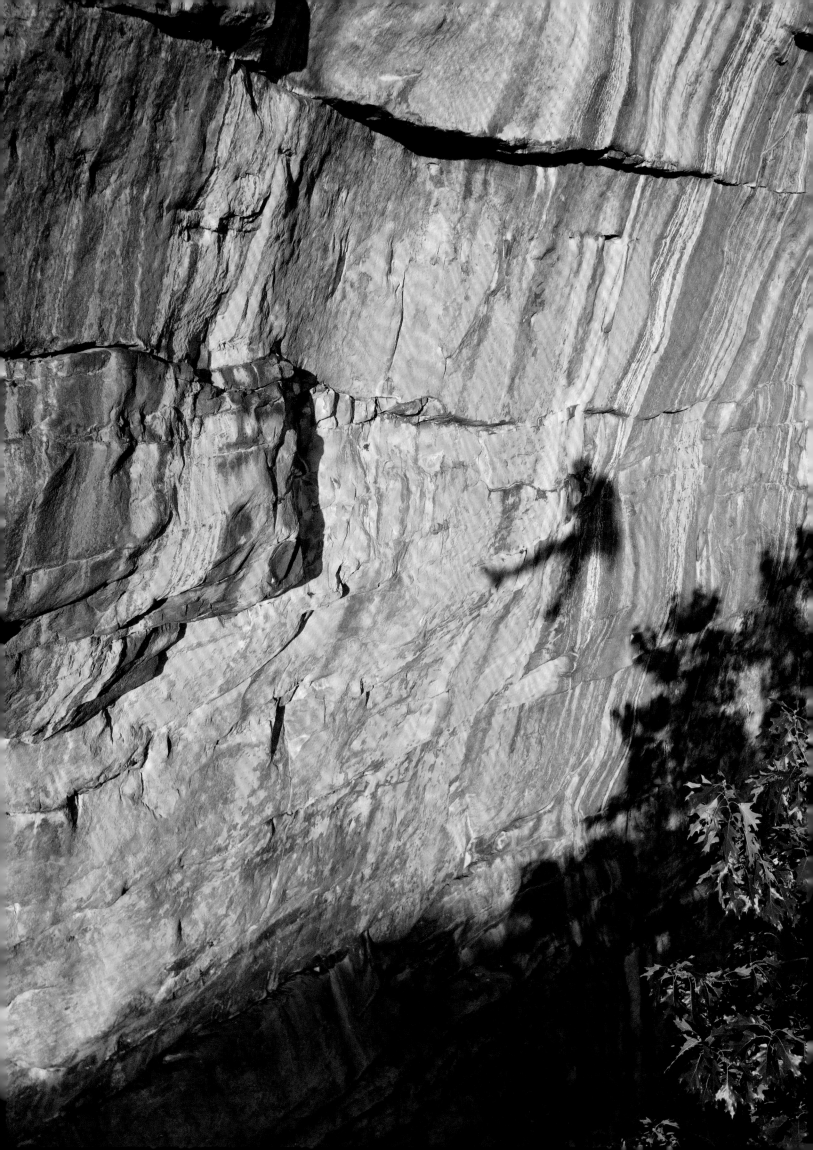

PHOTOGRAPHY

By François Lebeau

If you would have told me five years ago that I would have a coffee-table book with my name on the cover, I would have not believed you for one second. The desire was always lingering in the back of my mind, but I would not have been ready to embrace the possibility at the time. One of my life goals that I wrote on a list many years back was, in fact, to write a book. I am finally able to check that box, although I didn't write it with a pen, but with my eyes, which I think is even better.

Photography has always been my most intuitive avenue of creation. In my youth, my mother always pushed us toward art and encouraged us to do what made the most sense to our eyes. I've been playing with cameras since a young age, and my interest kept growing over the years. When I got to the point in life when I needed to make the important choice of what I was going to do, the photography industry welcomed me. I found myself most drawn to documenting adventure, capturing the essence and natural beauty of people, and studying the art of natural light. Driven by a deep desire to learn about the experiences and stories of others, I have been on a quest to capture decisive moments with a documentary style that blends photojournalism, portraiture, and adventure photography.

Over time, rock climbing has become the primary way to practice my vision. I discovered the sport during my photography studies, and I loved it so much that my graduation exhibit was a rock-climbing triptych. The movement of the body, the textures of the different environments, the light from the sky, and being in magical places all made me fall in love with the pursuit. And to this day, I am grateful for every person I have met through this adventure of photographing rock climbing.

Family is the first word that comes to my mind when I think of the rock climbing community, and I feel utterly privileged to be part of it. This group nurtures a certain kind of soul that is generous, helpful, and supportive of its peers to accomplish any kind of objective. It always fascinates me to see climbers cheering and being so happy for others who achieve success with their own respective goals. This is part of why I am here today, showcasing these images that I am so proud of. Without your time, without your patience, and without your excitement, this book would have never seen the light of day. I am thankful to all of you whom I've crossed paths with along the way, and I look forward to meeting others in the future because I am not ready to leave the tribe.

What will happen in the next five years? It's impossible to know, but I'm ready for the next surprise.

Left
François Lebeau casting an auspicious shadow while shooting suspended in mid air at the Cirque, in West Virginia's New River Gorge.

INTRODUCTION

By Jesse Lynch

In October of 2006, bigwall guru Erik Sloan took me climbing for my first time. We happened to be roommates in Yosemite National Park, and as the house pianist at the Ahwahnee Hotel, I had a lot of free time. As I thrutched my way up a 5.8 crack at Swan Slab, I had no concept of what this activity and its tribe would come to mean. Twelve years later, climbing is a center of gravity for me—it creates meaning directly and metaphorically. It is a platform through which we transcend barriers of insecurity, fear, and doubt. It is a discrete world of tantalizing puzzles, a slow and persistent reliance on creative execution. It is a dance with chaos, employing an ever-sharpening program of self-control. It is precariously securing oneself to a vertical horizon, surrounded by the void. It is addicting and it is goddamned fun.

Climbing has enriched my life not only by influencing my psychology but also by syncing me with nature in a way often lacking in contemporary culture. The life of the rock climber is married to the seasons. As with other migratory species, the natural ebb and flow of conditions and weather dictate our movements. We calibrate to the changes in atmosphere, temperature, humidity, and precipitation, and we seasonally congregate below cliffs, canyons and mountain ranges sprawled across the continent.

Climbing Rock invites the reader to follow this journey through a one-year cycle of climbing life. We begin in the spring and end in the winter, adventuring across the North American landscape one iconic climbing destination at a time.

I met the photographer François Lebeau in Kentucky's Red River Gorge several years back. He was personable and cool, and we had a great connection. When he shared his photography, I was taken aback. Not only was he able to capture amazing moments of athletes on the stone, but he did it with the eye of an artist. By the time I approached him to submit work for this project, he had a sizable portfolio of some of the best climbing photography in the world.

It is important to distinguish that this book is not a comprehensive guide to the best climbing areas in North America. It is a curated cross section of a single photographer's work over the span of several years. The areas represented are mostly world-class, but in a few cases are more regional or obscure. Although we did our best to exhibit the biggest possible range of climbing styles and locations, there are notable omissions that any seasoned climber will acknowledge.

The quotes throughout the book were submitted by the international climbing community. Many of the quotes are from the subjects photographed within, although a few were not. Both in the photographs and quotes I wanted to present a cross section of passionate climbers, regardless of years logged or resume.

The power of this book is in its uncompromised aesthetic. Its pages comprise grime, sweat, stench, blood, fear, exhilaration, and camaraderie. It is a deeply beautiful survey of climbing—presenting not only the stark nature of the walls, but also uniquely capturing the humanity of the people who journey upward.

Right *El Sendero Diablo* (**5.11c**)
Jesse Lynch holding on tight to the tiny holds of the crux pitch. This six-pitch classic sports an array of styles from delicate slab to technical face climbing.

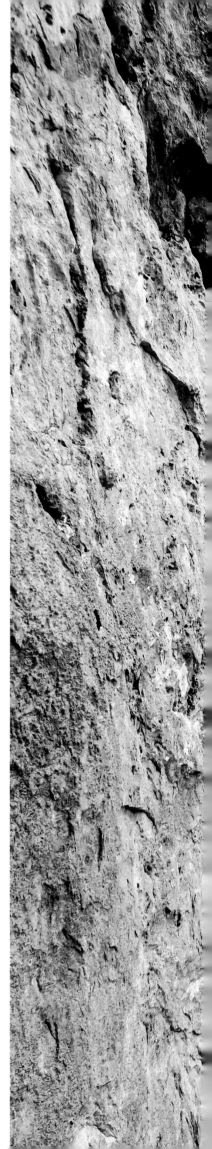

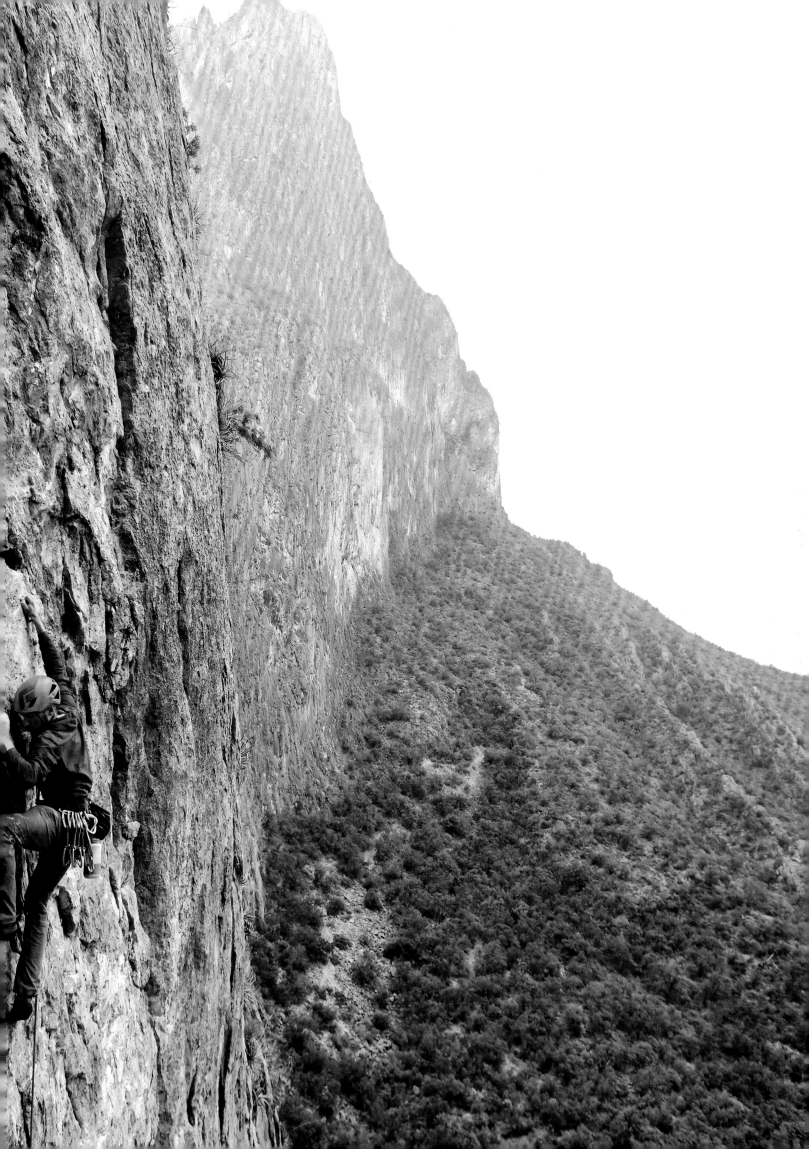

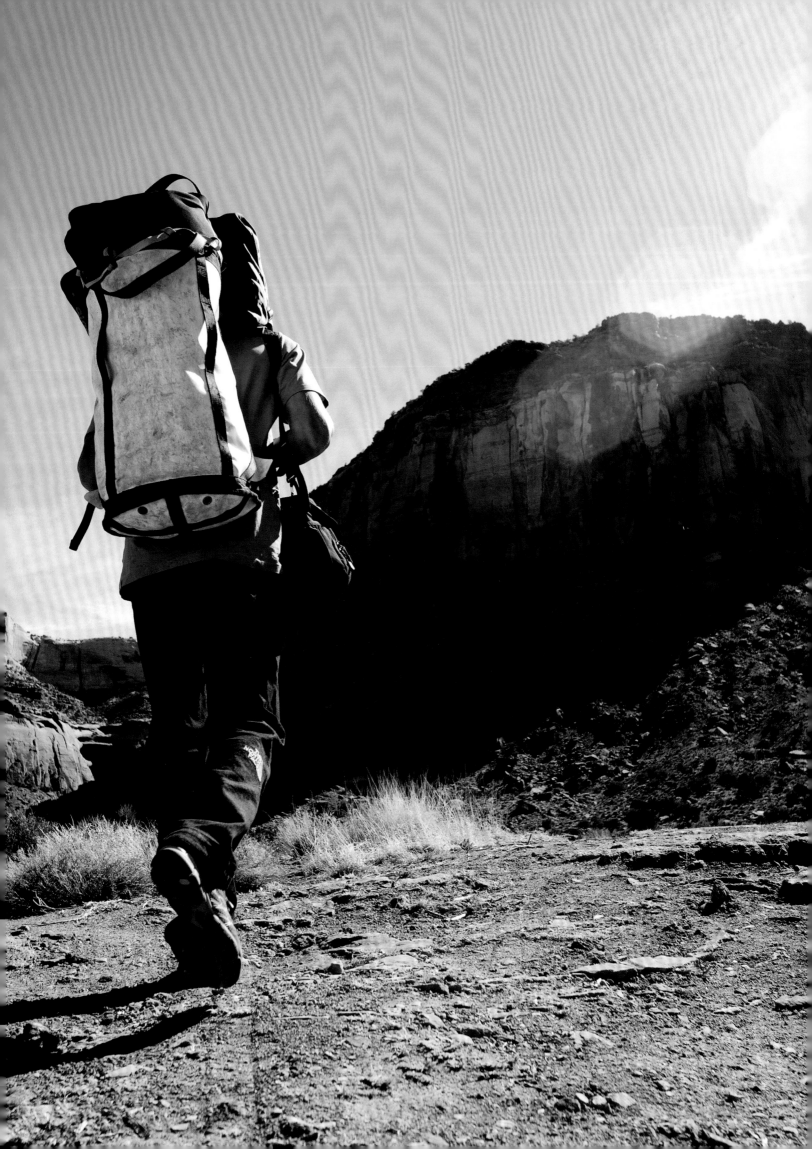

SPRING

The winter is over and the lush days of stone are upon us. The monkey tribe has patiently kept busy training indoors or by escaping to dry southern climates. But in the springtime the doors blow wide open. Most of the country's climbing is accessible and the conditions—when dry—are stellar. Few regions are more epic, exciting and accessible than the American West, hosting some of the most iconic destinations on the planet. An ideal spring road trip might trace a long arc through Colorado, Utah, Arizona, Nevada and California.

The season might begin on the tricky three- dimensional overhangs of **Rifle**, CO. Rifle is a chunky limestone labyrinth, arranged mostly in two aspects: overhanging and more overhanging. Given the difficulty of even the easiest climbs on many walls here, climbers sometimes employ hangboard warm-ups before attempting their chosen routes [p. 21]. Extra duct tape may be essential for attaching knee pads on some climbs. Rifle is known for its cryptic, beta-intensive climbing, and projecting is the name of the game—climbers may take months or even years to seamlessly complete a single pitch. Devoted winter training pays off here in spades.

Moving westward into the stunning panoramas of Utah, we are baptized by the great Southwest desert. The collective sigh of relief is palpable when entering these stark landscapes of surreal sandstone. The sky is large and the life is simple.

The endless canyons comprising the **Moab** area present a bounty of desert goodness. From single-pitch cracks to long aid and free routes, to a number of monolithic desert towers, there is an outrageous wealth of opportunity. Of particular note in this region are the oddly perfect vertical cracks, dubbed "splitters" on account of their uncanny symmetry. The global Mecca of splitter crack climbing, and the most esteemed locale in the Moab region, is Indian Creek outside Canyonlands National Park. Easy camping, an international community, and seamless access to unique and challenging climbing on thousands of perfect, parallel-sided cracks [p. 28] make it one of the most popular climbing areas in the country. The mind settles by degrees into the minimal desert landscape. Extended trips here loosen the hold of civilization and provide a modicum of tranquility.

A hidden gem for high-caliber climbers can be found in a large sport climbing cave in the southwest part of the state, outside the small town of Hurricane, UT. Appropriately, this gaping mouth of incredibly steep limestone goes by the name of **Hurricave**. The route quantity there is meager and the difficulty level is very high. Notably there is a Joe Kinder line that goes by the name of *Life of Villains*, at the remarkable grade of 5.15a [p. 41].

A mere 30 minutes down the road lie the otherworldly sandstone canyons of **Zion National Park**. Zion is a stunning destination for any visitor, and for climbers the park is befitting of its lofty namesake. Historically they employed specialized gear for aid ascents of these colossal walls, but the modern era has seen a surge of bold free ascents of these adventurous lines. The ambitious and strong may aspire to tangle with the 1,200-foot *Moonlight Buttress* [p. 44]. Pitch after pitch of steep, demanding climbing up a single, continuous finger crack attracts the attention of climbers worldwide.

Farther along the road we discover quite the opposite type of location. In the narrow chasm of the **Virgin River Gorge**, AZ, one finds impeccable overhanging limestone sport routes overlooking the unscenic Interstate 15, complete with the soundtrack of whooshing 18-wheelers and general highway clamor below. Despite the ambiance, these challenging testpieces offer sustained climbing, fantastic movement and truly world-class stone.

The convoy soon settles in unlikely Las Vegas, Nevada. Contrary to common knowledge, the wildest experience in Sin City is raging up the legendary walls of **Red Rock Canyon**. A 20-minute drive from the Strip, Red Rock hosts a lifetime of climbing across all disciplines. It's a raw and adventurous destination only a short distance from the glitz of Vegas. On the approach to any number of classic long routes, one has plenty of time to ruminate while plodding across the austere, prickly landscape. After some mythological desert adventures, an evening meal and libations at a nearby casino provide a surreal contrast to the day's events.

Hearts quicken and palms sweat in anticipation of visiting the motherland of rock climbing, **Yosemite Valley**, CA. Setting eyes on Yosemite for the first time, one realizes "breathtaking" can be a literal term. One is in reverence even to stand on the valley floor, dizzy beneath 3,000-foot granite walls and enormous waterfalls. As the climber ascends, proud ponderosa pines resolve into a carpet of green far below the spires, slabs and ledges above. The proportions of the Valley shock the nervous system and stagger the mind. Few of nature's rock walls are more intimidating and inspirational than El Capitan. The world's most famous and arguably best bigwall, El Capitan was first climbed half a century ago, taking 47 days. Modern climbers ascend most El Cap routes in one to five days, often deploying portaledges to sleep on the wall during longer ascents. The elite of the tribe commit to the challenge of free climbing these iconic lines, on routes such as *Freerider, the Salathe Wall, Zodiac* [p. 70] and, of course, *The Dawn Wall* [p. 74]. Pulling wild free moves a few thousand feet off the deck, it's hard to believe these walls weren't designed for climbing.

Rifle

Colorado

Type of Climbing:
Sport

Rock Type:
Limestone

Climbing Style:
Steep, blocky, cryptic

Number of Climbs:
400+

Elevation:
5,353 ft

Prime Season:
April–October

Classic Climbs:
Dr. Strangelove (5.9), *Carlin* (5.10a), *80 Feet of Meat* (5.11b), *Feline* (5.11b), *Ricochet* (5.12a), *Pump-O-Rama* (5.13a), *Easy Skankin* (5.12b), *the Beast* (5.13a), *Living in Fear* (5.13d), *The Anti-Phil* (5.13b), *Zulu* (5.14-)

Previous
Jacopo Larcher venturing out for a midday session at the *Meat Wall*, in Utah's Indian Creek.

Right
Fat Camp (5.14d)
Joe Kinder stringing the moves together on a route he bolted. The first ascent of *Fat Camp*, one of the hardest routes in Rifle, was completed by Jon Cardwell in 2016.

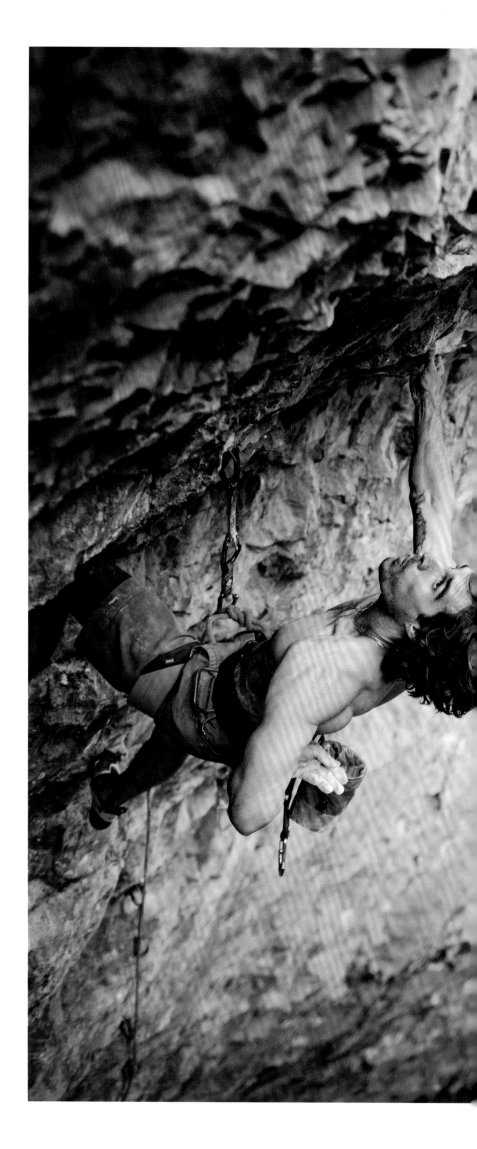

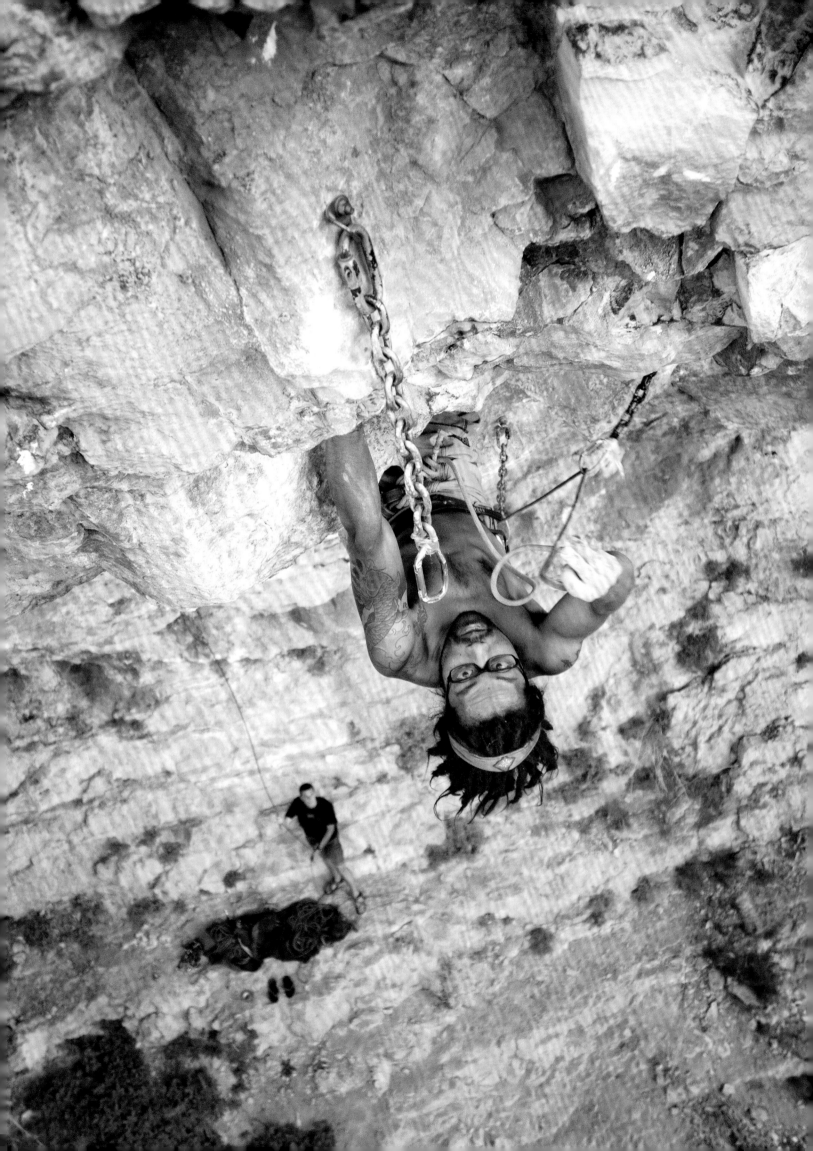

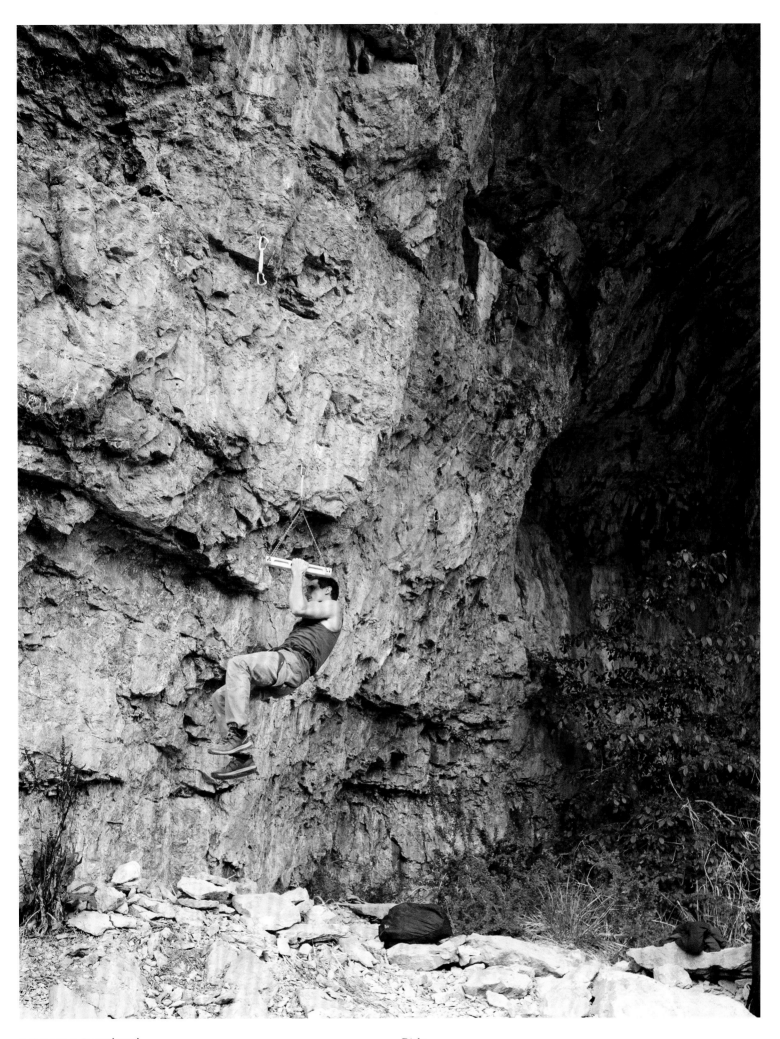

Left *Pump-o-Rama* (5.13a)
Jamie Gatchalian attentively clips his way past chain draws on this imposing, strenuous route. Despite the generally large holds, the Arsenal crag holds some of the steepest and most continuous routes in the park.

Right
Carlo Traversi using a portable fingerboard to warm up his fingers for smalls holds. In Rifle, climbers sometimes choose creative solutions like this, as opposed to climbing multiple pitches, to keep their skin intact for their project.

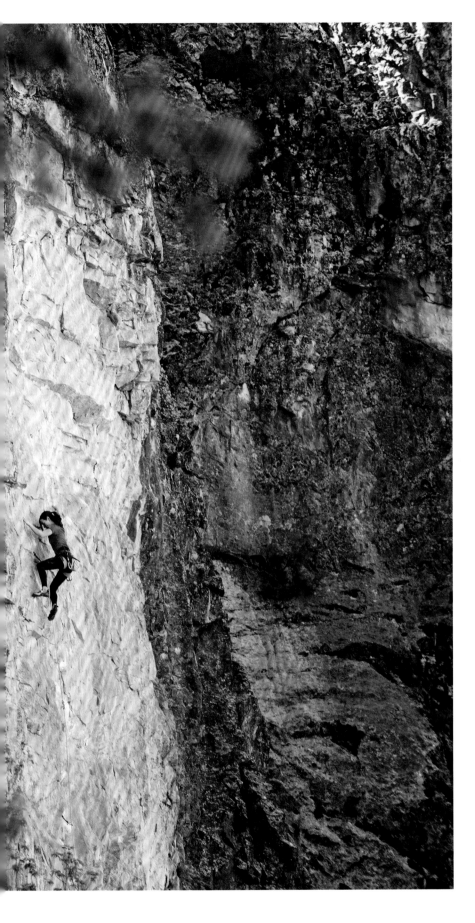

"For many of us, being a climber implies a deep spiritual connection to the Earth, a desire to live simply, a value system that favors experience over property, and yes, an inclination for climbing rocks. I appreciate passionate people; they may not share my love of rocks, but at least they understand my devotion to them."

—Max Shaffer

Left
***PMT* (5.10c)**
Mary Mecklenburg spotted through Rifle's spring foliage, navigating moderate, vertical terrain— something generally in short supply at this steep, demanding crag.

Moab

Utah

Type of Climbing:
Trad, sport, bouldering, aid

Rock Type:
Sandstone

Climbing Style:
Splitter, remote, adventurous

Number of Climbs:
~2,600

Elevation:
4000 ft

Prime Season:
March–April and October–November

Classic Climbs:
Supercrack of the Desert (5.10), *Incredible Hand Crack* (5.10), *Stolen Chimney* (5.10), *Jah Man* (5.10c), *North Face of Castleton Tower* (5.11-), *Fine Jade* (5.11a), *Lightning Bolt Cracks* (5.11-), *Primrose Dihedrals* (5.11+), *Way Rambo* (5.12-)

Right
Jacopo Larcher and Barbara Zangerl survey the horizon on their first trip to Indian Creek, scoping out the classic profile of the Six Shooters across the wide desert expanse. The north and south Six Shooter towers are host to a few classic tower climbs, most notably *Lightning Bolt Cracks* (5.11-), which finishes on an outrageous summit.

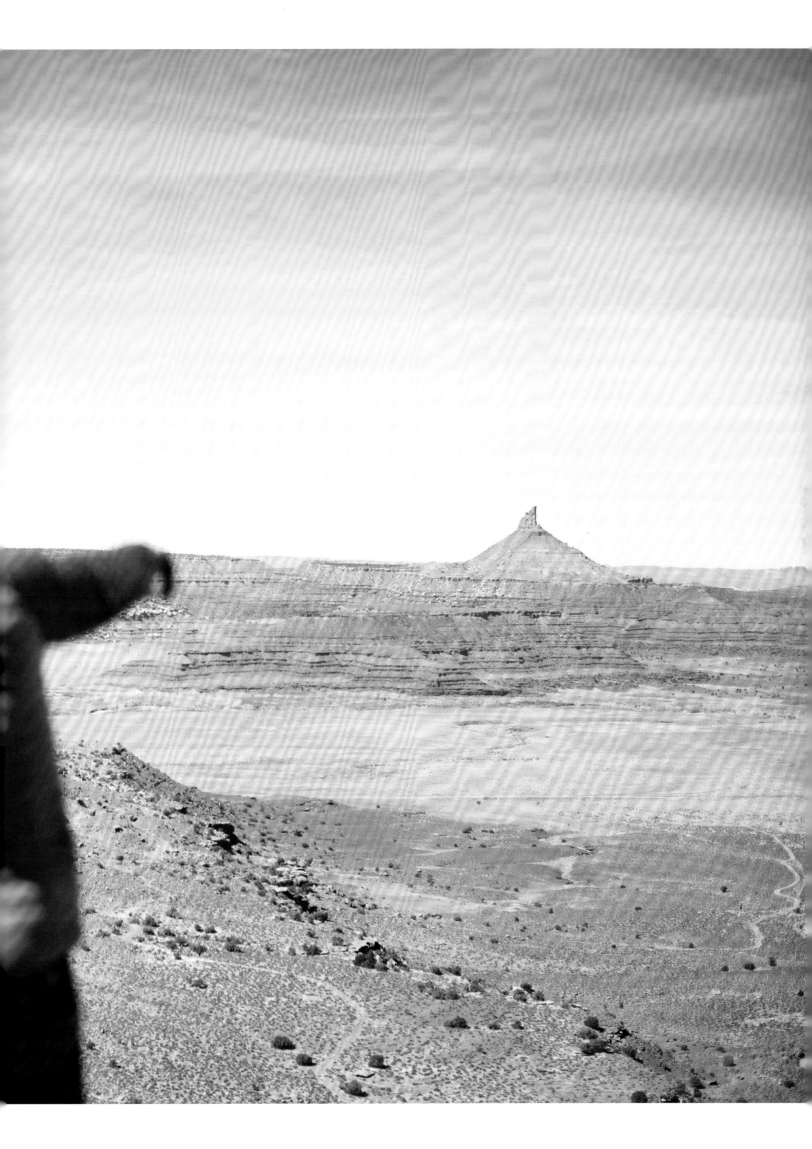

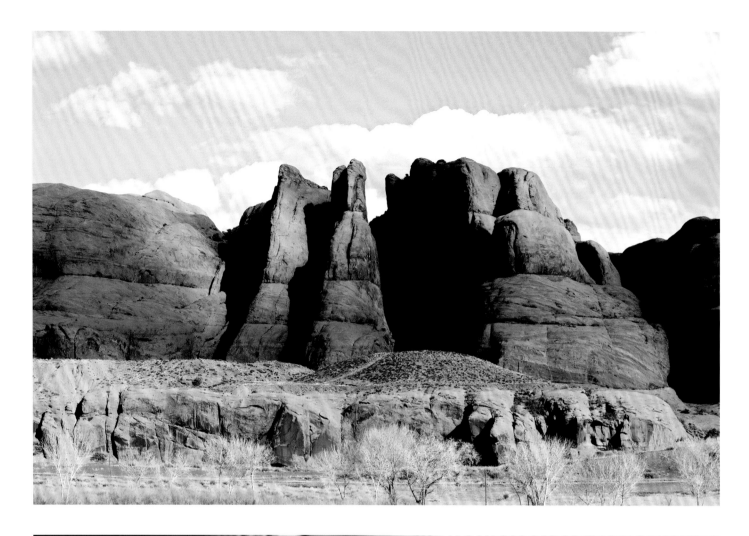

Top
Textures of Moab sandstone, as seen from across Potash Road.

Bottom
Homemade tape gloves offer some—but clearly not complete—relief from abrasion while stuffing hands in cracks.

Right
Skinwalker (5.11)
Sarah Watson putting her face to the stone to pull a unique move in Moab.

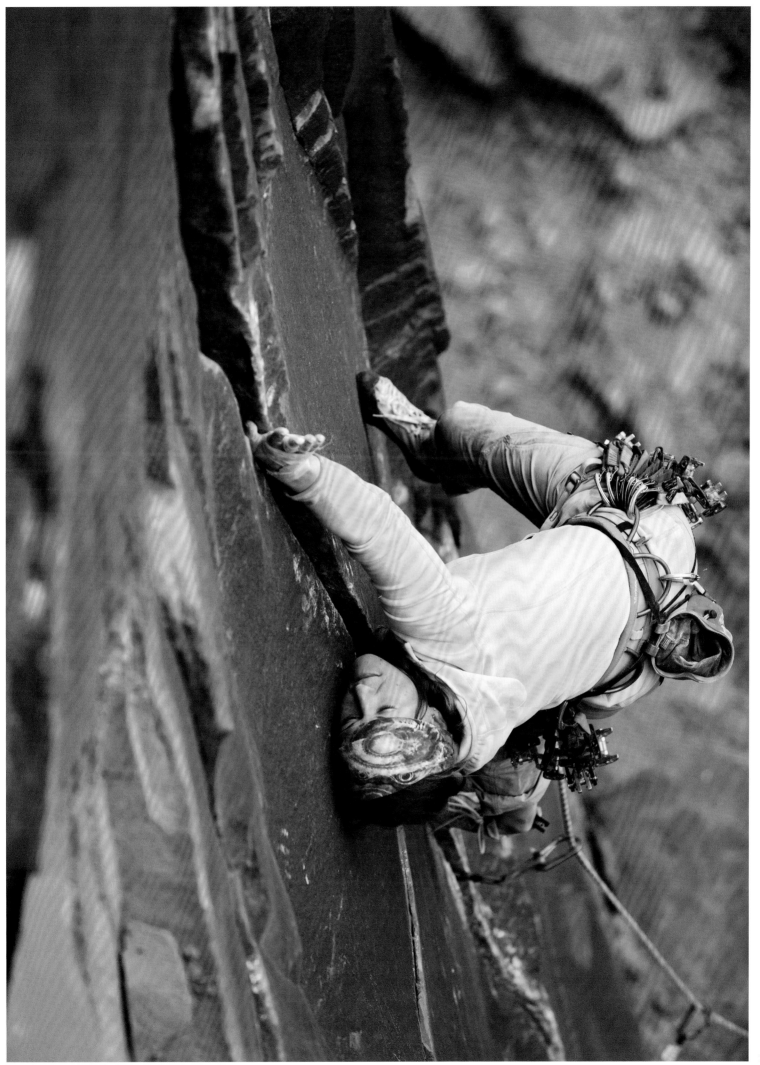

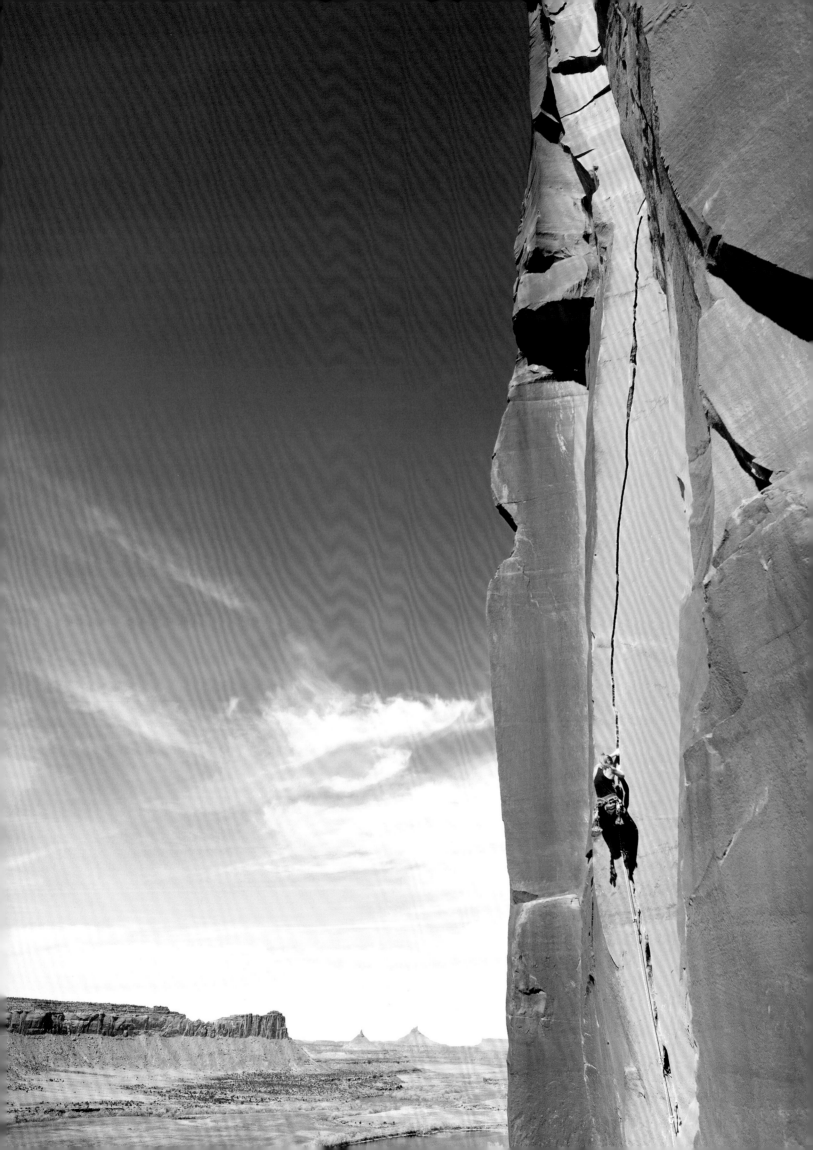

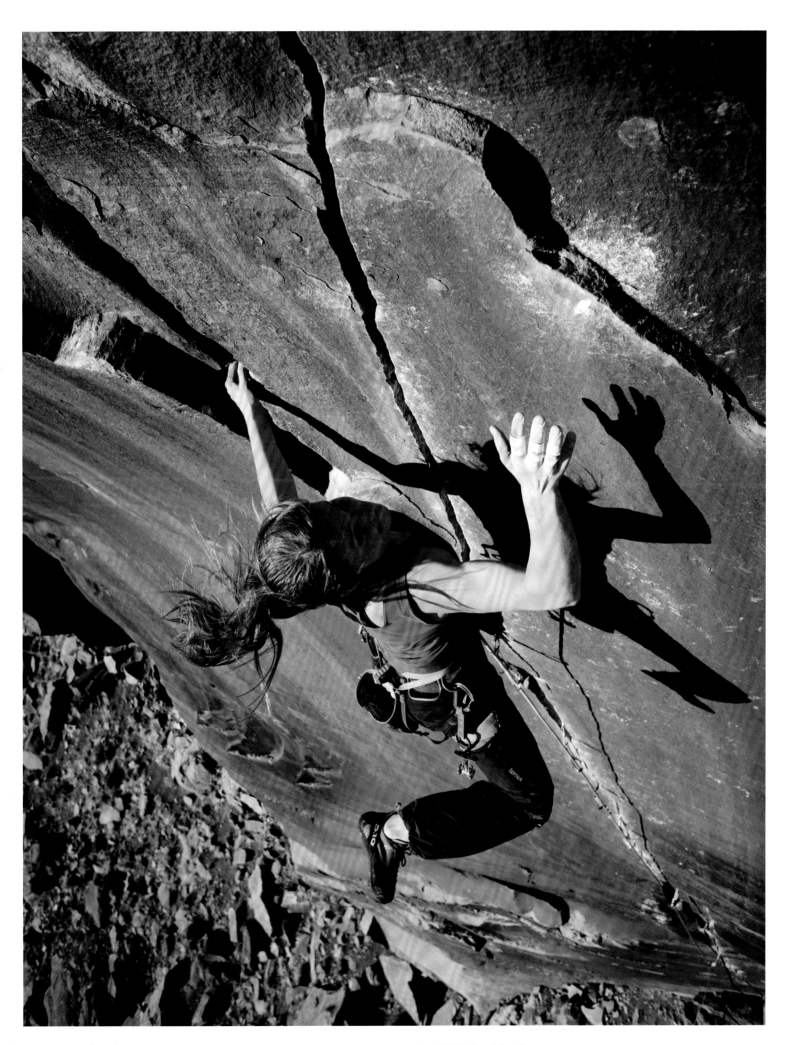

Left *Scarface* **(5.11b)**
Barbara Zangerl cruises up one of Indian Creek's most classic and photogenic cracks. Due to their uniform nature, climbing the splitters of the Creek often requires an extensive rack of the same-sized cams.

Right *Middle Crack* **(5.12)**
Barbara Zangerl commits to a dynamic move to attain the widening crack above.

"My favorite moment on a climb is the choice of no choice—the point where I decide that everything in my mental, physical, and emotional existence goes all in to make and stick the move. It feels like you're defying what's possible through synergy and will."

—Alana Terumi Murao

Right
Extra Lean (5.12-)
Jacopo Larcher laybacking a section of fingercrack on this tricky pitch.

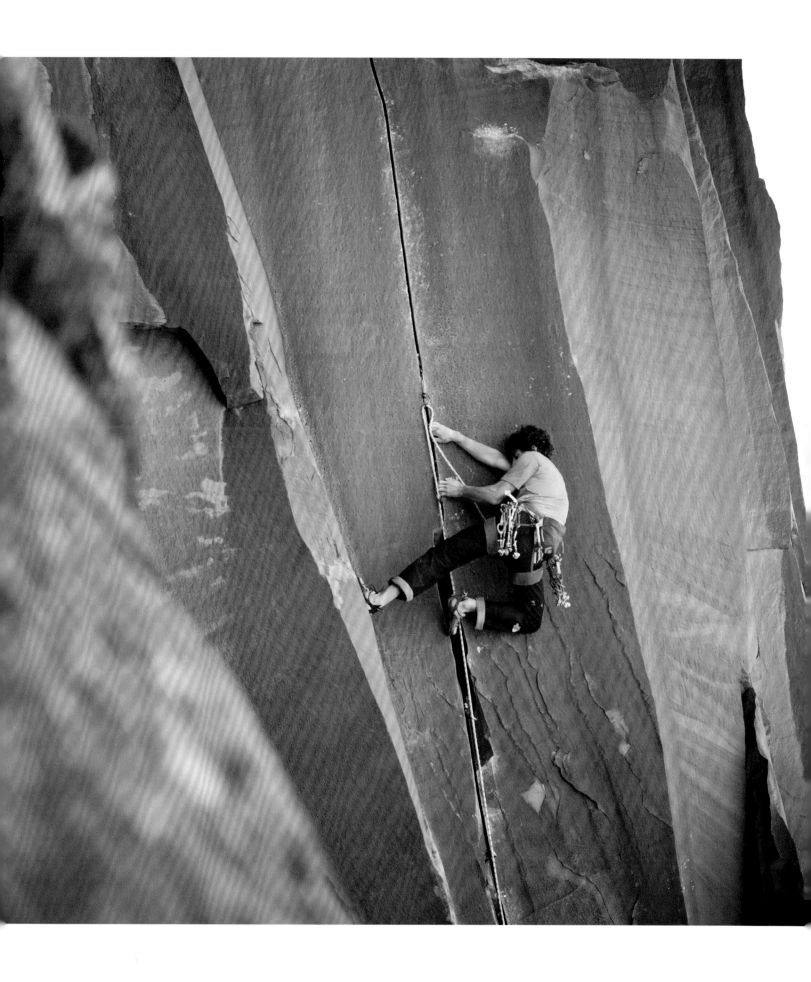

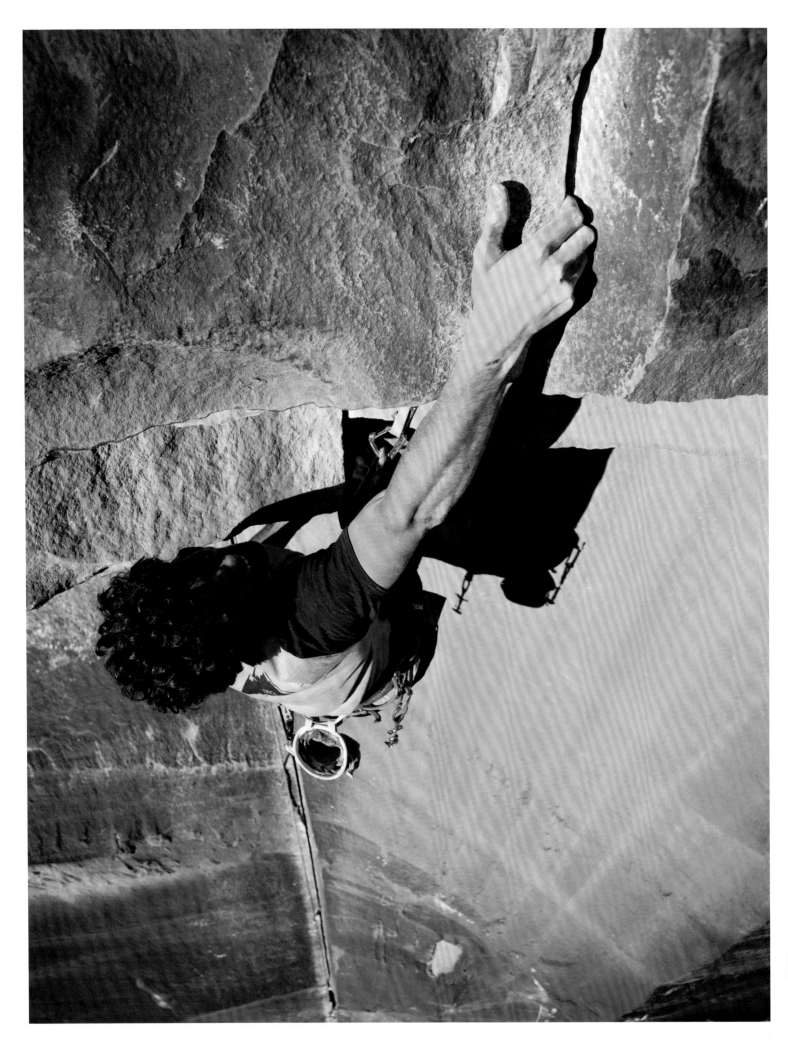

Left *Ruby's Cafe* **(5.12d)**
Jacopo Larcher securing thin fingerlocks above an intimidating roof on this classic Indian Creek testpiece.

Right *Extra Lean* **(5.12-)**
Barbara Zangerl eyeing up a small cam placement before committing to the sustained fingercrack sequence.

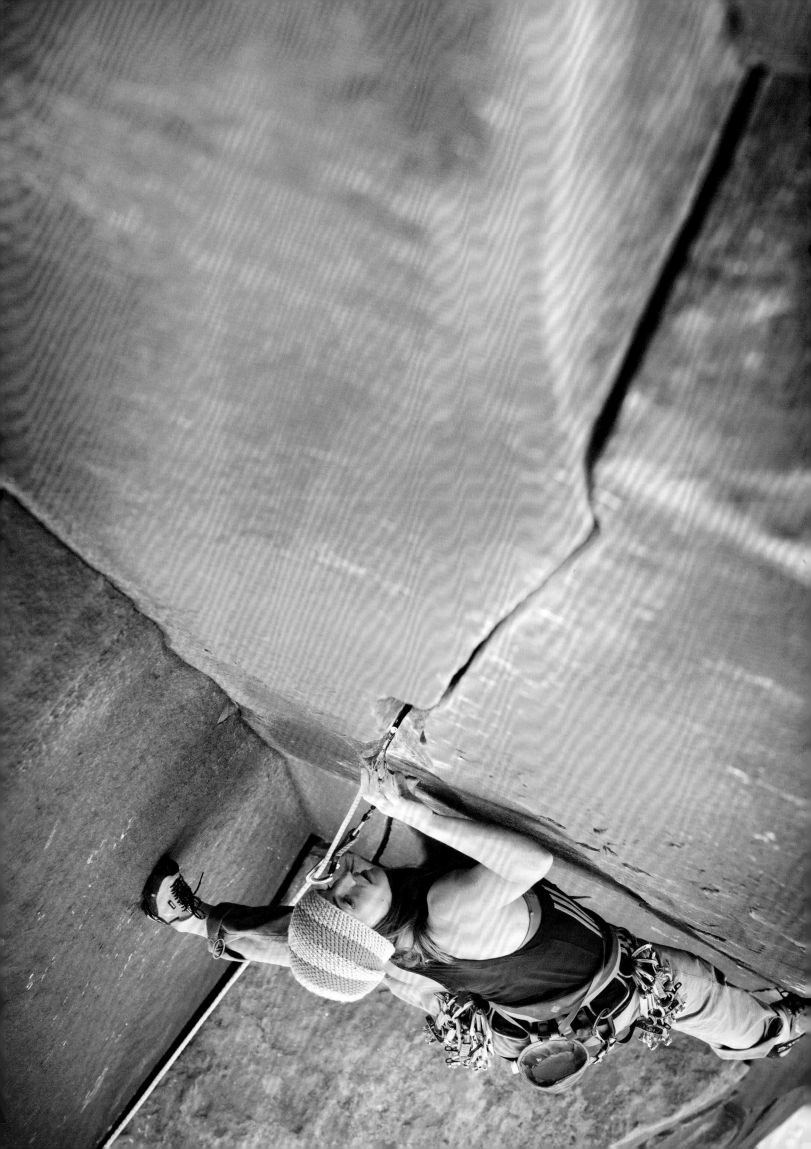

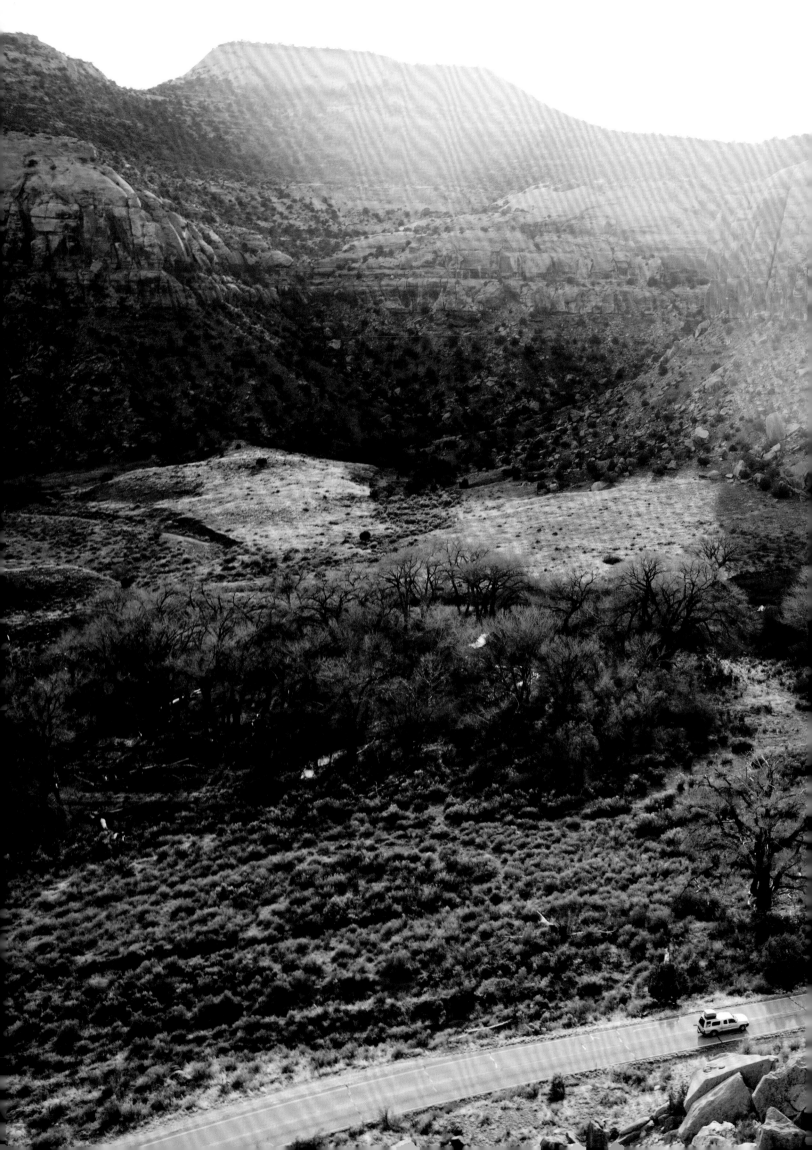

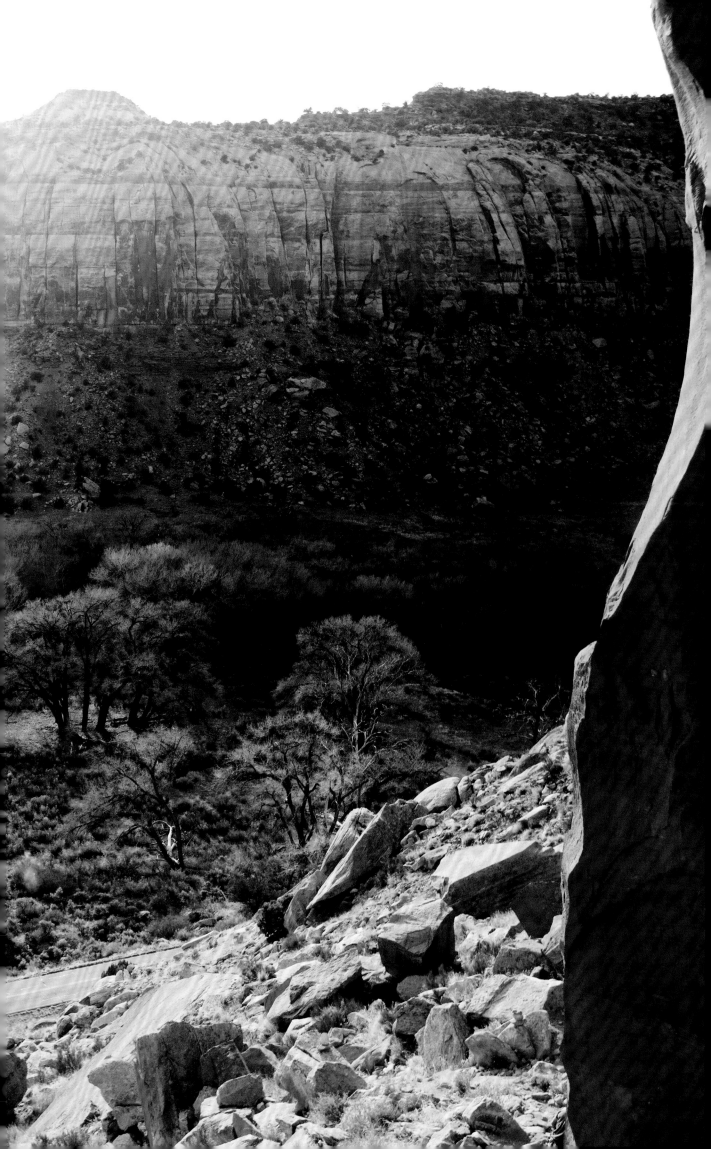

Hurricave

Utah

Type of Climbing:
Sport

Rock Type:
Limestone

Climbing Style:
Inverted, chossy, thuggy

Number of Climbs:
~20

Elevation:
3,000 ft

Prime Season:
October–April

Classic Climbs:
Pot Hunter (5.11b), *Over the Transom* (5.11d),
Grey Fox (5.12c), *Cliffdwellers* (5.13a), *Low
Jam* (5.13a), *Life of Villains* (5.15a)

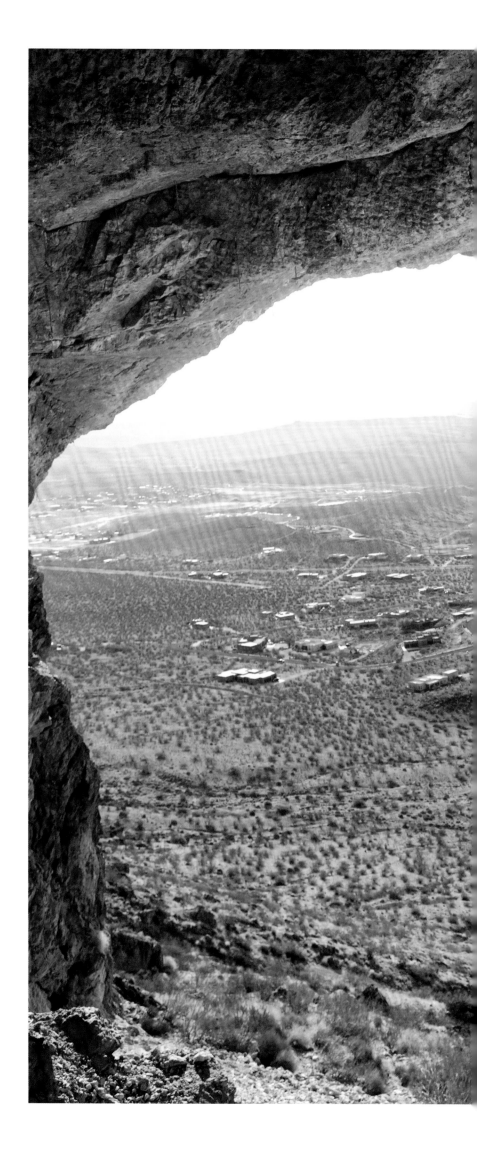

Previous
Indian Creek
On the main road entering into Indian Creek—
one of the country's most revered and popular
climbing areas. The landscape surveyed from the
car is remarkable to the uninitiated, but the best
perspectives are reserved for vertical endeavors.

Right
Flight of the Concords (5.14c)
Jon Cardwell gives a burn on another of Joe
Kinder's bolted testpieces, in the Hurricave of
southwestern Utah.

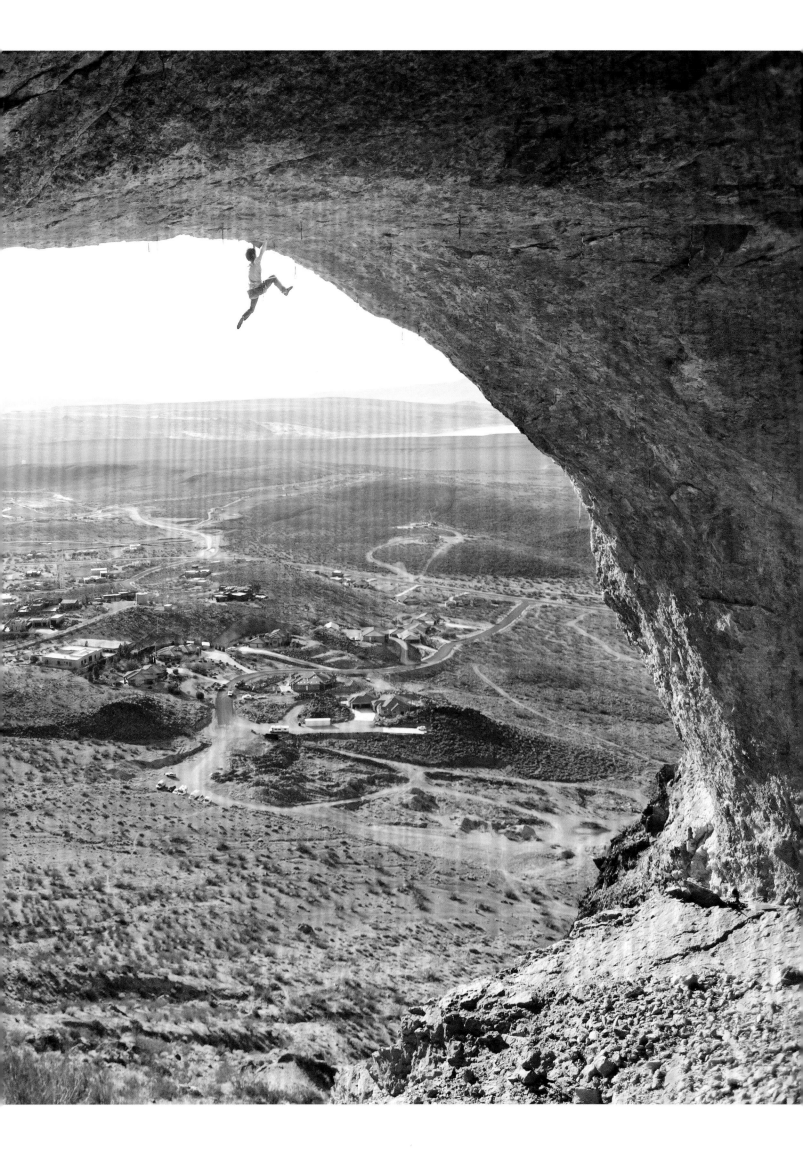

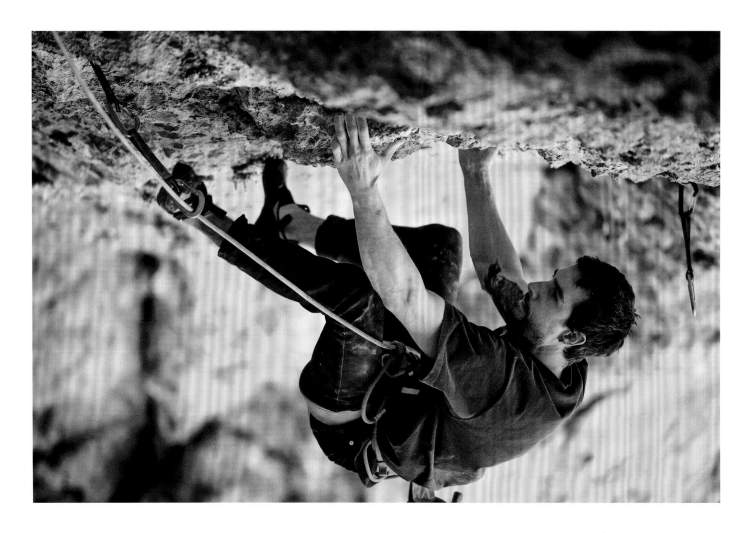

Top
Project
Joe Kinder feeling out the moves on a future project in the center of the Hurricave.

Bottom
Barbara Zangerl and Jacopo Larcher soaking up in the sun in between tries. Attempts on such pumpy overhangs require significant rest between efforts.

Right
The Activator
Joe Kinder on an undone climb that still waits for a redpoint.

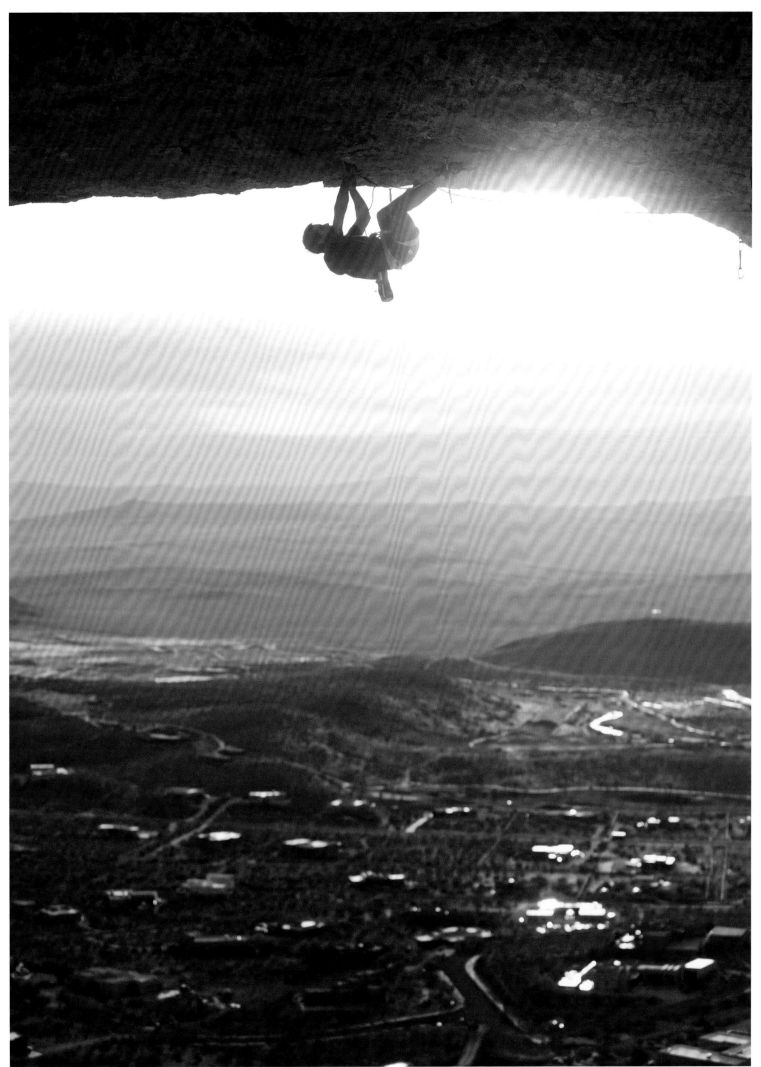

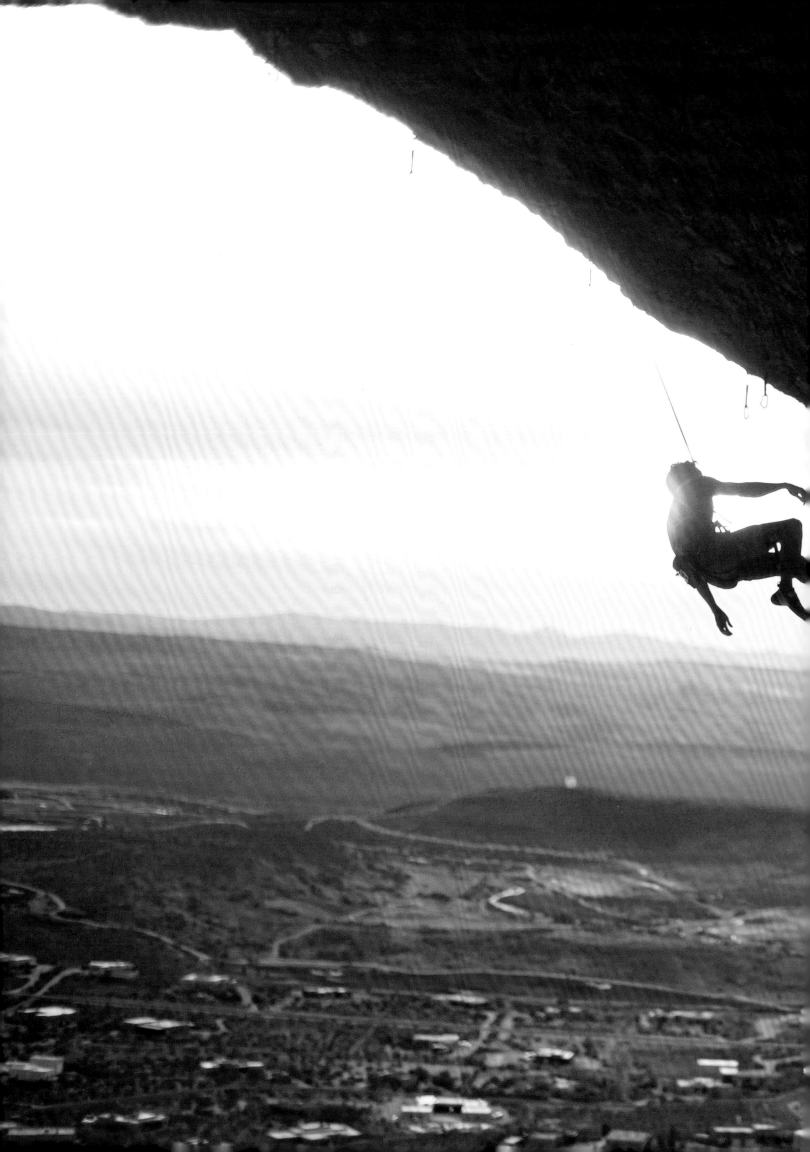

Zion

Utah

Type of Climbing:
Bigwall, trad, sport, bouldering, aid

Rock Type:
Sandstone

Climbing Style:
Adventurous, committing

Number of Climbs:
~300

Elevation:
5,458 ft

Prime Season:
March–May, October–November

Classic Climbs:
Prodigal Son (5.8 C2), *Touchstone Wall* (5.9 C2),
Moonlight Buttress (5.12+), *The Headache* (5.10),
Iron Messiah (5.10b), *Shune's Buttress* (5.11+),
Monkeyfinger (5.12), *Huecos Rancheros* (5.12b/c)

Previous
Life of Villains **(5.15a)**
Ben Spannuth on a redpoint attempt of one of Joe
Kinder's extremely difficult routes. Joe sent this
long-term project in spring 2018 after sixty days
of effort. It was his first climb at the grade, at age
thirty-seven.

Right
Play of light and textures in Zion, the view across
the canyon from Moonlight Buttress.

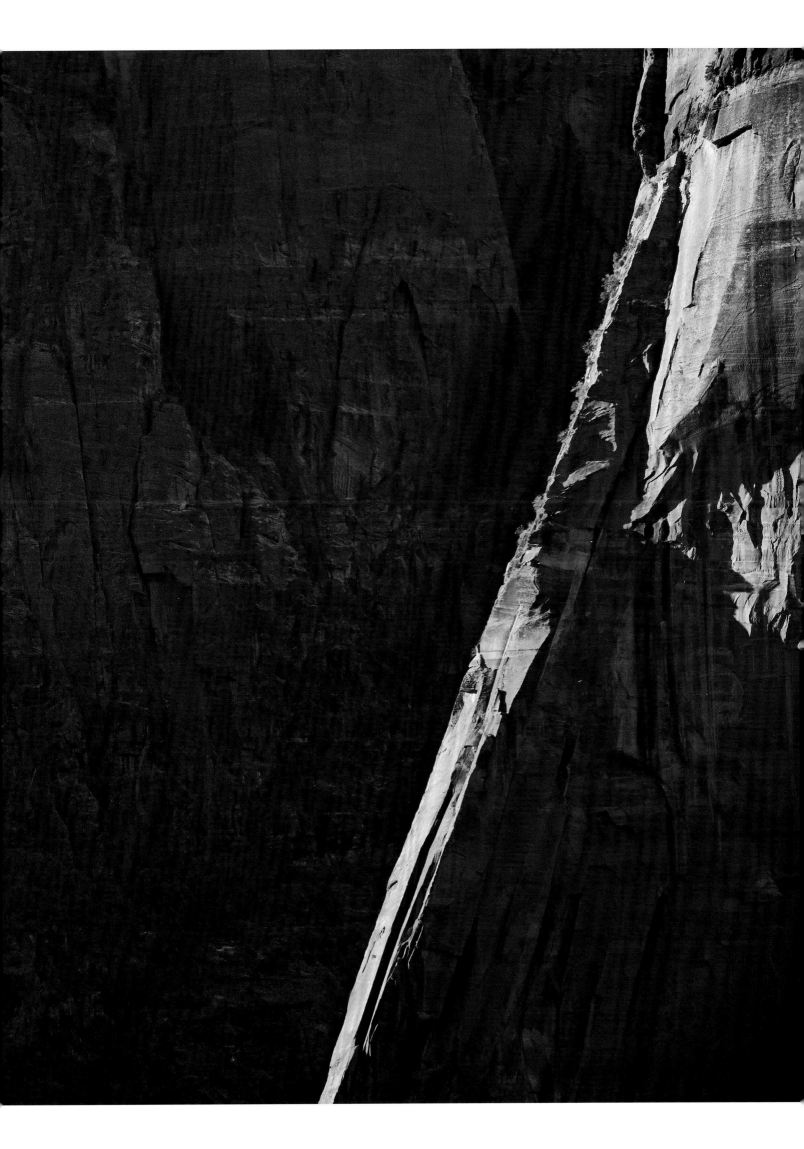

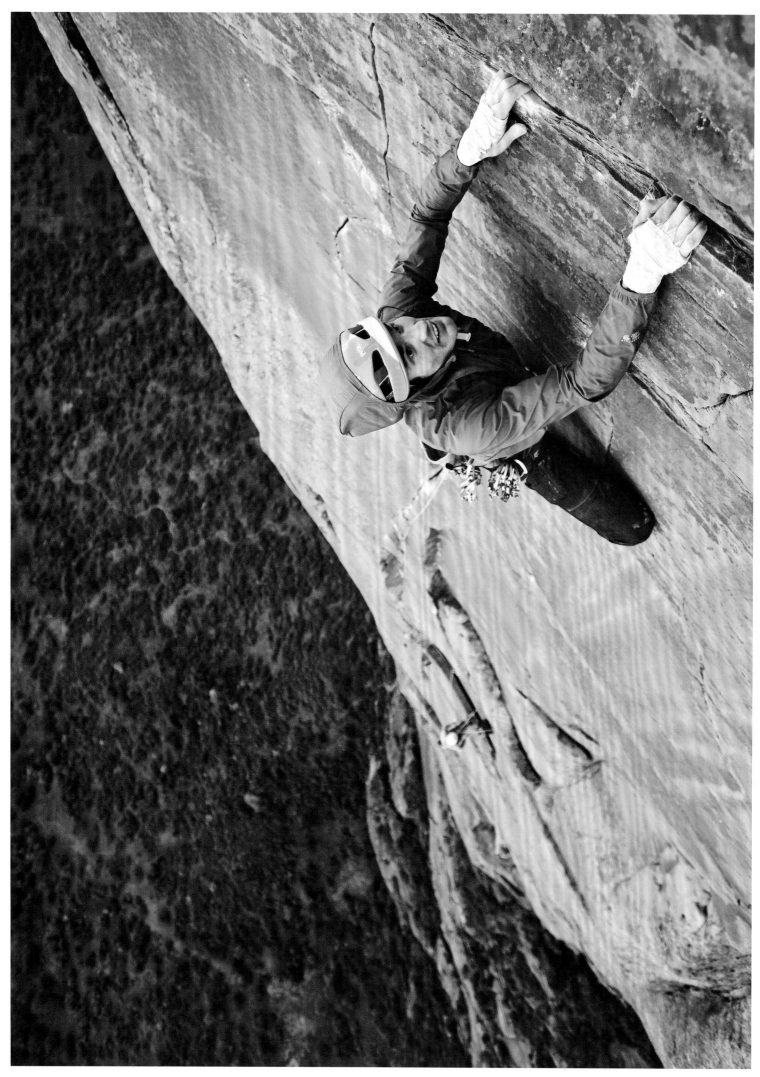

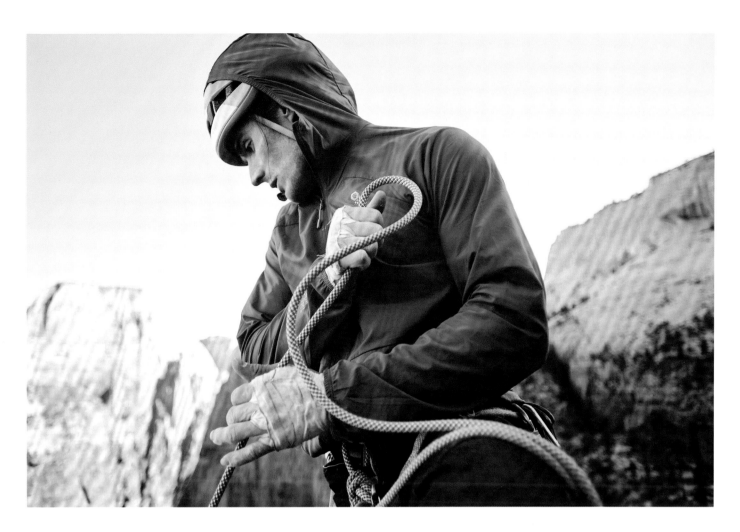

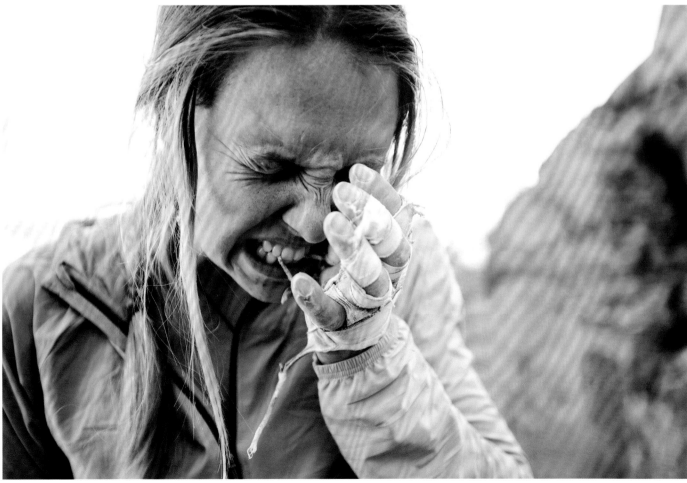

Left
Moonlight Buttress (5.12+) pitch 9
Ethan Pringle enjoying the relief of a pleasant horizontal after one of the last difficult sections of the 1,200-foot wall.

Top
Ethan Pringle pulling up rope after topping out _Moonlight Buttress_ (5.12+).

Bottom
Tiffany Hensley initiates the classic tape glove removal process after climbing _Moonlight Buttress_ (5.12+).

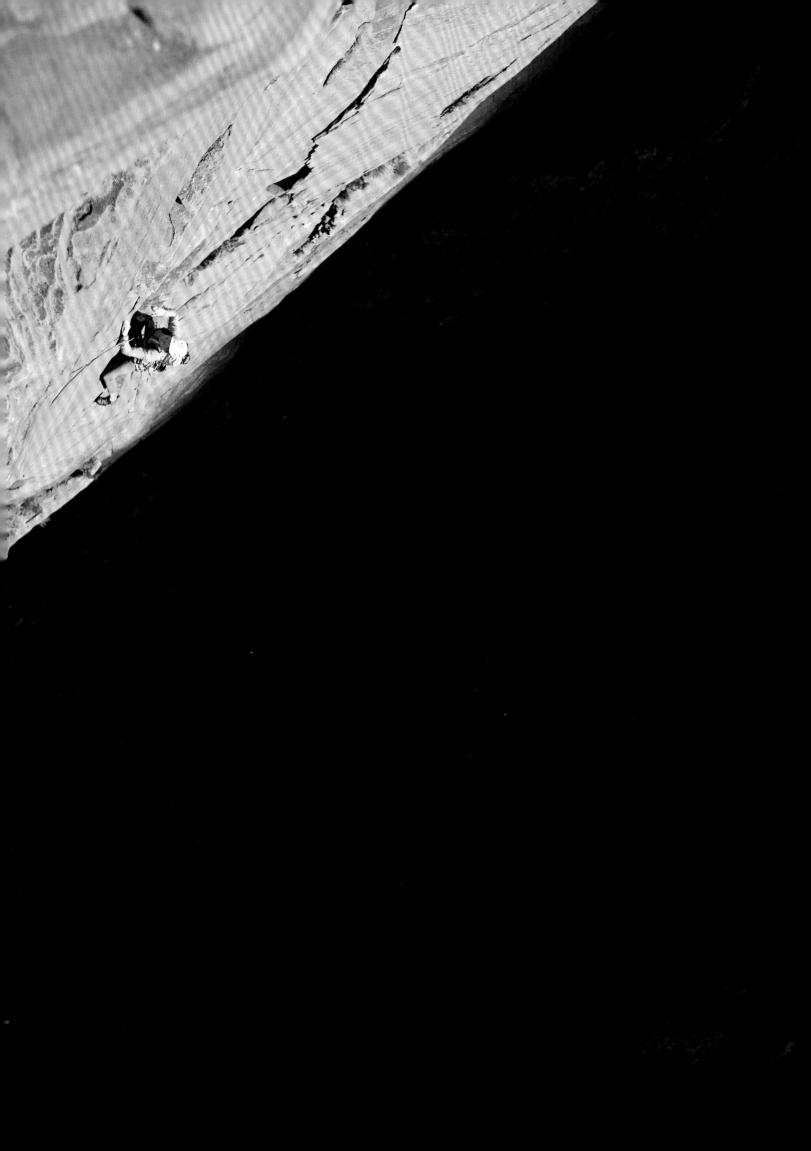

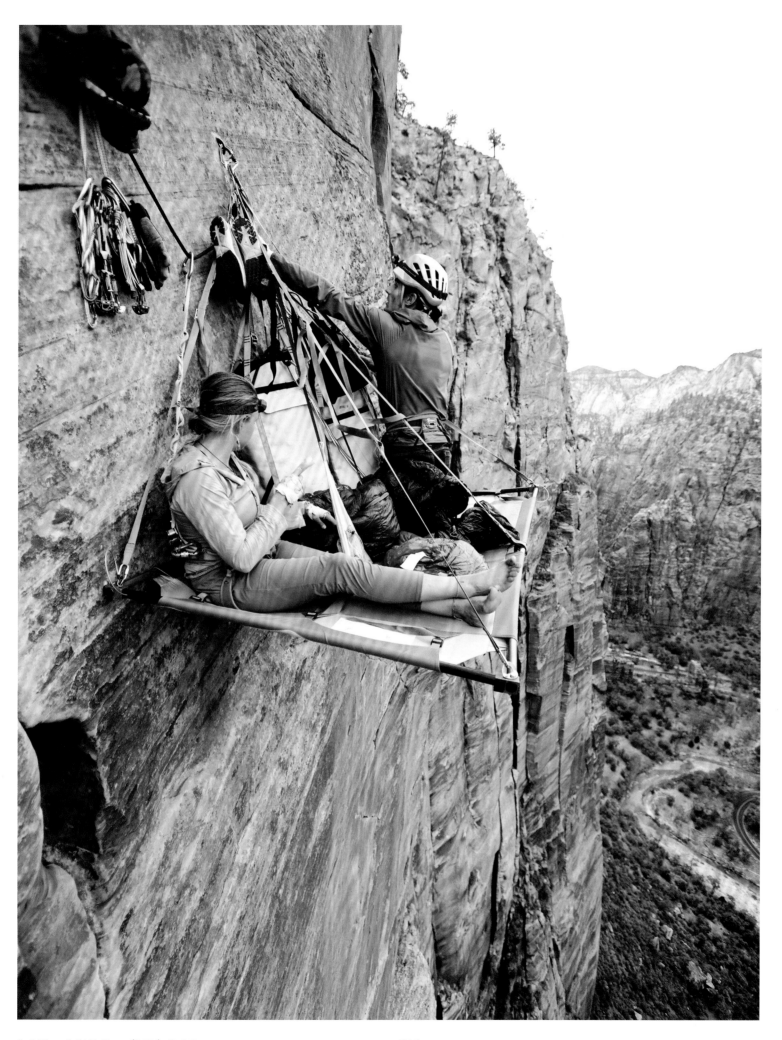

Left *Moonlight Buttress* **(5.12+) pitch 3**
Tiffany Hensley warming up on the lower sections of the wall in the early morning light.

Right
Ethan Pringle and Tiffany Hensley setting up a portaledge on the wall of *Moonlight Buttress*, after his onsight. There's nothing quite like relaxing into a scenic evening on a portaledge after a long day on the wall.

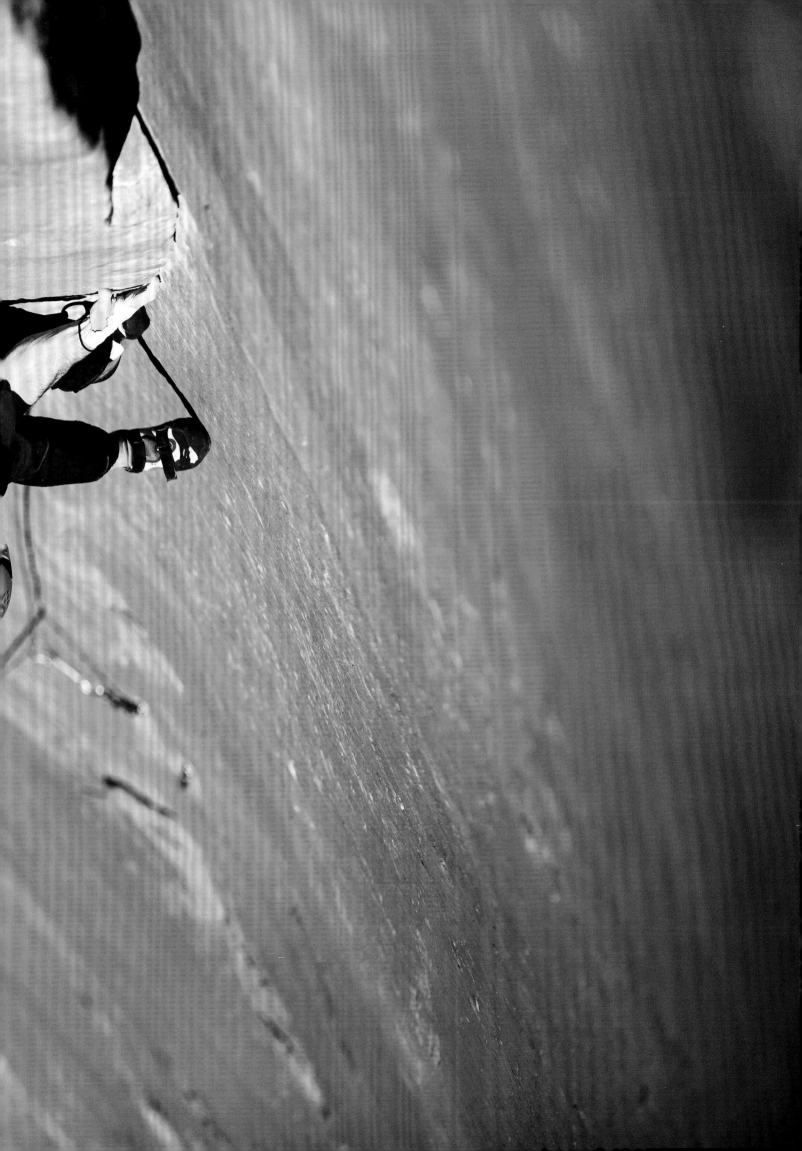

"I love the presence of mind that difficult climbing requires. If you're distracted by the fear of your perceived limitations, of failure or injury, of judgment from yourself or others, you cannot climb near your limit. But paradoxically, you must first notice and identify this fear, to return to the present moment. Moving over stone, like moving through life, is a practice of noticing, and continually returning to the present moment."

—Ethan Pringle

Previous
Moonlight Buttress **(5.12+) pitch 5**
Ethan Pringle working his way up a sea of sandstone. This is the famed boulder problem pitch, which arguably contains the hardest single move on the wall.

Right
The scenic landscape of Zion National Park. Walking between buttresses provides access to Angel's Landing, the wall on the west side containing a variety of bigwall routes and more beautiful perspectives on the prevailing canyon.

Virgin River Gorge

Arizona

Type of Climbing:
Sport

Rock Type:
Limestone

Climbing Style:
Sustained, technical

Number of Climbs:
~50

Elevation:
2,258 ft

Prime Season:
November–March

Classic Climbs:
Bloody Mary (5.11c), *Forever Man* (5.12b), *Mentor* (5.12b), *Dirt Cowboy* (5.12c), *Joe Six Pack* (5.13a), *The Fall of Man* (5.13b), *Necessary Evil* (5.14c)

Right
Jon Cardwell exploring to find a sunny rest spot to recover between attempts.

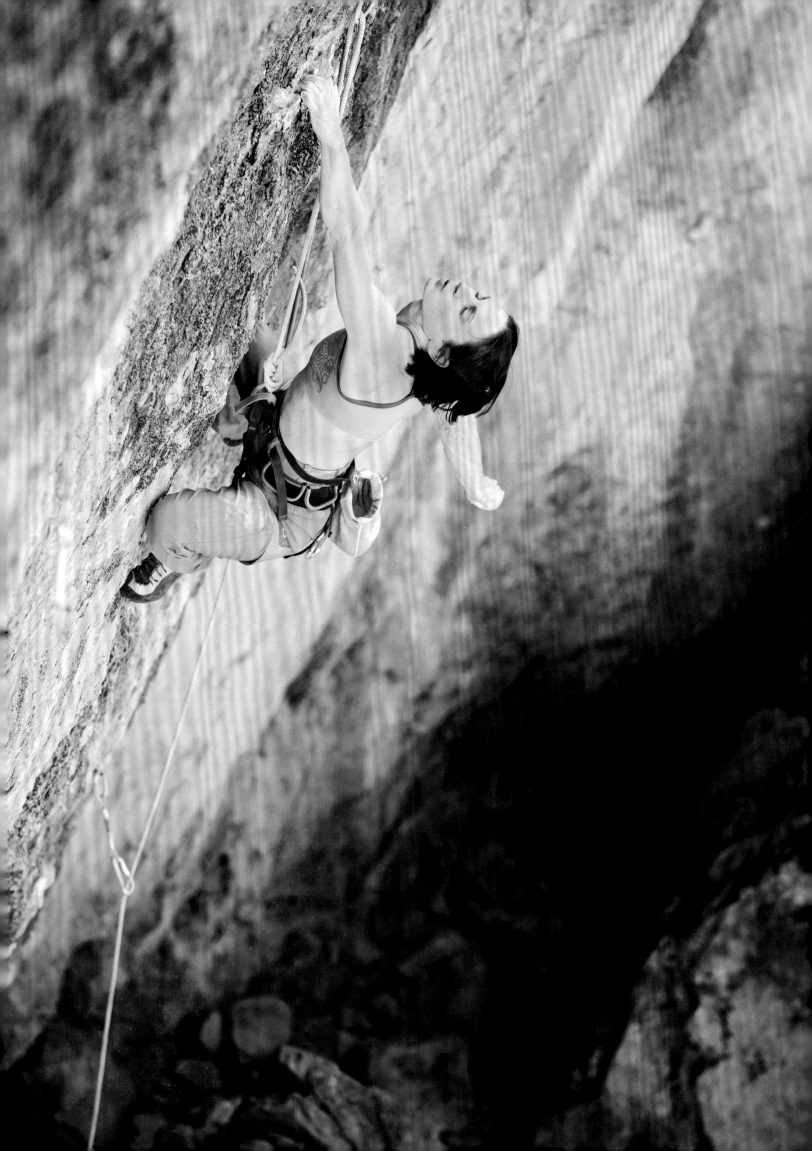

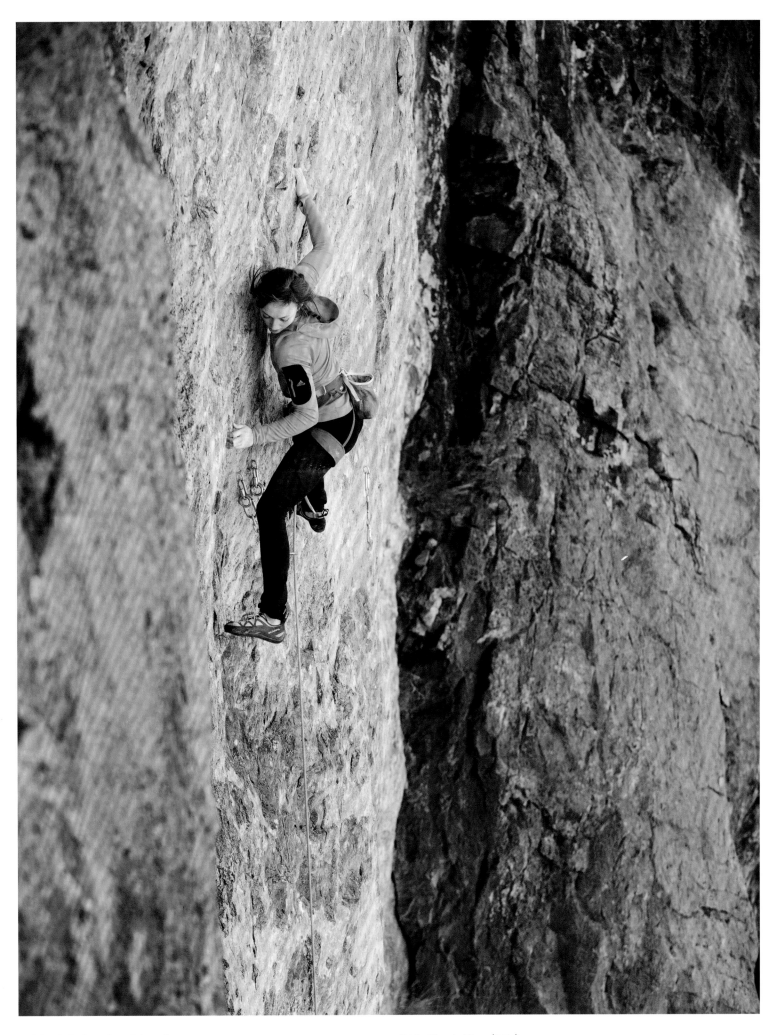

Left ***Don't Call me Coach*** (5.13d)
Anne Struble working gracefully through the sustained, quality limestone of the VRG.

Right ***Bloody Mary*** (5.11c)
Jessica Sewell tic-tacs her way up some delicate face moves.

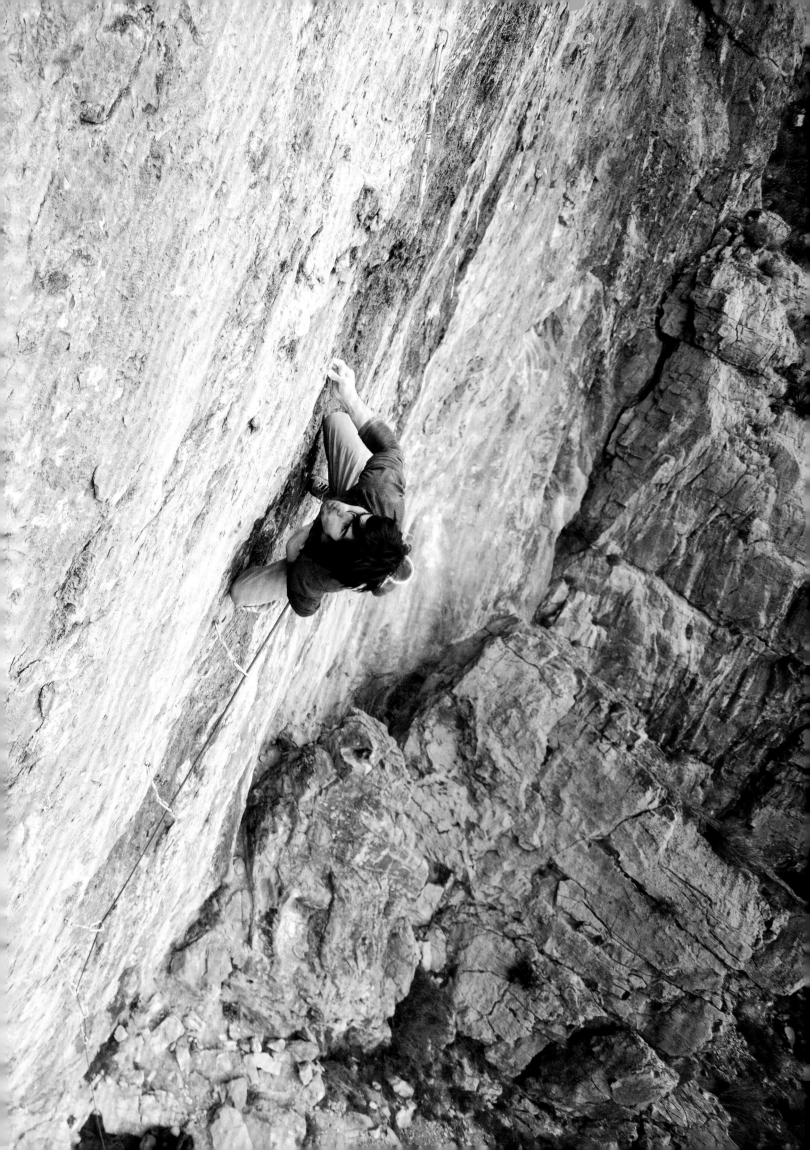

"From the original masochistic malcontents who pulled the choss, moss, and death blocks off of rock walls to unearth either worthy, compelling routes or contrived torture relays, to the later generations who stepped up to do battle with all who sent the line before them, any fledgling adventurers who were previously terrible conversationalists and no fun at parties can venture out to attempt rock climbing, and thereby calm their almost unquenchable desire to individuate themselves from a world otherwise filled with the faint of heart and feeble of mind. These brave souls voluntarily leap into the trenches of solitary warfare, and, if they survive, re-emerge refined, hardened, and special, bound to their comrades-in-arms who sacrificed themselves before them in order to advance the line. Thus does our sport progress."

—Lydia McDonald

Previous
Necessary Evil (5.14c)
Jon Cardwell during a redpoint attempt on this notorious route. Although Chris Sharma made the first ascent over 20 years ago, it remains challenging to today's top climbers.

Right
Jon Cardwell taking in the scenery—as well as the exhaust—of the Virgin River Gorge.

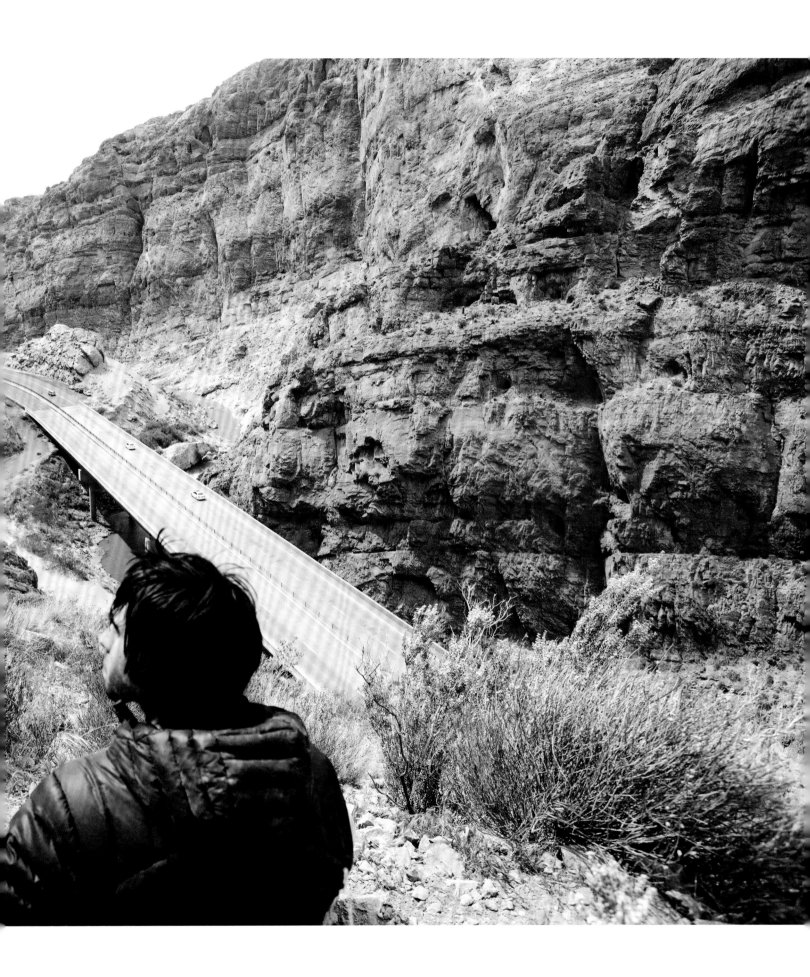

Red Rock

Nevada

Type of Climbing:
Trad, sport, bouldering

Rock Type:
Sandstone

Climbing Style:
Adventurous, panoramic, expansive

Number of Climbs:
2,400+

Elevation:
3,702 ft

Prime Season:
March–April, October–November

Classic Climbs:
Solar Slab (5.6), *Dark Shadows* (5.8),
Epinephrine (5.9), *Triassic Sands* (5.10),
Levitation 29 (5.11b/c), *Original Route on
Rainbow Wall* (5.12-), *Cloud Tower* (5.12a),
Plumber's Crack (V2), *Hyperglide* (V5),
Fear of a Black Hat (V9)

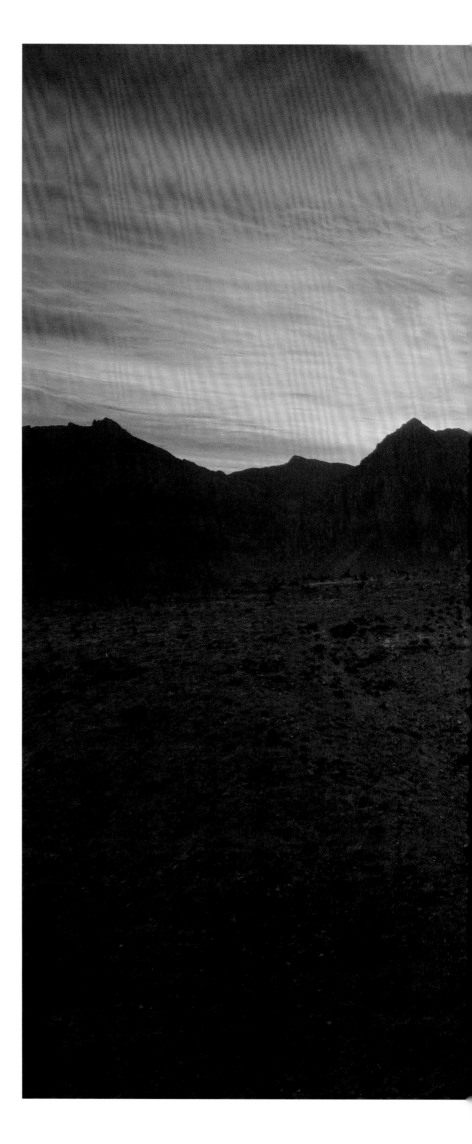

Right
Perspective of the iron-striated mountains of Red
Rock, from the vantage point of the Gallery crag.

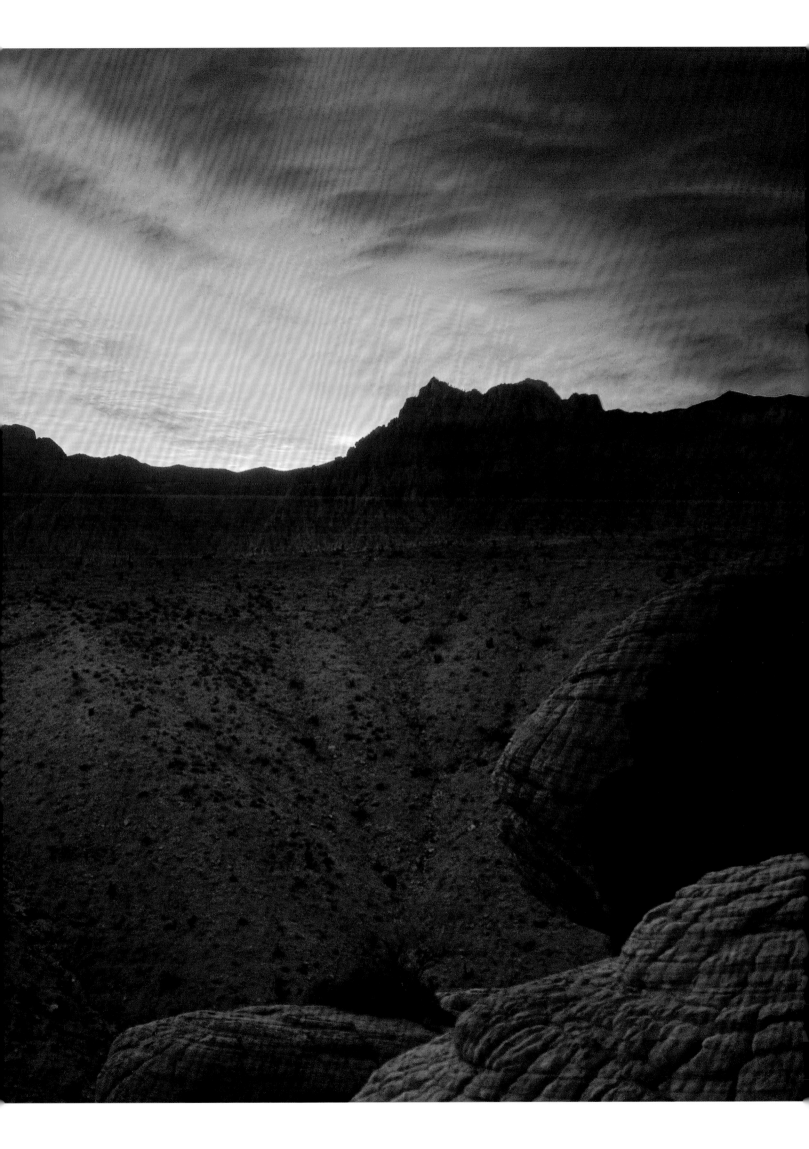

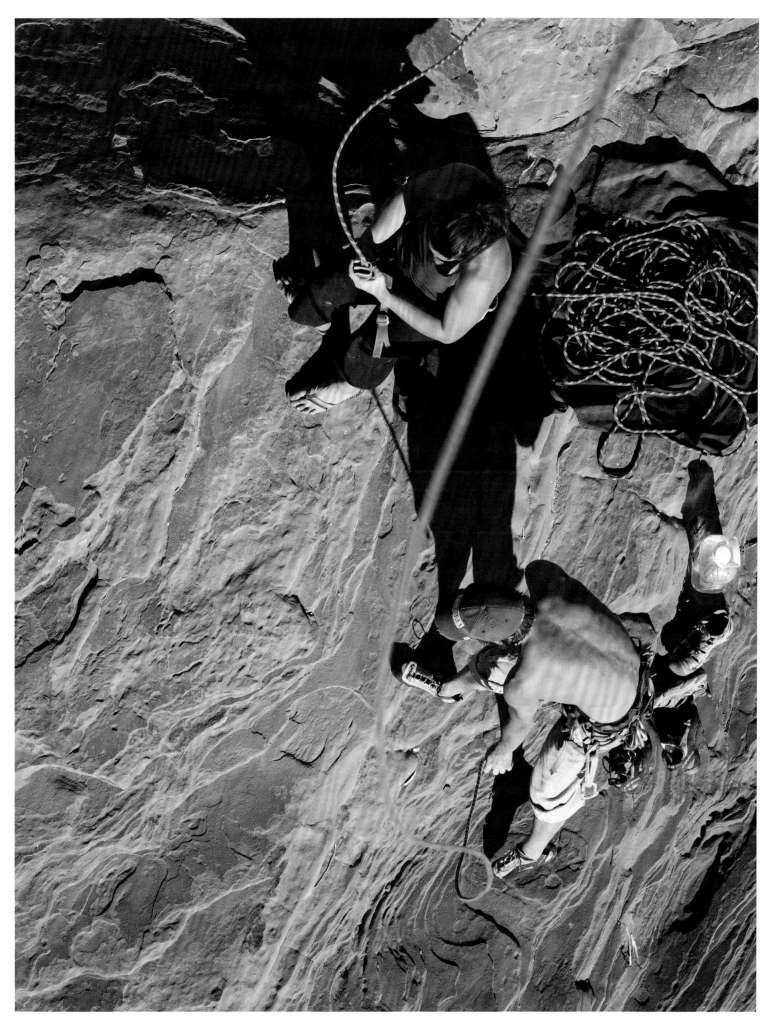

Left *Fear and Loathing* (5.12a)
Eve-Lyne Rochon working through overhanging jugs before the crux section of this popular climb.

Right
Eve-Lyne Rochon and François Yvon exchanging belays after climbing *Yaak Crack* (5.11c) at the Gallery.

"Some wild aspect of our nature chooses chaos over order, danger over safety, and suffering over comfort. But in doing so, it somehow gives us a chance to make sense of it all. For what gives life more meaning than the awareness of death, the chance to overcome, and a glimpse of the staggering beauty of these ancient forms? That is the gift of the mountains."

—Van Vu

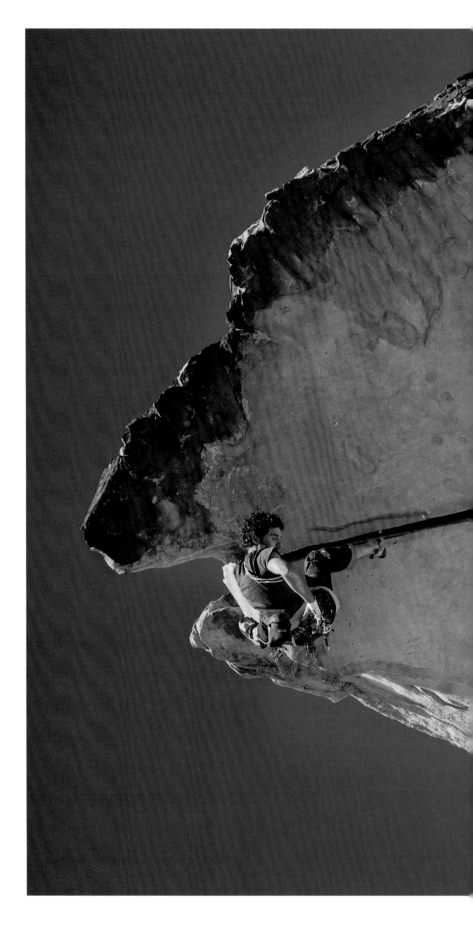

Right
Desert Gold (5.13a)
Jacopo Larcher casts a surreal shadow from a surreal stance. This incredible roof crack, attained only after a sequence of hard moves down below, is one of Red Rock's legendary routes and attracts attention from top climbers worldwide.

Following
Desert Gold (5.13a)
Barbara Zangerl works her way across the famous roof crack with a dancer's precision.

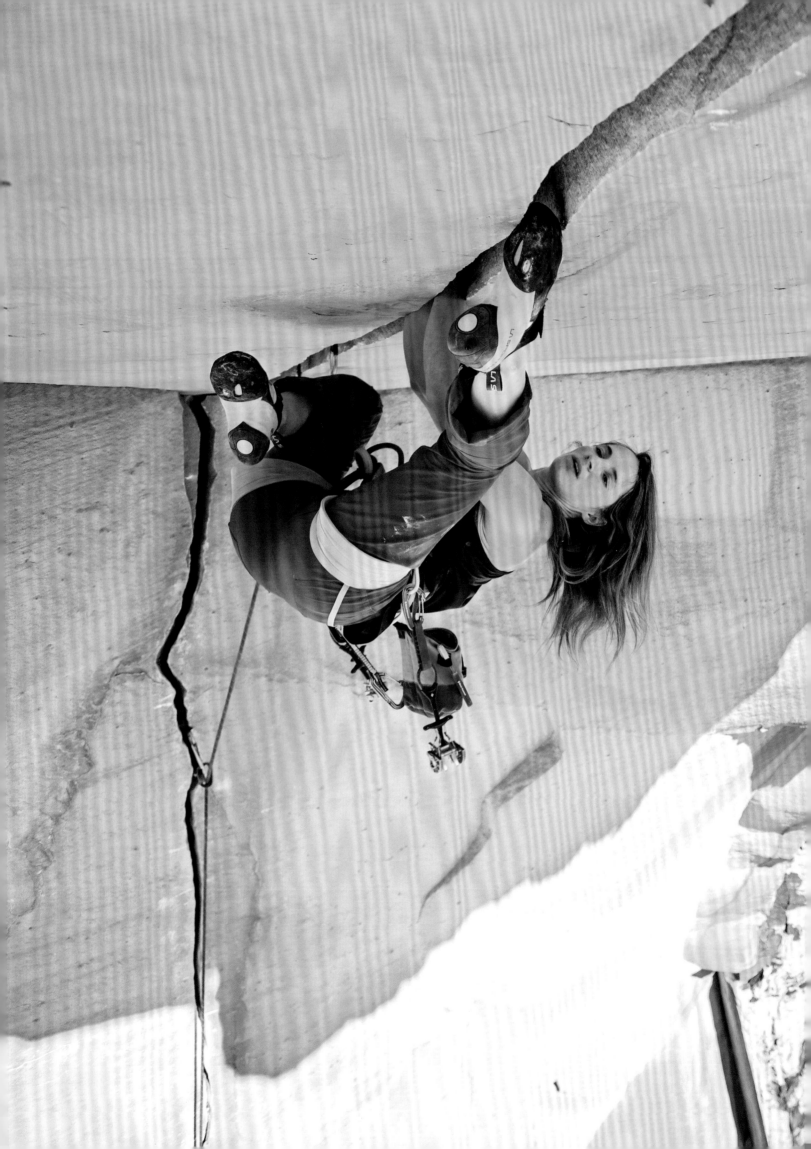

Yosemite Valley

California

Type of Climbing:
Bigwall, trad, sport, bouldering

Rock Type:
Granite

Climbing Style:
Slab, cracks, technical

Number of Climbs:
~1,800

Elevation:
4,000 ft

Prime Season:
May–October

Classic Climbs:
Royal Arches (5.7), *Nutcracker* (5.8), *Regular Northwest Face of Half Dome* (5.9 C1), *The Nose* (5.9 C2), *Salathe Wall* (5.9 C2), *Steck-Salathe* (5.10-), *The Rostrum* (5.11c), *Astroman* (5.11c), *Separate Reality* (5.12a)

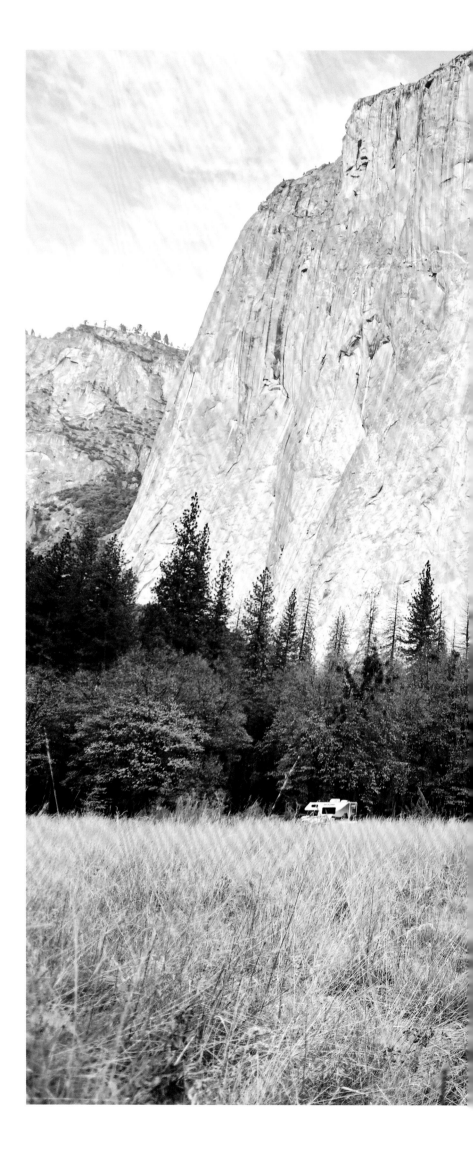

Right
El Capitan Meadow
Marco Jubes and Jernej Kruder scoping out *Golden Gate* (5.13a), one of El Capitan's hard free routes. The route was freed in 2001 by Alexander Huber and Max Reichel. The free-climbing revolution on El Cap began in 1988 with Todd Skinner and Paul Piana's free ascent of *Salathe Wall* (5.13b), and has slowly picked up steam over the last three decades.

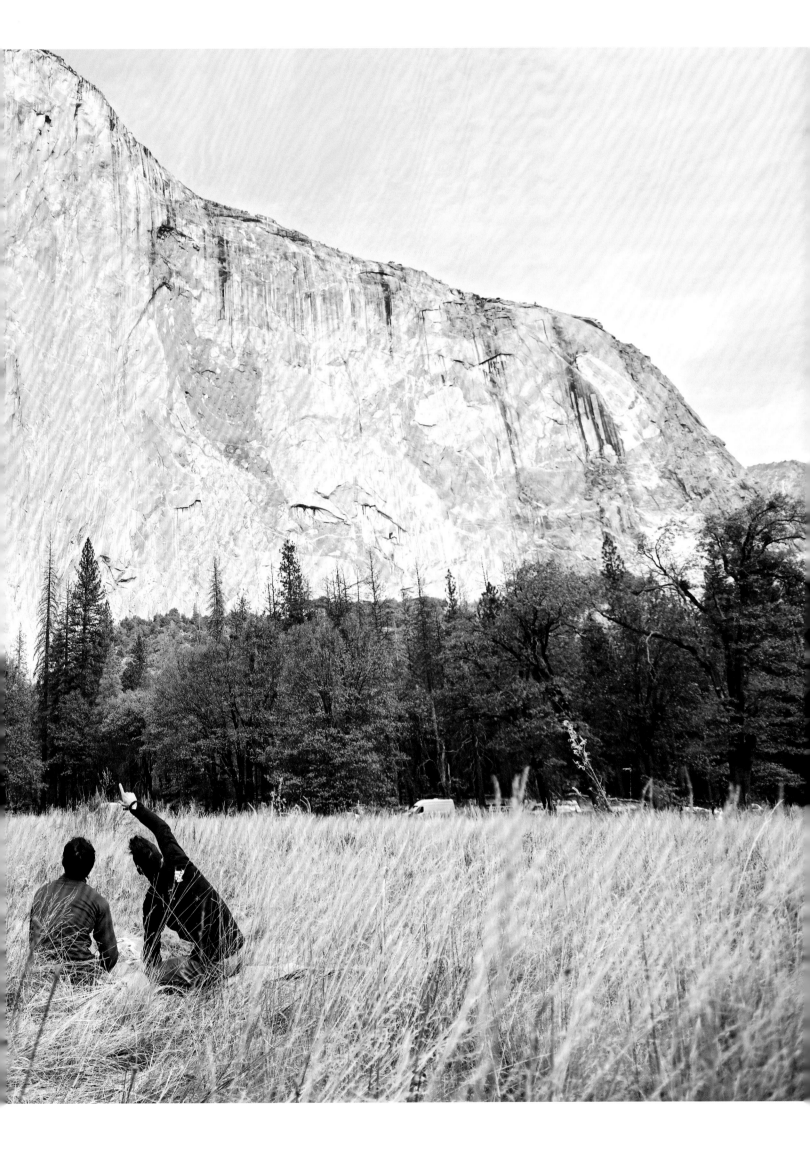

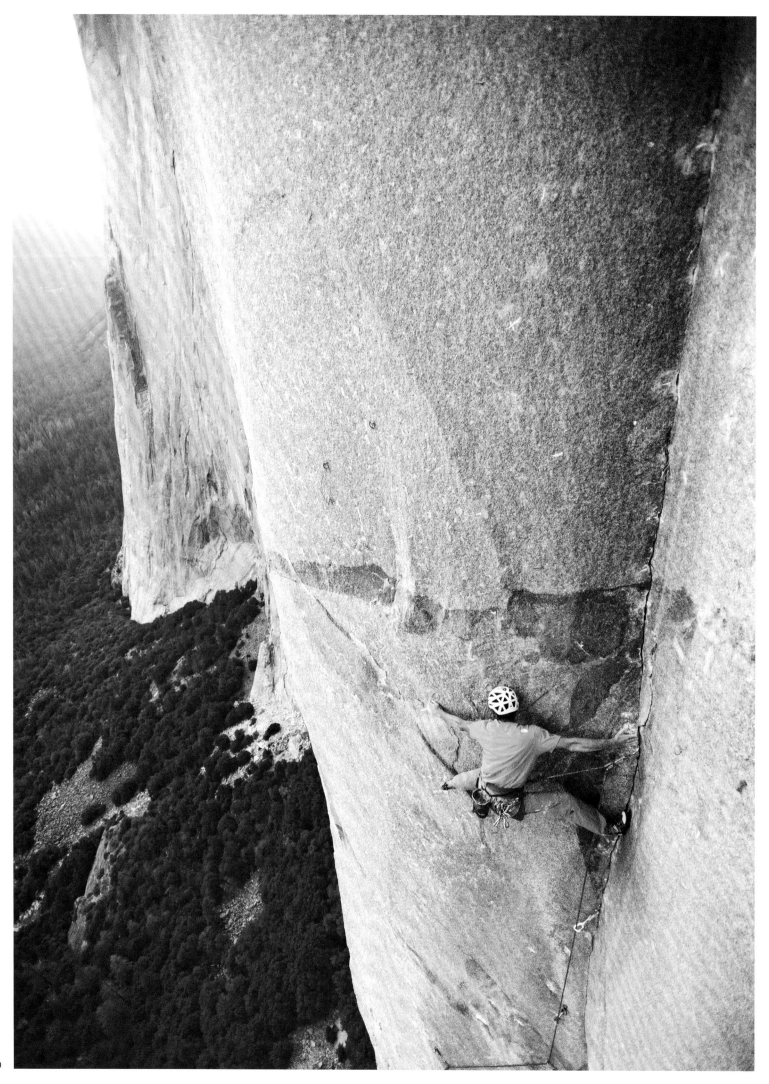

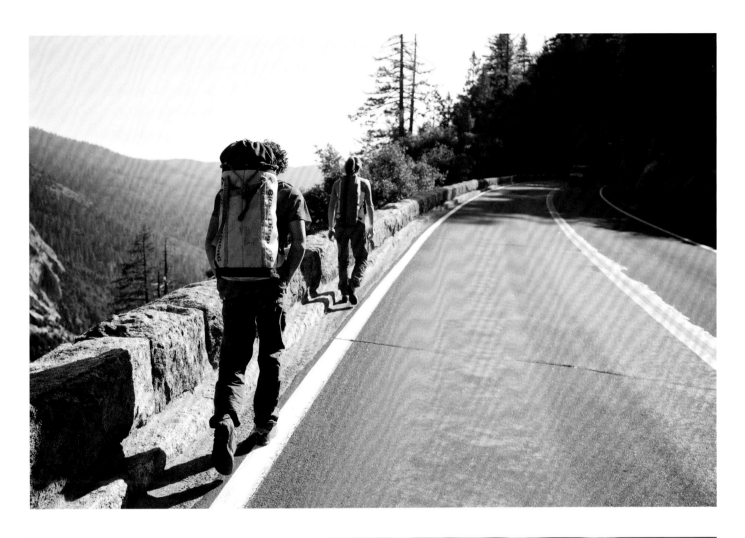

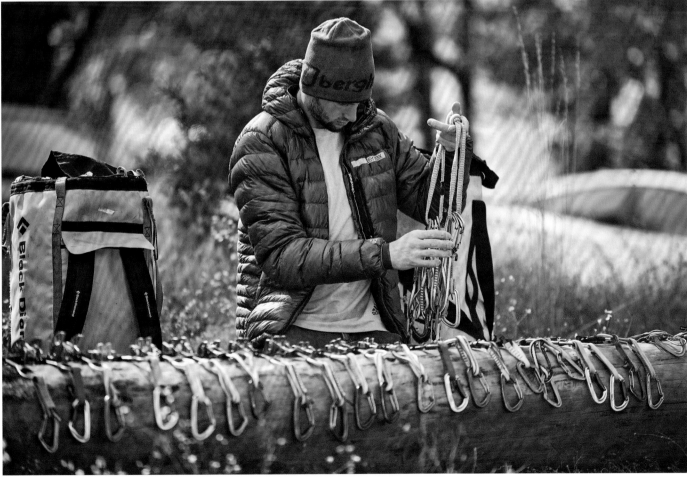

Left
***Zodiac* (5.13+), Open Book Pitch**
Jacopo Larcher testing the full potential of his wingspan on a five-day free ascent of this famous route on El Capitan.

Top
Jacopo Larcher and Barbara Zangerl on the Highway 120 approach toward *Separate Reality*.

Bottom
Jernej Kruder re-racking his gear after an ascent of *Golden Gate*.

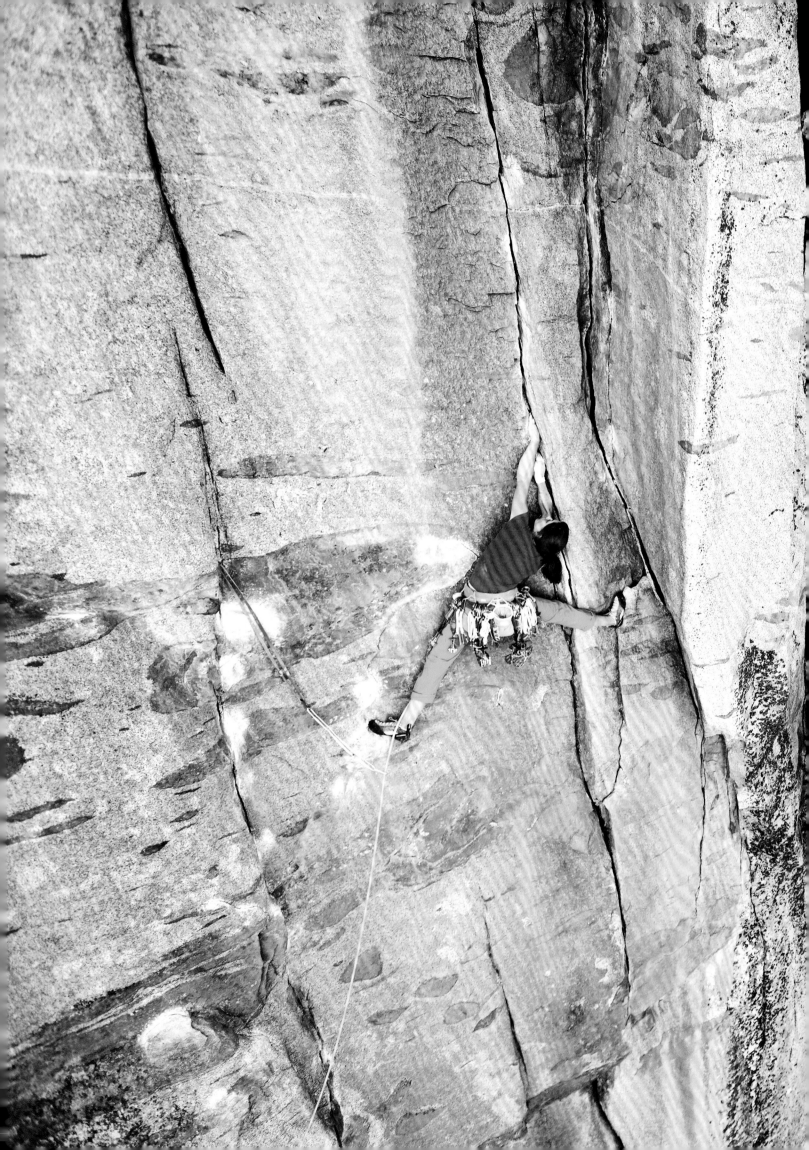

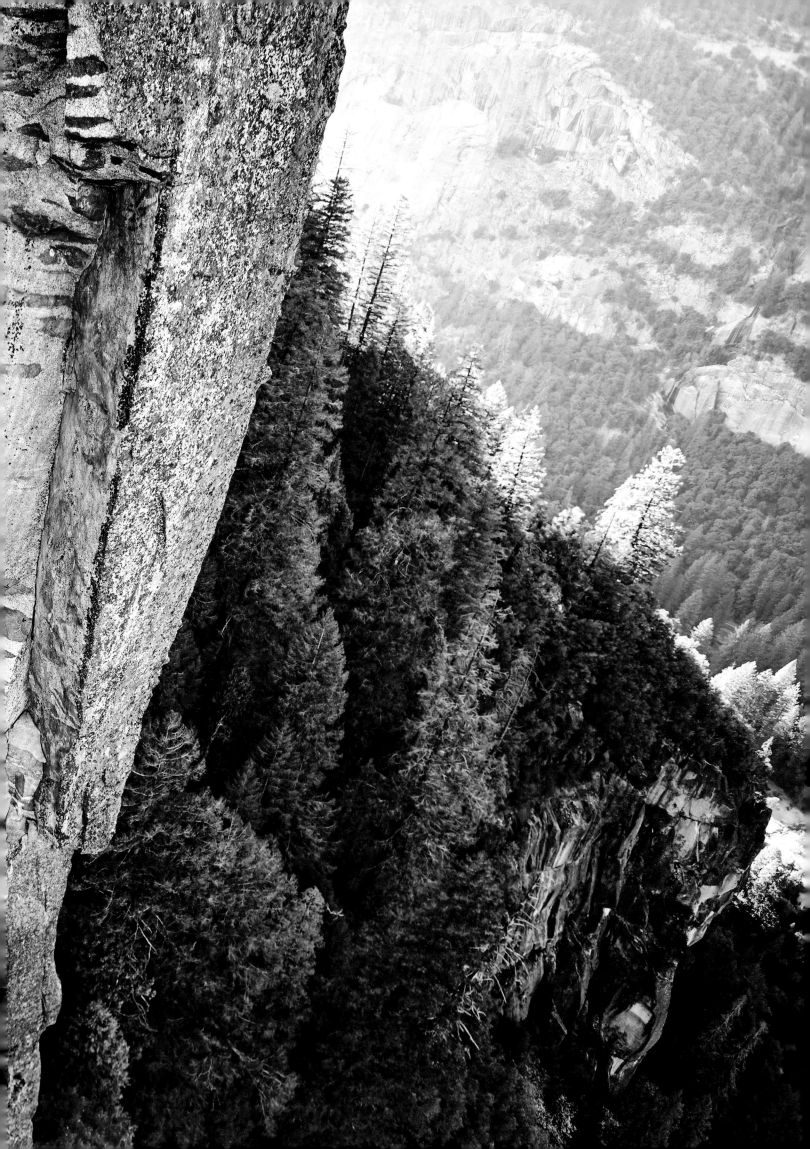

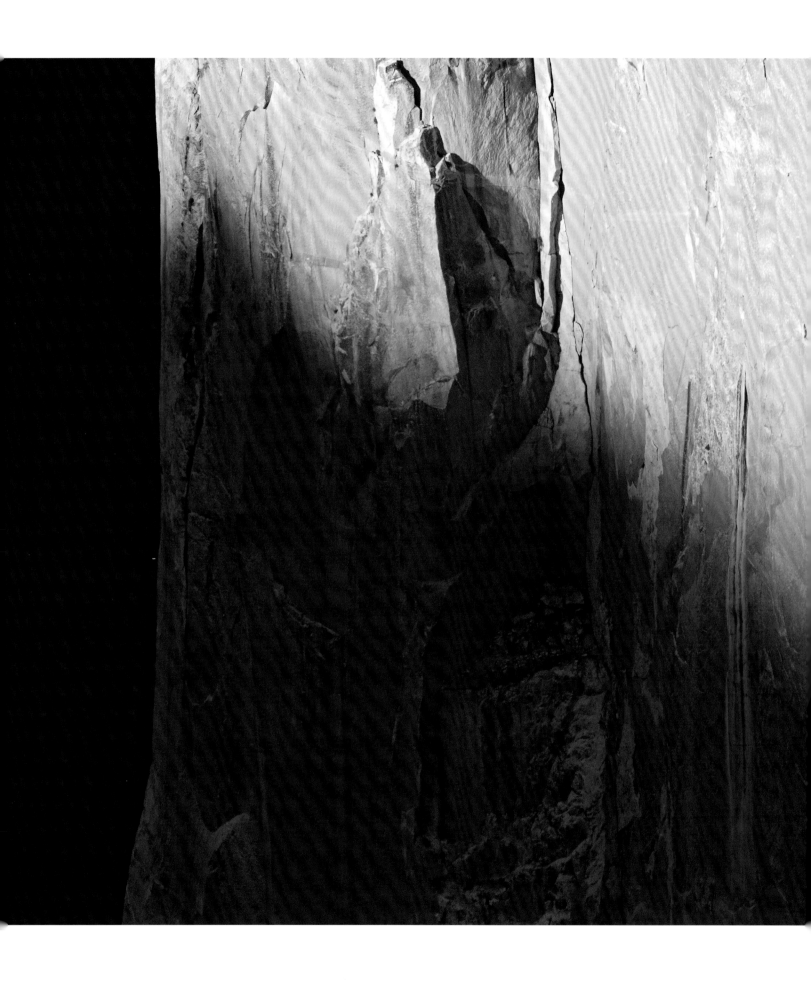

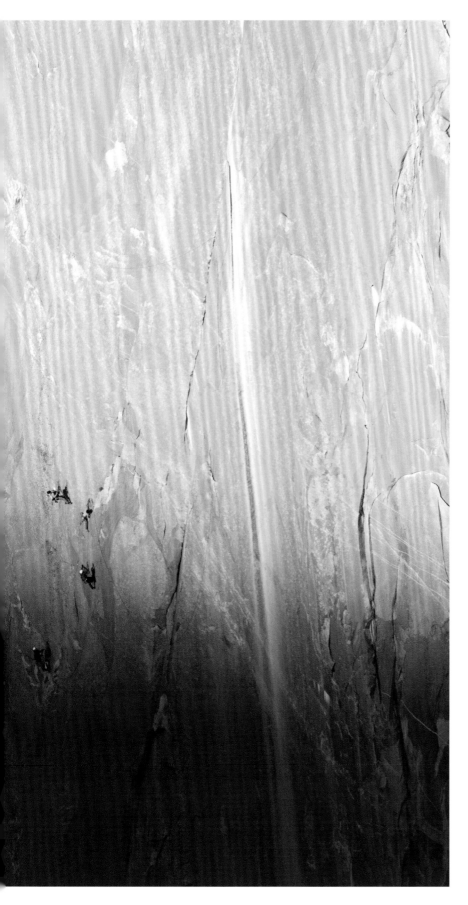

"For sure the mountains want us to worship them, to step/slap/dance our way up their waves of unique perfection, to have our own tiny moment on those skyscraper-sized oil paintings, swirlingly perfect though incomprehensible to the grounded sensibilities that we subscribe to day in day out—infinity is real! We can go there!"

—Erik Sloan

Previous
The Rostrum (5.11c)
Nina Caprez transferring crack systems on pitch 6 of one of Yosemite's most famous multi-pitch climbs. For elite climbers of a certain ilk, the *Rostrum* is a sought-after freesolo. When Peter Croft first soloed the insecure traverse pictured, he repositioned a sling hanging from a piton so that he might grab it in case of a slip. Ultimately he decided this was "impure" and returned, flinging the sling from his possible reach and sending with glory.

Left
The Dawn Wall (5.14d)
Adam Ondra and his entourage during his legendary eight-day send of the *Dawn Wall*, arguably the world's hardest bigwall route. Seeking perfect conditions to stick to the route's tiny holds, Adam often climbed through the night, his battle cries echoing across the granite expanses of El Capitan.

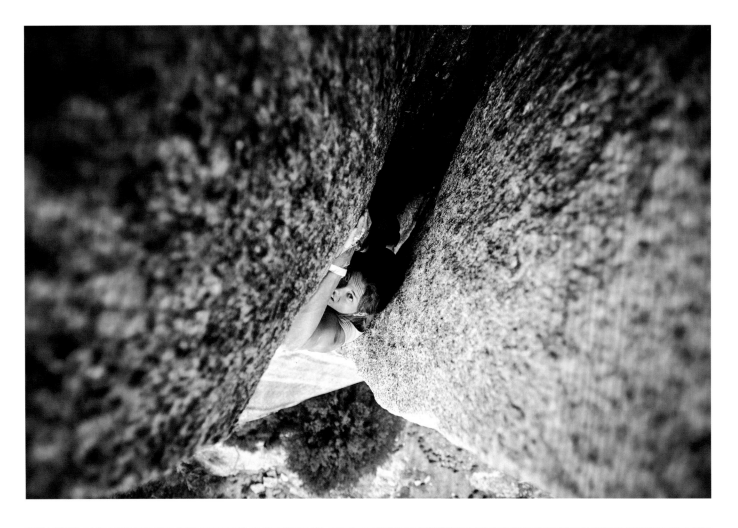

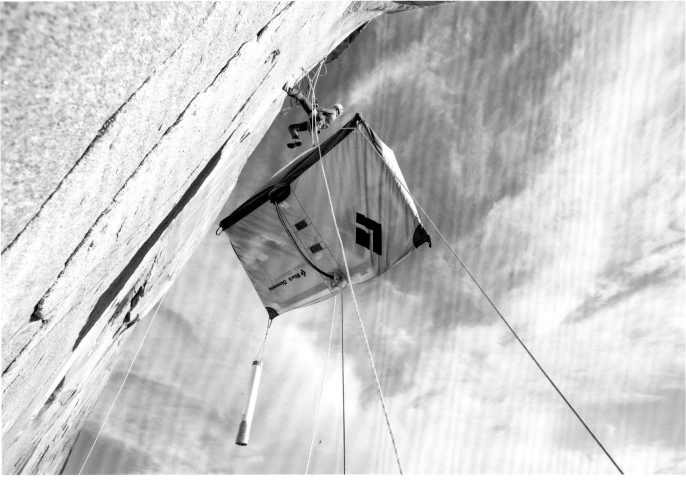

Top
***Tales of Power* (5.12b)**
Nina Caprez muscling up the final offwidth section before the chains.

Bottom
Barbara Zangerl raising the portledge for a good night's rest on *Zodiac*.

Right
***Magic Mushroom* (5.14a), pitch 21**
Barbara Zangerl on an 11-day ascent of one of the hardest free routes on El Capitan. Tommy Caldwell snagged the first free ascent of this bigwall in May 2012.

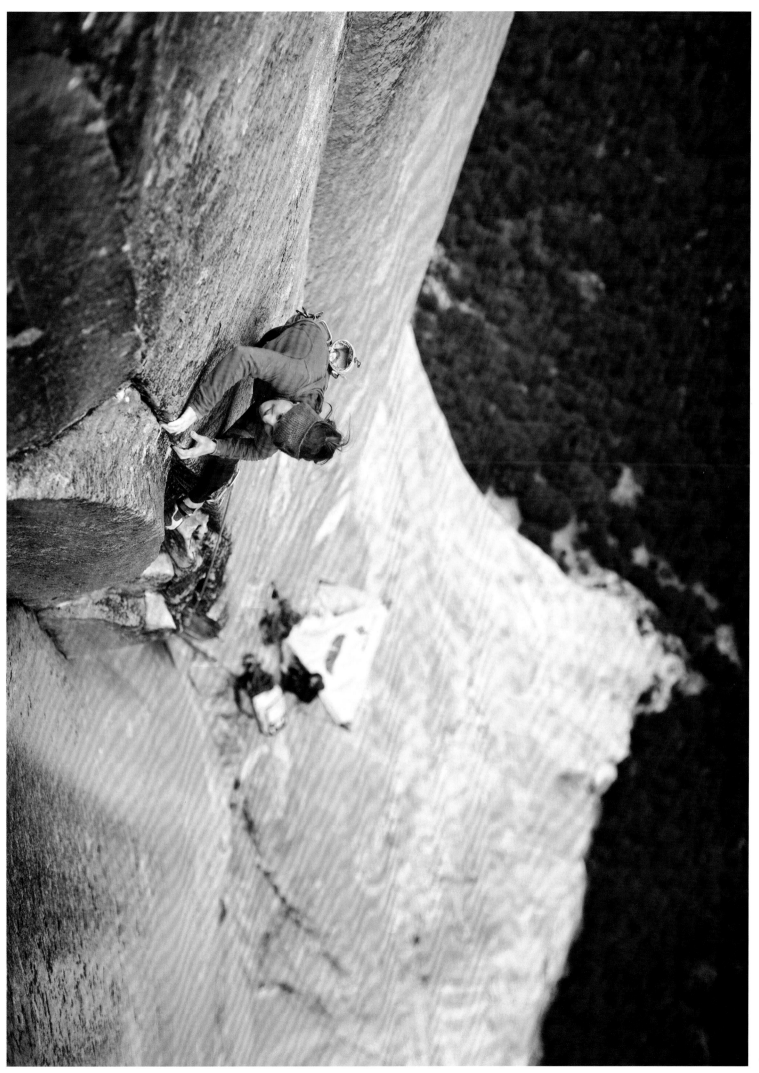

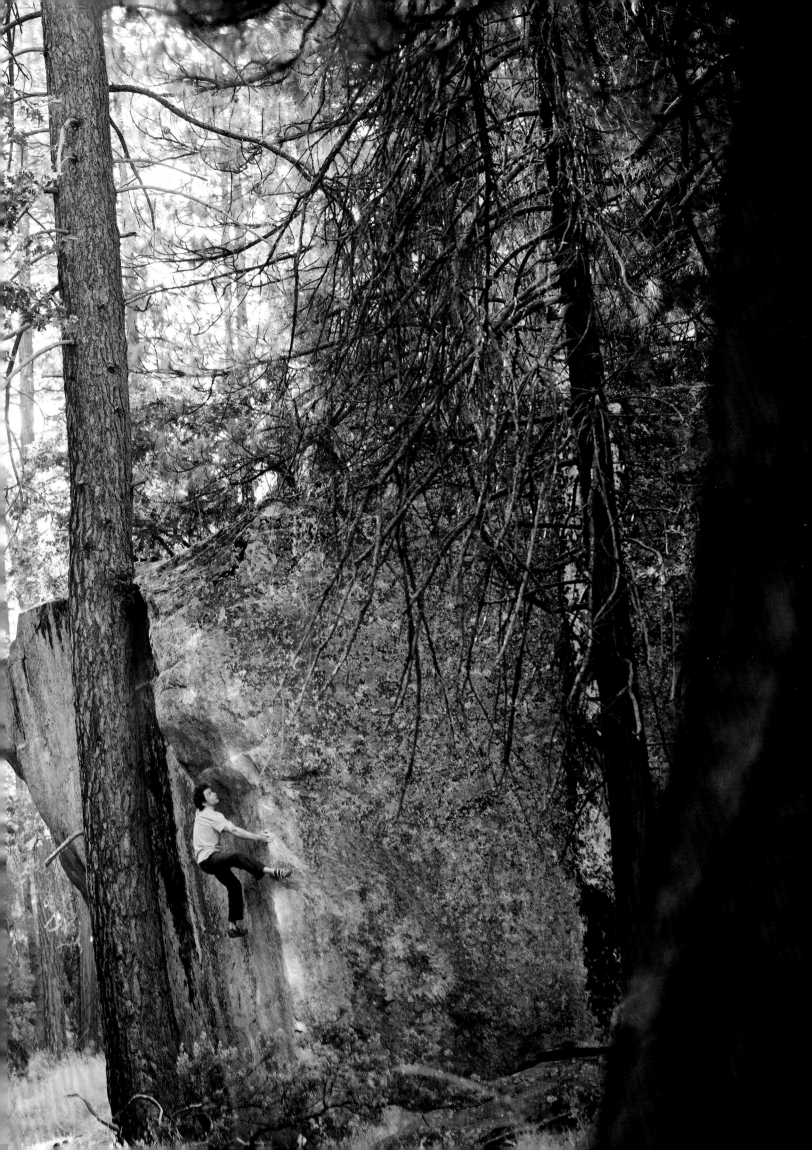

"What makes Yosemite so special to me is not the climbing itself, but what comes with it. It's spending several days on the wall, sharing a ledge, waking up in the sun when the valley is still in the shade; all these little moments make every trip unforgettable."

—Jacopo Larcher

Previous
The Woodyard Arête (V6)
Giovanni Traversi digging in a delicate heel while contemplating the upcoming choreography.

Right
Zodiac (5.13+), Nipple Pitch
Jacopo Larcher sending the climb's second crux. He described the following movements up the dihedral as similar to holding a refrigerator in both hands while shuffling feet up a featureless wall.

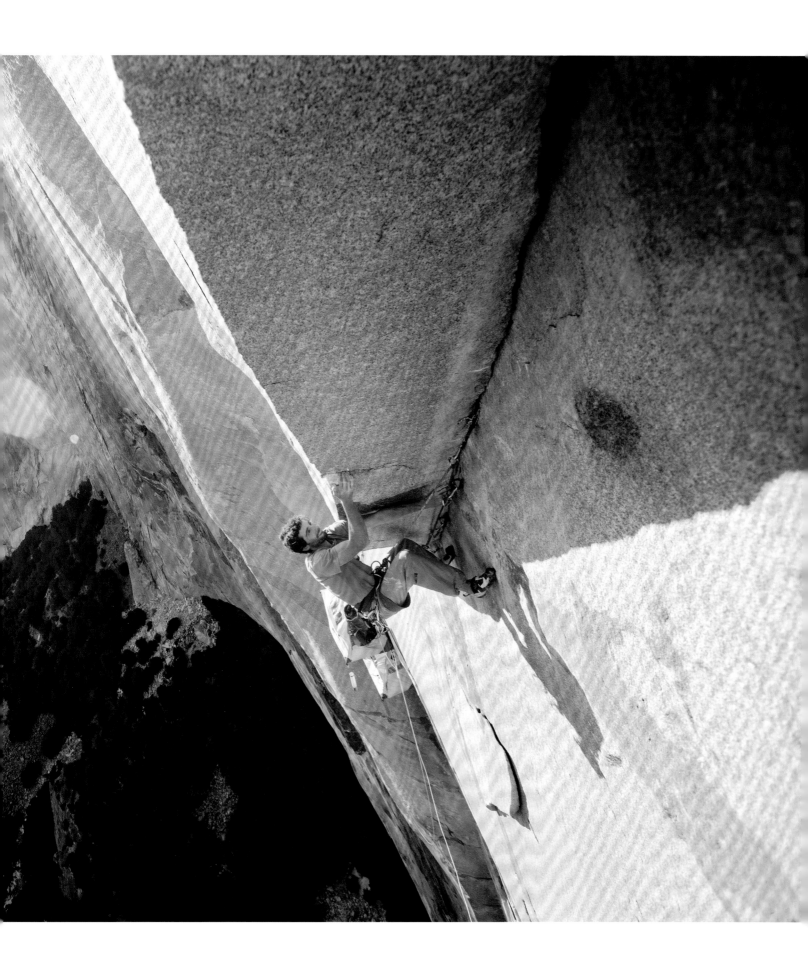

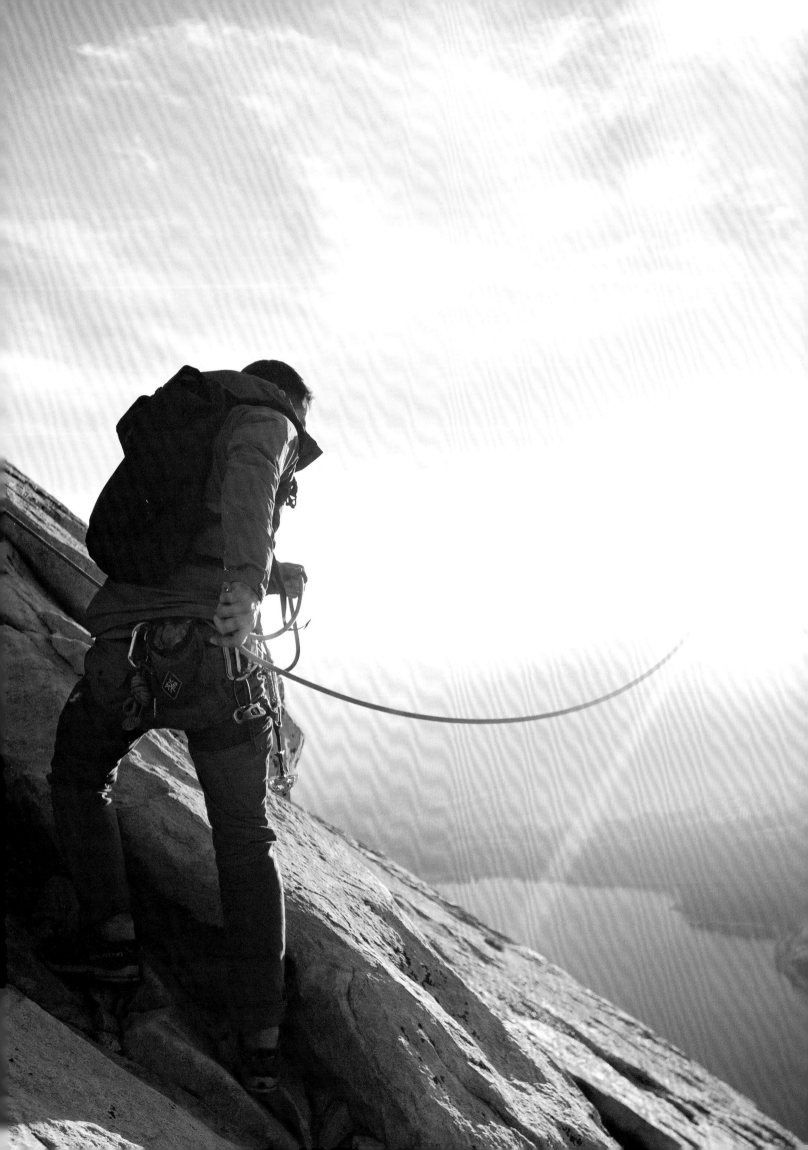

SUMMER

The heat and blazing sun of summer render many favorite climbing areas undesirable. The rock feels sweaty, friction fails, mojo is marginal. Like the birds and butterflies, the monkeys migrate north, preserving energy in cooler, higher latitudes. For the bold and exploratory, this is alpine season. Ironically, in the summertime many climbers are found traversing snowy landscapes, navigating high-altitude approaches to remote peaks. The line blurs between rock climbing and mountaineering; for seasoned alpinists, these bold, tactical adventures reward with great satisfaction. However, the summer doesn't have to mean alpine. A range of high-elevation and/or high-latitude locations support excellent climbing through the season.

We don't have to travel far from our spring finale of Yosemite to find impeccable summer conditions. A scenic drive through greater Yosemite National Park takes us into the **High Sierra** of California—an endless array of striking peaks above the arid desert to the east. Having departed from Yosemite Valley, we come first into Tuolumne Meadows— a pristine and elevated sanctuary dotted with granite domes [p. 88–89]. For untold miles both north and south of here, the peaks of the High Sierra are prime summer alpine objectives. The *Third Pillar of Dana* [p.90] is a terrific moderate climb just shy of Yosemite's eastern border. The greater area is austere and gorgeous, rich with cool alpine lakes up high and steamy hot springs down in the valley for rest days. Cold seasons find the surrounding mountains picturesquely shrouded in ice and snow, and climbers escape to nearby Bishop for lower-elevation bouldering [see Winter].

Recovering from the demanding odysseys of Yosemite and the High Sierra, the northward migration begins. The climate around scenic **Lake Tahoe**, California is ideal. Cool lake breezes from below encourage hard trad, sport, and bouldering on the pristine granite of Donner Summit. Crags like Snowshed Wall are quickly accessible and offer an array of single pitch sport and trad options across the grades. Multi-pitch climbing as well as bouldering is plentiful in nearby Lover's Leap. The vantages gained from the top-outs reward with beautiful panoramas of the forest sprawling below.

Crossing the Canadian border and passing through Vancouver, we come to the small former logging town of **Squamish**, BC. Imagine a mini-Yosemite containing everything from long crack systems to bouldering and sport climbing, nestled into a quiet Canadian village. The centerpiece of Squamish climbing is the Stawamus Chief, a massive granite cliff that proudly looms over town and is home to many legendary multi-pitch routes [p. 122]. Also legendary are the moody clouds and mists that are quick to roll in, shrouding the mountains in dramatic weather, often resulting in slick rock.

Dialing up the adventure meter, the Canadian alpine beckons; the tribe rambles across British Columbia to the otherworldly **Bugaboos**. This glacial refuge provides solitude and inspiration, as well as impeccable alpine granite. Surveying the horizon from the rock outcropping of Applebee Campground, the prevailing landscape is wonderous [p. 124]. The mountains are sheer and dark, the weather is fickle, the snow and ice ubiquitous. Navigating the glaciers is necessary to move from peak to peak, and requires some basic ice tools and some general wits to assess their structural integrity. Hiking and climbing in the Bugs feels like true adventure, and carries real risk along with real payoff—from the summits it's possible to see endless rolling snow-capped mountains in almost every direction.

High Sierra

California

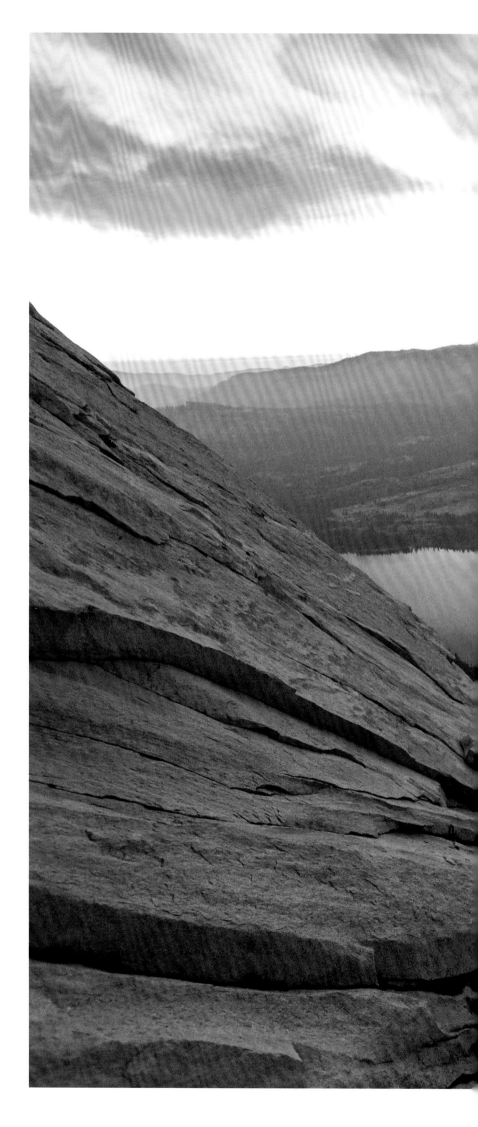

Type of Climbing:
Trad, alpine, bouldering, sport

Rock Type:
Granite

Climbing Style:
Rugged, vertical, committing

Number of Climbs:
300+

Elevation:
9,943 ft

Prime Season:
June–September

Classic Climbs:
East Buttress of Mt. Whitney (5.7), Evolution Traverse (5.9), Mithril Dihedral of Mt. Russell (5.9+), Third Pillar of Mt. Dana (5.10-), Positive Vibrations (5.11a), and Venturi Effect (5.12) on the Incredible Hulk

Previous
Northwest Buttress of Tenaya Peak (5.5)
Gabe Matson on a late afternoon lap up *Tenaya Peak*, dislodging his rope from a stuck position down below.

Right
Northwest Buttress of Tenaya Peak (5.5)
Gabe Matson entering "night-mode" in the higher pitches of this moderate classic. Tenaya Lake down below is one of many pristine alpine lakes in the High Sierra.

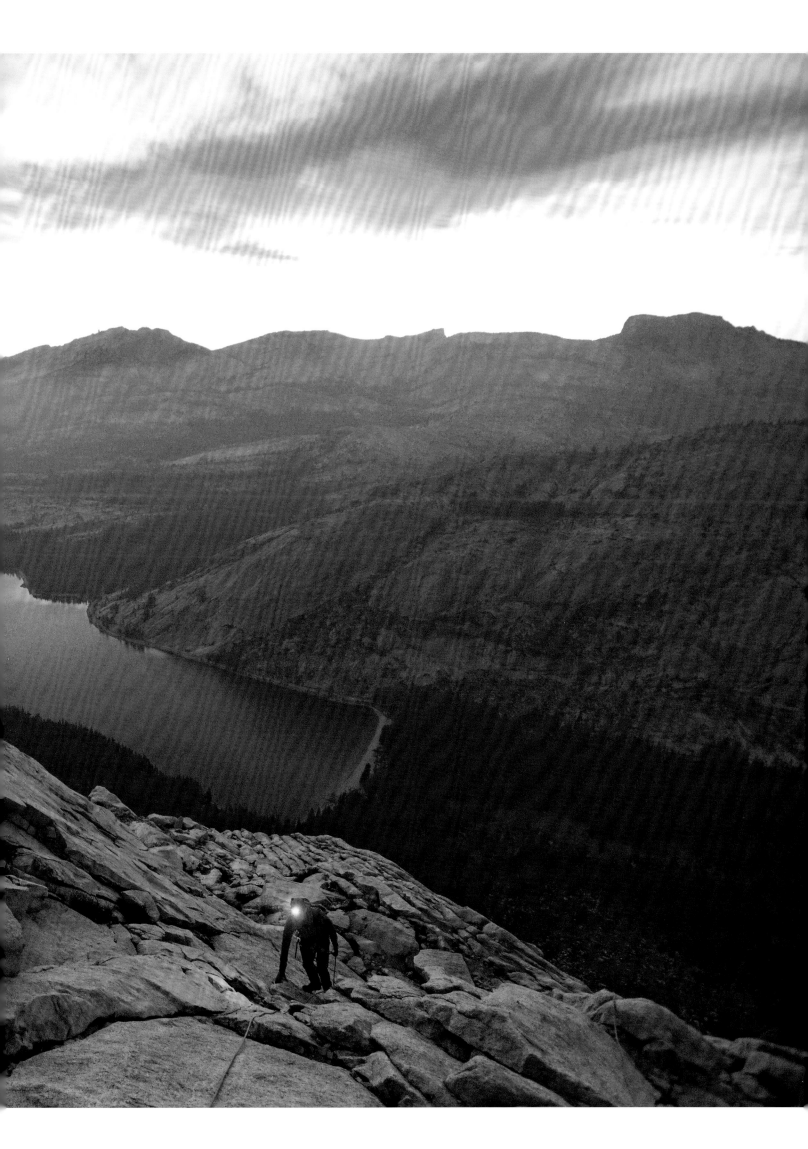

"My inspiration from the beginning
with climbing started with the love
for movement, problem solving,
and pushing my boundaries as well
as the camaraderie and openness of
the community. And of course, the
deep connection to the land that
we experience as we tread lightly in
these fragile environments. Every
day is a new opportunity to read
the rock, become more precise and
calculated with my movements, and
find my boundaries."

—Alix Morris

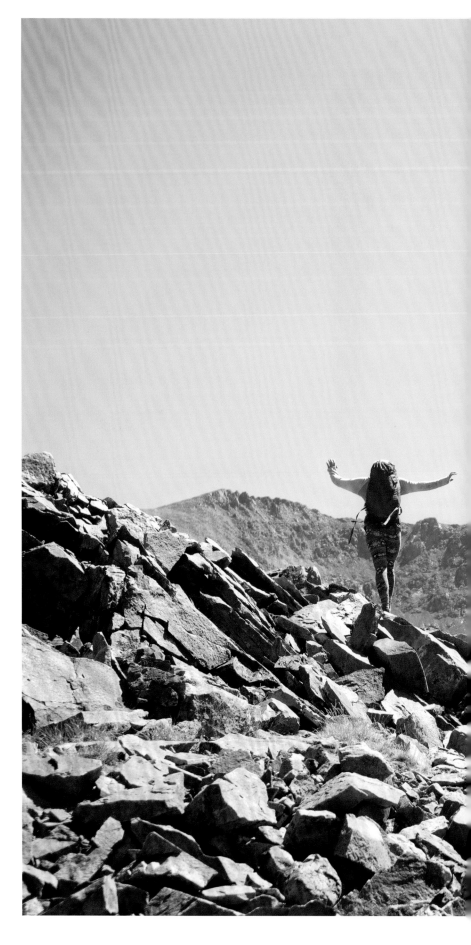

Right
Alix Morris joyfully dancing up the scree field
approach to *Third Pillar of Dana* (5.10-).

Following
Late evening skies blossoming over the gentle
domes of the High Sierra.

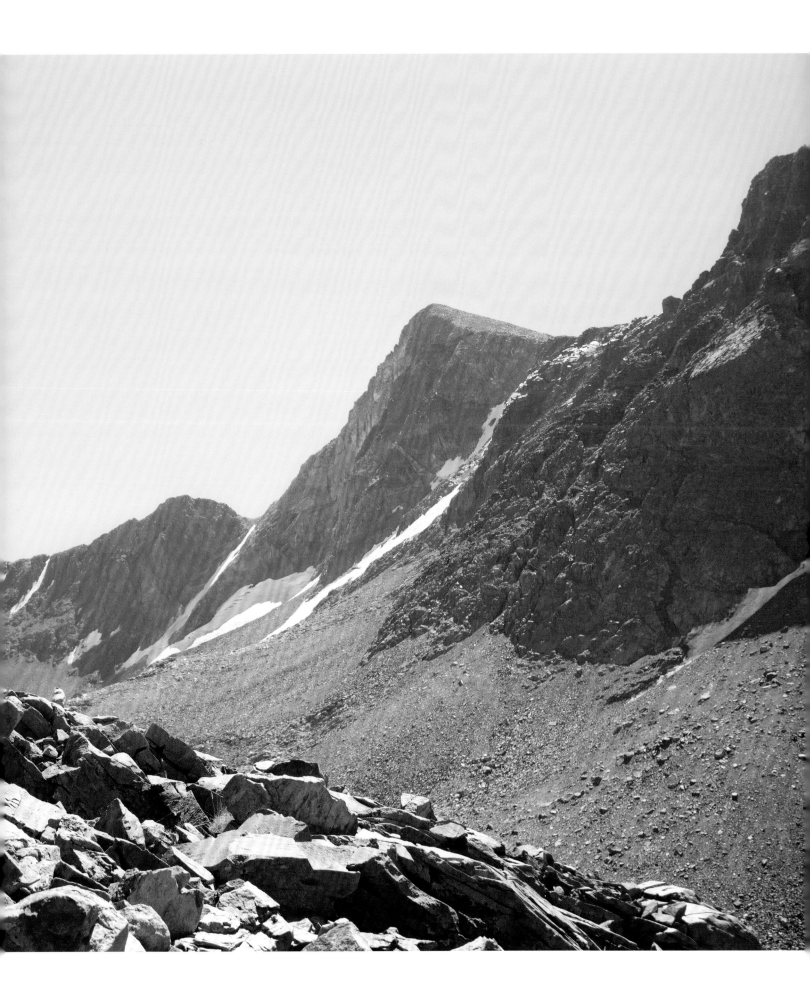

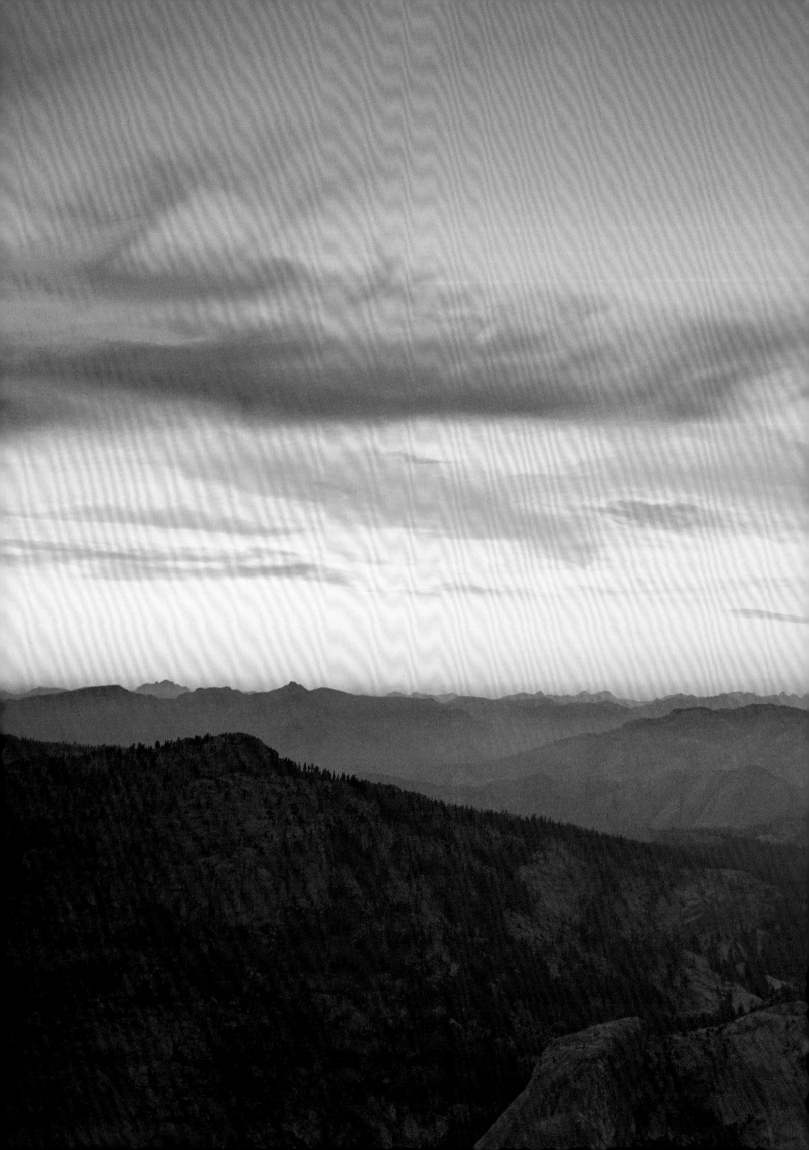

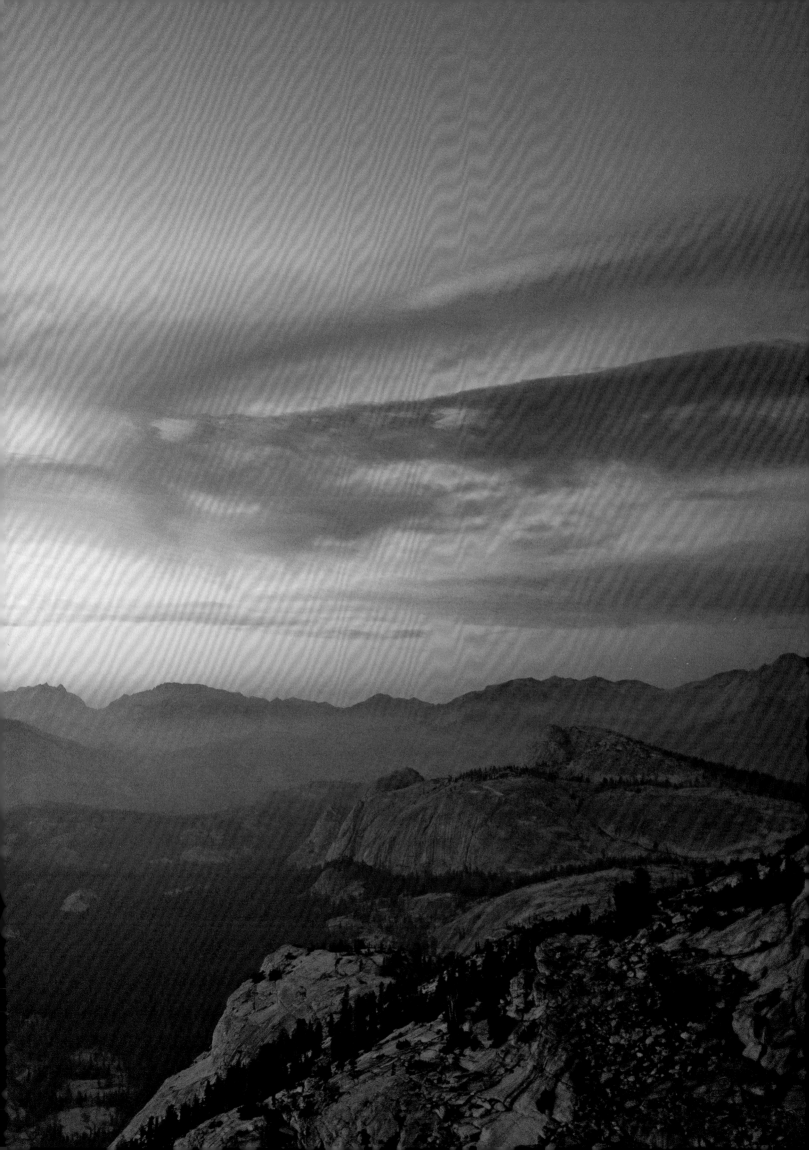

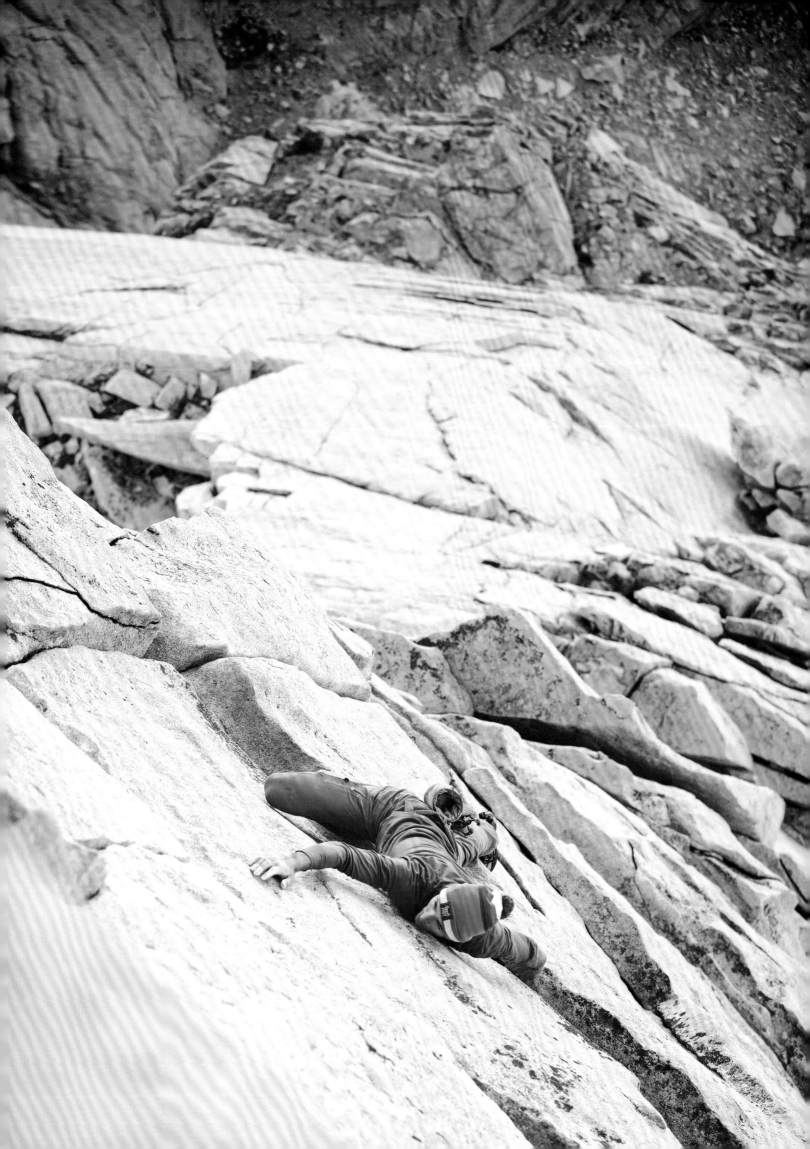

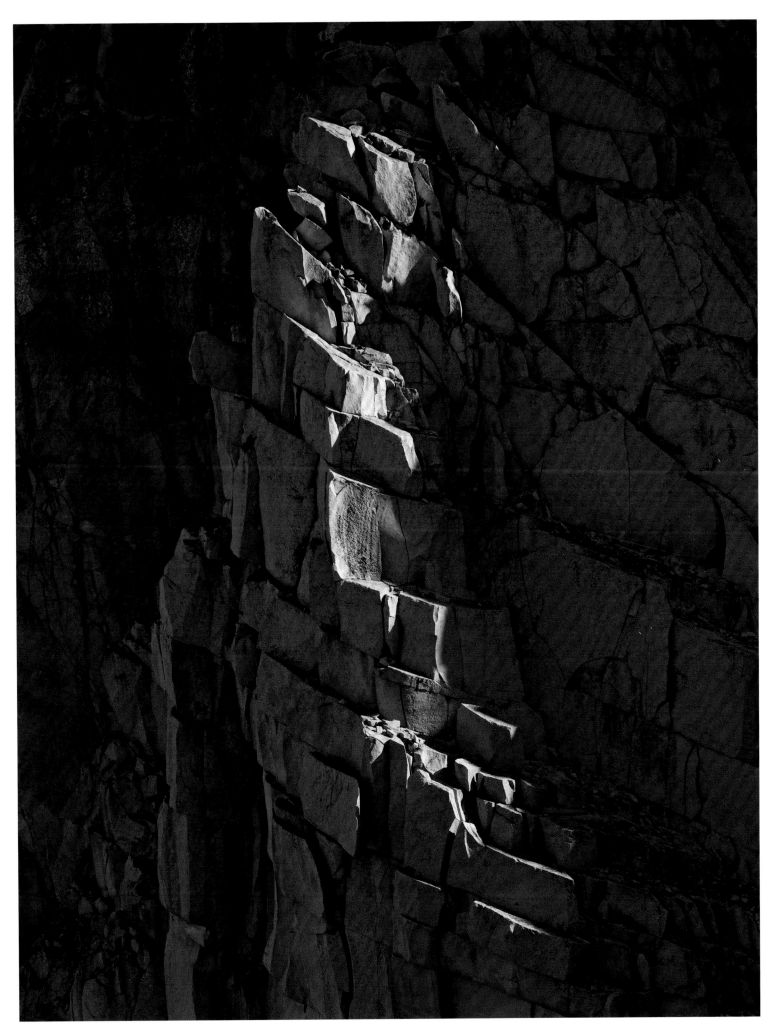

Left ***Third Pillar of Dana* (5.10-)**
A surprise visit by free soloist Matt Cornell, cruising through the crux
sequence of this five-pitch Sierra classic.

Right
Textures of sun and rock as seen from the *Third Pillar of Dana* massif.

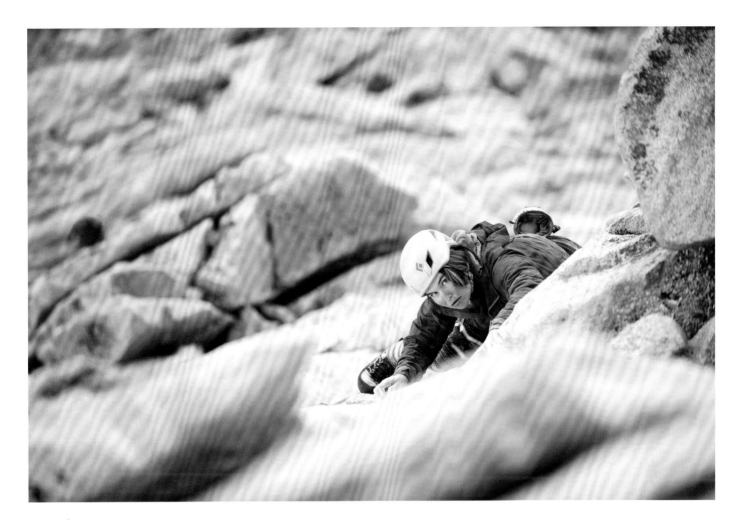

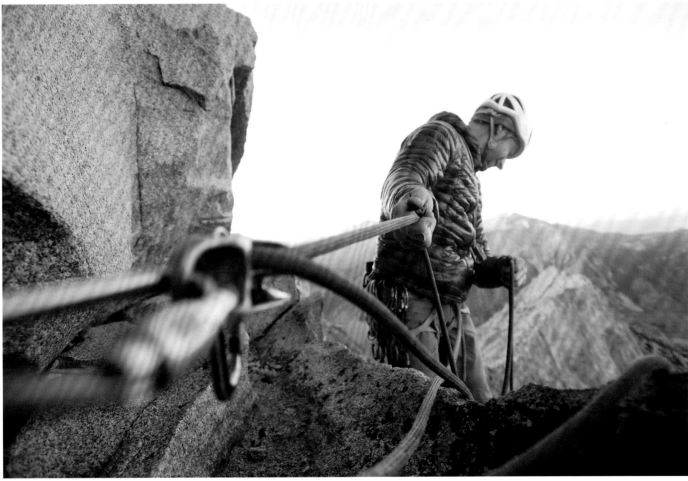

Left
***Third Pillar of Dana* (5.10-)**
Peter Juvan reduced to a red speck in an ocean of alpine granite.

Top
***Third Pillar of Dana* (5.10-)**
Alix Morris calculating her next movements halfway up the route.

Bottom
Peter Juvan stepping out to get a better view while belaying Alix from the summit.

"First wish for it, feel it, then let it go and your body will flow with no second thoughts. You will know when to speed and when to stop. There will be no top and no bottom, just the present moment. I feel satisfaction at the top, but I know it will not last. I enjoy looking beyond the top more and I transfer my focus to the next. I flow again and I feel in control, but then it faces me and it smiles to me. The flow is broken. I try not to let it conquer me.

Days pass, people and places as well. I enjoy the journey with many desires and no final destination. I remember the people. I forget their names, but I remember the feelings we shared. I reflect on all these feelings and I create a future for me and for those whom I touch."

—Peter Juvan

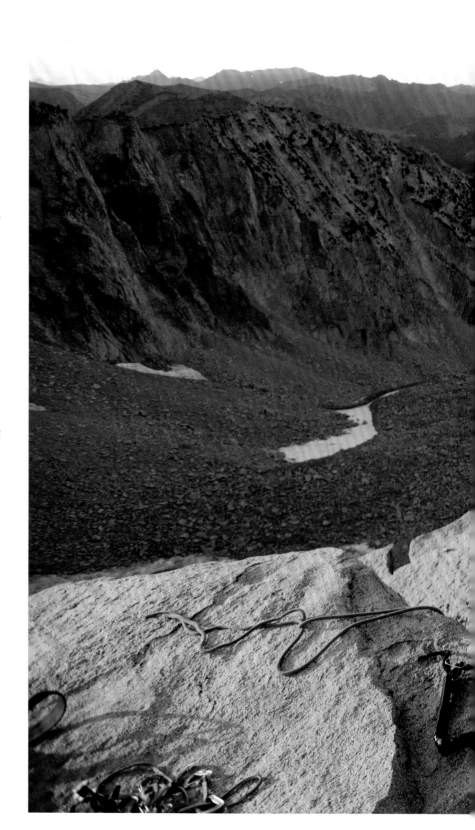

Right
Peter Juvan soaking up the final rays of the day atop the summit of the Third Pillar of Dana.

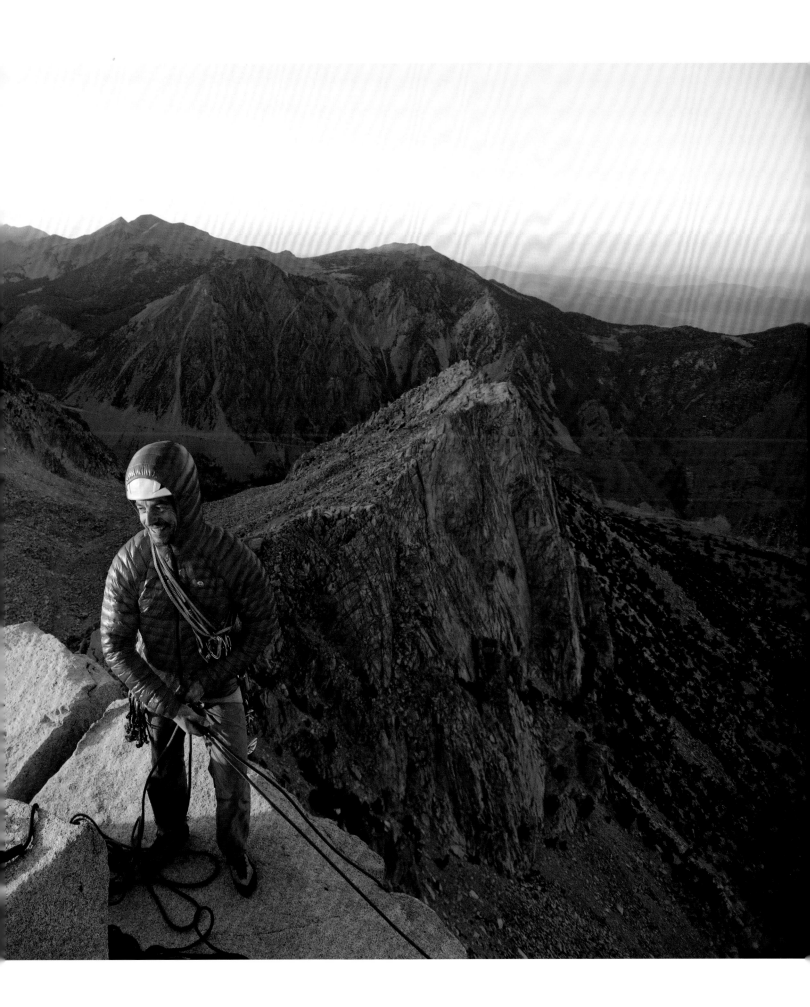

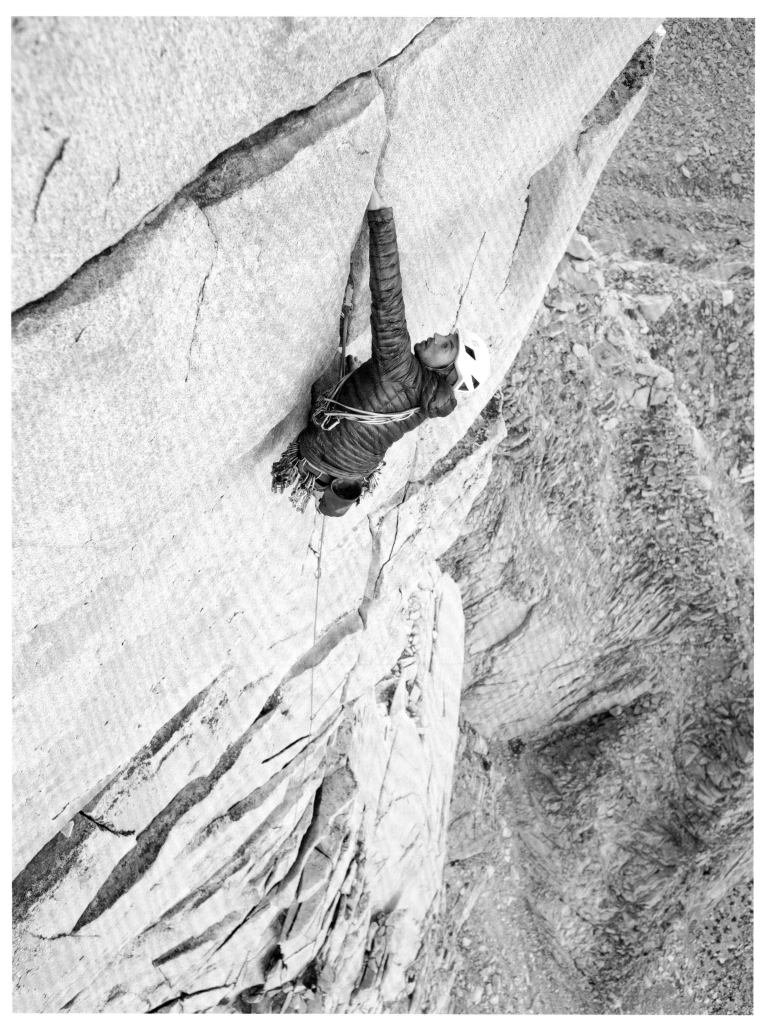

Left *Third Pillar of Dana* (5.10-)
Peter Juvan cruising through locker hand jams on the final pitch of the *Third Pillar of Dana*.

Right
With night falling, the climbers switch on their headlamps to illuminate their descent from the *Third Pillar of Dana*.

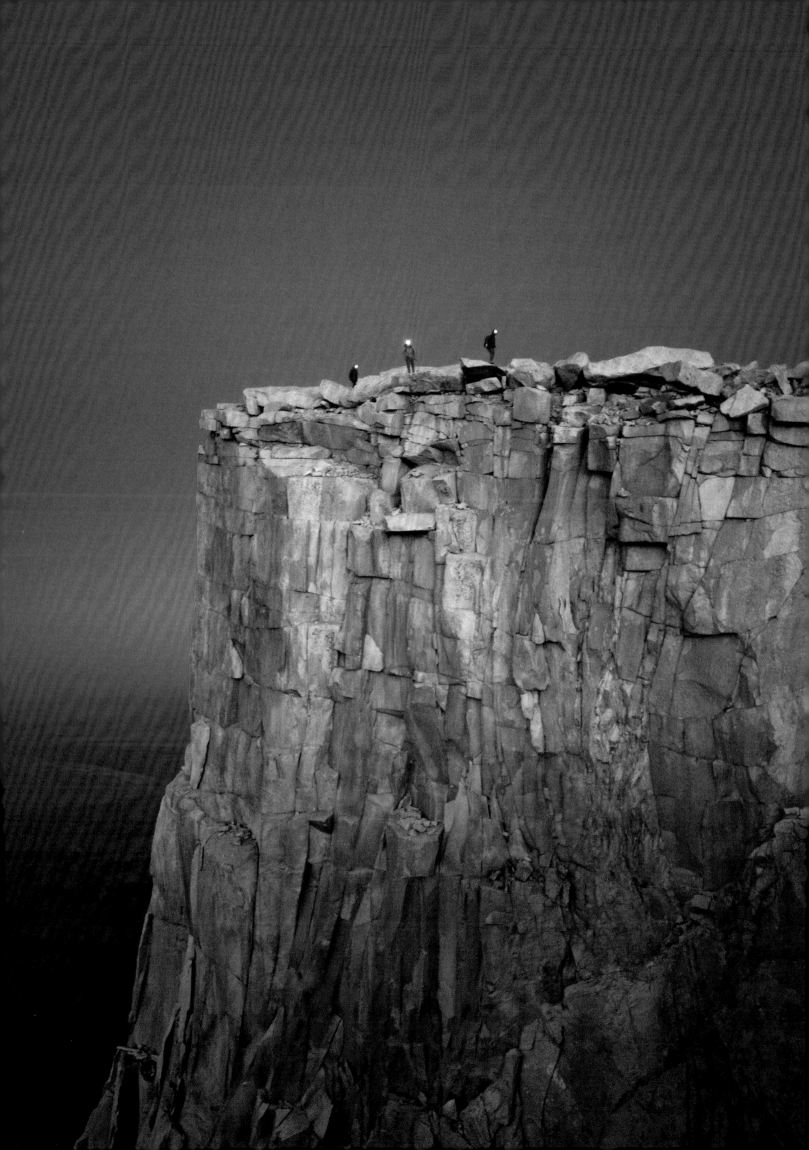

Lake Tahoe

California

Type of Climbing:
Trad, sport, bouldering

Rock Type:
Granite

Climbing Style:
Vertical cracks, slab, varied

Number of Climbs:
2,400+

Elevation:
6,225 ft

Prime Season:
May–October

Classic Climbs:
Composure (5.6), *Corrugation Corner* (5.7),
Jellyroll Arch (5.8), *One Hand Clapping* (5.9),
Bottomless Topless (5.10a), *Seams to Me* (5.10c),
Peter Principle (5.11a), *Monkey Paws* (5.12a),
Panic in Detroit (5.12b/c), *Nemesis* (V2-3),
Gunslinger (V5), *White Lines* (V8)

Right
***Primer* (5.9)**
Merryn Venugopal on this short but sweet hand-
to-finger crack on Donner Summit.

Following
***Mallorcan Dreams* (5.12c)**
Ethan Pringle flying solo above Emerald Pools—a
crag on the west side of the Sierra, near the
Tahoe region.

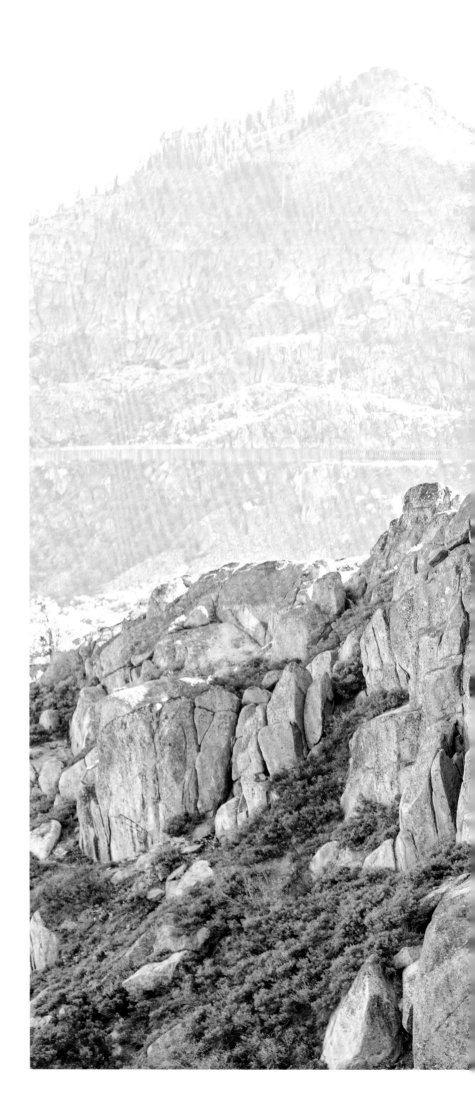

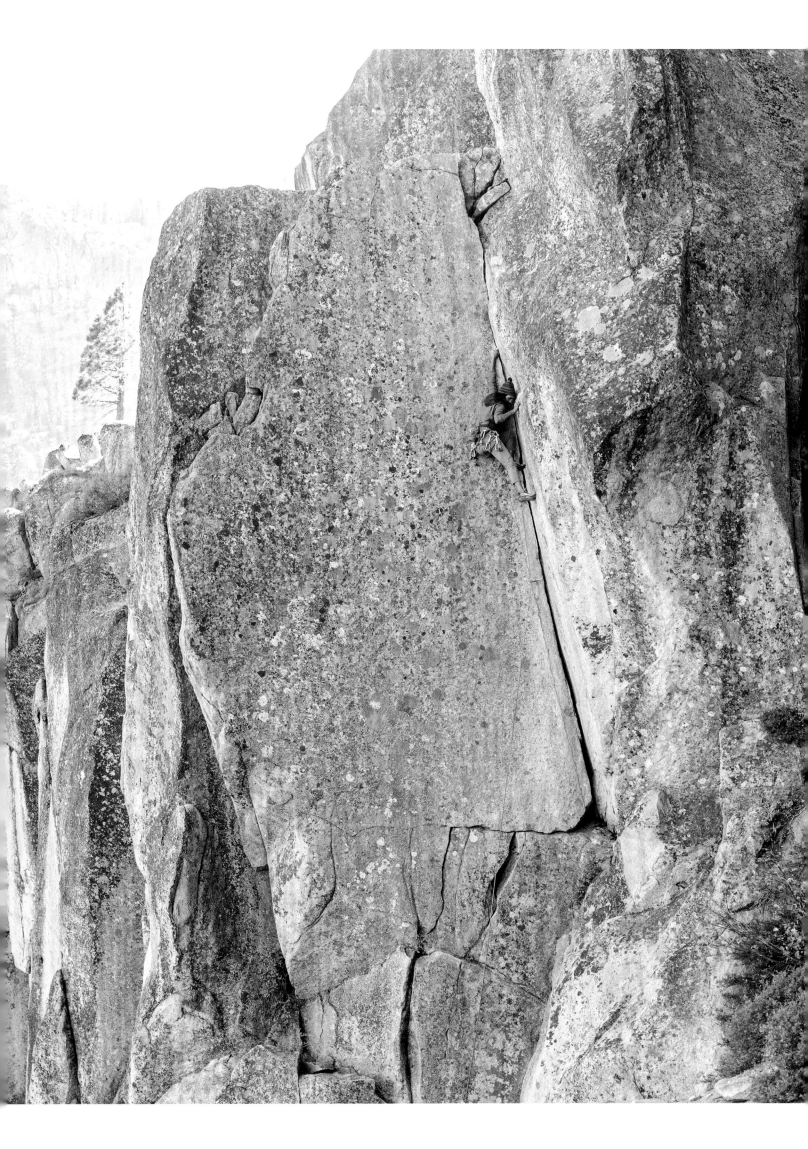

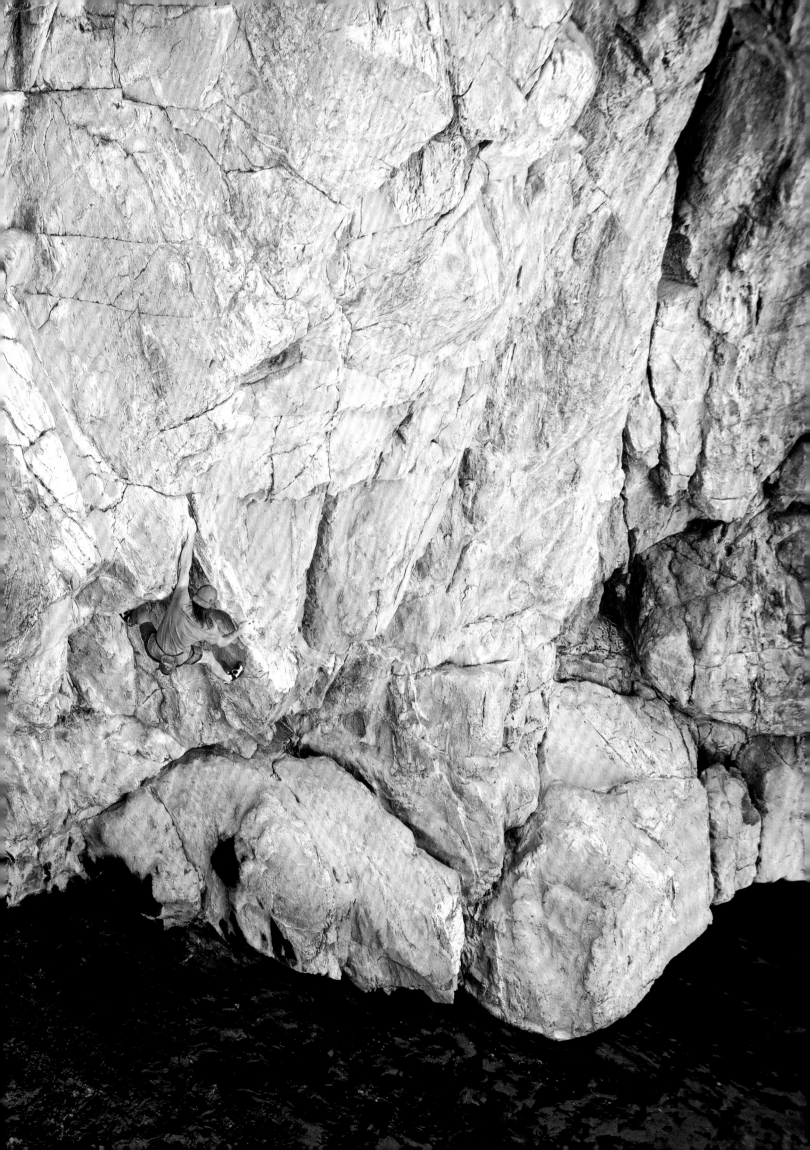

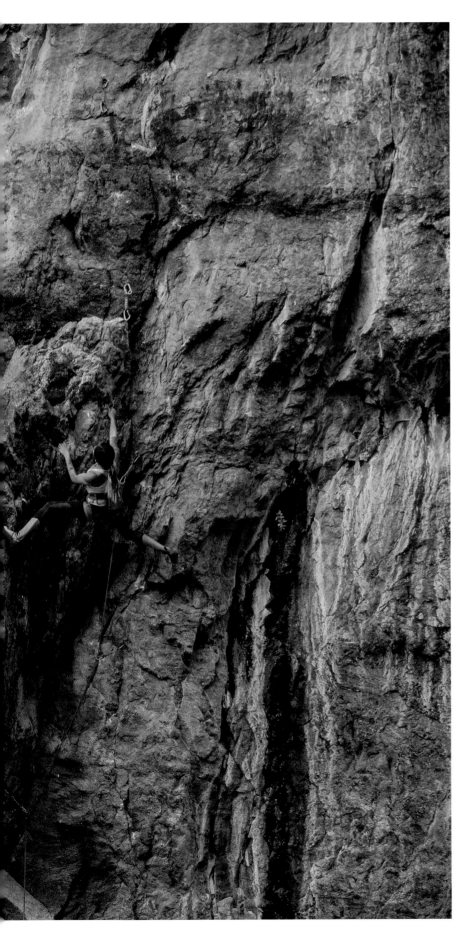

"For me, climbing is a form of exploration that inspires me to confront my own inner nature within nature. It's a means of experiencing a state of consciousness where there are no distractions or expectations. This intuitive state of being is what allows me to experience moments of true freedom and harmony."

—Lynn Hill

Left
Hundredth Monkeys **(5.11c)**
Sarah Lin escapes the glare of the evening light at Emerald Gorge.

Following
Friends preparing for a summer day at the Snowshed Wall on Donner Summit. The quick approach from the car and variety of grades between sport and trad make Snowshed a popular Tahoe destination.

"Climbers are all trying to navigate their way to the top; we all experience the physical and mental challenges of rock climbing. Climbers are a community, a group of people converging together to share a common pursuit. It's so cool that regardless of what level you climb, we can all gather at a wall and enjoy this beautiful sport together."

—Dru Mack

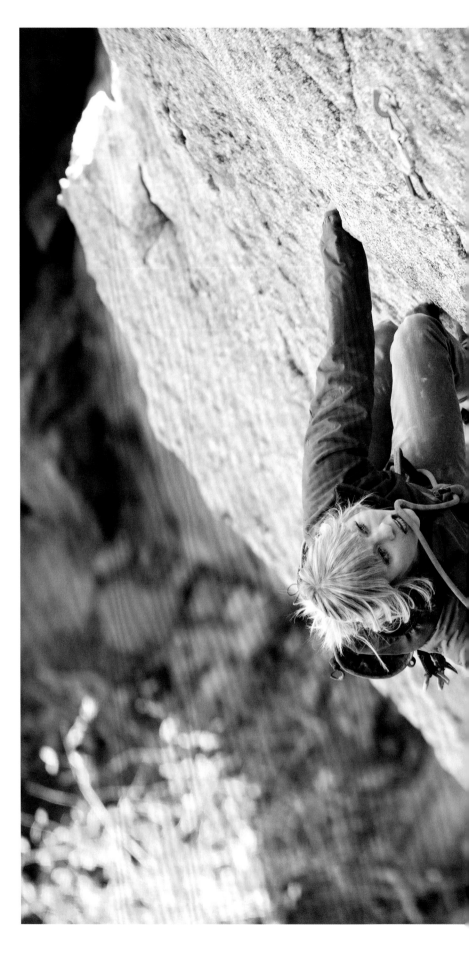

Right
Cannibals (5.12d)
Anna Liina Laitinen with a creative clipping technique on some tenuous terrain.

Squamish

British Columbia, Canada

Type of Climbing:
Trad, sport, bouldering

Rock Type:
Granite

Climbing Style:
Vertical cracks, slab

Number of Climbs:
1,200+

Elevation:
16 ft

Prime Season:
July–August

Classic Climbs:
Diedre (5.7), *St. Vitus' Dance* (5.9), *Exasperator*
(5.10c), *Sunset Strip* (5.10+), *Crime of the
Century* (5.11b/c), *The Grand Wall* (5.11a),
Burning Down the Couch (5.11d), *Summer
Vacation* (V0), *Superfly* (V4)

Right
Out of the Darkness, Into the Light (5.12a)
Lenore Sparks rising from betwixt mosses
at Cheakamus Canyon. This area provides
overhanging sport climbs that are a perfect
option for a typical rainy Squamish day when
most of the climbing near town is wet.

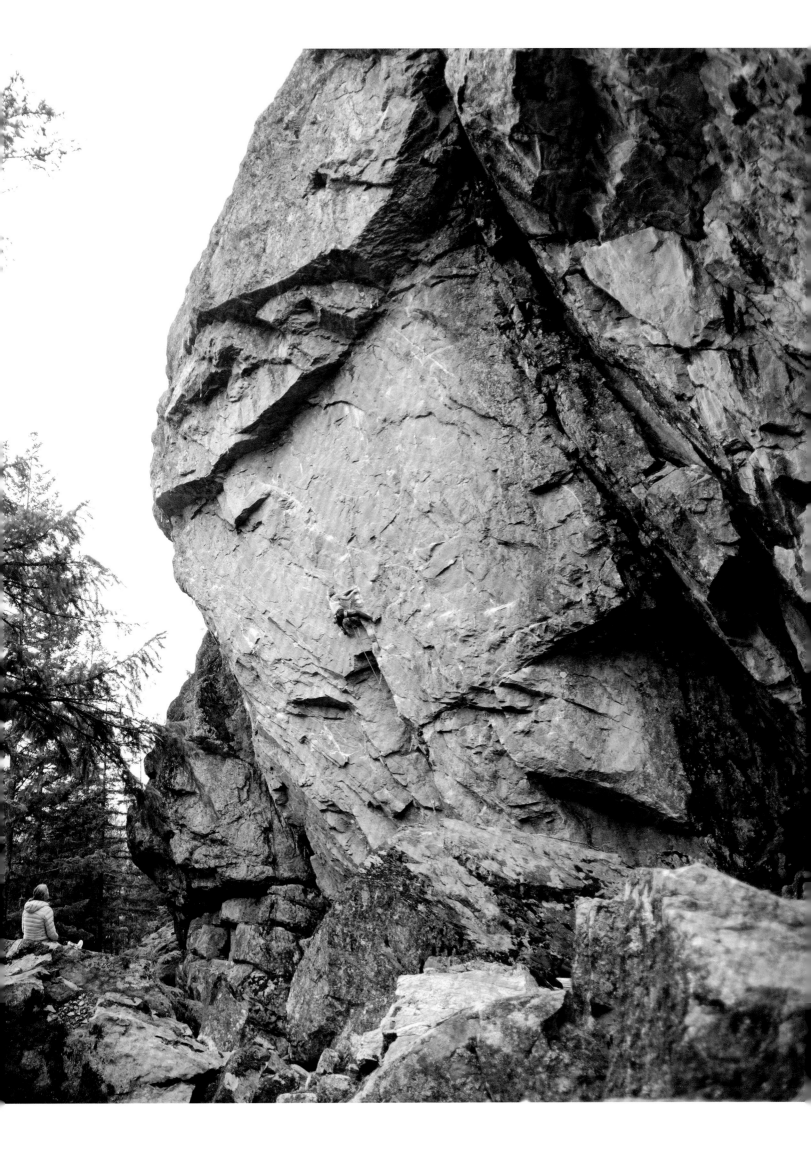

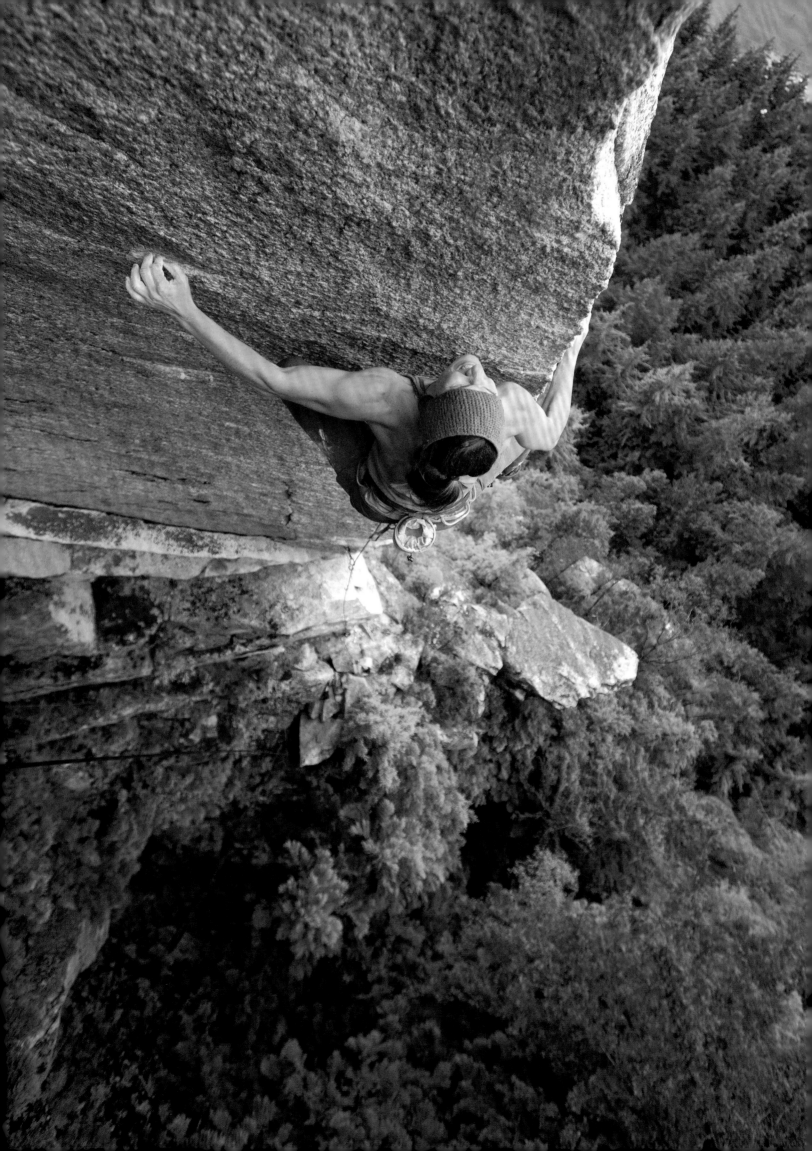

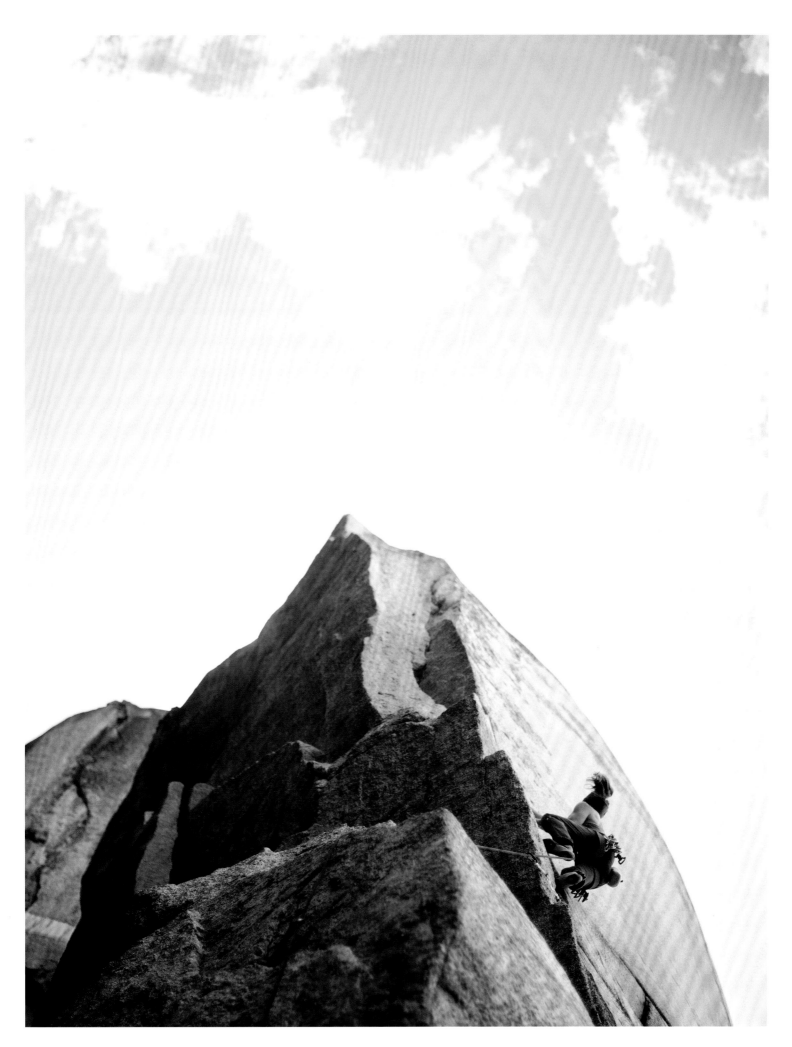

Left *Eurasian Eyes* **(5.13b)**
Barbara Zangerl working the delicate and burly arete.

Right
Alternate view of facing page.

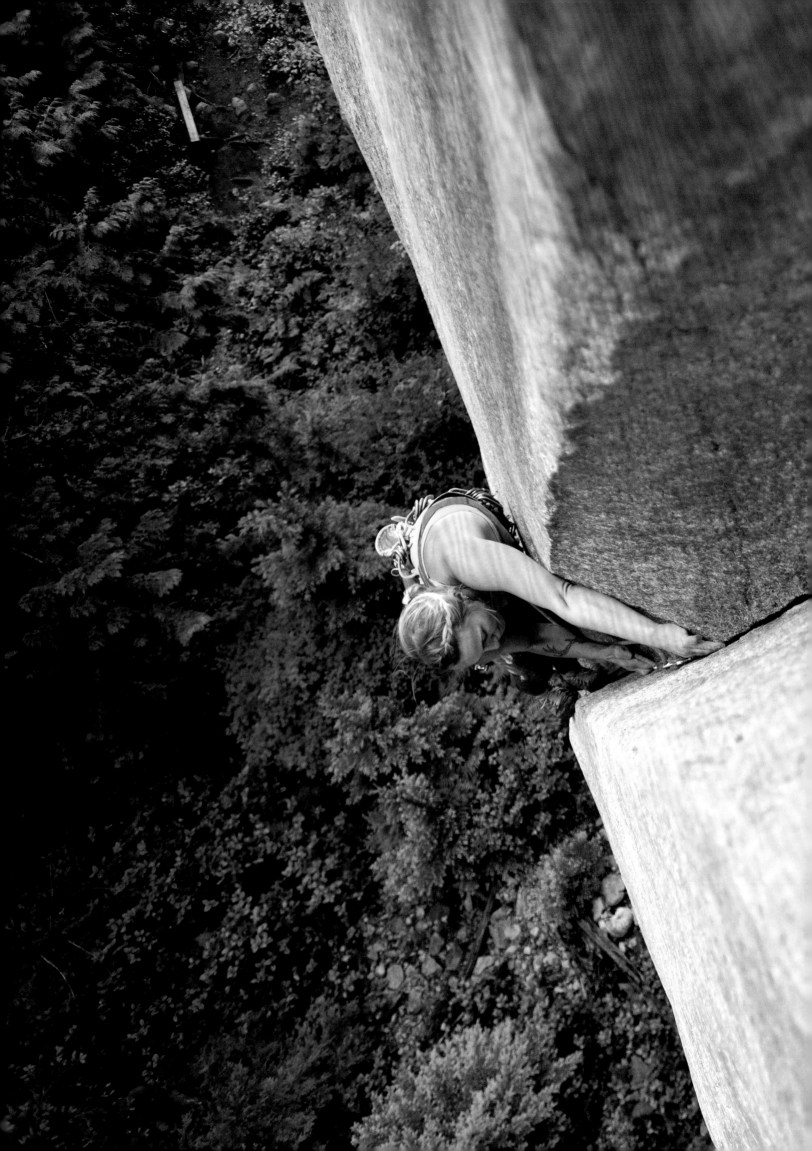

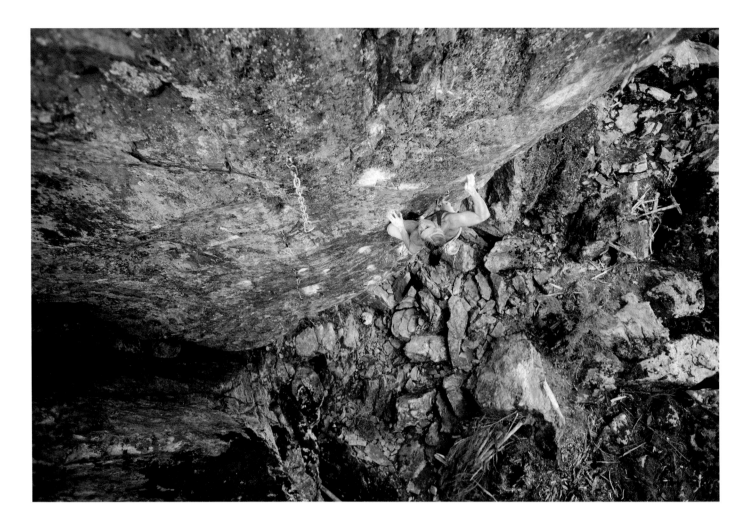

Previous
Flight of the Challenger (5.12c)
Lenore Sparks following the contour of the
stone at Murrin Park.

Top, Right
The Lorax (5.13a)
Mandoline Massé-Clark working up this high-
quality pumpfest in Cheakamus Canyon.

Bottom
Copious rainfall throughout the year fosters
healthy flora like this robust lichen growth.

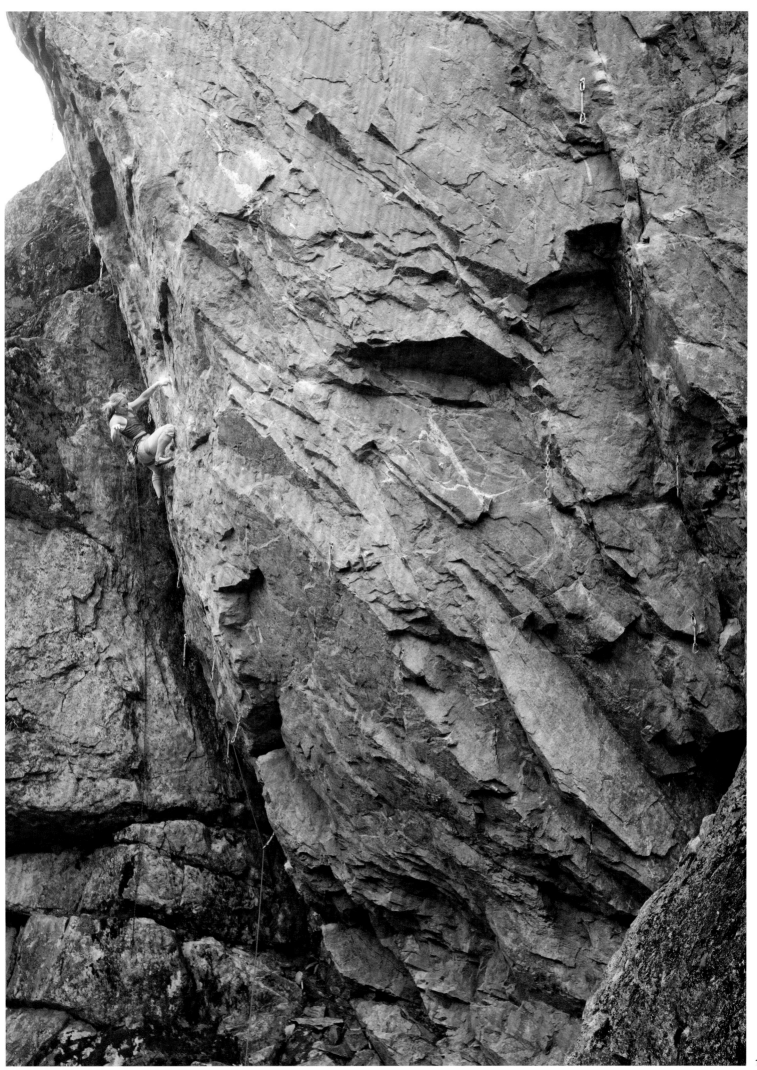

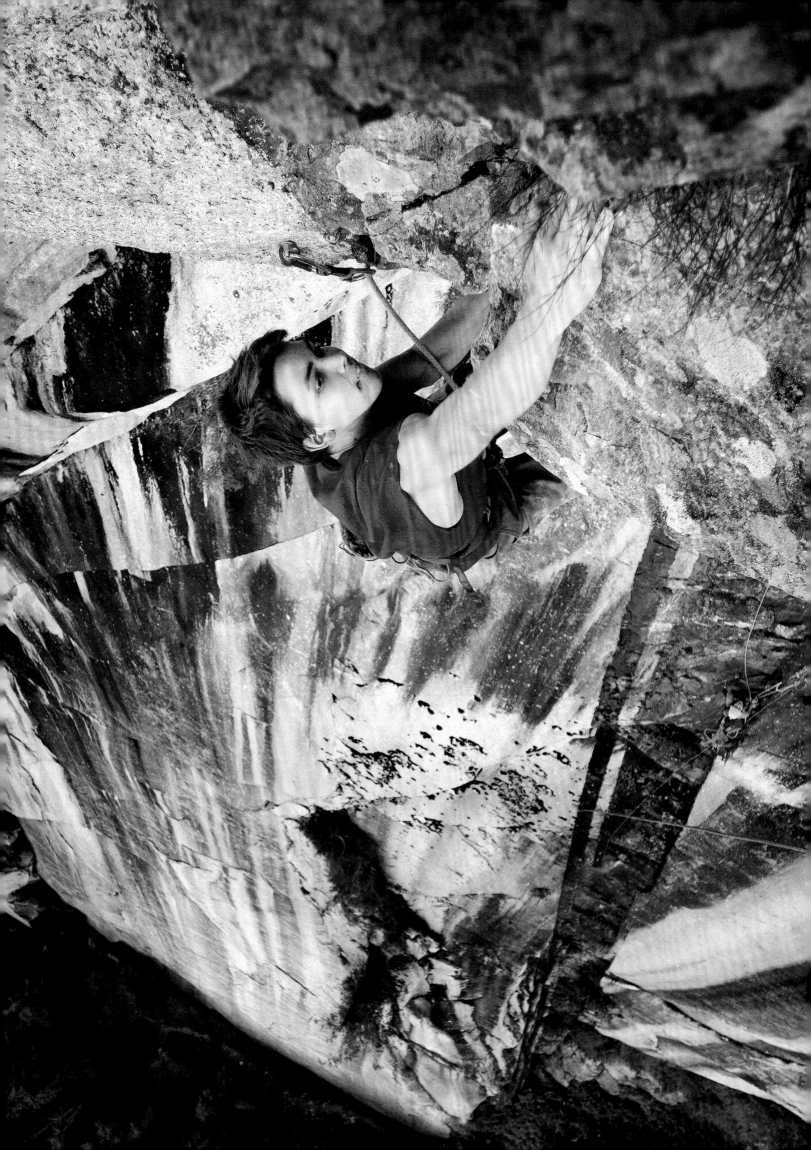

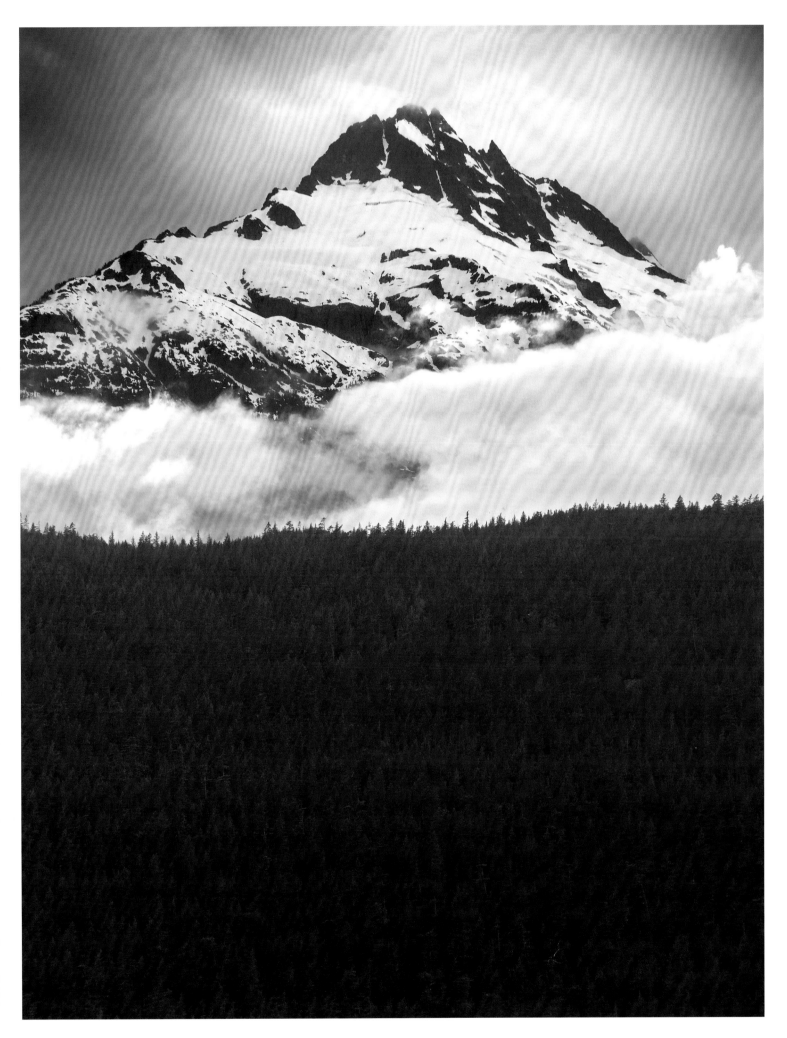

Left *The Black Dyke* **(5.13b)**
Félix Bourassa-Moreau grabbing around the grasses on this unique bolted line, following a rare strip of jet black basalt that bisects the white granite of the Chief.

Right
Fog and clouds rising from the base of Mount Tantalus above Squamish.

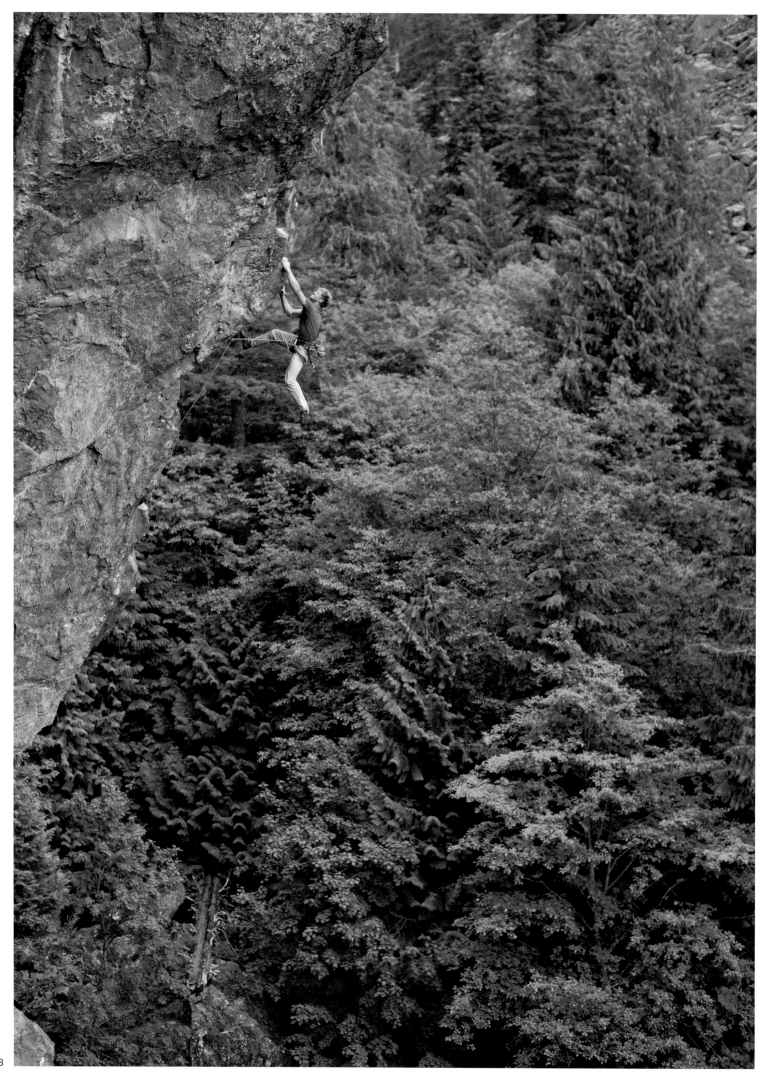

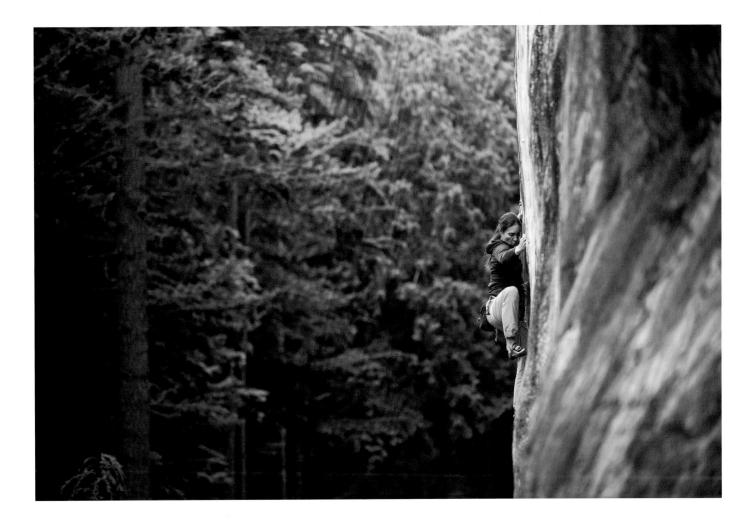

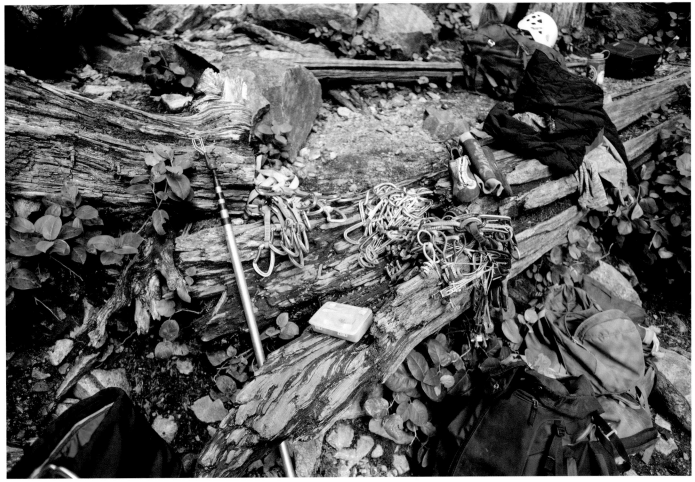

Left
Project
Tim Emmett dangling into a lush void on his
own bolted project at the Big Show crag in
Cheakamus Canyon.

Top
Emilisa Frirdich stepping on the tiny textured
granite features of *Rocket* (5.12d).

Bottom
In Squamish, it's best to have all the gear
ready—trad and sport—just in case.

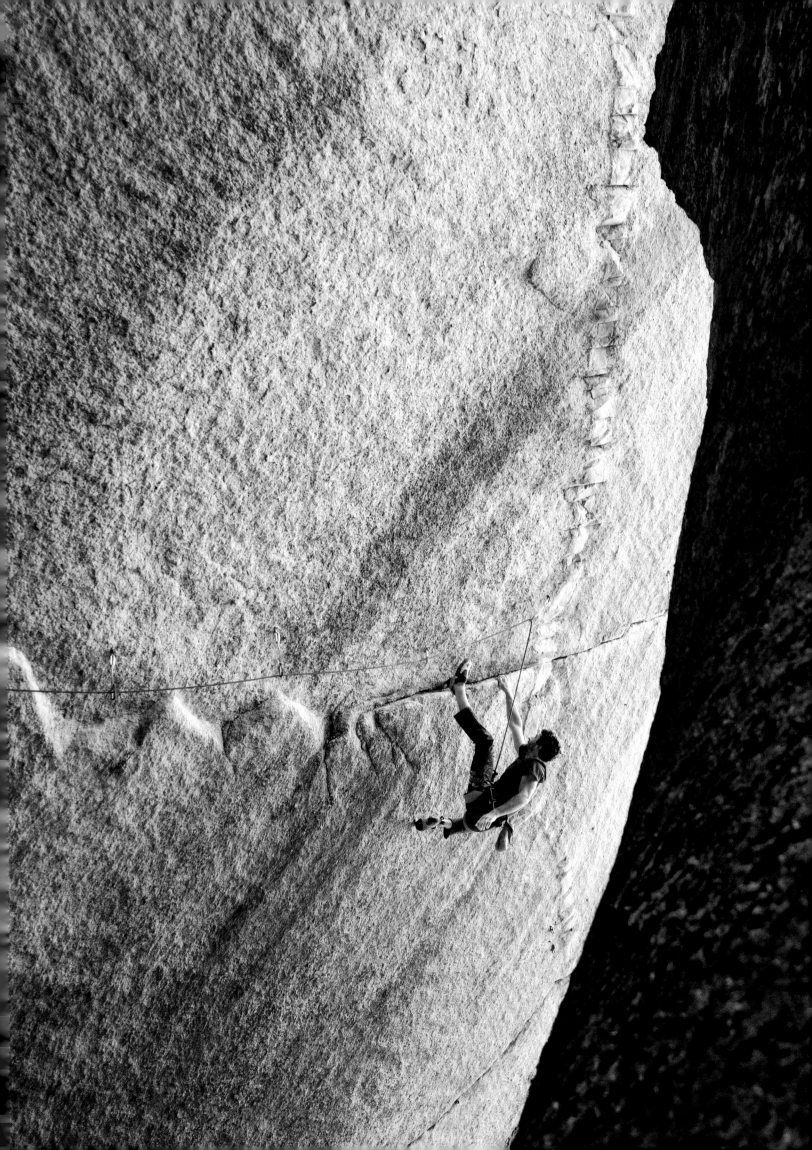

"Climbing is the best, stupidest game. It is hard, and scary, and demands a delicate interplay between mind, body, and will. It is also an excellent opportunity to scream, grunt, bleed, get dirty, poop in the woods, and say terrible, terrible things to your closest friends while performing dangerous stunts in beautiful places. A bad day climbing is better than a good day doing most anything else."

—James Bachhuber

Previous
Dreamcatcher (5.14d)
Jacopo Larcher trying his hand at one of the iconic hard routes of North America. In 2005 Chris Sharma bolted the line and put up the first ascent.

Right
The Stawamus Chief above Squamish, shrouded in moody morning fog.

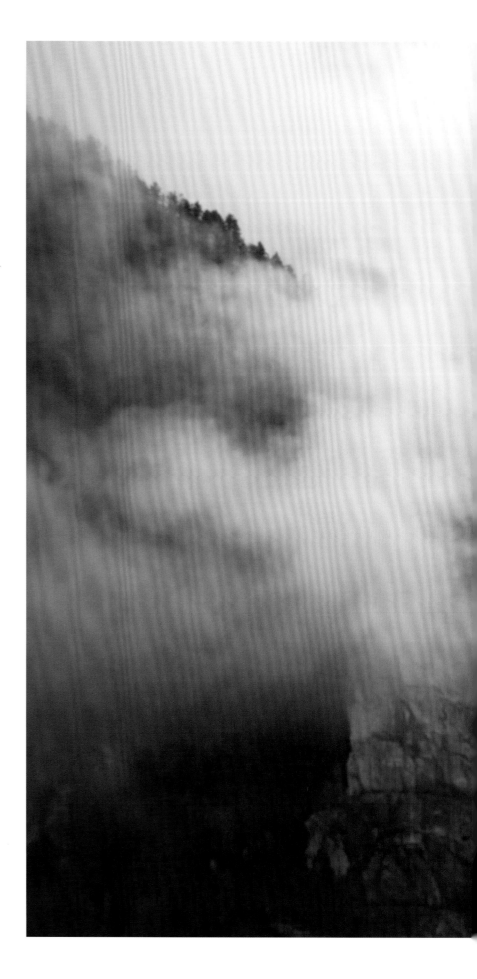

Bugaboos

British Columbia, Canada

Type of Climbing:
Alpine, trad, bigwall

Rock Type:
Granite

Climbing Style:
Vertical cracks, slab, adventurous

Number of Climbs:
250+

Elevation:
7,500 ft

Prime Season:
July–August

Classic Climbs:
West Ridge of Pigeon Spire (5.4), *Snowpatch Route* (5.8), *McTech Arete* (5.10-), *Beckey-Chouinard* (5.10), *Sunshine Crack* (5.11-), *All Along the Watchtower* (5.11 C2-)

Right
Amélie Goulet-Boucher and Zoe Hendrickson traversing the snowy, glacial landscape of Bugaboo Provincial Park. The steep, snow-laden gap between the peaks ahead is the Bugaboo-Snowpatch col, which provides access to many of the larger objectives in the park.

Following
Amélie Goulet-Boucher and Zoe Hendrickson on the approach trail to the Bugaboos. For fit climbers this steep trail may be underestimated, but with the elevation and a week's provisions on one's back, it can prove a worthy adversary.

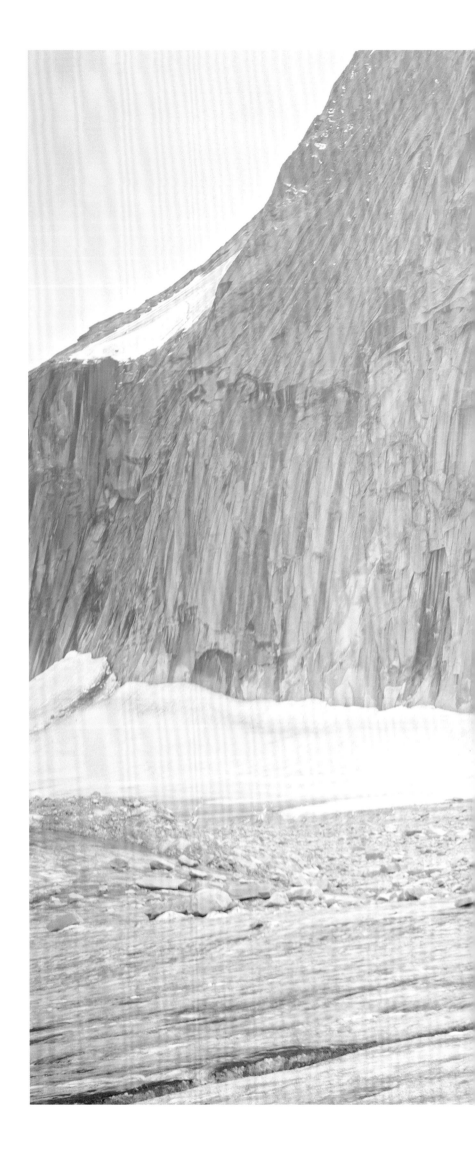

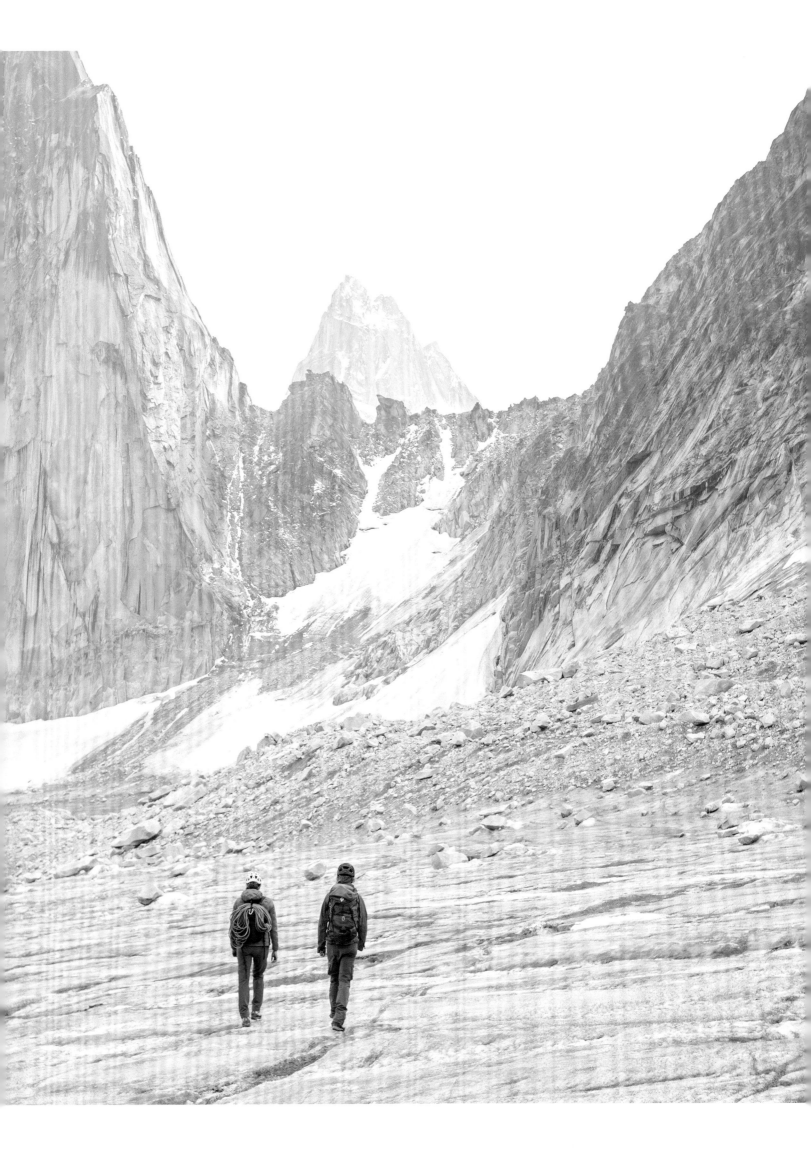

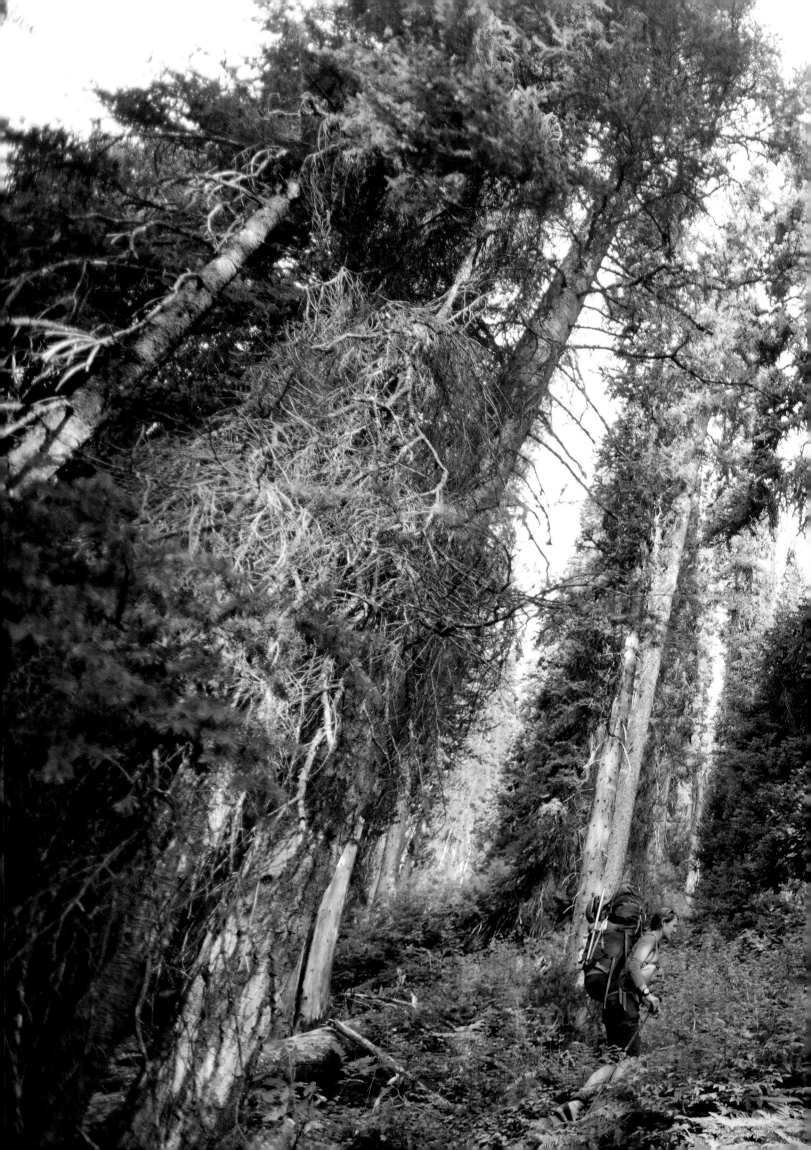

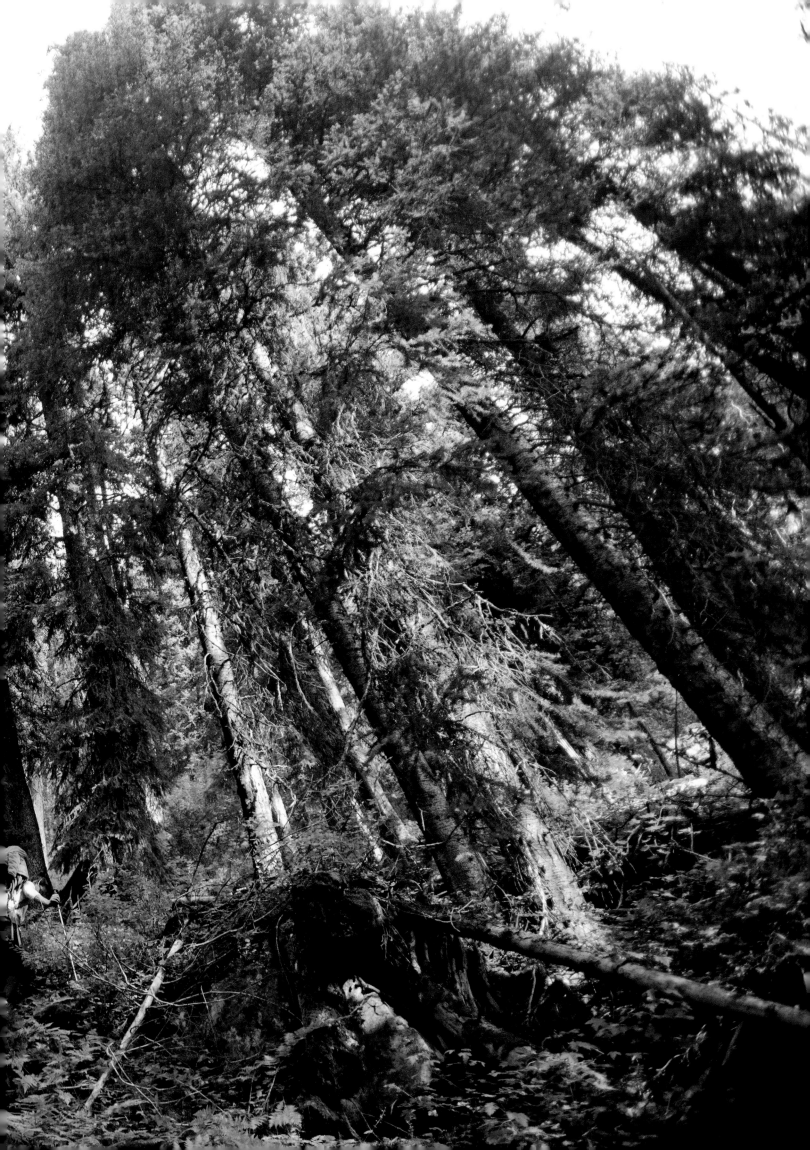

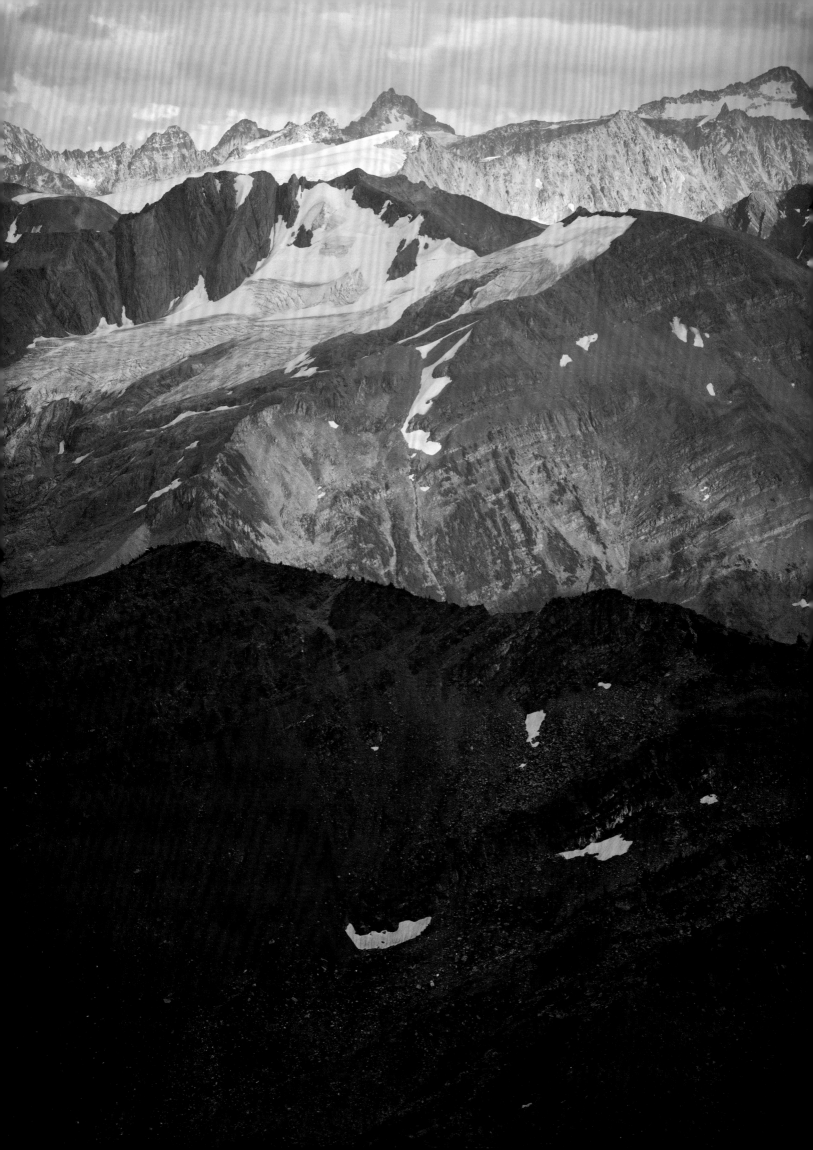

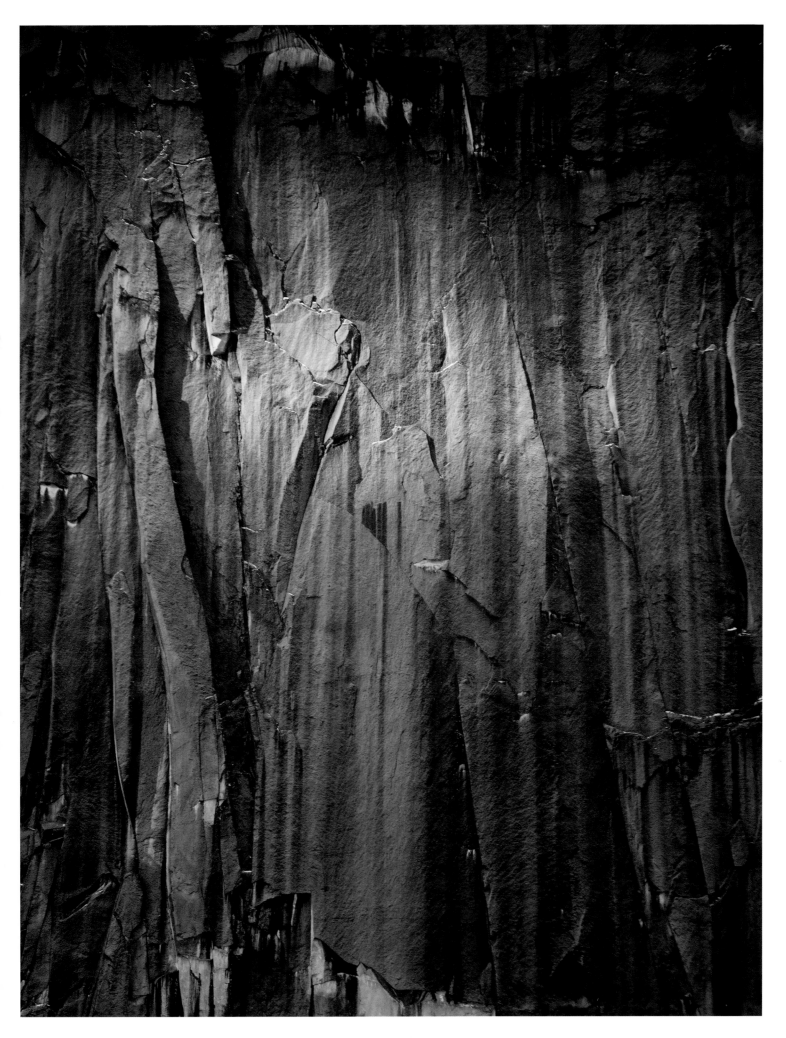

Left
Mountain vastness. The rolling yet jagged spread of the southern Purcell Mountains, as observed from Applebee Campground.

Right
Morning light on Snowpatch Spire. This same face was recently the stage for one of the most cutting edge alpine free climbs, the *Tom Egan Memorial Route* (5.14), first freed by Will Stanhope.

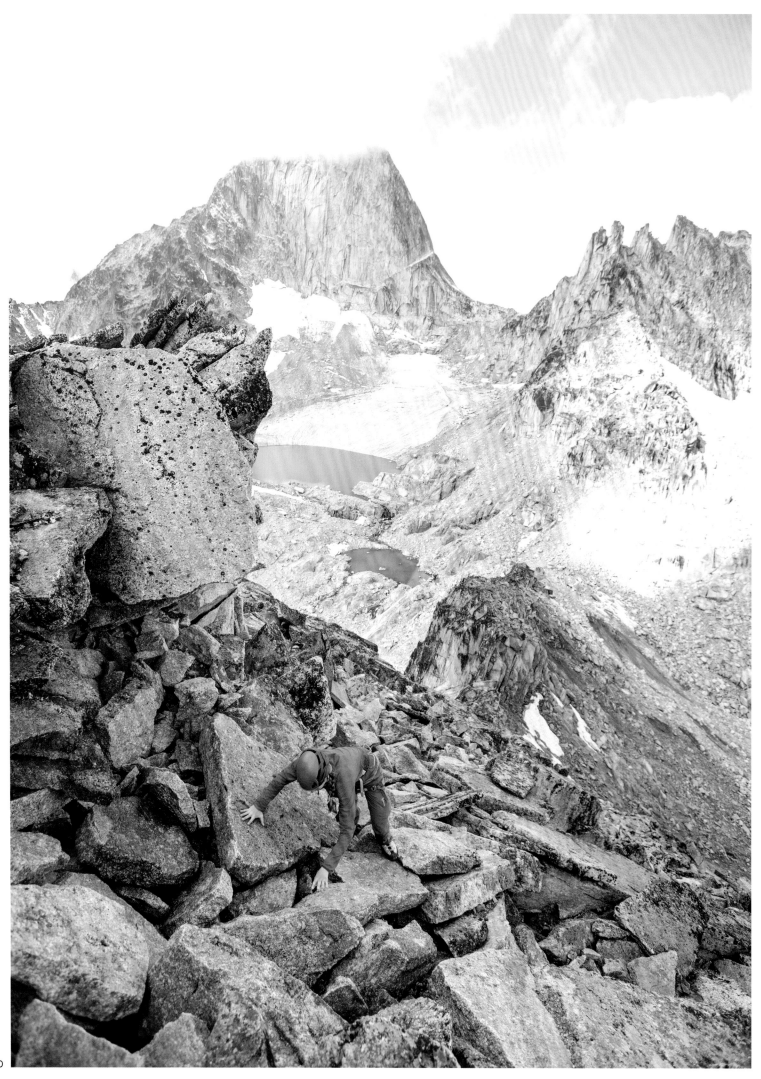

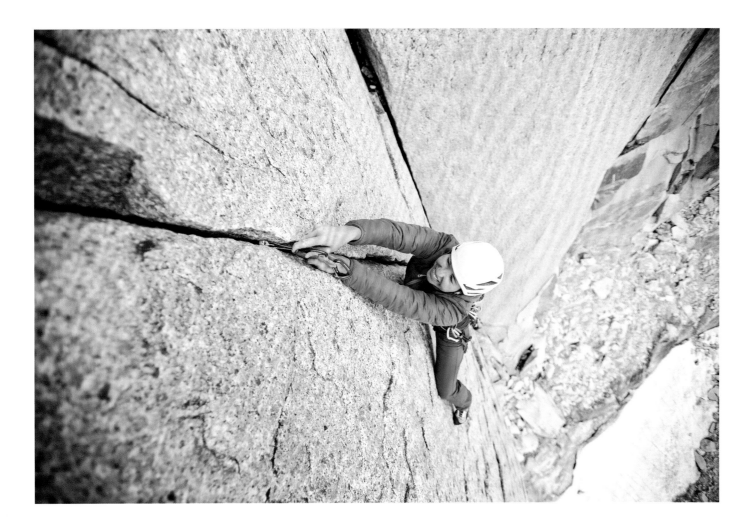

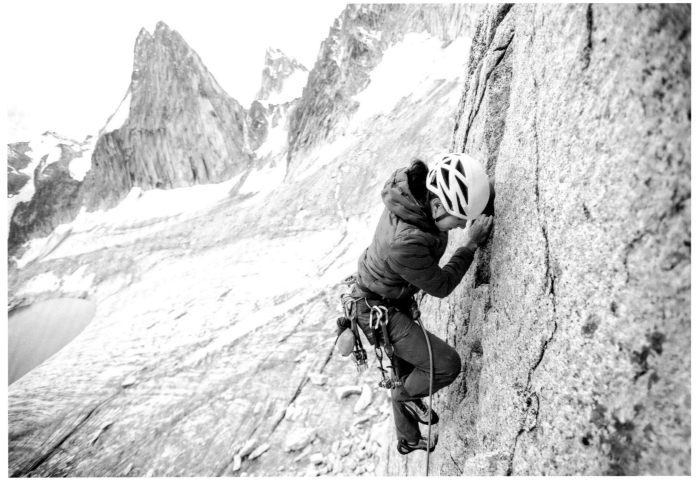

Left
Zoe Hendrickson scrambling up Eastpost
Spire.

Top
McTech Arête (5.10-)
Amélie Goulet-Boucher placing a bomber cam
before launching into some perfect fingerlocks.

Bottom
McTech Arête (5.10-)
Amélie Goulet-Boucher romping up this
classic route near camp, with Snowpatch Spire
proudly perched in the background.

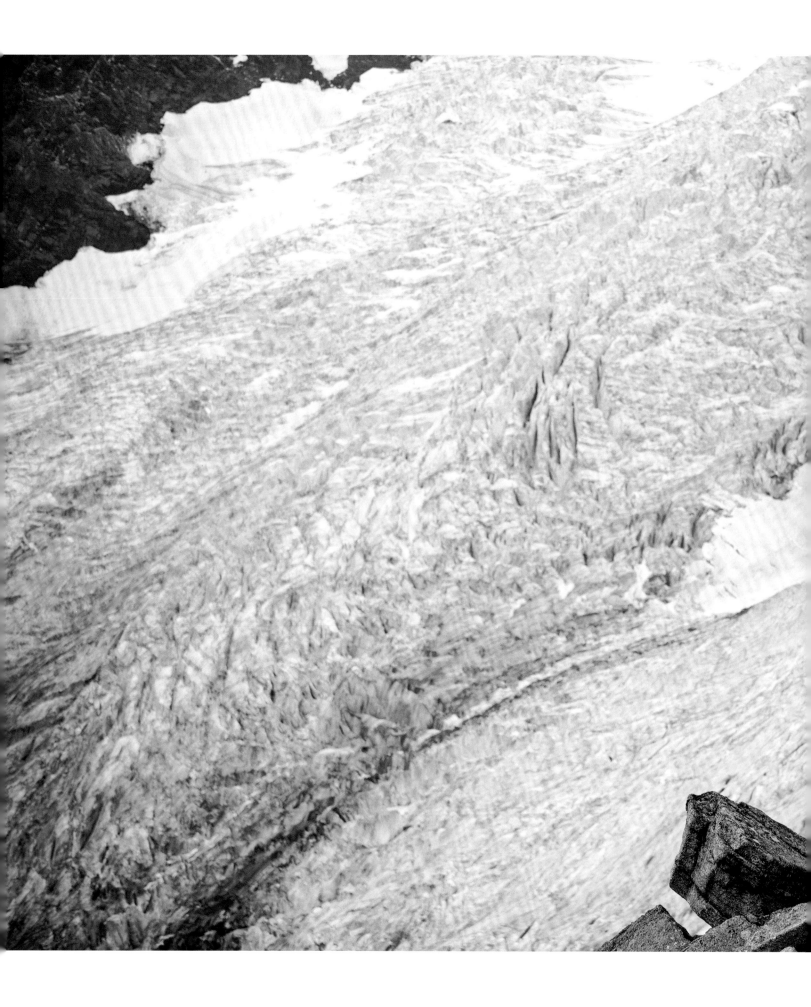

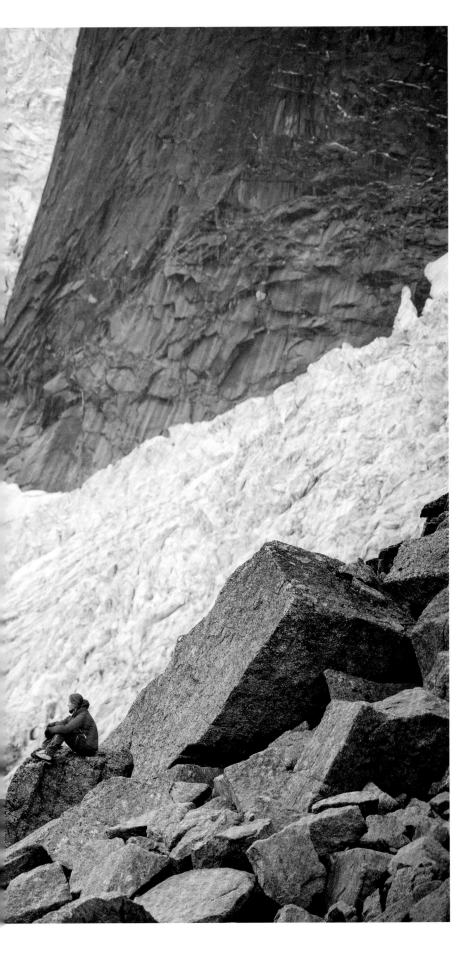

"The mountains seem to have conquered us long before we set foot on them, and they will remain long after our brief existence. This indomitable force of the mountains gives us humans a blank canvas on which to paint the drive of discovery and, in the process, test the limits of human performance."

—Conrad Anker

Left
Zoe Hendrickson taking a morning moment in front of the Bugaboo Glacier.

Following
The long, quiet march back to camp after another day on the rocks.

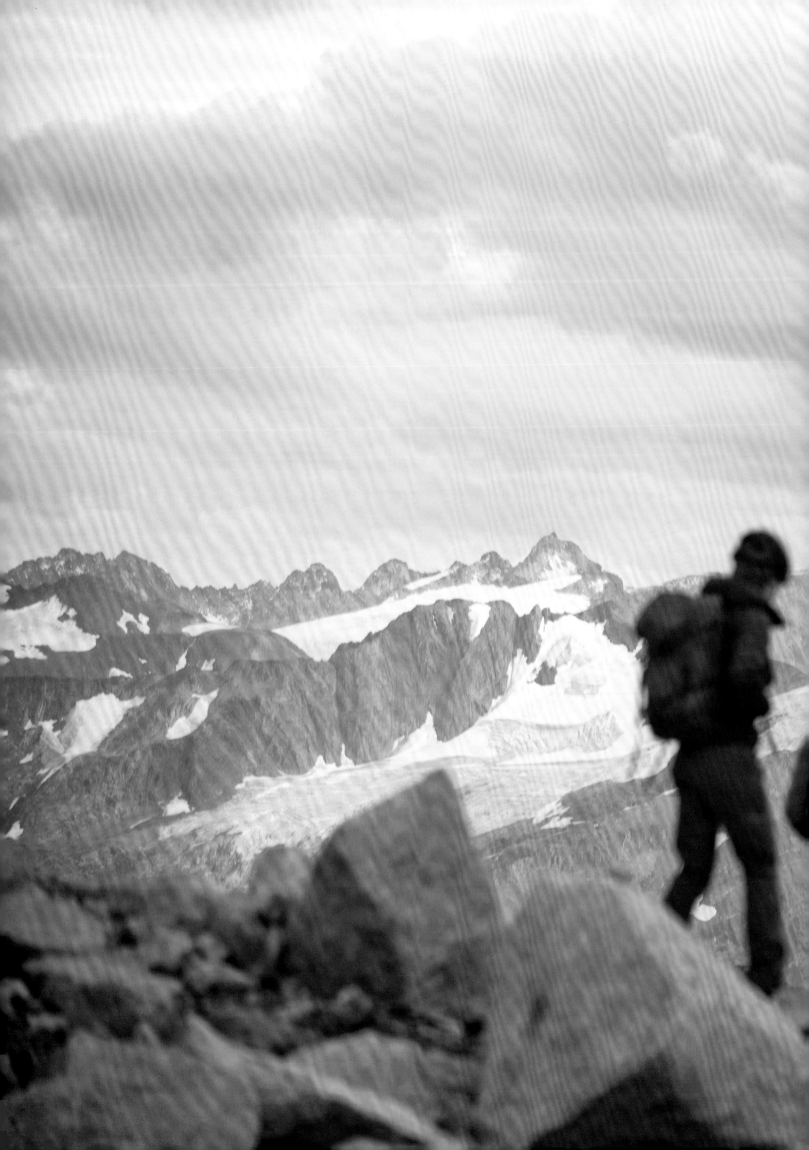

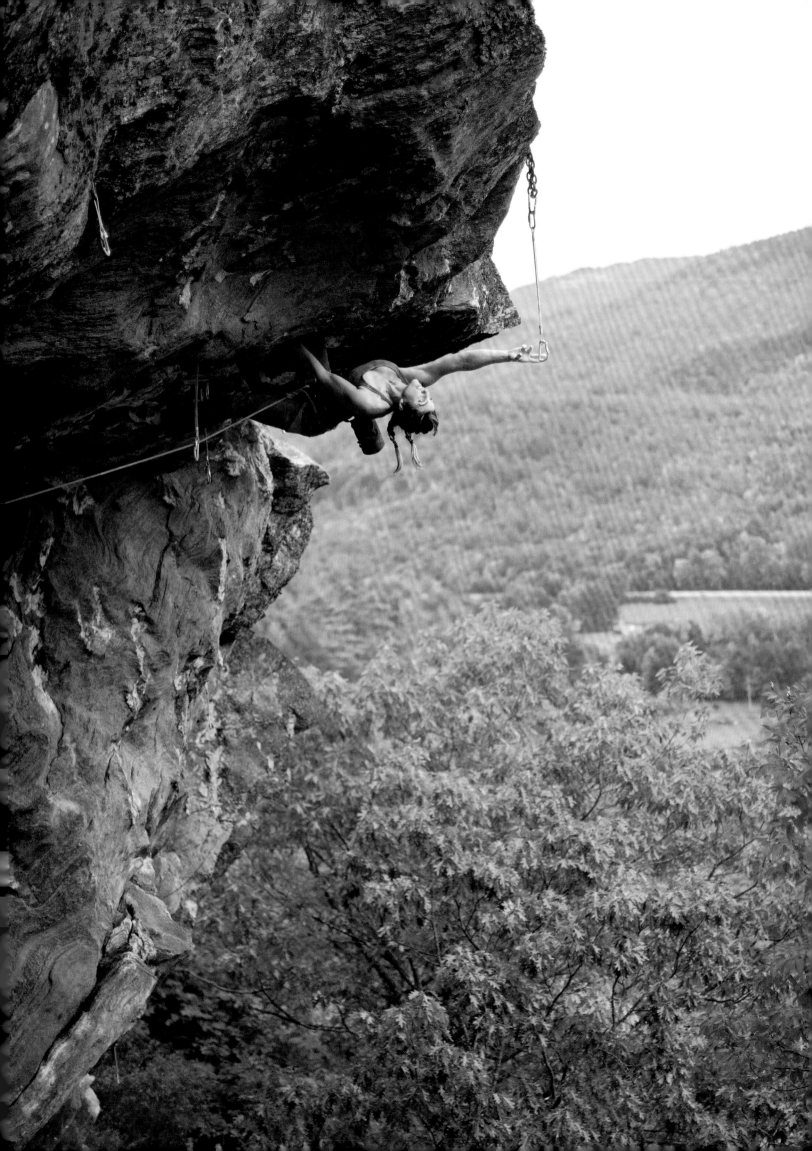

FALL

Around early September the Canadian alpine conditions harshen and the monkeys roam eastward. Fall for a climber is open season for most areas, but the iconic New England foliage provides a magnificent backdrop for stone rambling. The feeling of pulling onto a ledge or summit over a rainbow of autumn down below is priceless. The friction is pristine, the cool breeze is encouraging, the views are spectacular. Conditions are prime to sample the best of the East Coast.

New Hampshire is known to laypeople and climbers alike as the Granite State, and for good reason—the volume of quality rock in this tiny state is staggering. The White Mountains perch proudly in the north of the state, housing the tallest peak in the east, Mt. Washington. The state is chock full of excellent trad climbing and bouldering, but we begin our season in the sport climbing epicenter of **Rumney**, NH. Rumney rock is a unique strain of schist speckled with reflective micah. The climbing is bouldery, sharp, technical, and aesthetic. The Waimea crag [p. 140] is so striking it could be an art exhibit, and happens to offer some of the highest quality (and most difficult) sport climbs around. The oddly sparkling stone and the lush sloping forest teeming with frogs and salamanders lend Rumney a fairy-tale quality. The post-climb swimming hole [p. 150], usually replete with rope swing, is not to be missed.

The **Gunks** (Shawangunks) is a discontinuous cliff band in upstate New York, cherished by local climbers and respected worldwide. For an average of one to two pitches per climb, the Gunks knows how to pack a punch. Those who sharpen their trad skills on the quartz conglomerate of the Gunks are forced to develop their mental game quickly. A classic Gunks route involves delicate slab climbing to an enormous bouldery roof. Although the crag is but 200 feet tall, it sits perched on a rise that provides a distinct feeling of altitude and exposure to most climbs. The exposure yields long lateral views of the cliff, stretching out for quite some time in both directions. The Yellow Wall is one such section of the cliff, comprised of particularly beautiful stone patterns, and featuring several of the best (and most daunting) hard Gunks classics [p. 160]. Most routes are overhanging, traverses abound, the cracks are horizontal instead of vertical, and the gear placements demand competence.

A day's drive gives way to one of the most underrated destinations on the continent. With seemingly endless sandstone cliff bands pitched above the winding banks of the New River, West Virginia's **New River Gorge** is both photogenic and world-class. The aptly named Endless Wall [p. 166] spans three miles of unbroken cliff, crammed with trad and sport classics from end to end. Routes in the New number in the thousands, tend to be devious and technical, and are scattered along multitudinous crags of bullet-hard Nuttall sandstone tucked among lush and gorgeous eastern forest.

Nearby to the west lies the legendary **Red River Gorge**, KY. Spread generously across a vast forested landscape of gently rolling hills, the walls of The Red largely feature severely overhanging sandstone infused with iron bands of various shapes. The ensuing forearm pump from the steep, continuous climbing is infamous. Although this area is world-renowned as a sport climbing Mecca, trad diehards will find an array of enjoyable vertical cracks. Regardless of climbing modality, the tribe tends to meet at the end of the day for beverages and pizza at Miguel's, the community hub.

The deeper south is far too steamy in the summer and early fall for decent climbing. But by the late fall and early winter, the rock-rich areas of the **Southeast** become excellent choices for the season. Nestled in the foothills of the Appalachian Mountains, the greater Chattanooga region is the center for southeastern climbing. Surrounded by crags and boulders in all directions, there are thousands of climbs within a moderate radius of the city. Popular areas like Little Rock City in Tennessee, Horse Pens 40 in nearby Alabama, and Rocktown, across the Georgia border, host a wealth of sandstone boulder problems in every style imaginable.

Rumney

New Hampshire

Type of Climbing:
Sport, bouldering

Rock Type:
Schist

Climbing Style:
Sharp, powerful, bouldery

Number of Climbs:
1,000+

Elevation:
800 ft

Prime Season:
April–May, September–October

Classic Climbs:
Underdog (5.10a), *Millenium Falcon* (5.10c), *Tropicana* (5.11a), *Flying Hawaiin* (5.11b), *Black Mamba* (5.11c), *Technosurfing* (5.12b), *Predator* (5.13b), *Zig Zag Crack* (V1), *The Whale's Tail* (V4+), *Pyramid Power* (V8)

Previous
Man Overboard (5.12d)
Colette McInerney in full extension to clip one of the final draws on this inverted Rumney route.

Right
Restless Native (5.12c)
Lily Canavan setting up on a sloper high on this Waimea classic.

Following
Climbers down below at the Waimea crag—belaying, resting, spectating.

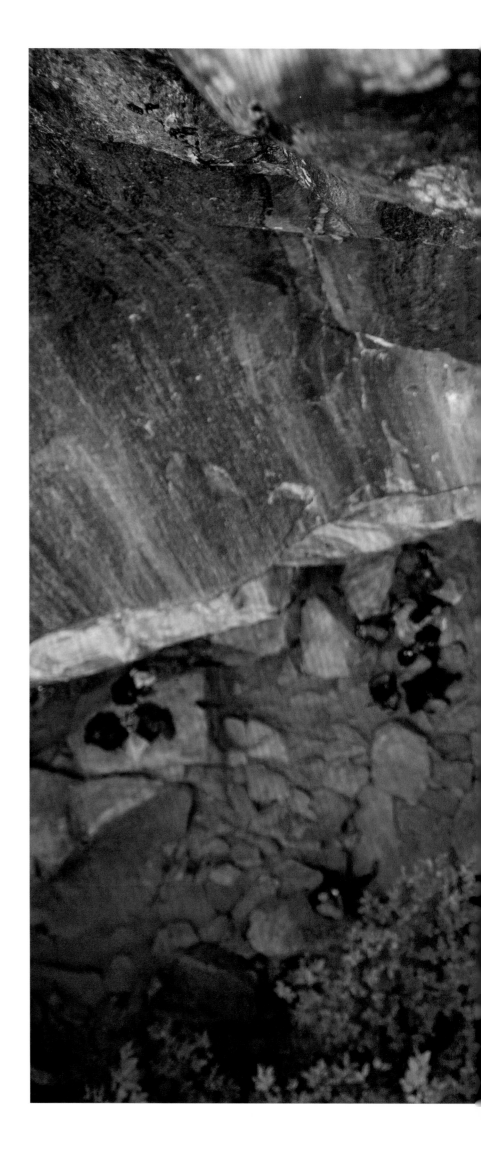

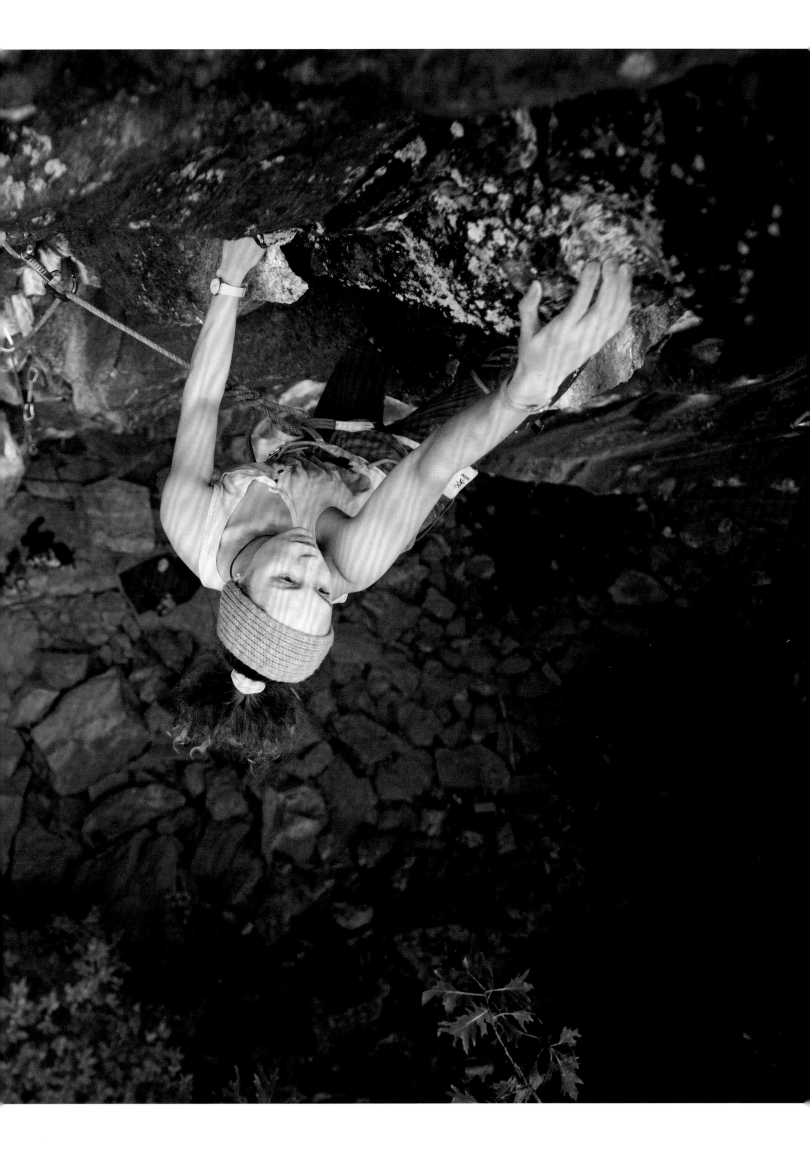

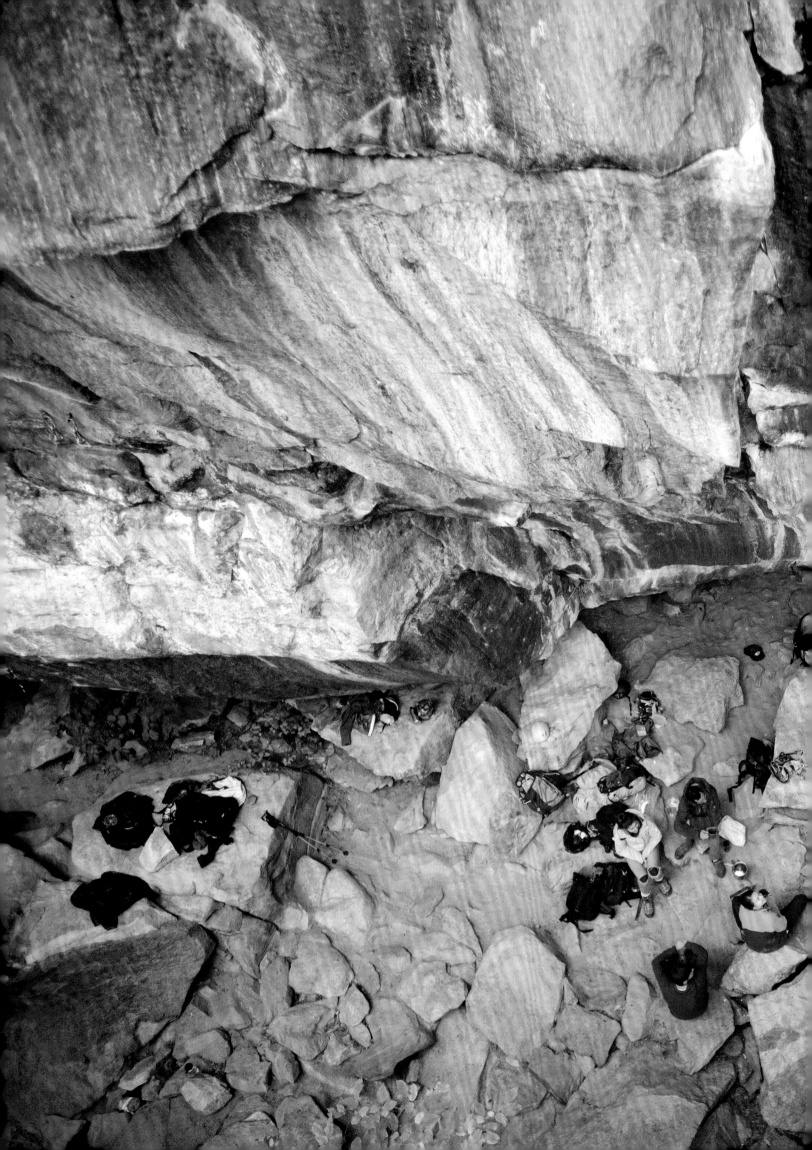

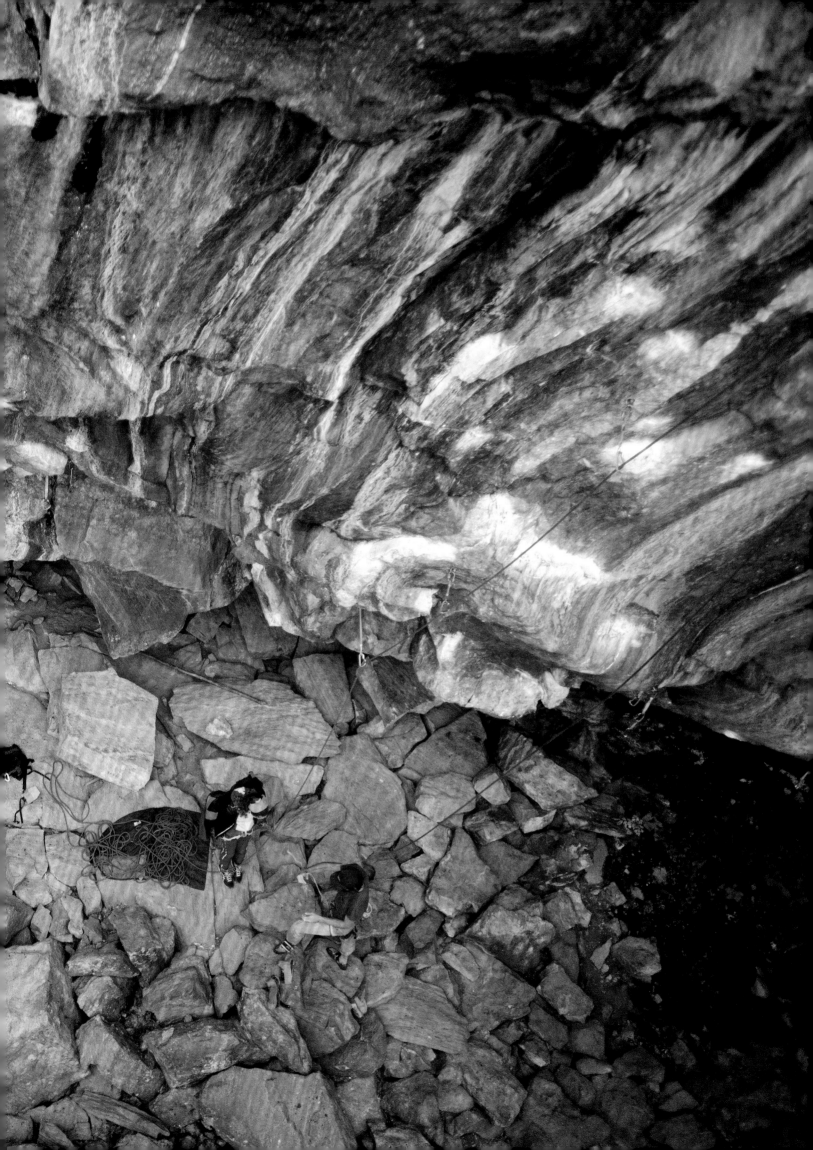

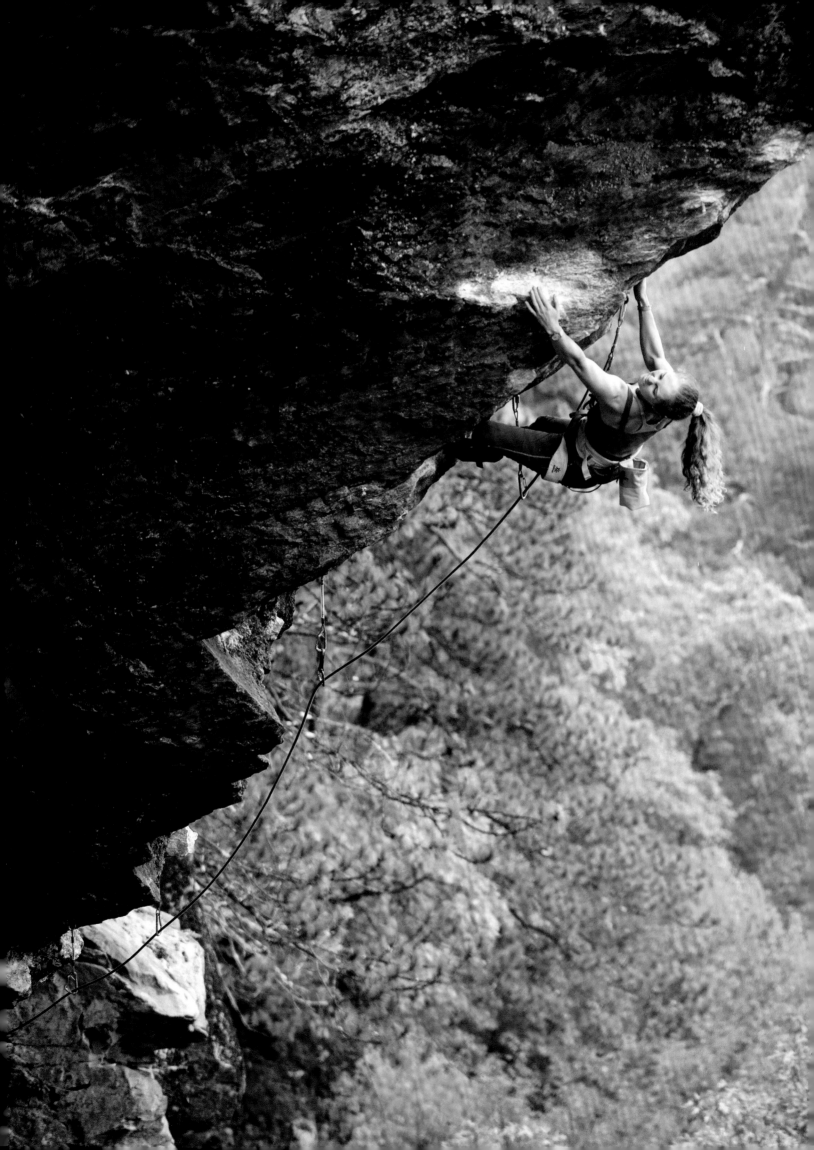

"It's these tales that make us laugh and cringe, gasp and groan, and ultimately bind us together as climbers. They teach us, help us teach each other, and remind us the biggest take-away is our resilience in overcoming obstacles and our tacit acceptance that climbing is always an adventure."

—Shabana Ali

Previous
***Predator* (5.13b)**
Lily Canavan on the striking Rumney testpiece.

Right
***Suburban* (5.13a)**
Dan Yagman on one of the most popular 5.13's at Waimea. Suburban is a variation of *Urban Surfer* (5.13d).

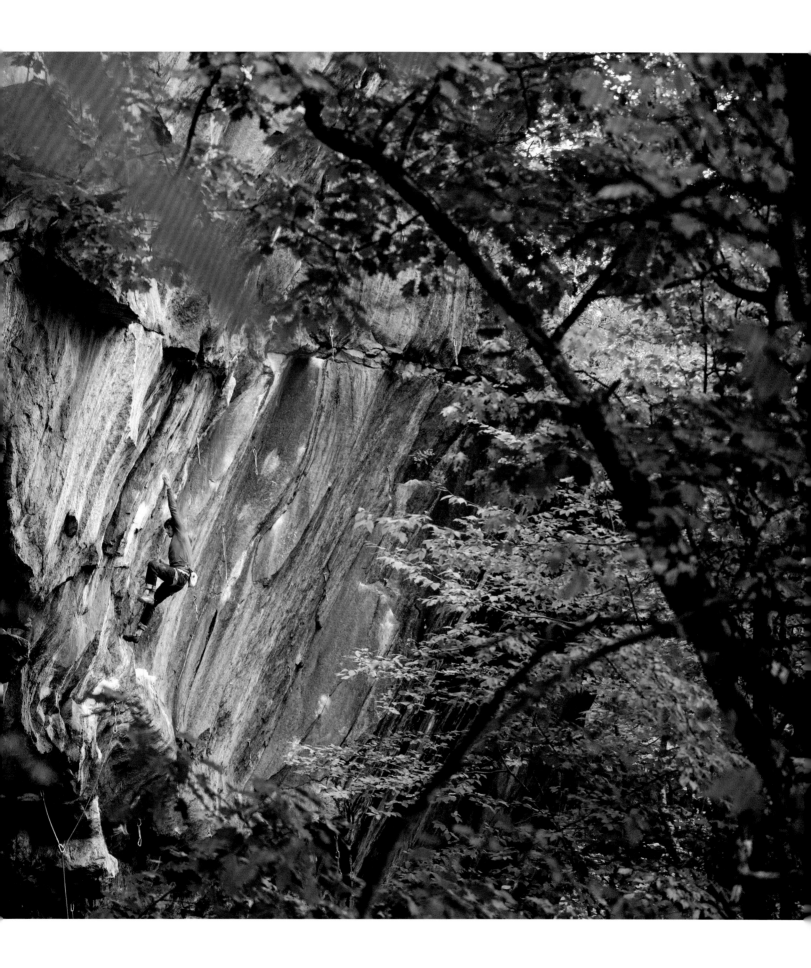

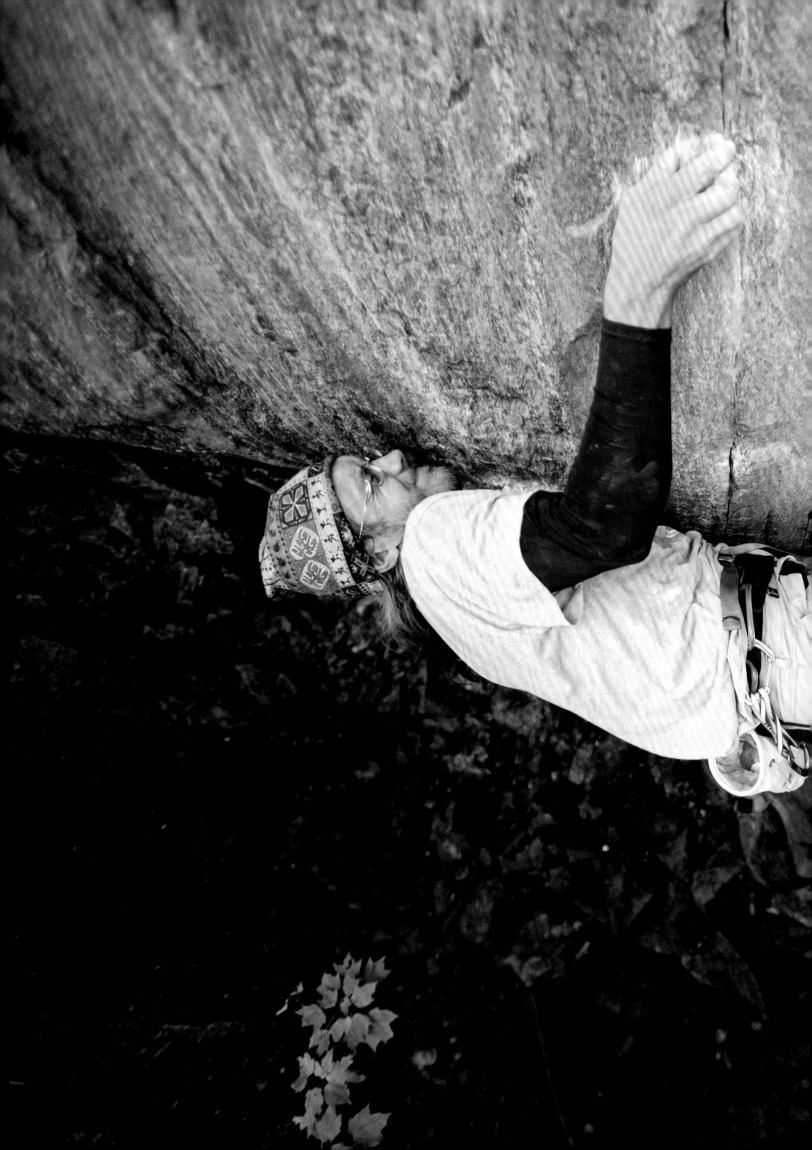

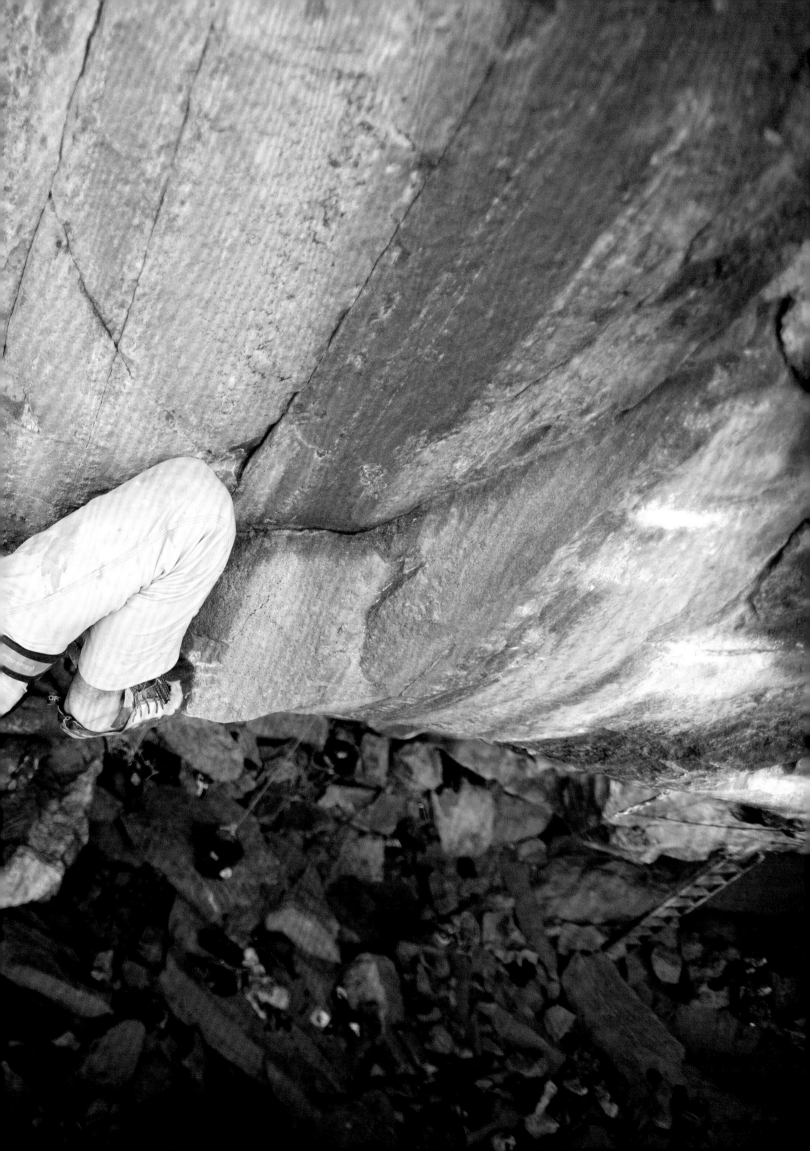

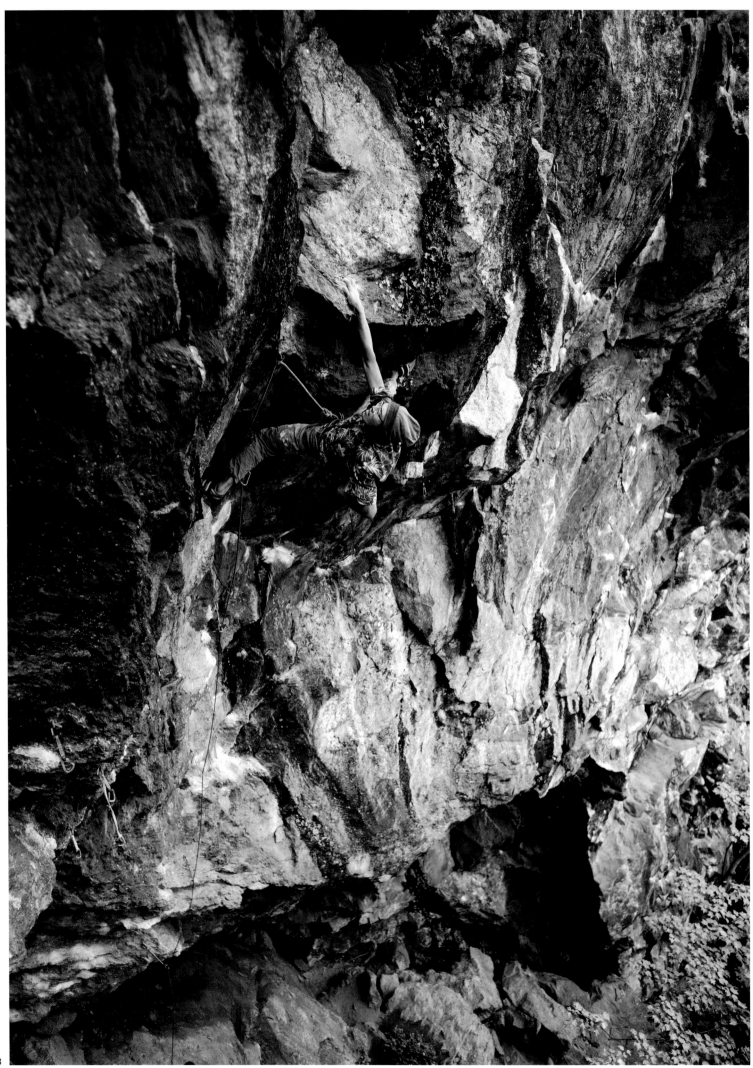

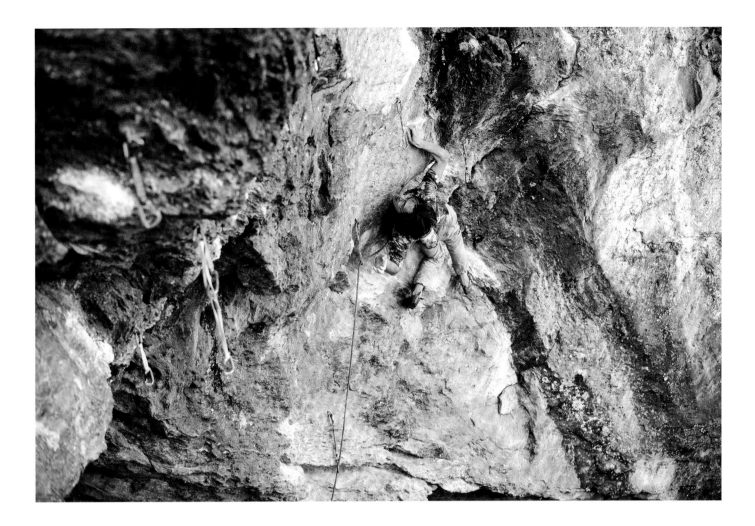

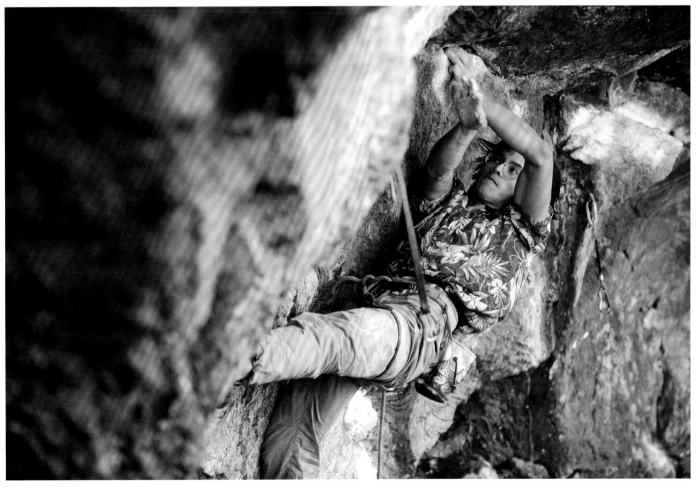

Previous
Tsunami **(5.12c/d)**
Denis Ovchinnikov exerting force and body tension to gain the upper slabs of this Waimea climb.

Left, Top, Bottom
Flying Monkeys **(5.12c)**
Colby Yee unfolding intricate, awkward, and balletic sequences to keep in contact with the schist.

"I have probably experienced some of the same emotions that people associate with spirituality: the feeling of oneness with the world and the sense of awe and wonder and our own smallness, which religious people equate with some kind of higher power or god. I just attribute that to the beauty of nature—and my love of the outdoors."

—Alex Honnold

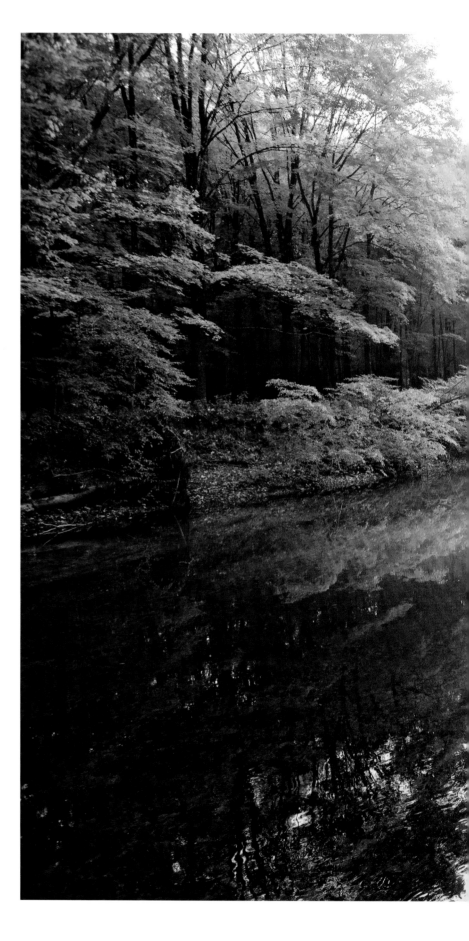

Right
One of the finest Rumney rituals is the end-of-day soak in the clear, cool waters of the Baker River.

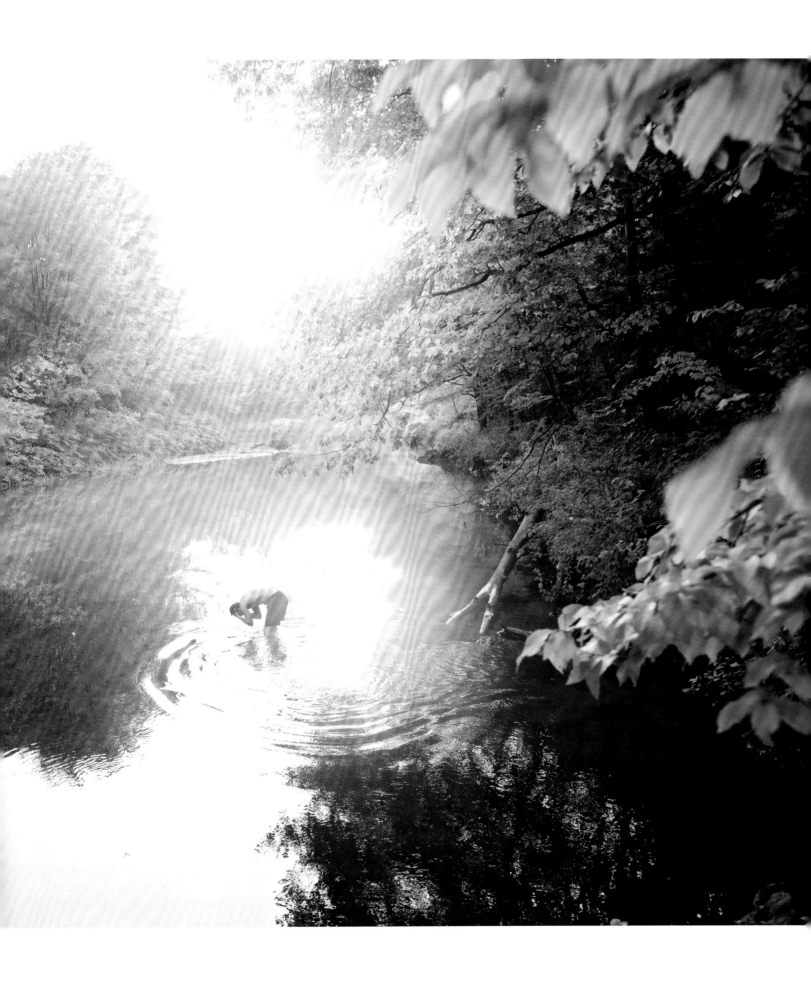

Left
Evening rays through New England's autumn yellows.

Top
Plush Rumney campgrounds allow for plush burrito stations.

Bottom
No Rumney trip is complete, especially in the crisp fall air, without a hearty bonfire.

Gunks

New York

Type of Climbing:
Trad, bouldering

Rock Type:
Quartz conglomerate

Climbing Style:
Roofs, horizontal cracks

Number of Climbs:
1,000+

Elevation:
900 ft

Prime Season:
April–June, August–October

Classic Climbs:
*High Exposure (5.6), Something Interesting
(5.7+), Cascading Crystal Kaleidoscope (5.8),
Modern Times (5.8+), Roseland (5.9), Welcome
to the Gunks (5.10b), Erect Direction (5.10c),
Yellow Wall (5.11c), Supper's Ready (5.12a)*

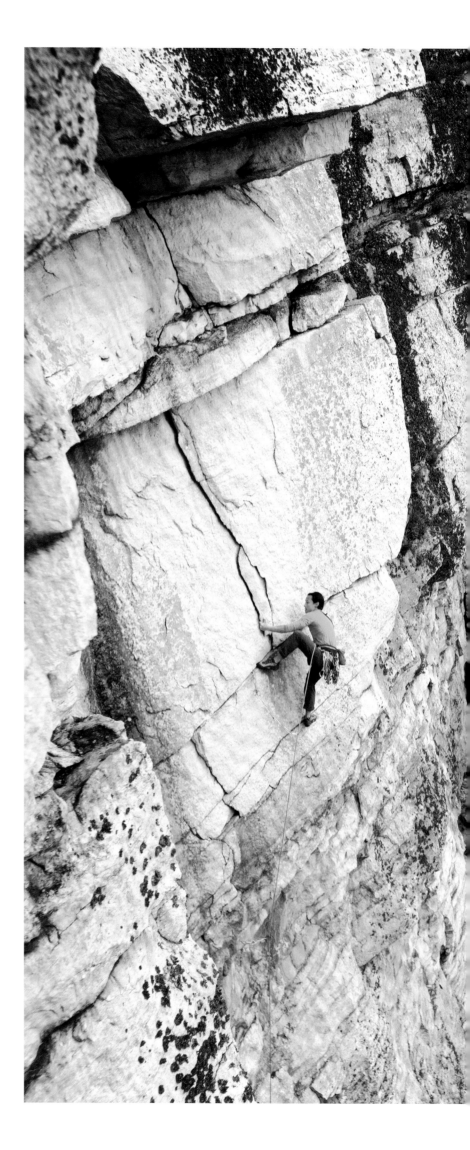

Right
Cascading Crystal Kaleidoscope (5.8)
Don Vu launching into the laybacks of this spicy
climb with unusual exposure for the grade.

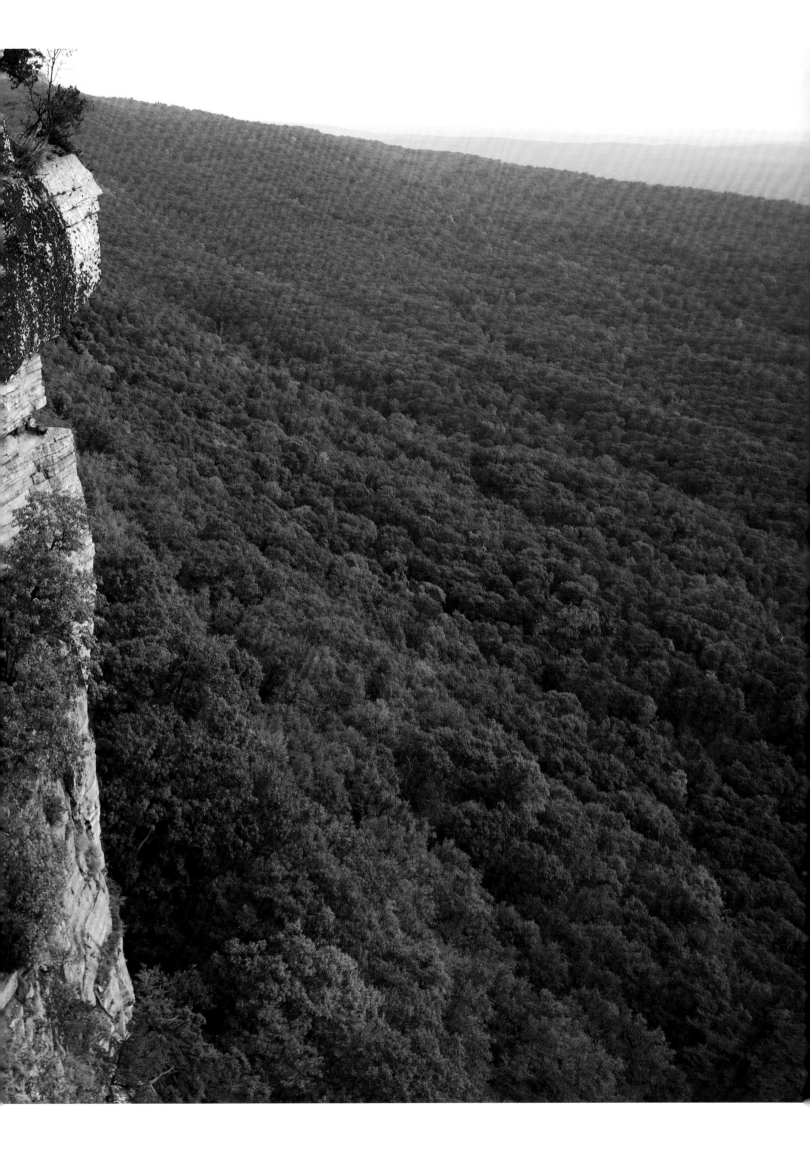

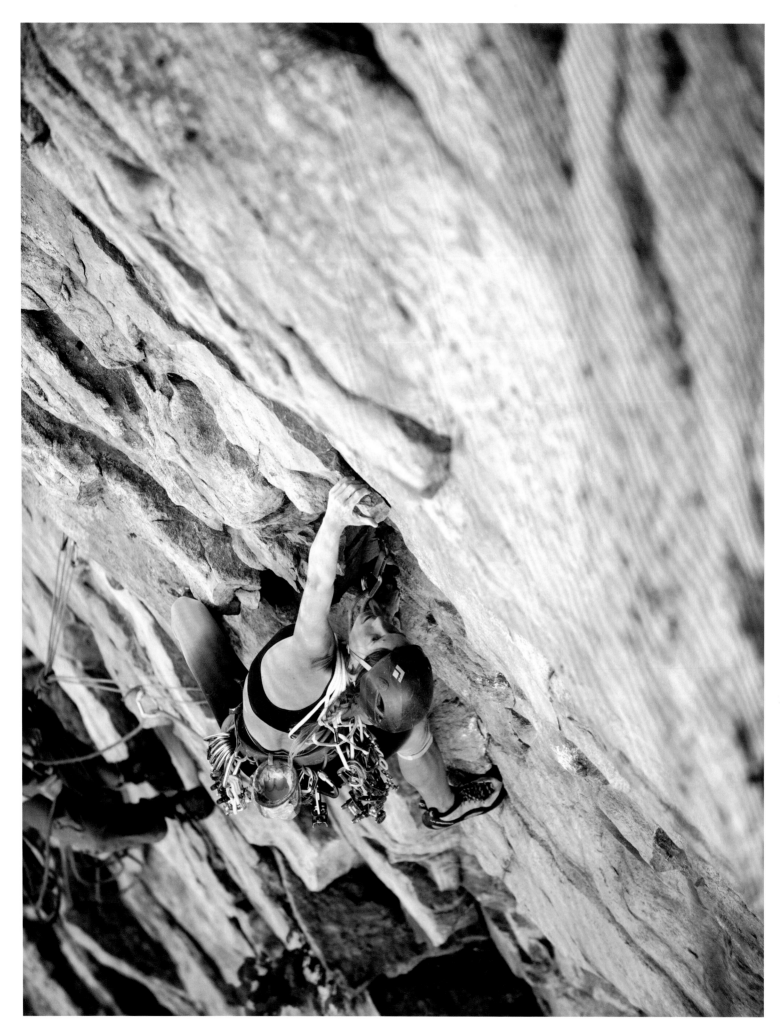

Left ***Madame Grunnebaum's Wulst*** (5.6)
Martynka Wawrzyniak getting rowdy on the overhanging jugs of this popular Trapps route.

Right ***Le Teton*** (5.9+)
Jesse Lynch gratuitously foot-jamming on an exciting exposed face.

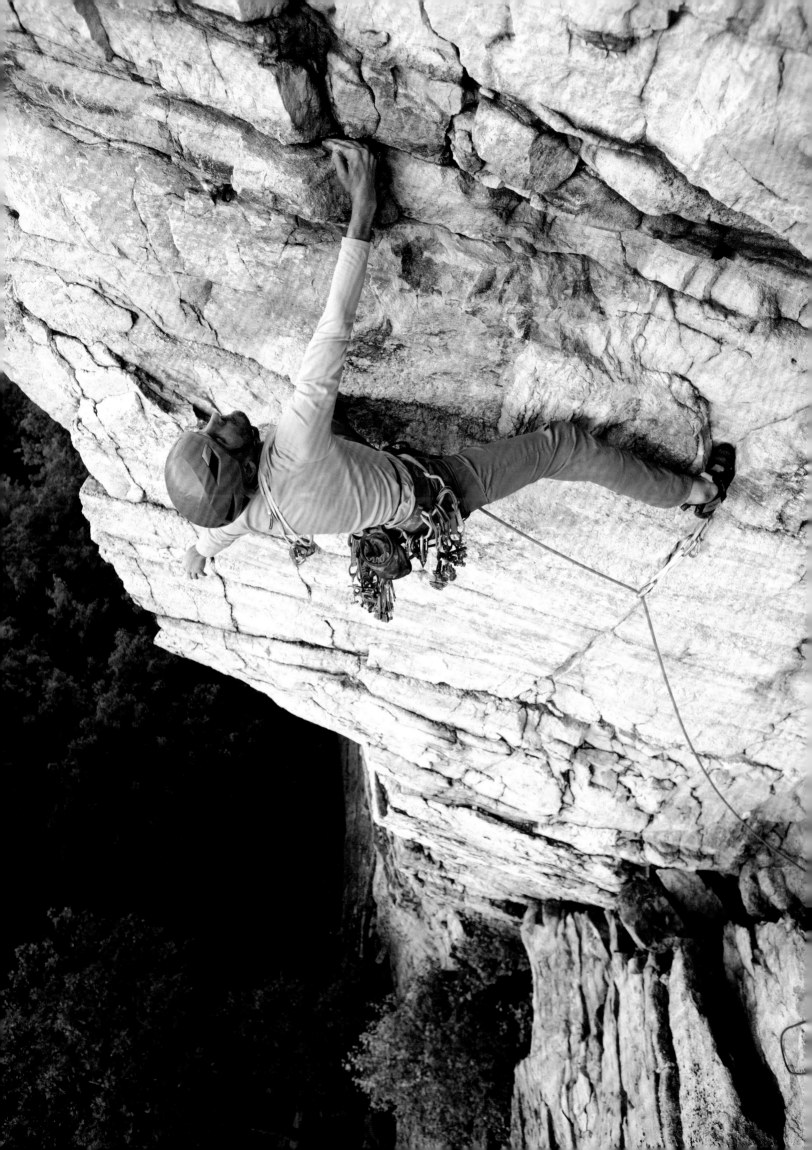

"There are some climbers who are borderline demented, but most approach the sport with either a Zen contemplativeness or giddy mischievousness. There's a weird pride in finding joy in situations that would be many people's nightmare. A climber must have an innate desire for the ability to control their fear and be honest with themselves about what they are capable of. One of the beautiful things about climbing is that success (and failure) is clearly defined."

—Justin Seweryn

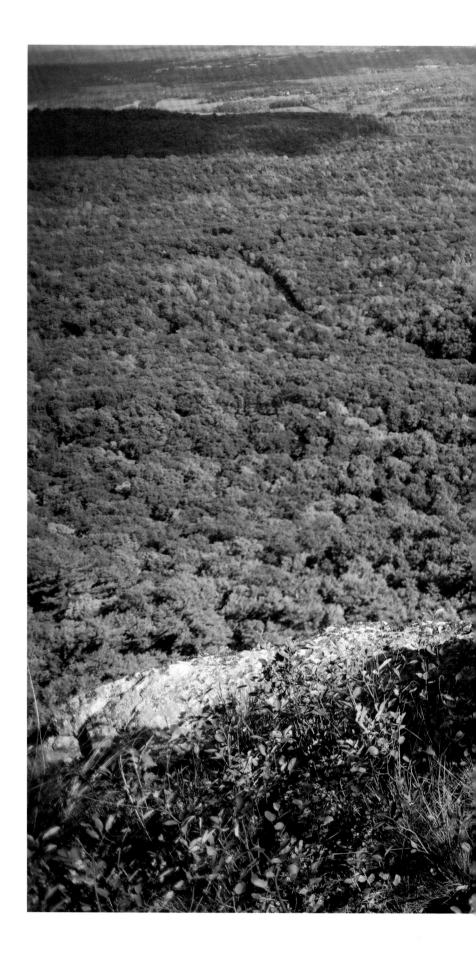

Right
Dean Rosenthal taking in the autumn panorama while belaying his partner from the top of the cliff.

Following
Yellow Wall (5.11c)
Jaysen Henderson milking the rest before the business begins.

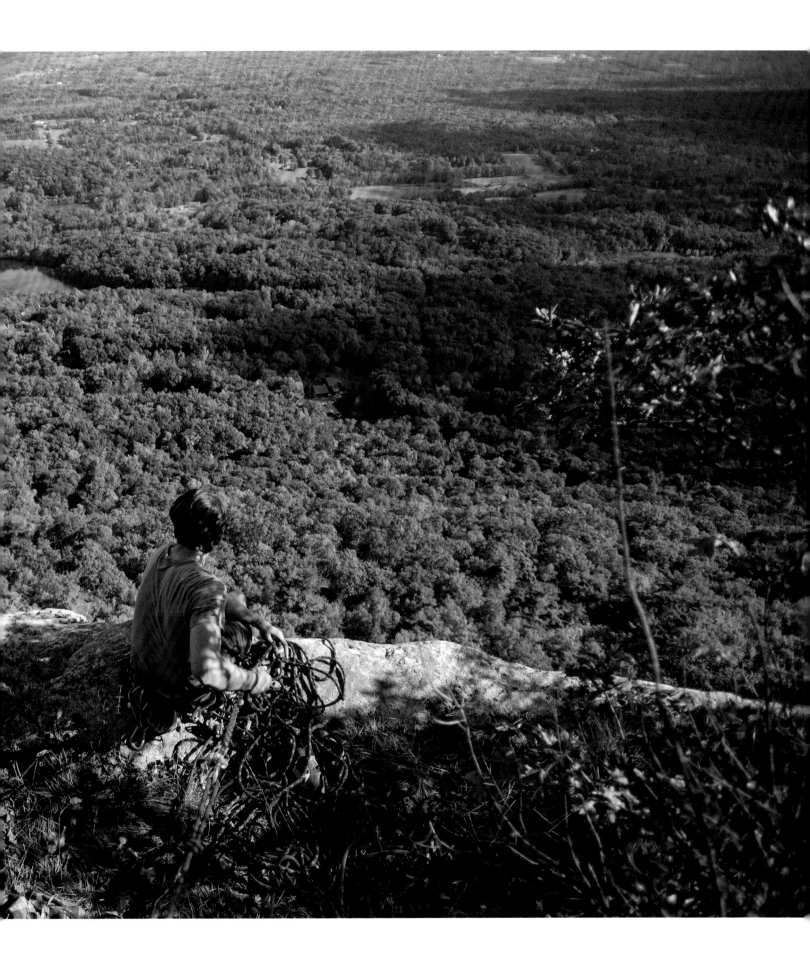

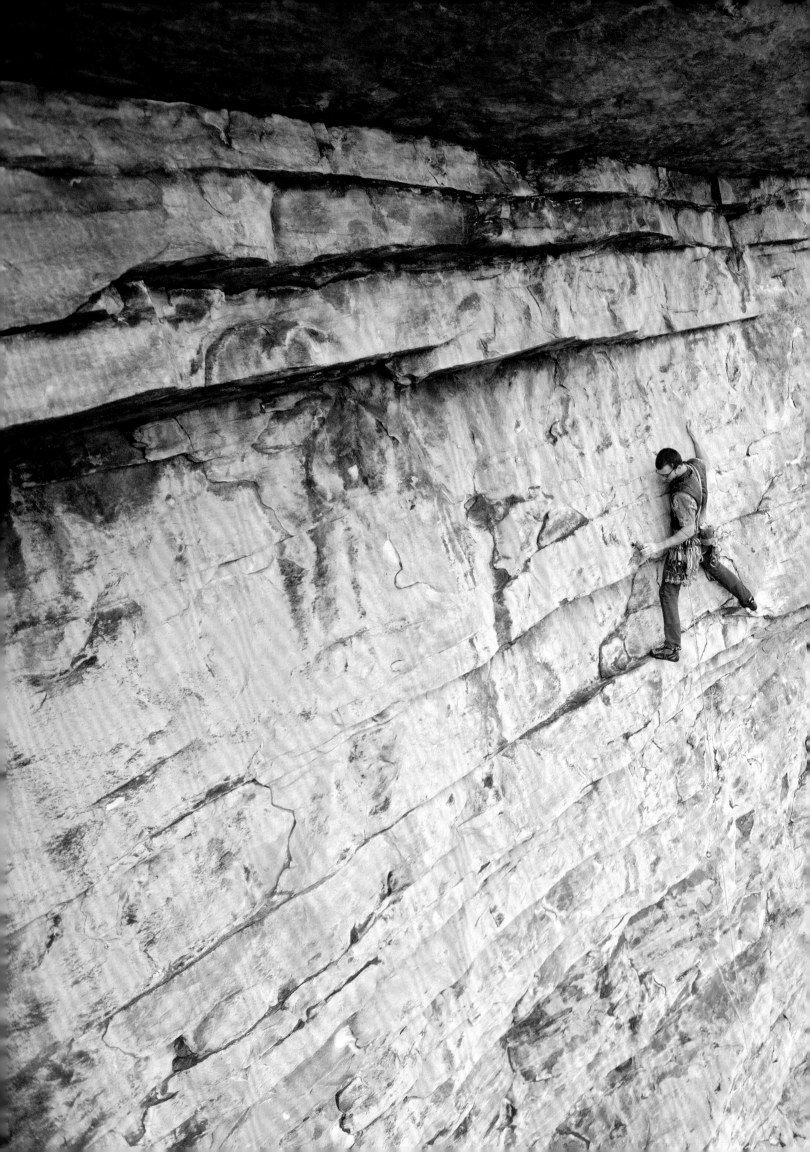

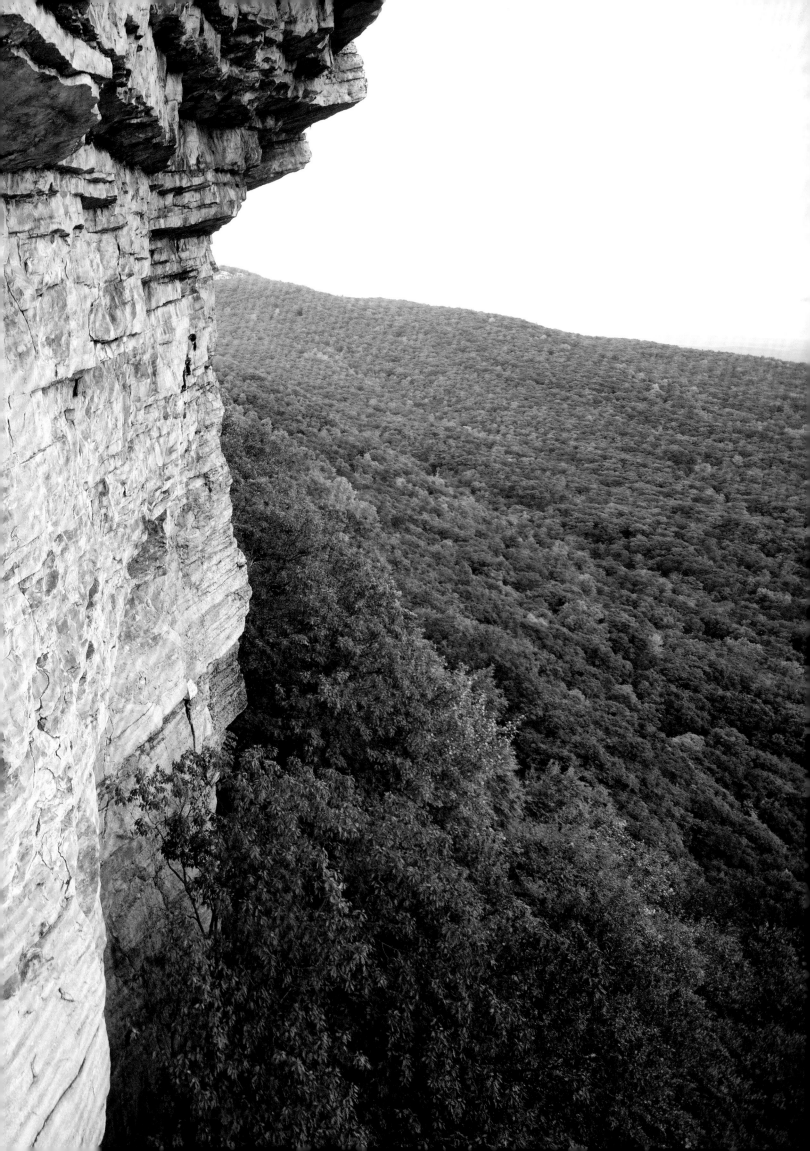

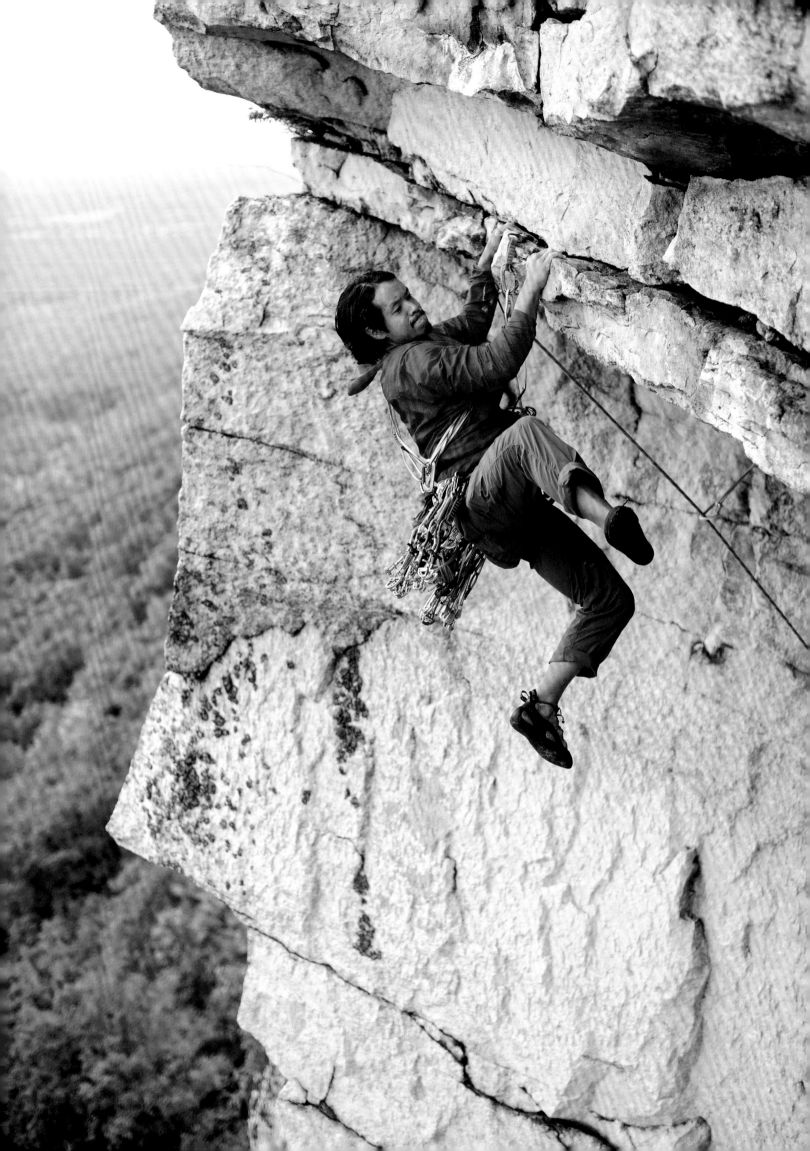

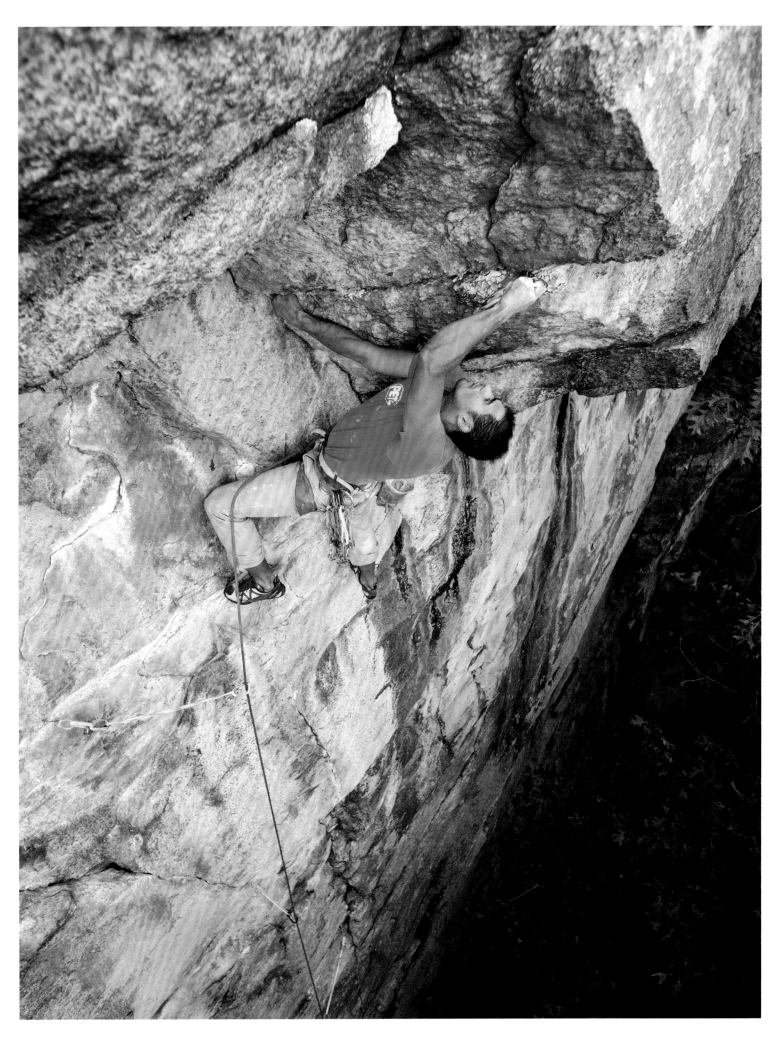

Left **Erect Direction (5.10c)**
Van Vu puts on his game face to pull one of the largest 5.10 roofs in the Gunks.

Right **MF (5.9+)**
Julian Acevedo clipping an old but welcome piton to protect the airy crux sequence to follow.

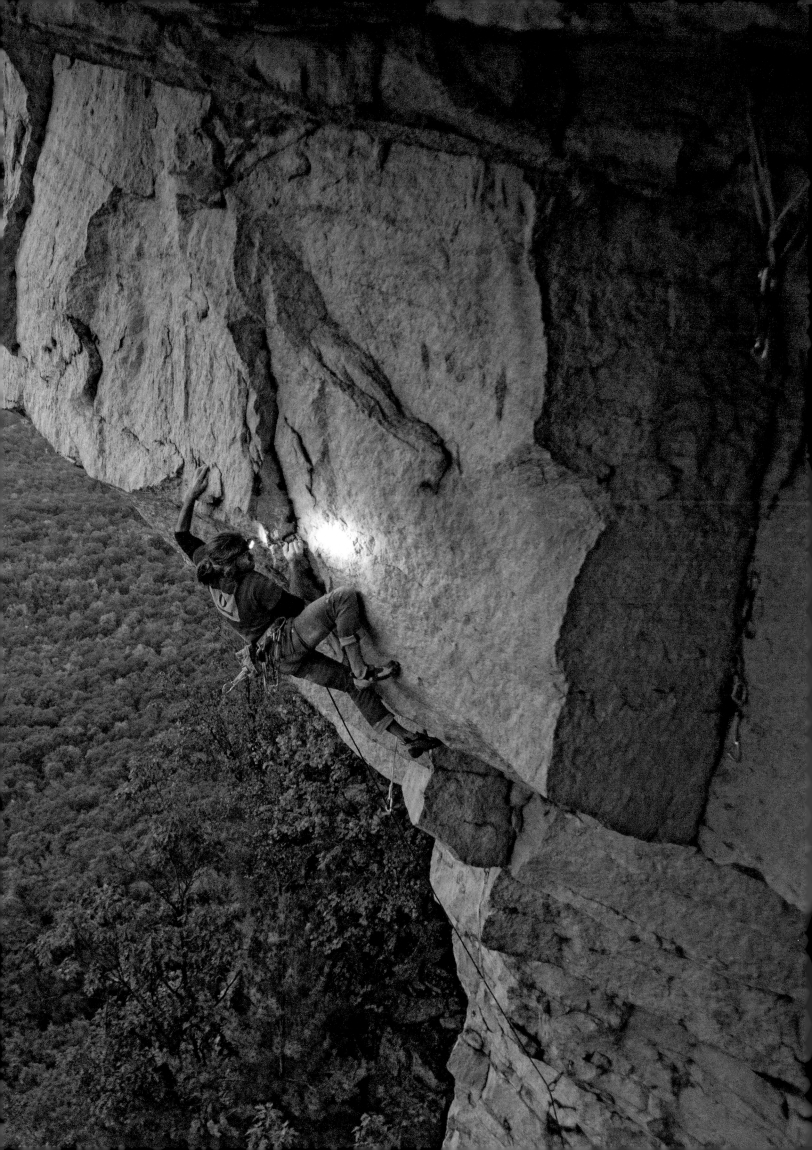

New River Gorge

West Virgina

Type of Climbing:
Trad, sport, bouldering

Rock Type:
Sandstone

Climbing Style:
Vertical cracks, steep, techy face

Number of Climbs:
~1,500

Elevation:
1,321 ft

Prime Season:
April–May, September–November

Classic Climbs:
Flight of the Gumby (5.9+), *Party in my Mind*
(5.10b), *Legacy* (5.11a), *Scenic Adult* (5.11c),
Leave it to Jesus (5.11c), *Freaky Stylee* (5.12a),
Quinsana Plus (5.13a), *Greatest Show on Earth*
(5.13a), *Proper Soul* (5.14a)

Previous
***The Best Things in Life Aren't Free* (A4)**
Andy Salo on one of his projects, trying to free an
aid climb originally put up in 1984 by Chris Monz
and Mike Sawicky.

Right
The spectacular Cirque at sunset. The Cirque is
part of the Endless Wall, which spans miles. Down
below flows the New River, winding and bustling.

Following
***Skull Fuck* (5.12c)**
Lydia McDonald skillfully using her legs to do the
heavy lifting. The pumpy and excellent climbs of
the Glory Hole crag are a good rainy-day option
for strong climbers.

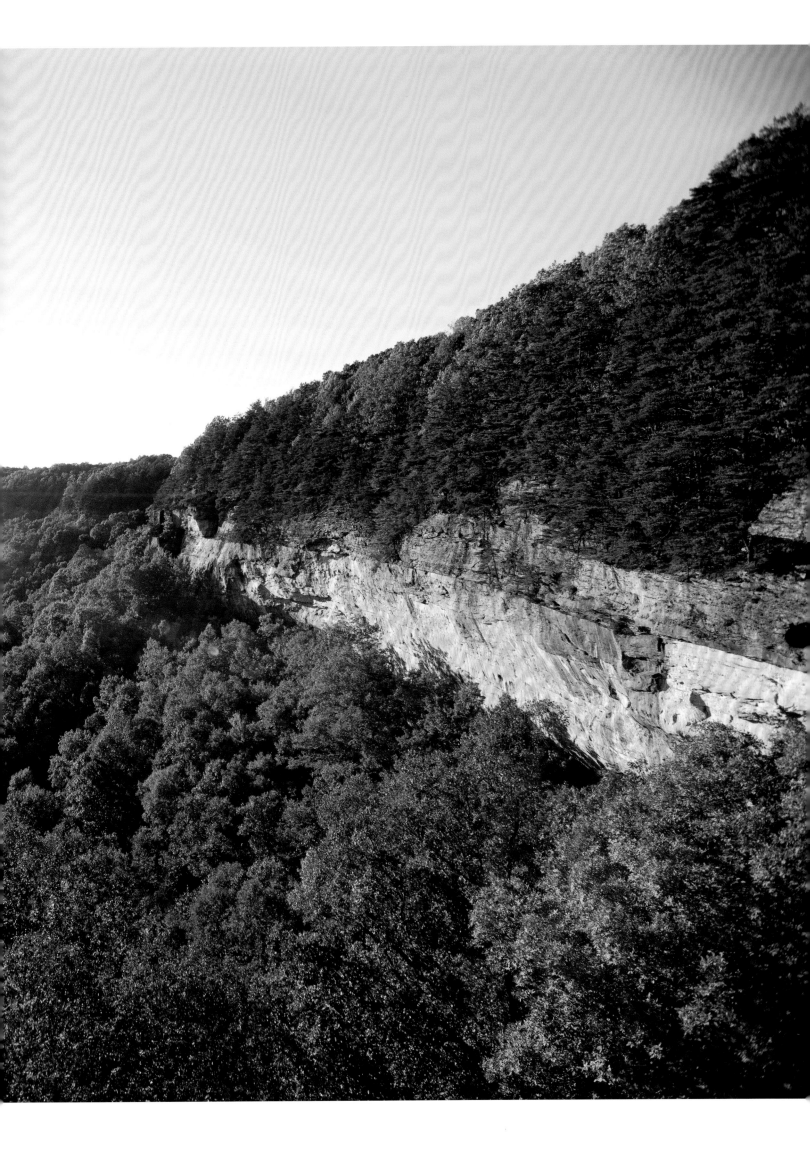

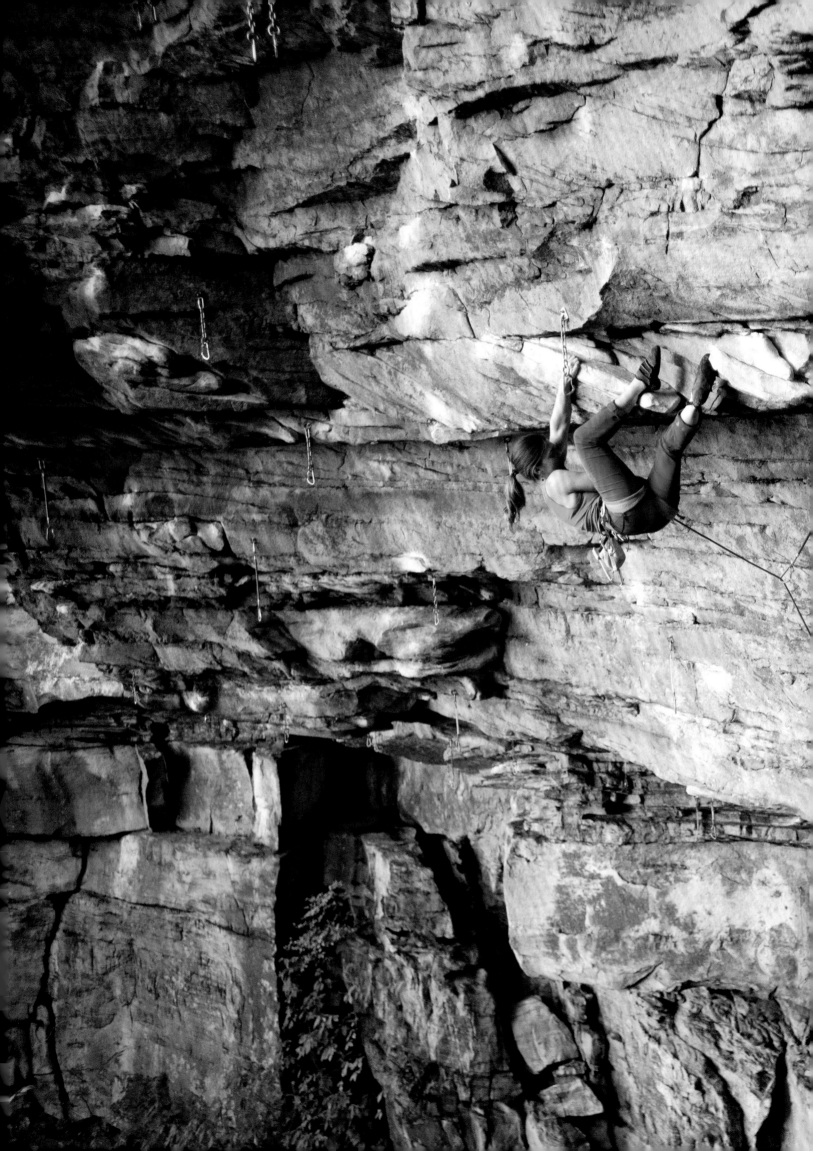

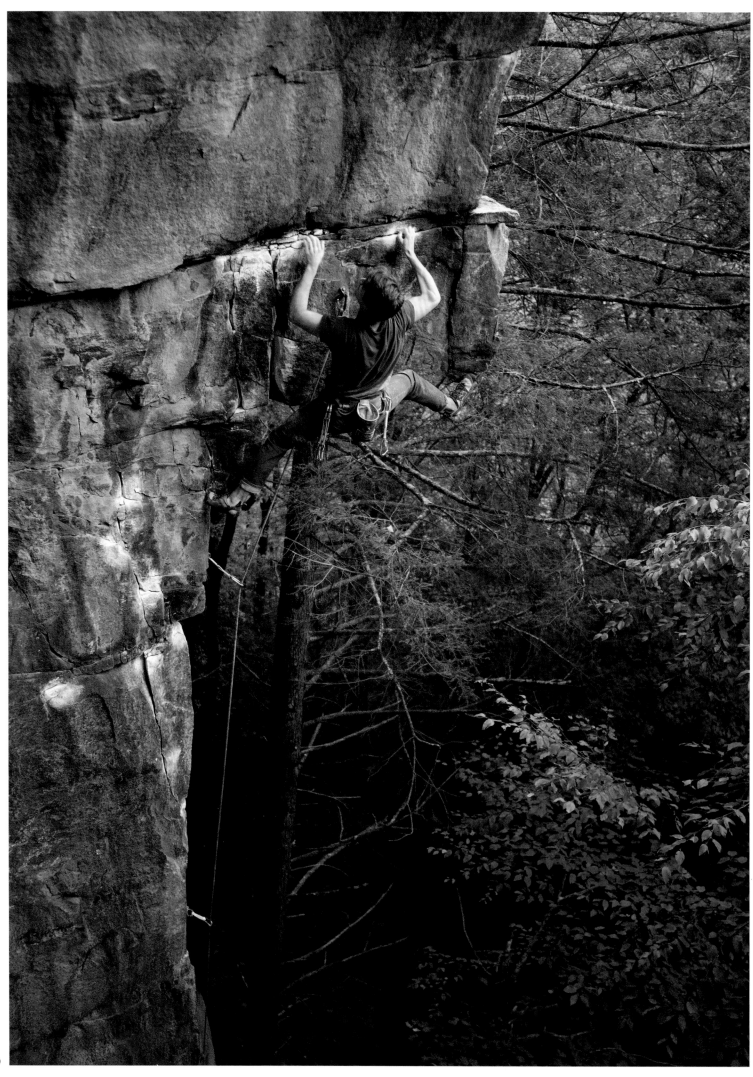

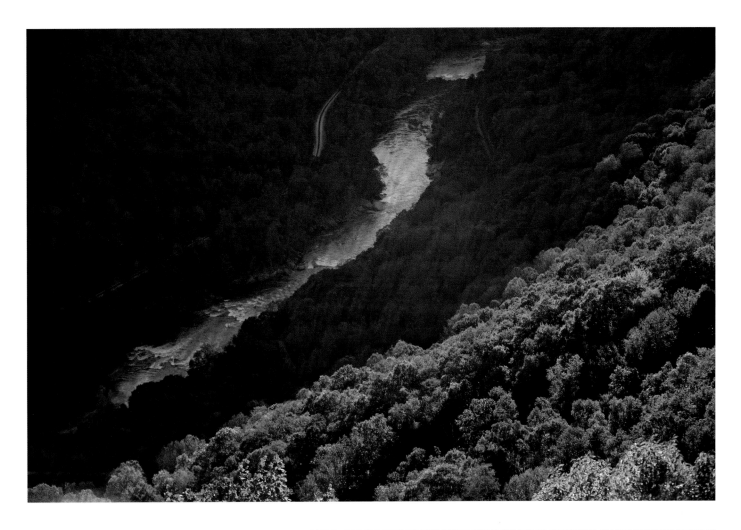

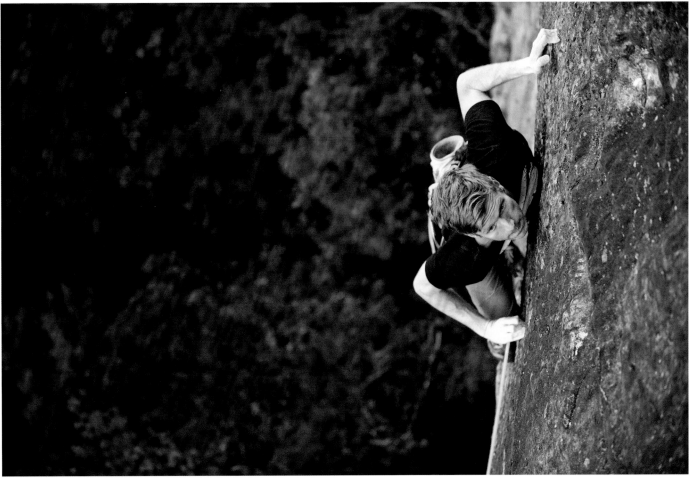

Left
Scenic Adult (5.11c)
Nathan Eggleston spanning an airy
roof traverse.

Top
The New River settling into its evening routine.

Bottom
Oblivion (5.12d)
Mark Paulson hardcore crimping on unique
black stone.

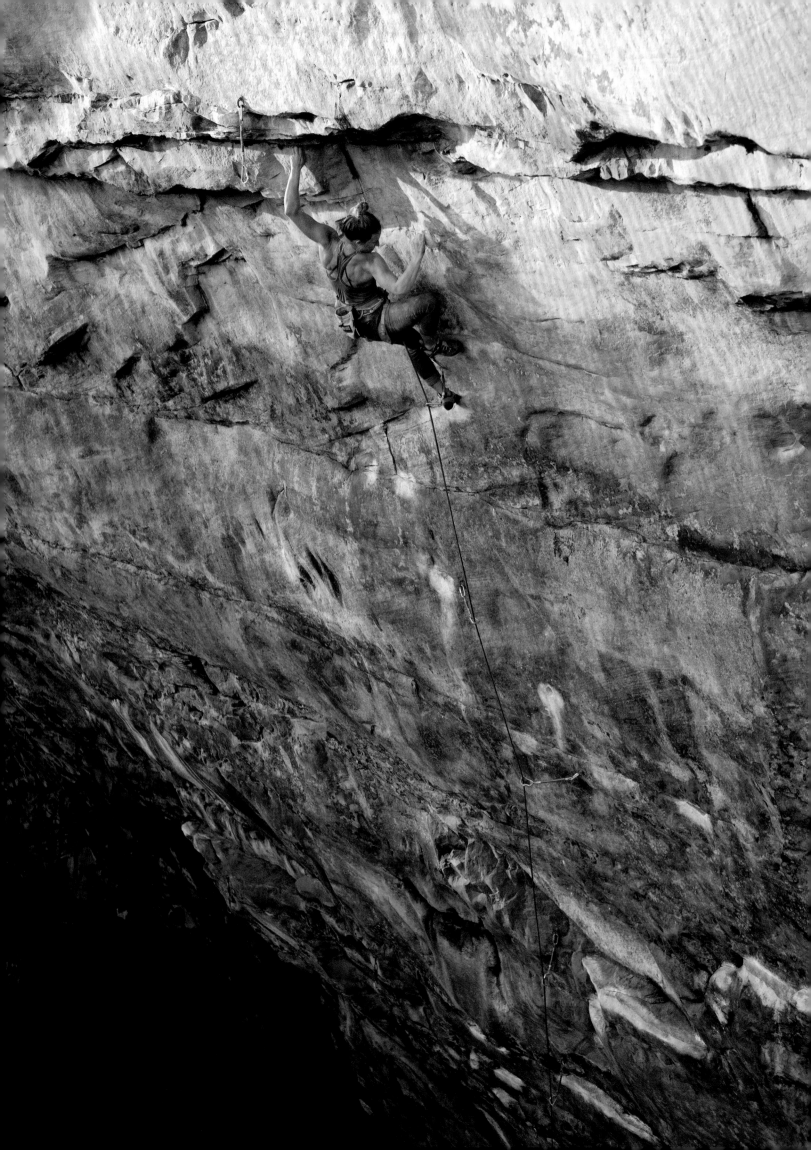

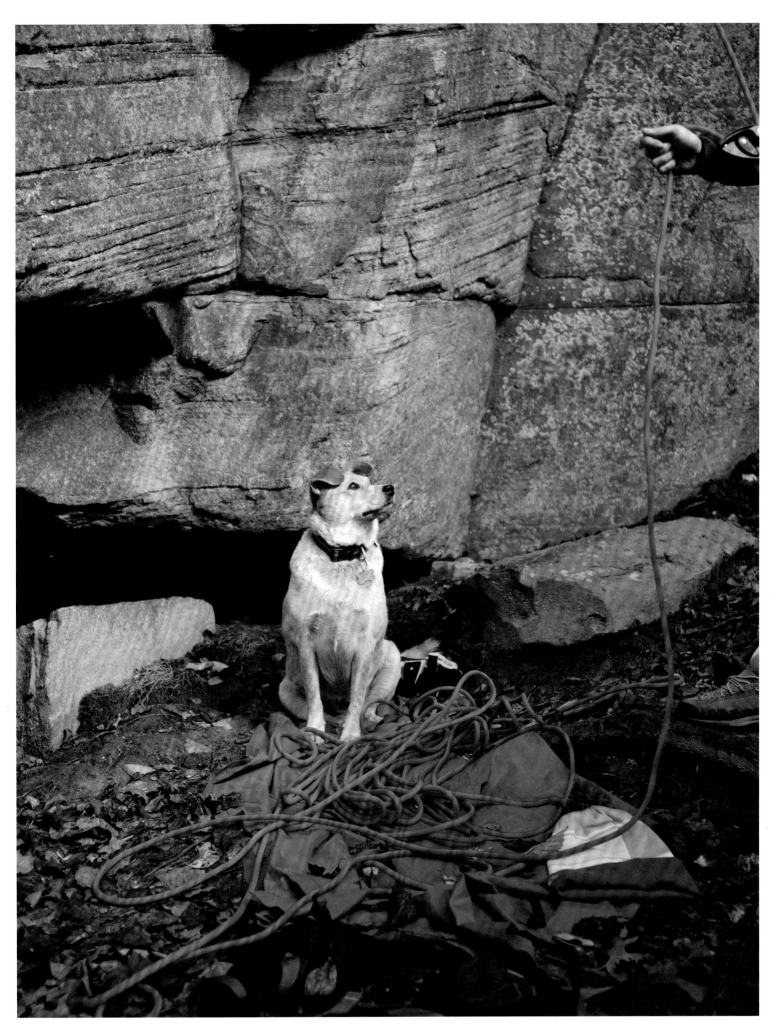

Left *Baby Trebuchet* (5.13b)
Kate Tierney negotiating the last strenuous sequence.

Right
Meadow Nelson is fascinated by the belaying habits of humans, to say nothing of the rock climbing. Mostly she is waiting for Kate to come down, for more snacks.

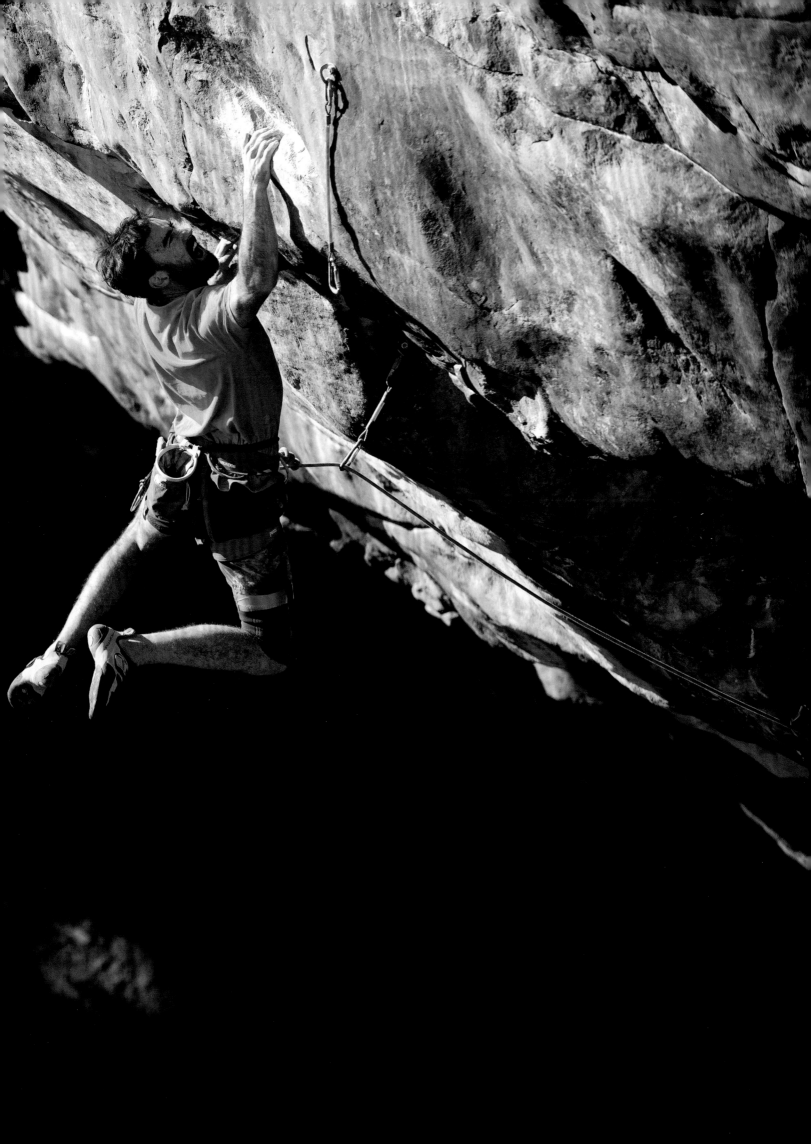

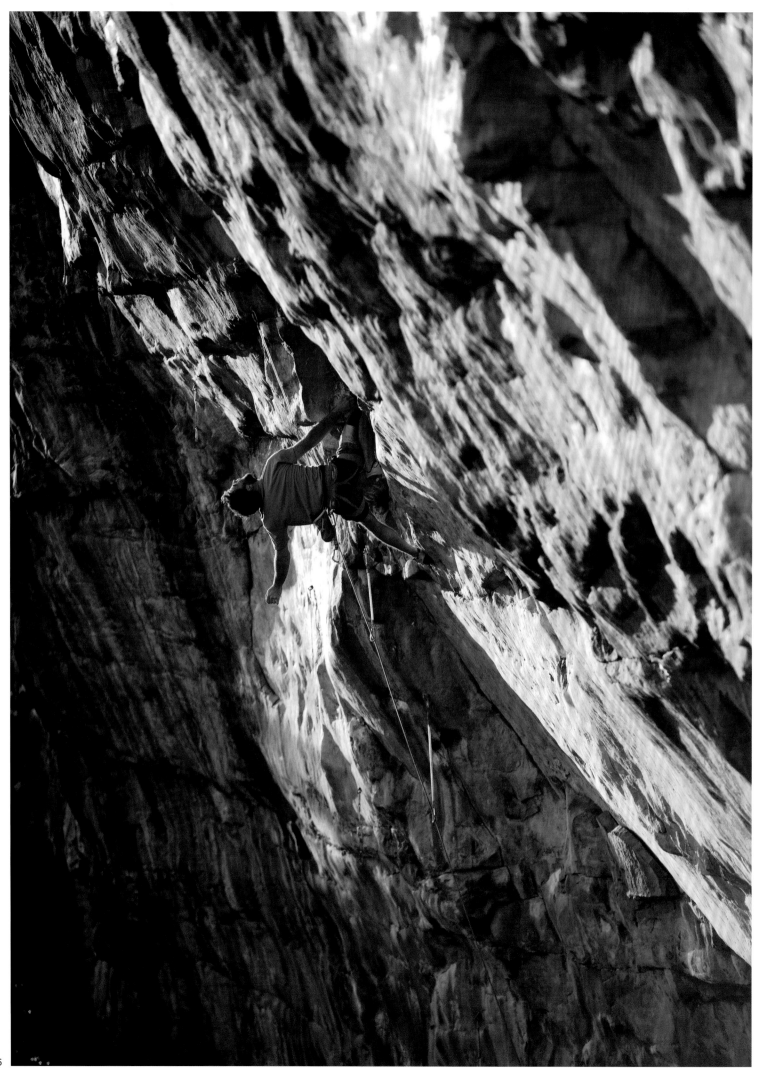

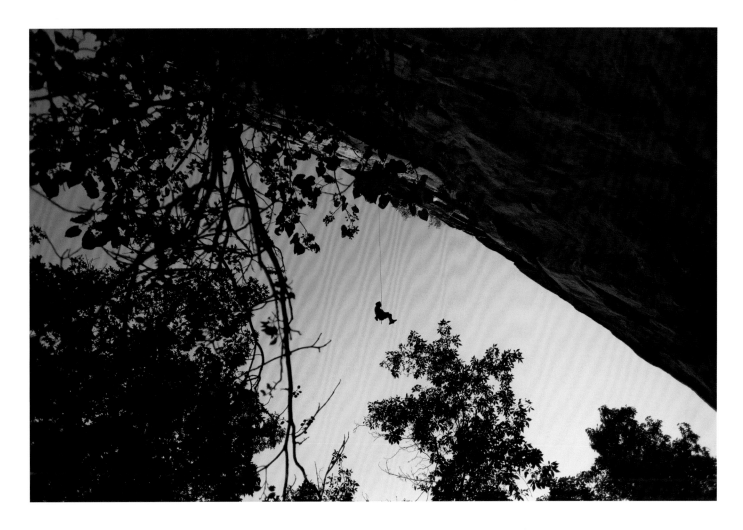

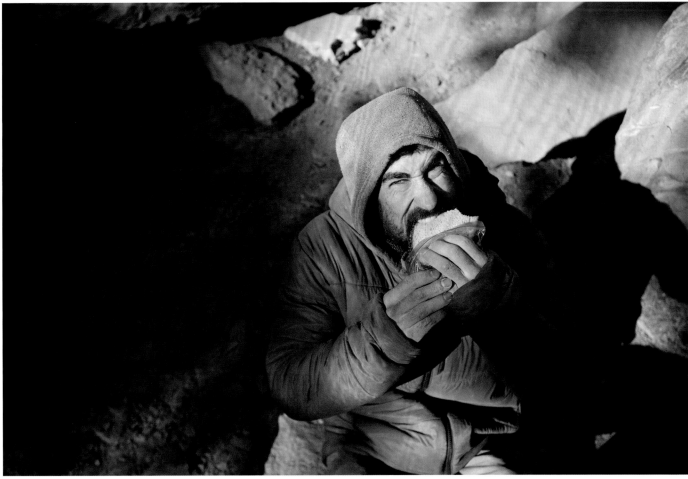

Previous
Proper Soul (5.14a)
Edwin Teran in all out battle mode on
one of the many cruxes delivered by this
coveted route.

Left
Proper Soul (5.14a)
Edwin Teran depumping on a high kneebar,
one of the rare spots to shake out on this
continuous line.

Top, Bottom
Edwin Teran returning to Earth and attacking a
PB&J after a proper workday on *Proper Soul*.

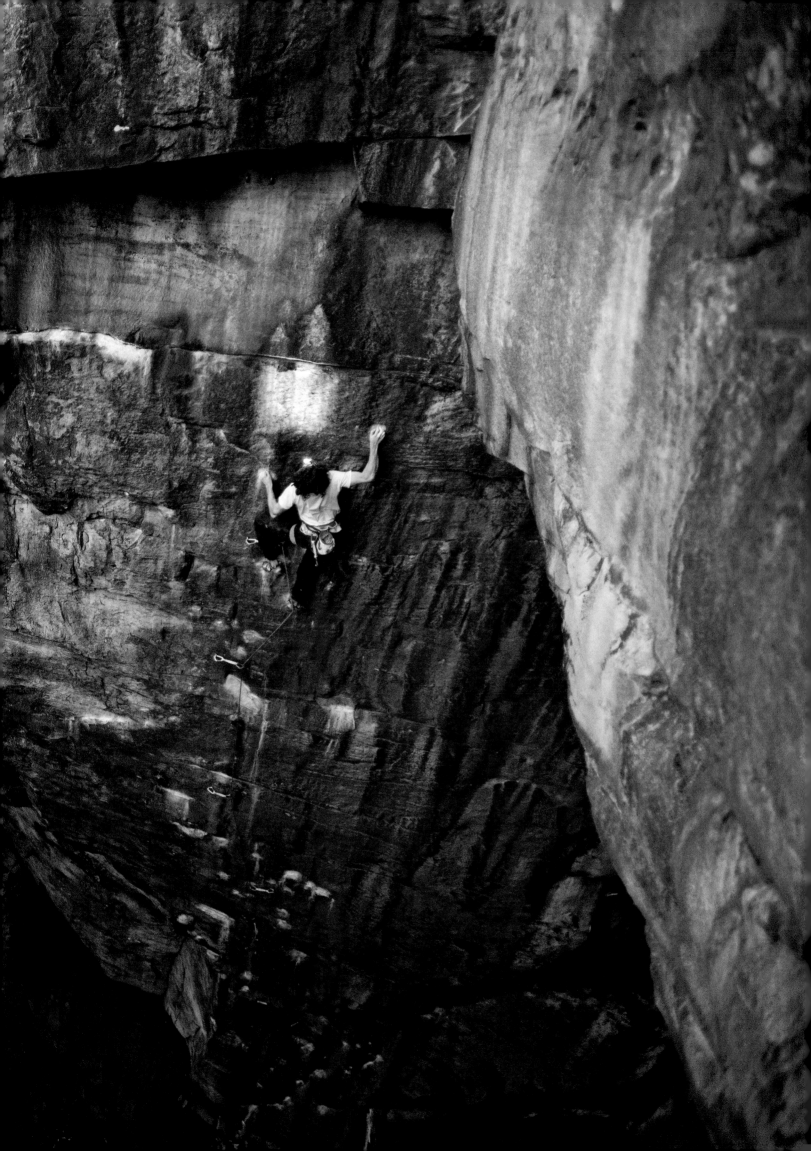

Red River Gorge

Kentucky

Type of Climbing:
Sport, trad, bouldering

Rock Type:
Sandstone

Climbing Style:
Pumpy, steep, featured

Number of Climbs:
2,000+

Elevation:
738 ft

Prime Season:
March–May, September–November

Classic Climbs:
27 Years of Climbing (5.8), *Rock Wars* (5.10a), *Fire and Brimstone* (5.10d), *Amarillo Sunset* (5.11b), *Too Many Puppies* (5.12a), *Check Your Grip* (5.12a), *Tissue Tiger* (5.12b), *Jesus Wept* (5.12d), *The Force* (5.13a), *The Golden Ticket* (5.14+)

Previous
Quinsana Plus **(5.13a)**
Parker Reed taking a late lap on a demanding and well-loved face climb.

Right
Kaleidoscope **(5.13c)**
Lee Smith working through the famed Red River Gorge pump on this gorgeous arete at the Drive-By Crag.

Following
Thanatopsis **(5.14b)**
Chelsea Rude crimps her way up a near-blank face on the left side of the legendary Motherlode cliff.

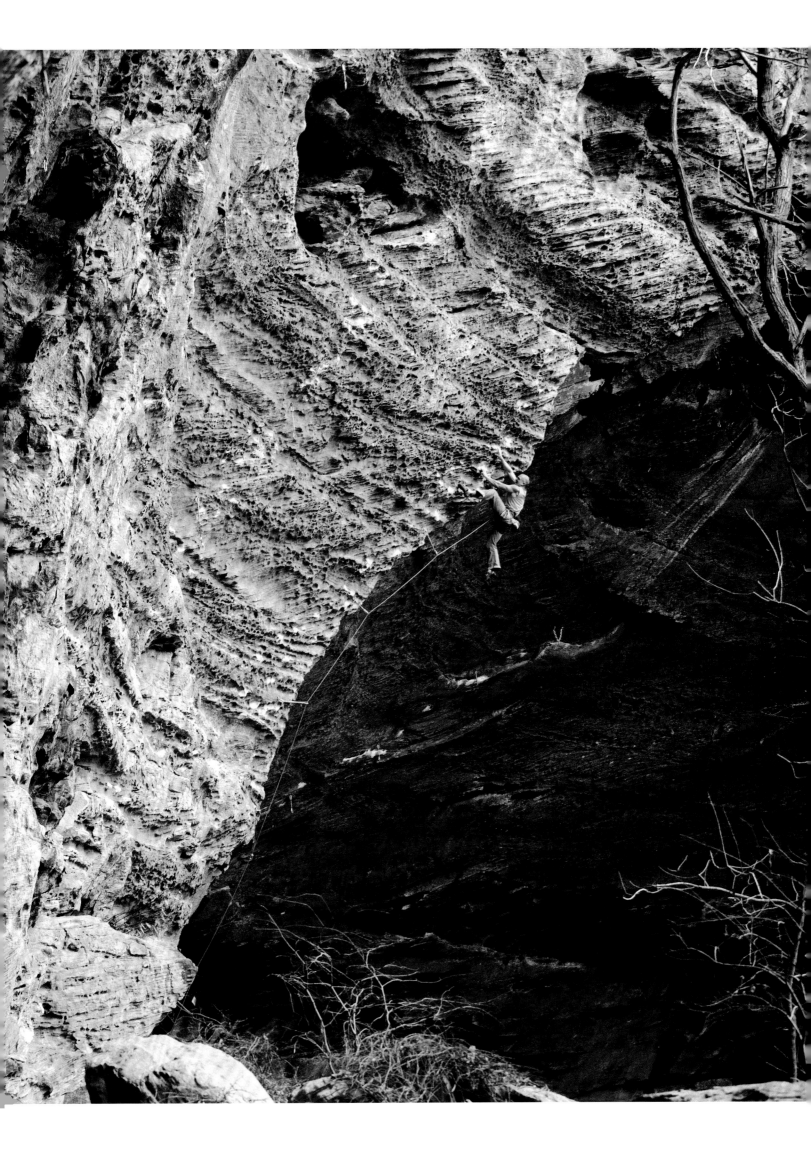

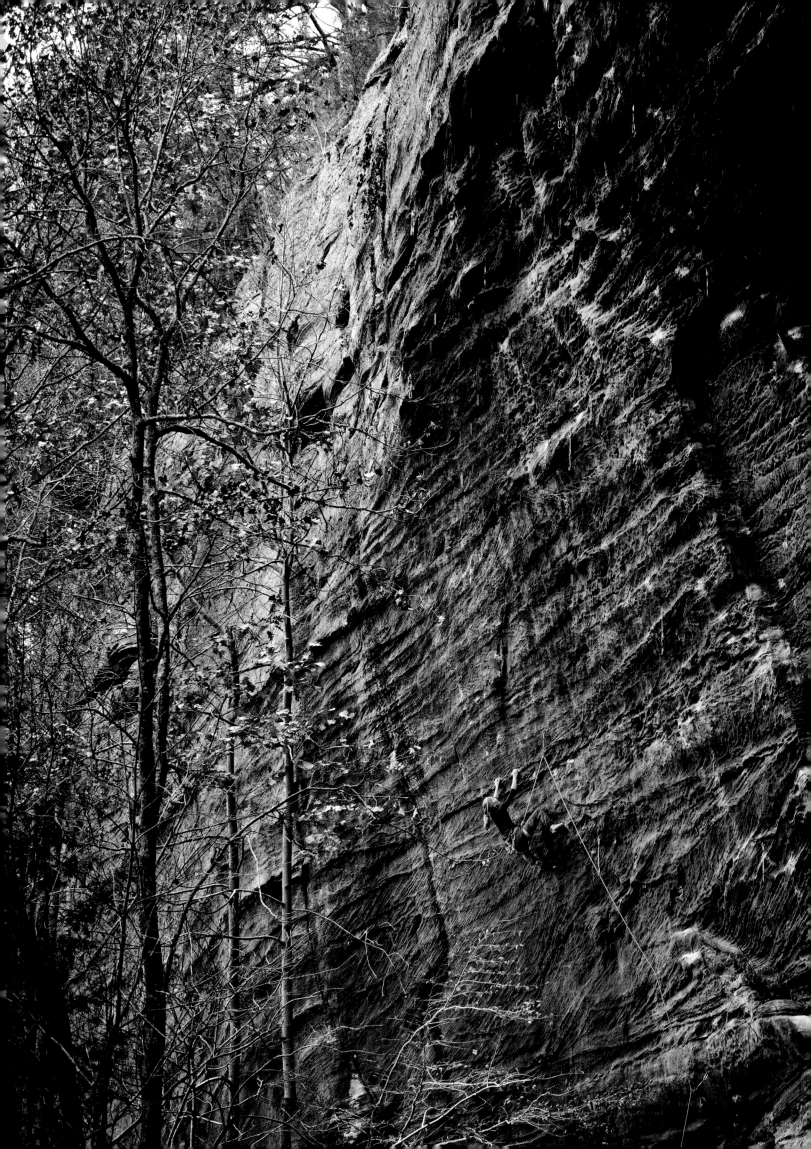

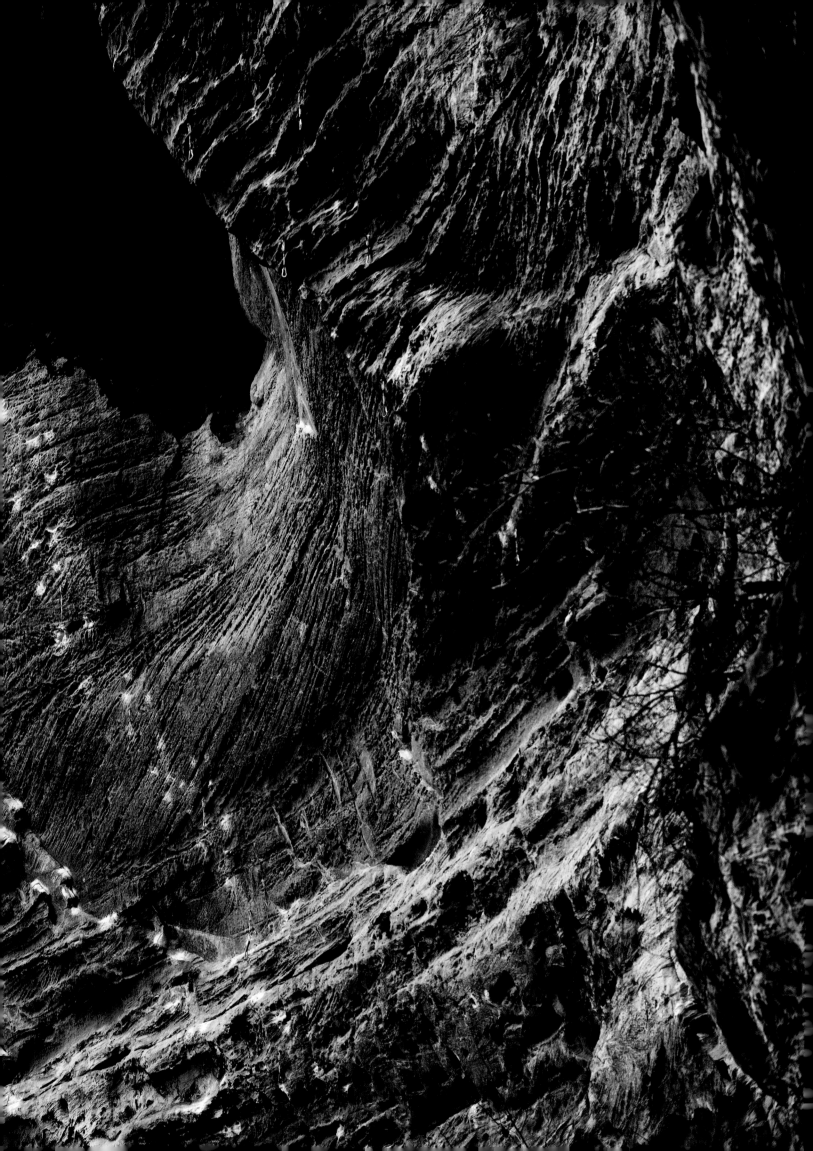

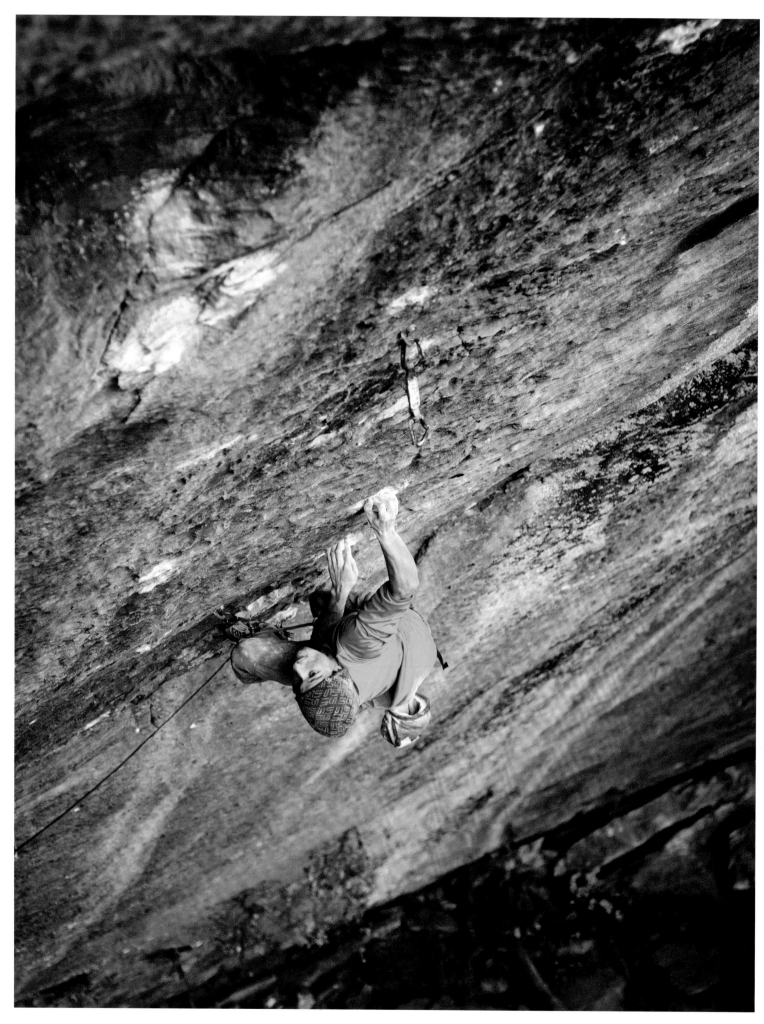

Left *Pure Imagination* (5.14c)
Gérôme Pouvreau on one of the hardest routes in the Red River Gorge.

Right *Golden Ticket* (5.14c)
Nick Duttle soldiering through another brilliant testpiece on the aesthetic
stone of the Chocolate Factory crag.

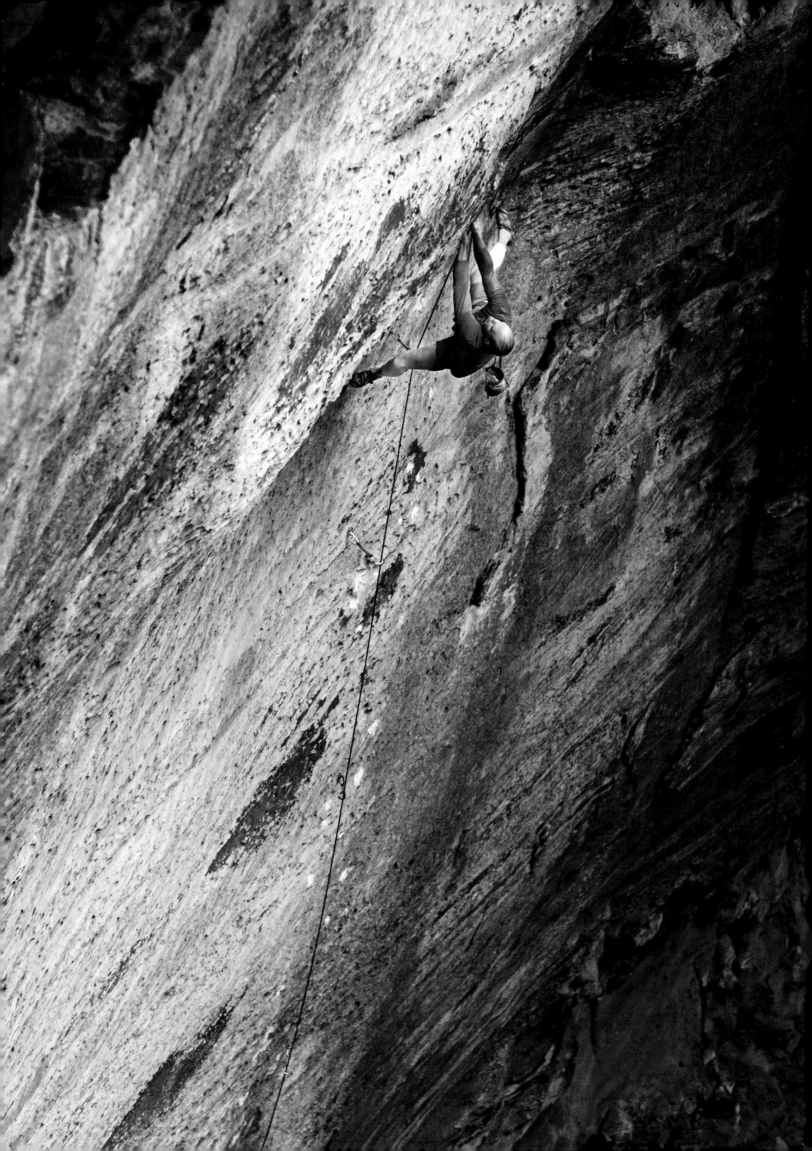

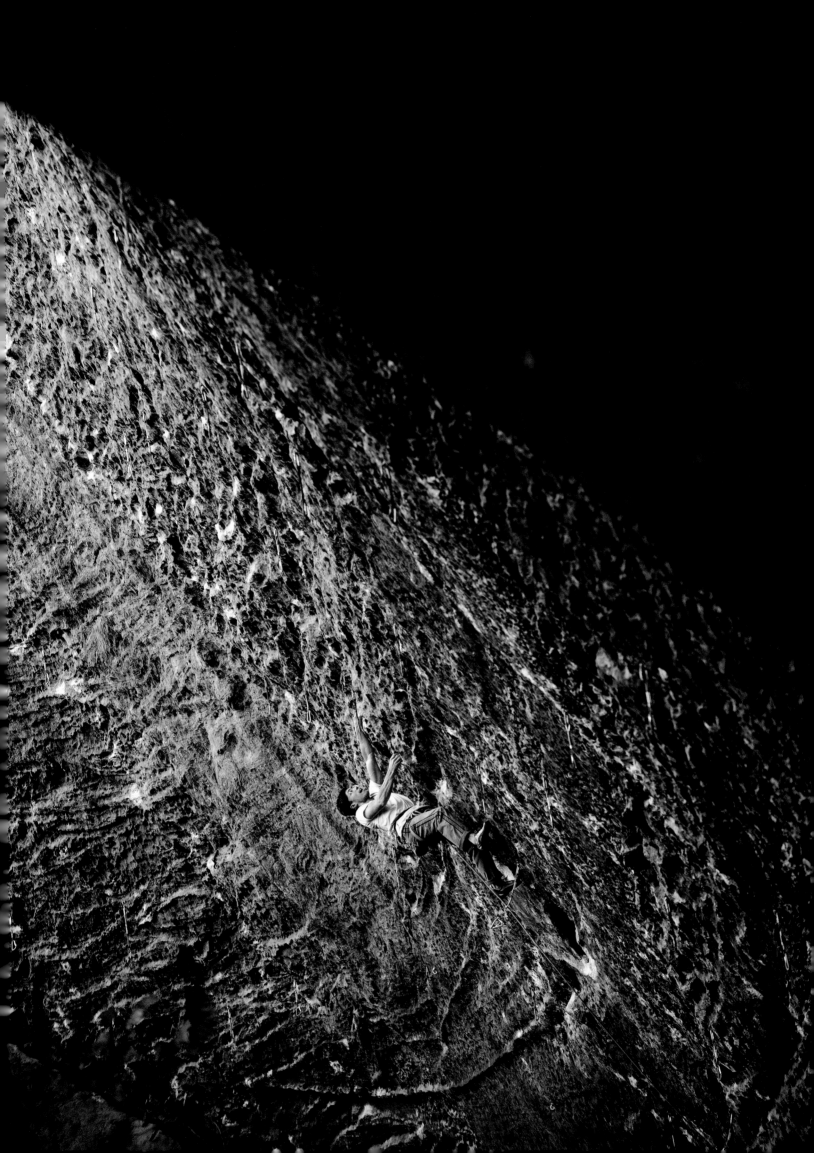

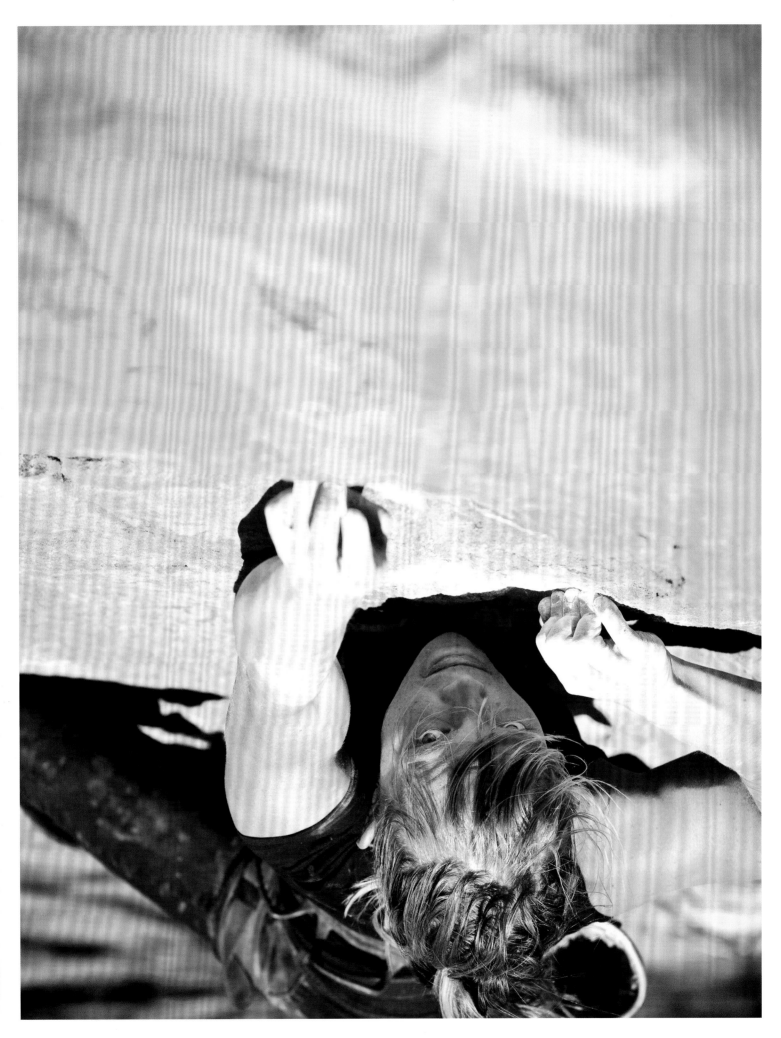

Left *The Force* **(5.13a)**
Stefan Baatz committing to the diagonal life at the Dark Side crag, in the Pendergrass-Murray Recreational Preserve.

Right *Orange Juice* **(5.12c)**
Elise Oren in a deep moment of *Orange Juice* concentration.

"When I am climbing, my breath becomes louder than my thoughts, and for once, I can think clearly; salvation and addiction all in one."

—Shawnee River

Right
True Love (5.13d)
Sasha DiGiulian goes to work on a slew of imposing slopers.

Following
Death by Chocolate (5.13a)
Luis Rodriguez keeping his composure on this exemplary Red River Gorge jug haul.

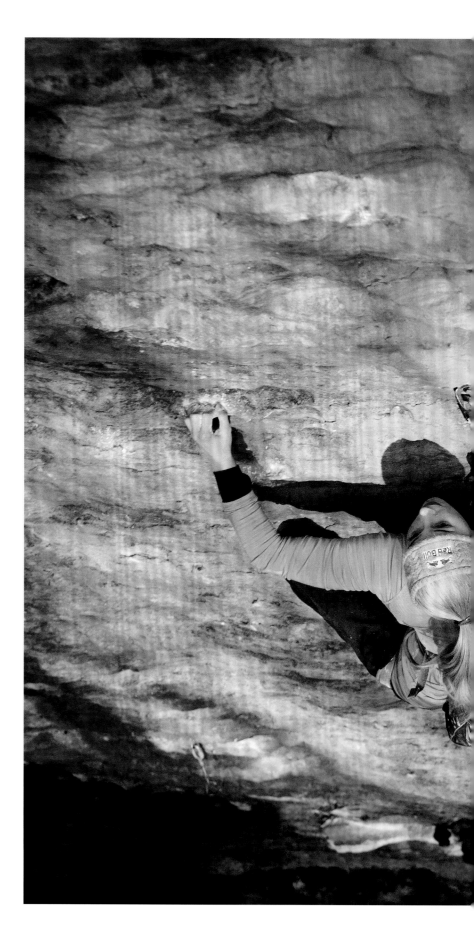

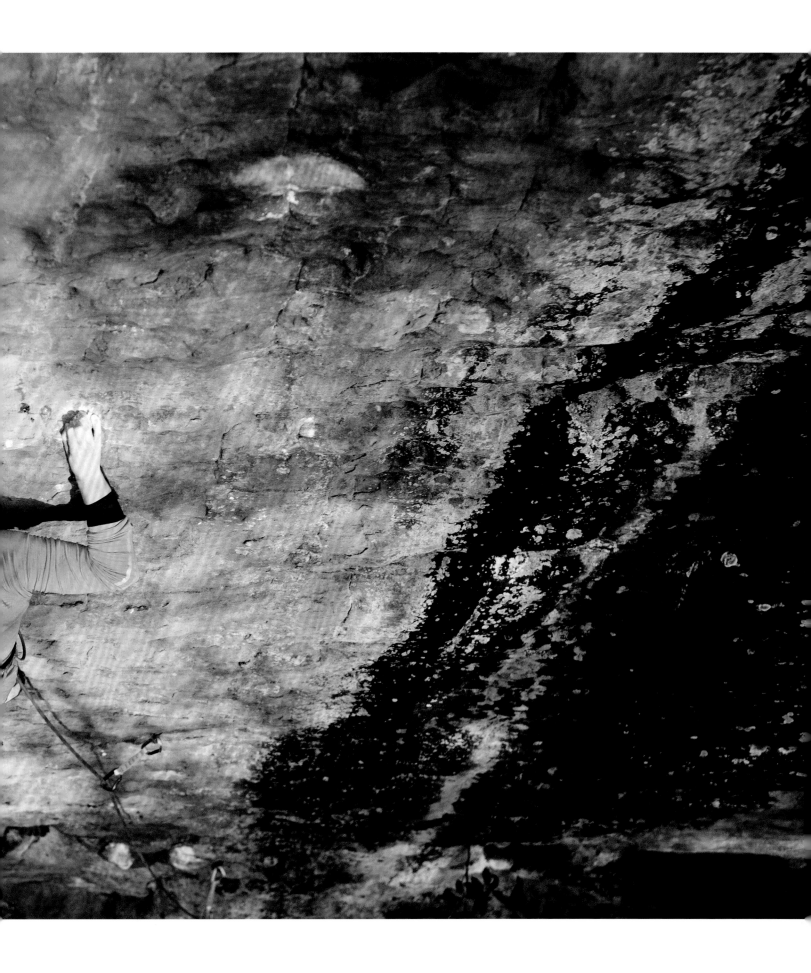

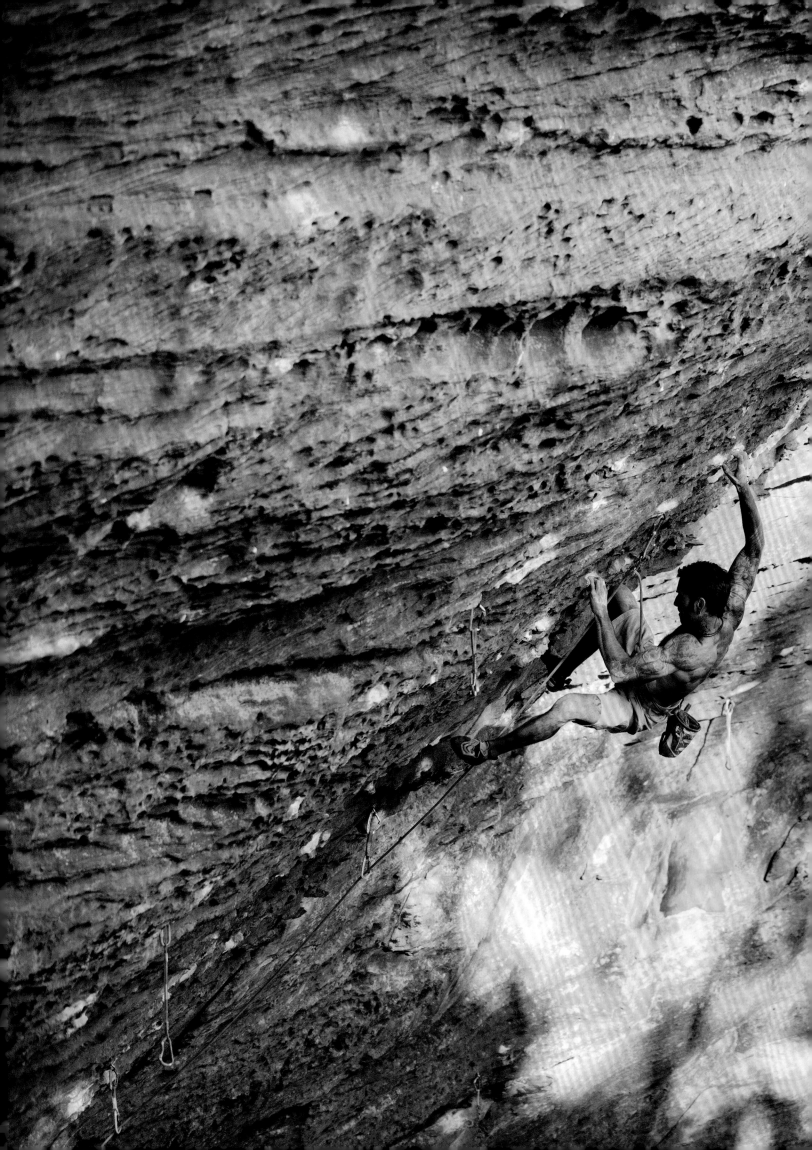

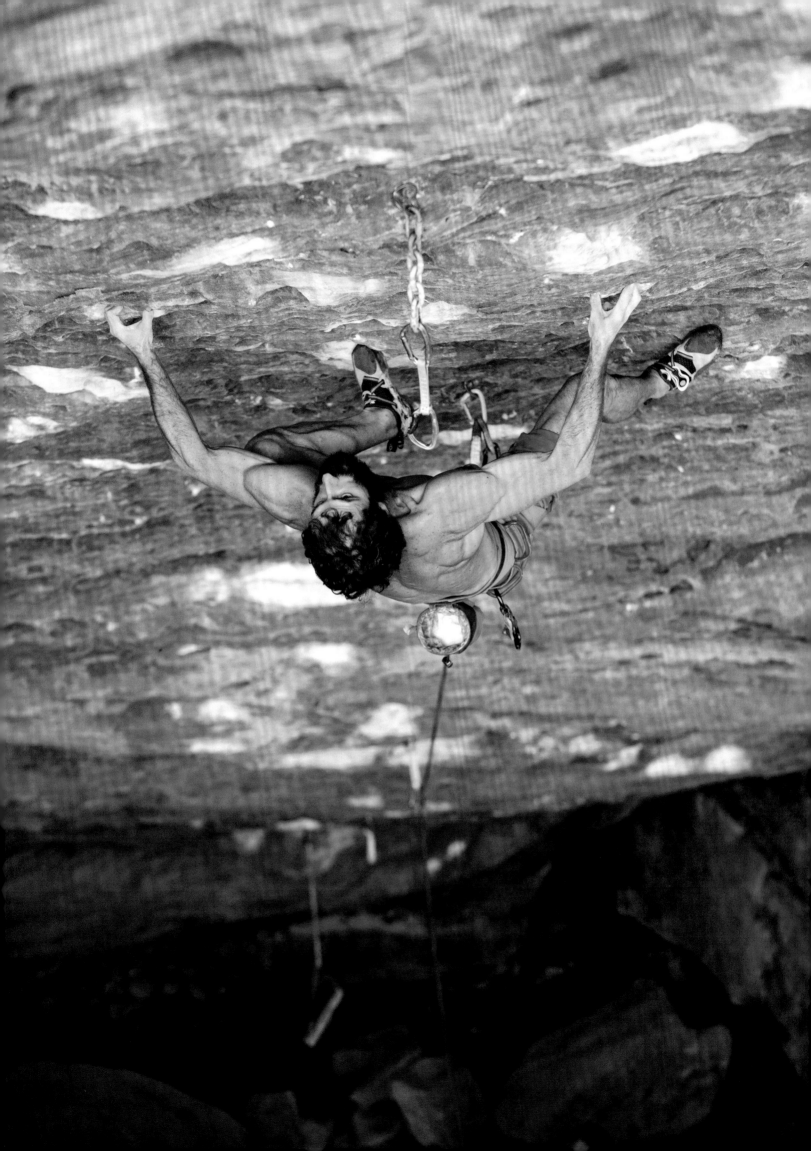

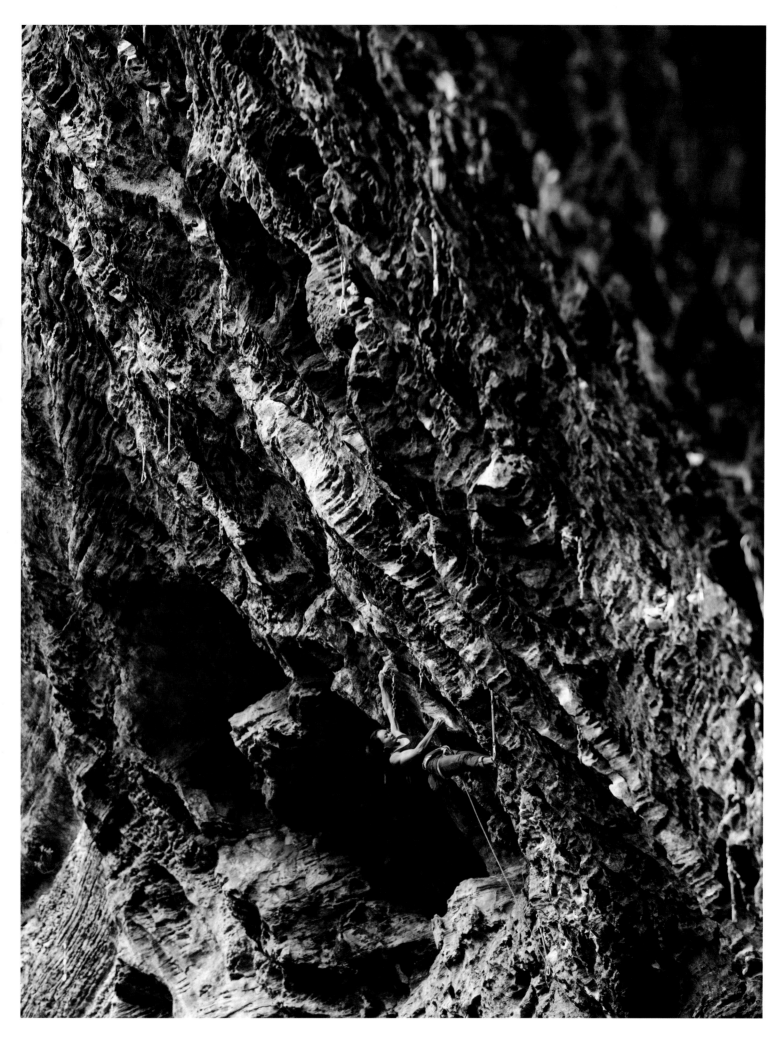

Left **Southern Smoke** (5.14c)
Patxi Usobiaga bearing down on overhanging pinches at the Bob Marley Crag.

Right **Leave it to Beavis** (5.12d)
Olivia Hsu dispatching with steep jugs and slopers at the Motherlode.

Southeast

Tennessee, Alabama, Georgia

Type of Climbing:
Bouldering, sport, trad

Rock Type:
Sandstone

Climbing Style:
Slopers, slab, cracks

Number of Climbs:
1,500+

Elevation:
1,036 ft

Prime Season:
March–May, October–January

Classic Climbs:
Incredarete (V1), *Bumboy* (V3), *Super Mario* (V4), *The Wave* (V6), *Step Child* (V7), *Cake Walk* (5.10a), *Spawn* (5.10b/c), *Heresy* (5.11c), *Solstice* (5.12a)

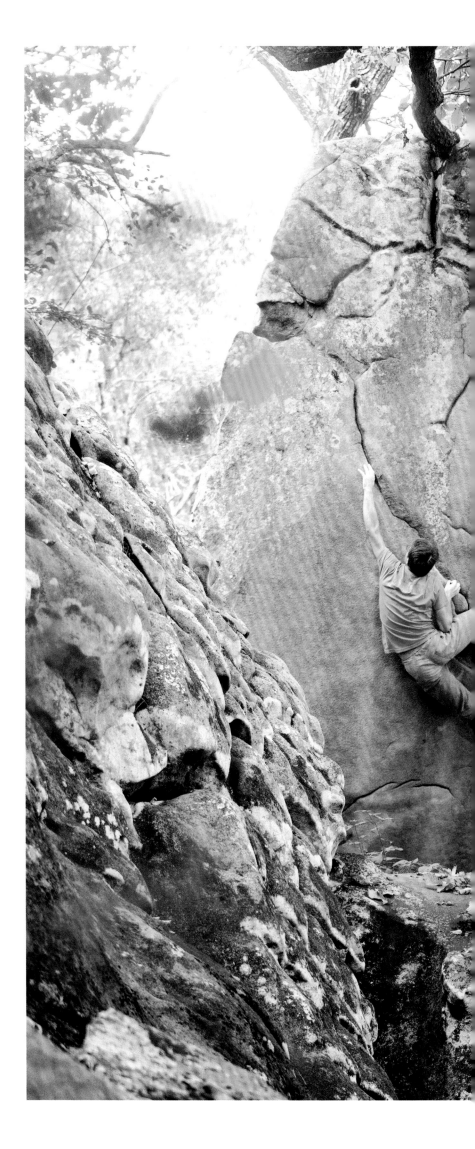

Right
The Shield (V12)
Nicholas Milburn gracing his way through some powerful moves in Little Rock City, a bouldering area considered to host some of the best rock and best boulder problems in the Southeast.

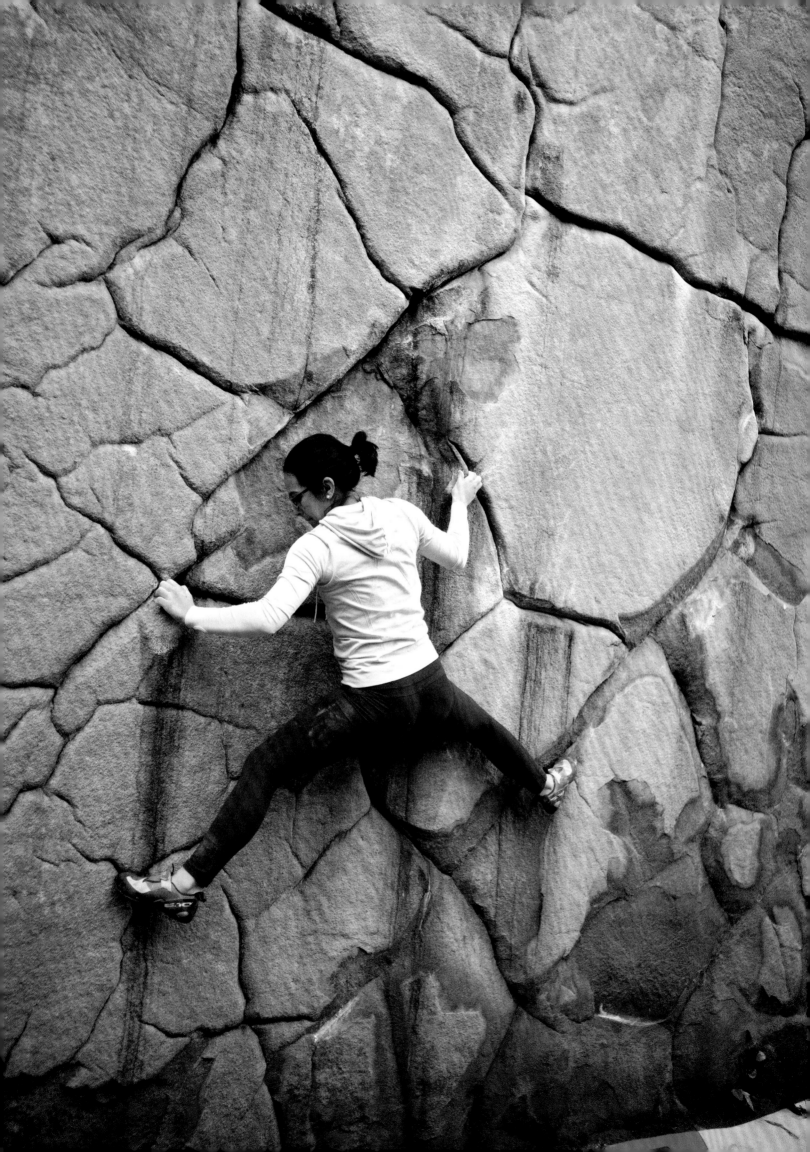

Left **Deception** (V7)
Tiffany Murphy finishing her day decoding the moves on this unique
aesthetic face.

Right
Textures of Little Rock City.

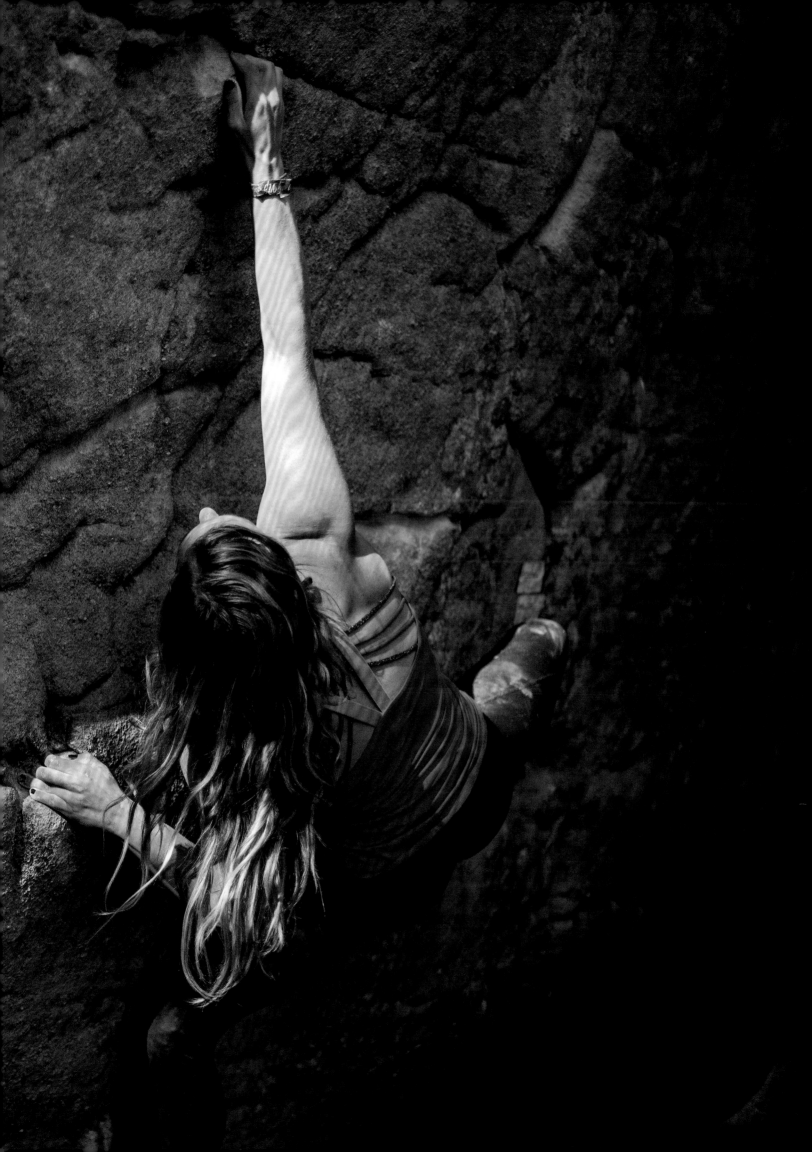

"The actual climbing is only part of the experience. The people, the places, and the way a cold beer tastes when you're done is what it's really all about."

—Cliff Simanski

Previous
Cleopatra-Cinderella Traverse (**V9**)
Michaela Kiersch experimenting with beta on a link-up of two problems on this boulder. One of the difficulties here is climbing so close to the ground (or crash pad) without touching it.

Right
The Orb (**V8**)
Daniel Patrick Spollen on the first crux, bumping between slopers on this Rocktown classic.

Following
Skywalker (**V9**)
Elizabeth Arce crimping into the light—on a classic boulder in one of the bouldering meccas of the south, Horse Pens 40.

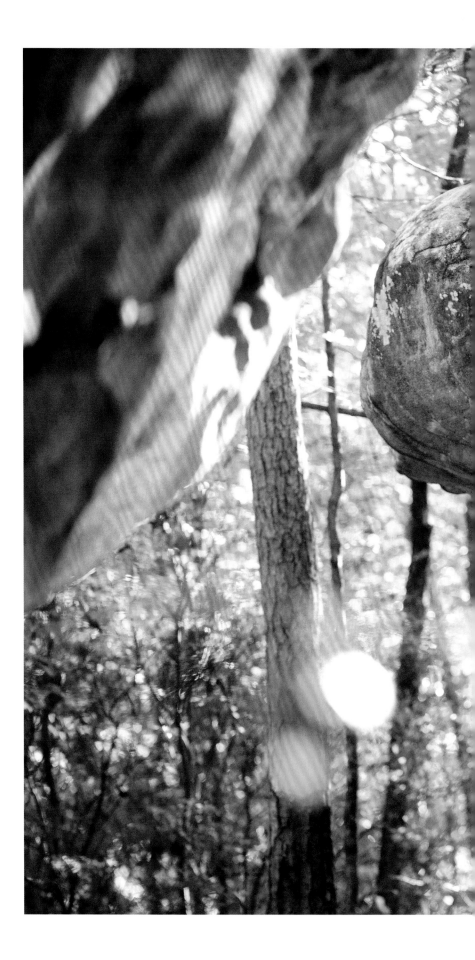

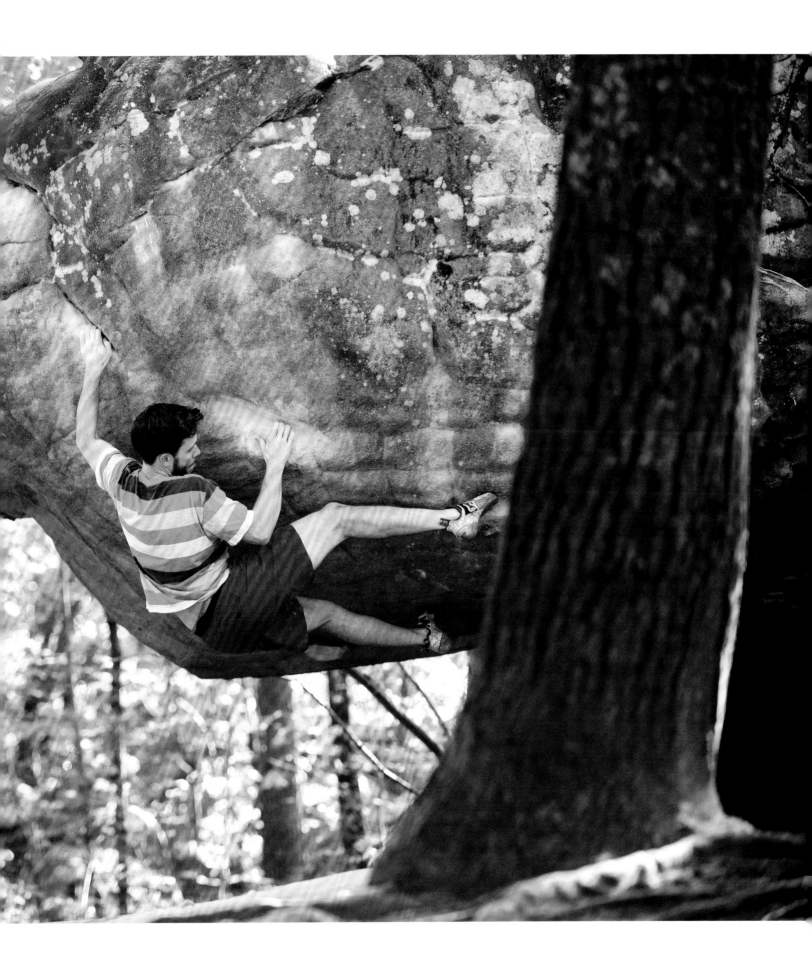

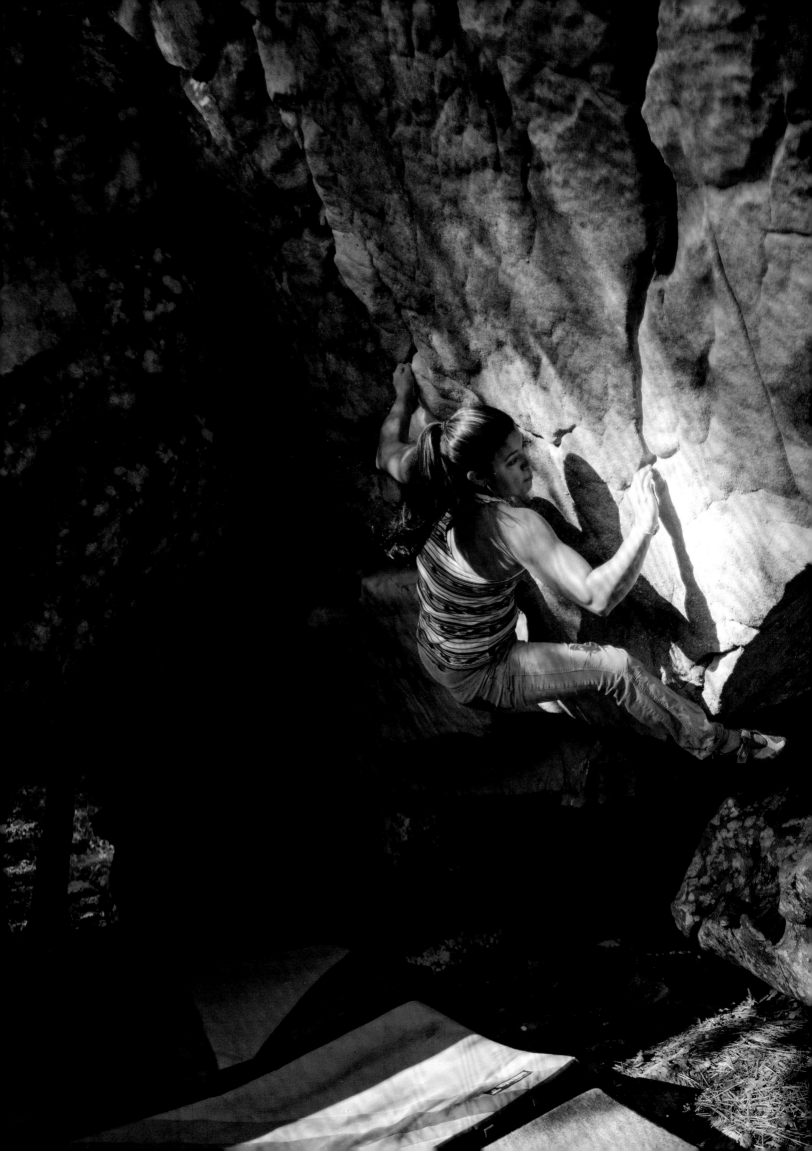

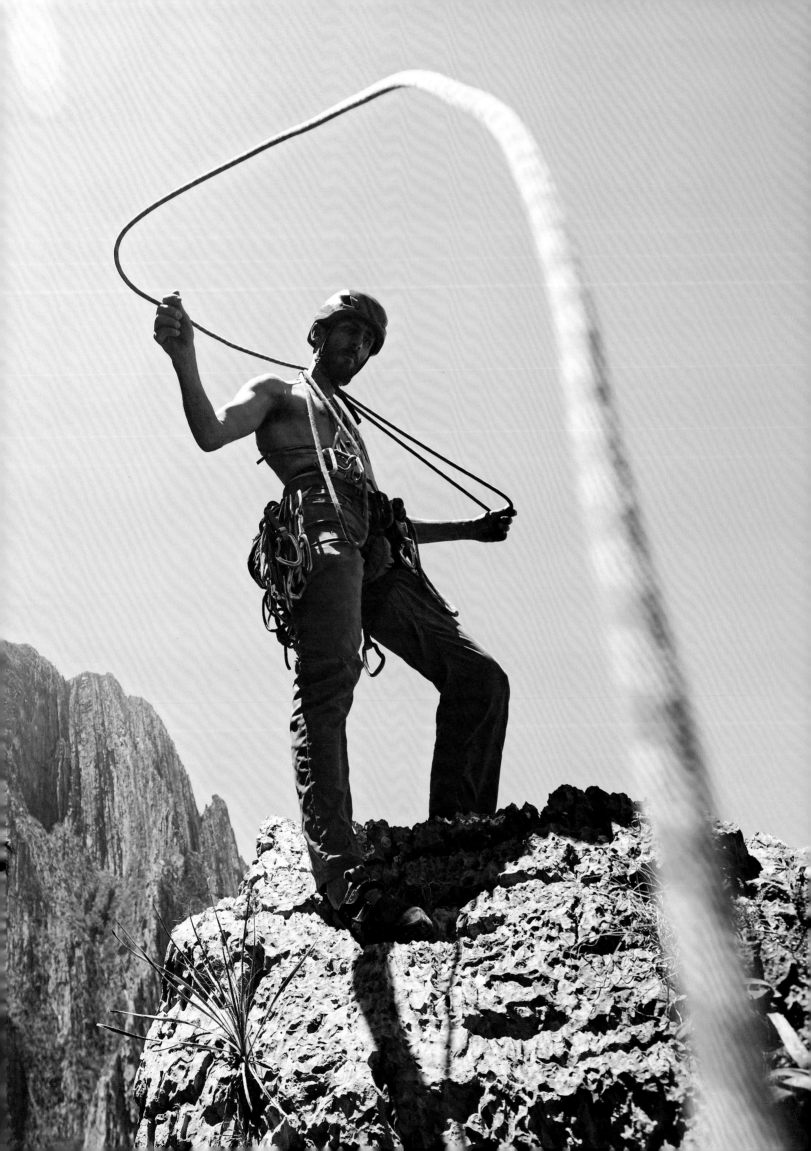

WINTER

The Southeast sandstone celebrations eventually must come to an end. In the cold months much of the North American stone ices over, or is found in climates inhospitable to rock climbing; the tribe responds accordingly. Some take up ice climbing, scaling frozen waterfalls and drainages with specialized equipment. Many simply hibernate for the winter, which could mean actual time off or hunkering down for some indoor training. With advancements in training technology, a focused indoor regimen can yield big payoffs in the spring. For those more flexible with time and funding, the winter can be an amazing season to travel to more exotic places where the climate is kind.

Climbers have been flocking to **Potrero Chico** in Nuevo Leon, Mexico from all over the world for the last three decades. Nothing cures January blues like clipping bolts up a Mexican bigwall in shorts and a T-shirt. The tall, thin canyon walls have a dreamy Jurassic quality and exhibit an unparalleled volume of epic multi-pitch routes. The climbs are typically sharp and vertical but Potrero is host to a wide range of limestone sport climbing styles—from techy slabs to overhanging tufa testpieces. Numerous local hostels and campgrounds are located within a 10-minute walk of many climbs. The local town of Hidalgo is refreshingly absent of tourism and makes one feel like a character in an old Western novel. Life is simple and warm, and the climbing is addictive.

Following Potrero, we come to close the large circular arc of our travels. Although we originally departed California in summer, now is the perfect time to revisit the winter-appropriate destinations of this geologically gifted state. The long and winding road from Mexico back to the West Coast delivers us first to the doorstep of one of the premier old-school trad destinations in the country, **Joshua Tree National Park**. The desert landscape is surreal, littered with thousands of its namesake trees [p. 221]. The granite is sharp and gritty, providing surprising amounts of friction for near-vertical slab climbing, or for cheese-grating one's skin while falling from a crux. It is a simple, quiet landscape riddled with countless odd piles of curvaceous stone. The grades are stiff and the routes, many of which were developed by Yosemite's original Stonemasters, are bold. Josh is a legendary land of testing one's mettle on some of the country's finest bouldering, sport, and trad lines.

Much of the journey has been spent alternating between climbing disciplines, but for those focused on stellar bouldering, few destinations rival **Bishop**, in California's Owens Valley.

This coveted destination is perched in the high desert of the Eastern Sierra, harboring a silent army of excellent granite and volcanic blocks. These plateaus provide a breadth of options for bouldering at every grade and size—Bishop is known for some serious highball problems [p. 226–227]. Only a dedicated few possess the strength, technique and mental fortitude required to calmly ascend problems like *Too Big to Flail* (V10) or *Evilution Direct* (V12-13). Nearby sport crags, most notably the Owens River Gorge, put this area over the top with enjoyable and demanding lines up bolted volcanic tuff. If all that weren't enough, evenings often involve soaking in one of the many nearby natural hot springs, massaging taxed forearms in sulfuric waters while marveling at the snowcapped panorama of the High Sierra.

Rising up through the Sierra to the north and west we come to the town of Sonora and the nearby crag of **Jailhouse Rock**. Similar to Rifle, the routes here are blocky and overhanging, rife with slopers and angular features. Climbers are prepared with their kneepads [p. 242], and always on the lookout for a no-hands-rest kneebar to mitigate the pump in their arms.

California's inland opportunities are deservingly venerated, but nothing encapsulates pure West Coast bliss like the oceanside cragging of the **San Francisco Coast**. Areas like Mickey's Beach and Stinson Beach offer an assemblage of boulders and sport crags set picturesquely against the sea [p. 250–251]. Taking some burns on a number of interesting—and some very hard—seaside climbs, followed by cool dips in the Pacific Ocean is just what the doctor ordered. As word to the uninitiated, sections of these beaches are designated "clothing optional," and au naturel ascents are not out of the question.

Following this lovely coastline up through California and into Oregon, we ultimately land in an auspicious resting point to mark the end of the climbing year. We find ourselves in the esteemed birthplace of sport climbing in America, **Smith Rock**, OR. Located near the tiny town of Terrebonne, Smith is a spread of volcanic welded tuff, accompanied by the lovely Crooked River. While the multitude of sport climbs is staggering, Smith has a bounty of trad cragging as well. A week in Smith is pleasant and inspiring—the surrounding high desert of central Oregon is rich in sprawling natural landscapes with views of the snowcapped Cascade volcanoes in the distance. Ideal visiting time is considered to be spring or fall, but in the late winter Smith can accommodate comfortable climbing.

Potrero Chico

Nuevo Leon, Mexico

Type of Climbing:
Sport, bouldering

Rock Type:
Limestone

Climbing Style:
Bigwall sport, technical, face

Number of Climbs:
500+

Elevation:
1,800 ft

Prime Season:
December–February

Classic Climbs:
Dead Man Walking (5.9), *Pitch Black* (5.10+),
Space Boyz (5.10d), *El Sendero Diablo* (5.11c),
Yankee Clipper (5.12a), *Time Wave Zero* (5.12a),
El Sendero Luminoso (5.12+)

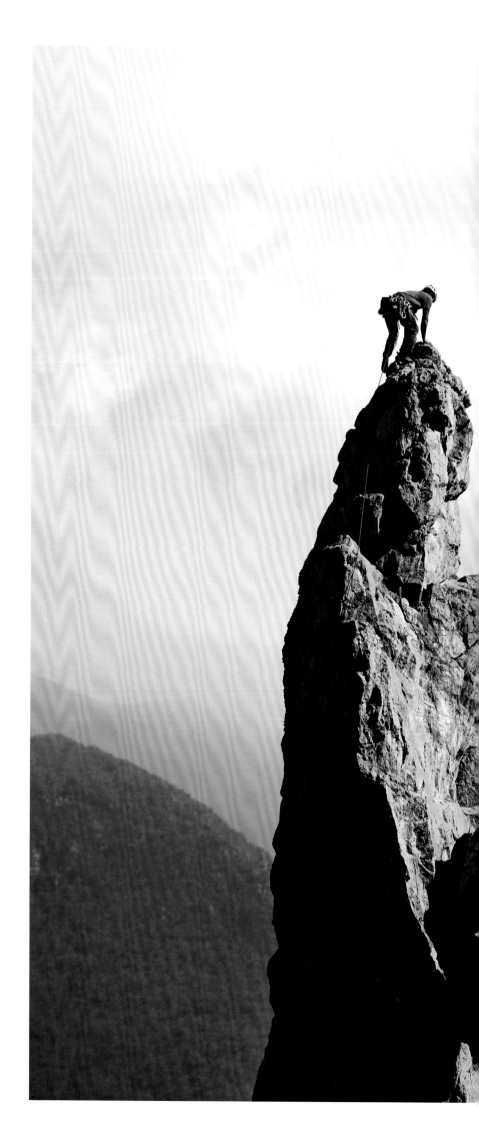

Previous
Will the Wolf Survive (5.10a)
Jesse Lynch tops out on a dramatically thin
ridgeline with vantages straight down the steep
canyon walls.

Right
Uber Machismo (5.11)
Van Vu gaining the final view on this two-pitch
spire with a tricky boulder problem near the
final chains. Mounting the spire is wild, vertigo-
inducing, and worth it for the view.

Following
Sendero Diablo (5.11c)
Jesse Lynch enjoying some delicate crimping.
This six-pitch classic offers fun, varied climbing
from near vertical techy slab to hueco acrobatics.
Higher pitches grant panoramic views of the
valley below.

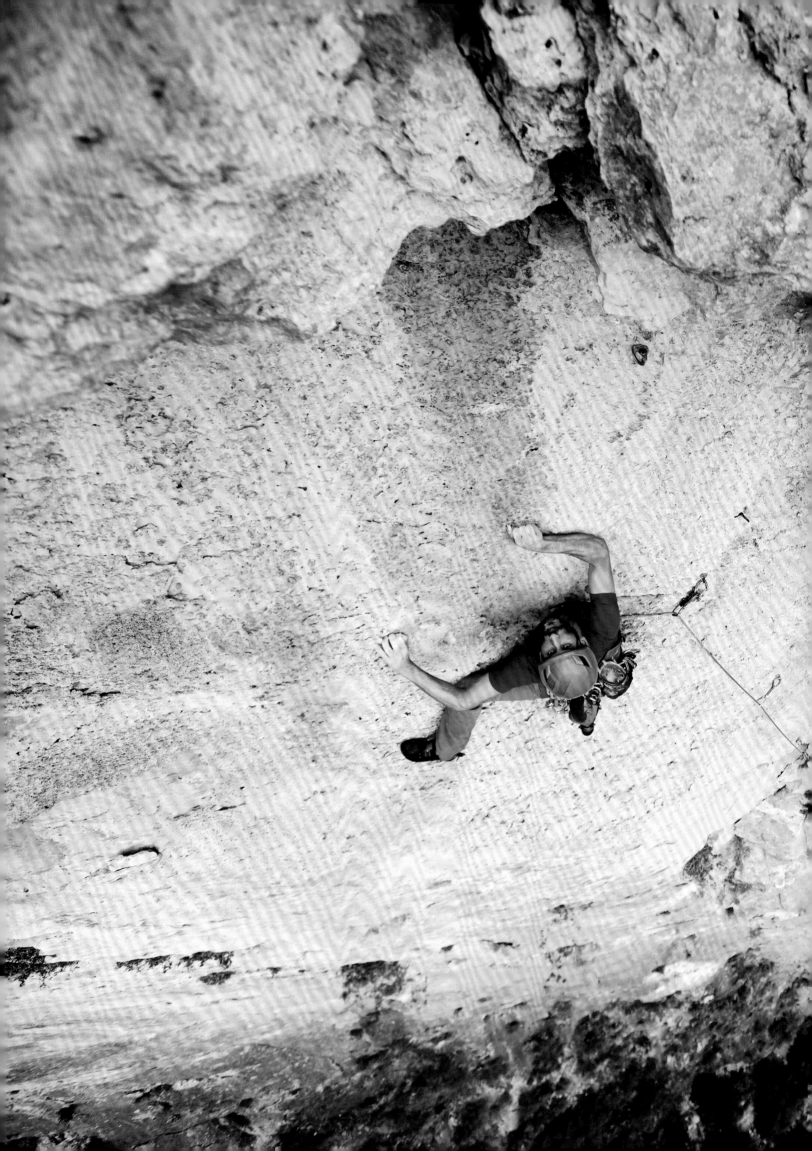

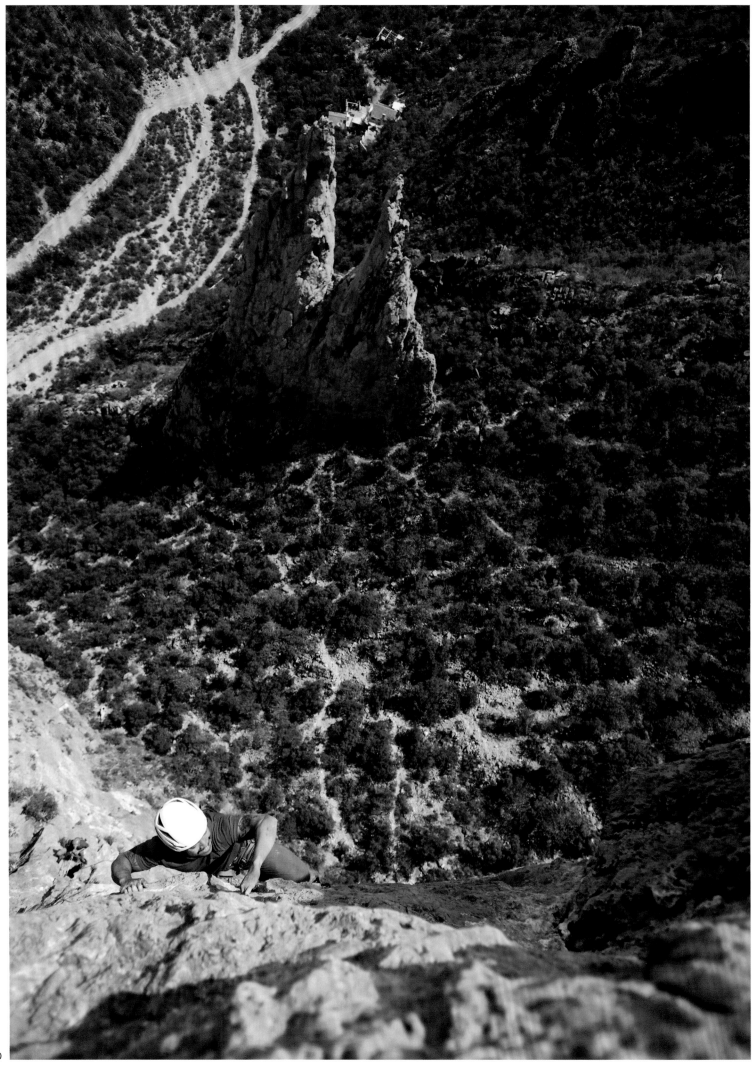

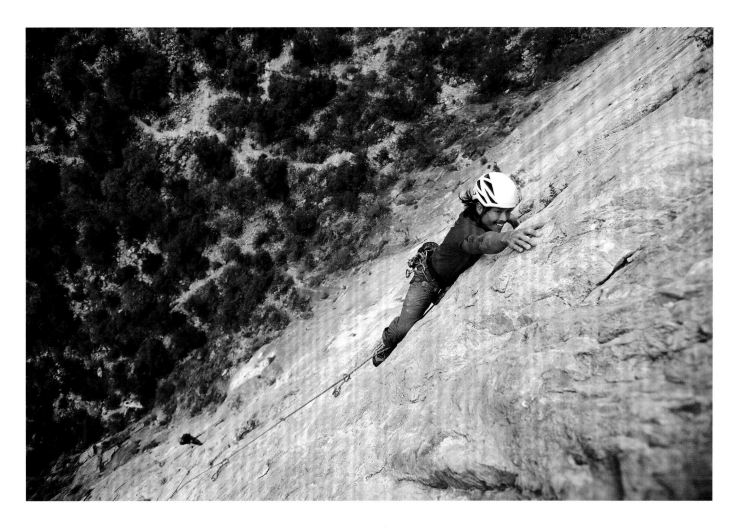

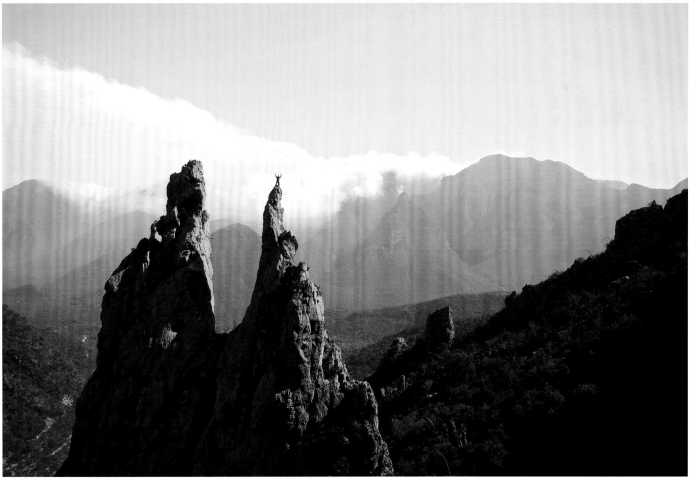

Left, Top
Sendero Diablo (5.11c)
Van Vu delicately wrestling with a provocative
face climbing sequence on pitch five.

Bottom
Uber Machismo (5.11)
Alternate view of p. 206— Van Vu celebrating
a wild perch.

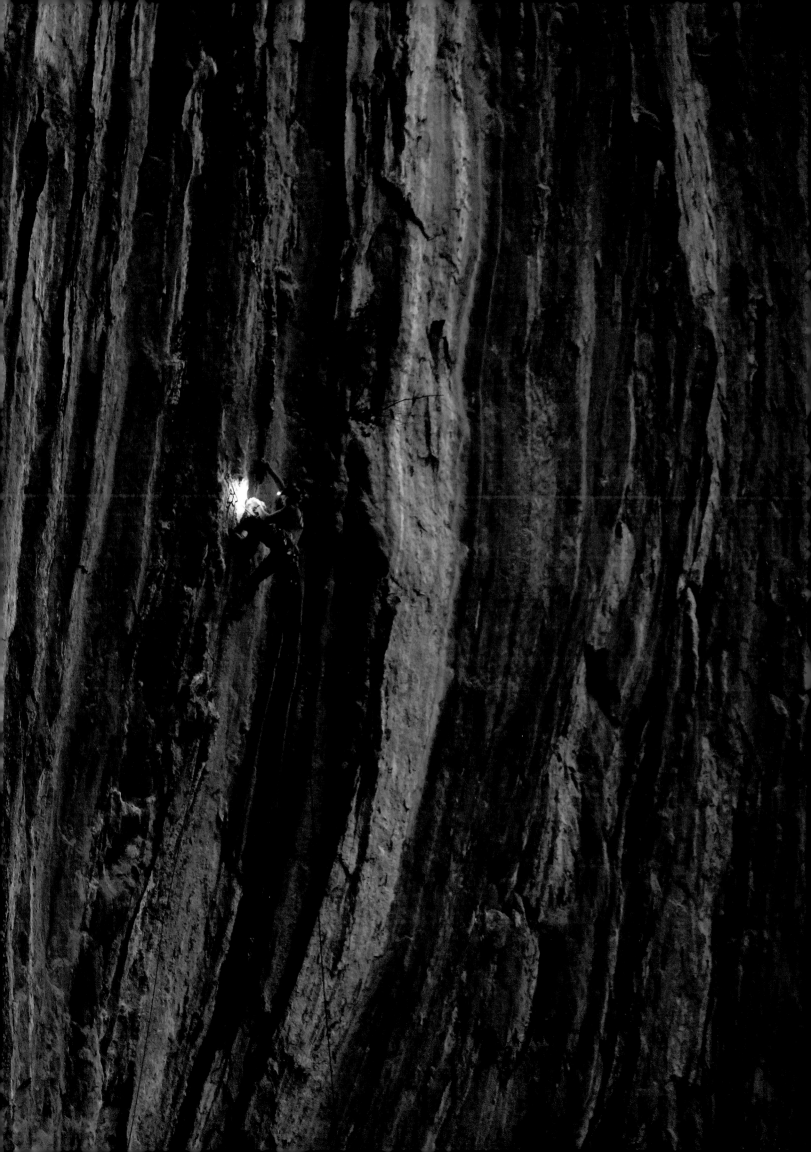

Joshua Tree

California

Type of Climbing:
Trad, bouldering, sport

Rock Type:
Granite

Climbing Style:
Vertical crack, gritty, slabby

Number of Climbs:
5,900+

Elevation:
4,200 ft

Prime Season:
October–March

Classic Climbs:
Double Cross (5.7+), *Sail Away* (5.8-), *Illusion Dweller* (5.10c), *Rubicon* (5.10c), *O'Kelley's Crack* (5.10d), *Heart of Darkness* (5.11a), *Wanger Banger* (5.11c), *Equinox* (5.12c), *Gunsmoke* (V3), *Stem Gem* (V4), *JBMFP* (V5), *Planet X* (V6)

Previous
Celestial Omnibus (5.12a)
The sometimes-local Tiffany Hensley enjoys a sunset lap up this two-pitch classic, featuring acrobatic movement through overhanging tufa jugs and pinches.

Right
Climber coiling rope at last light in the park.

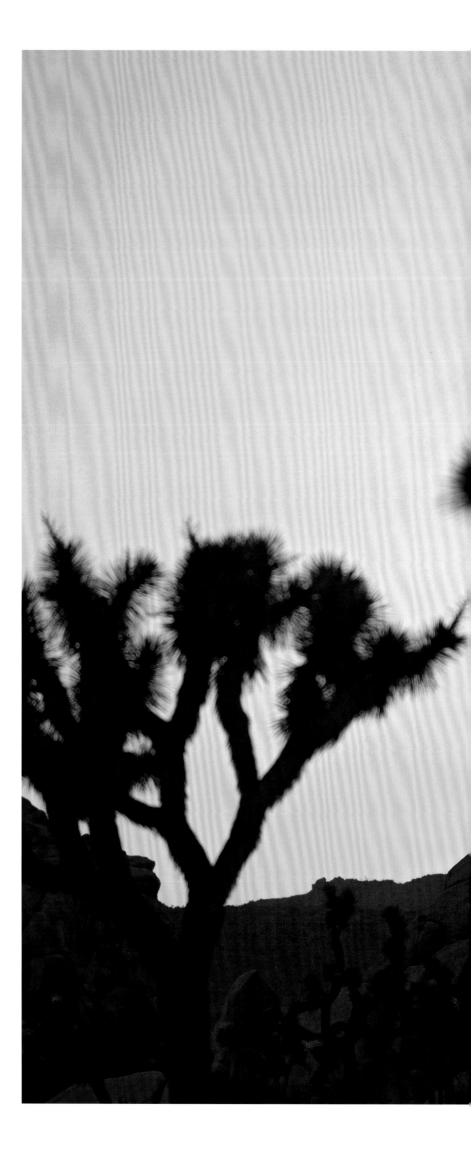

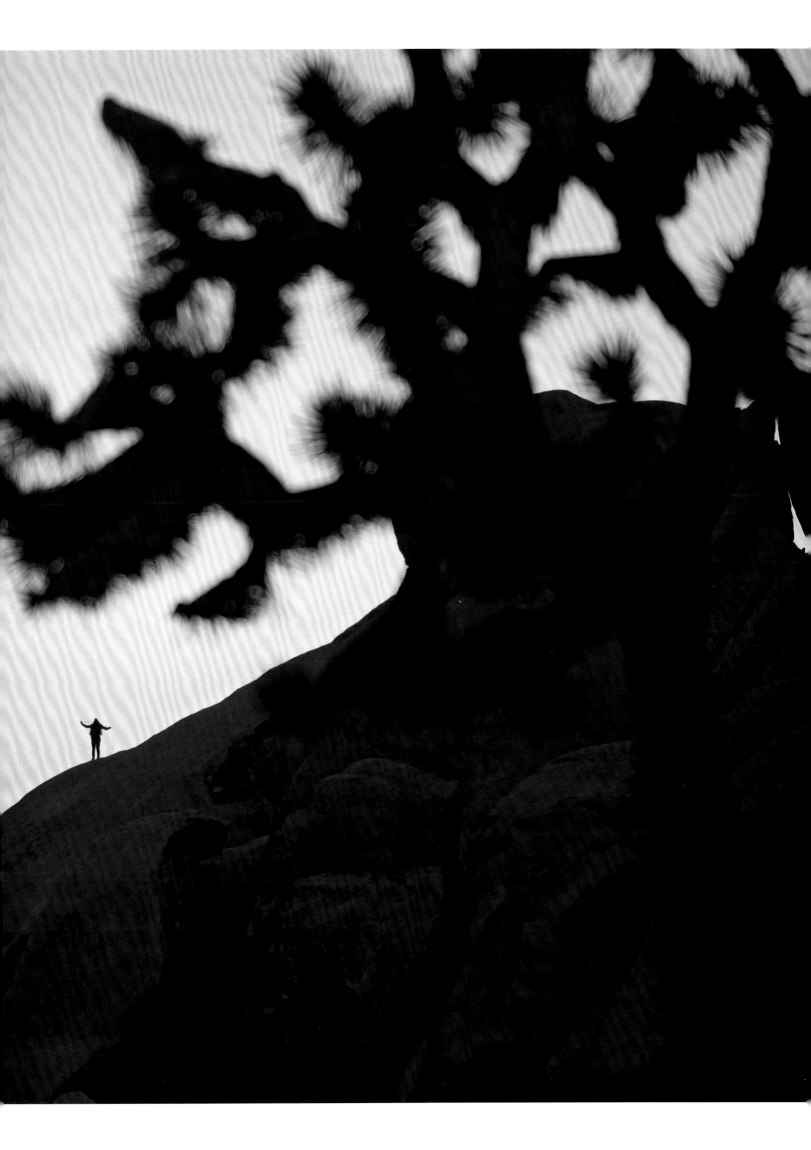

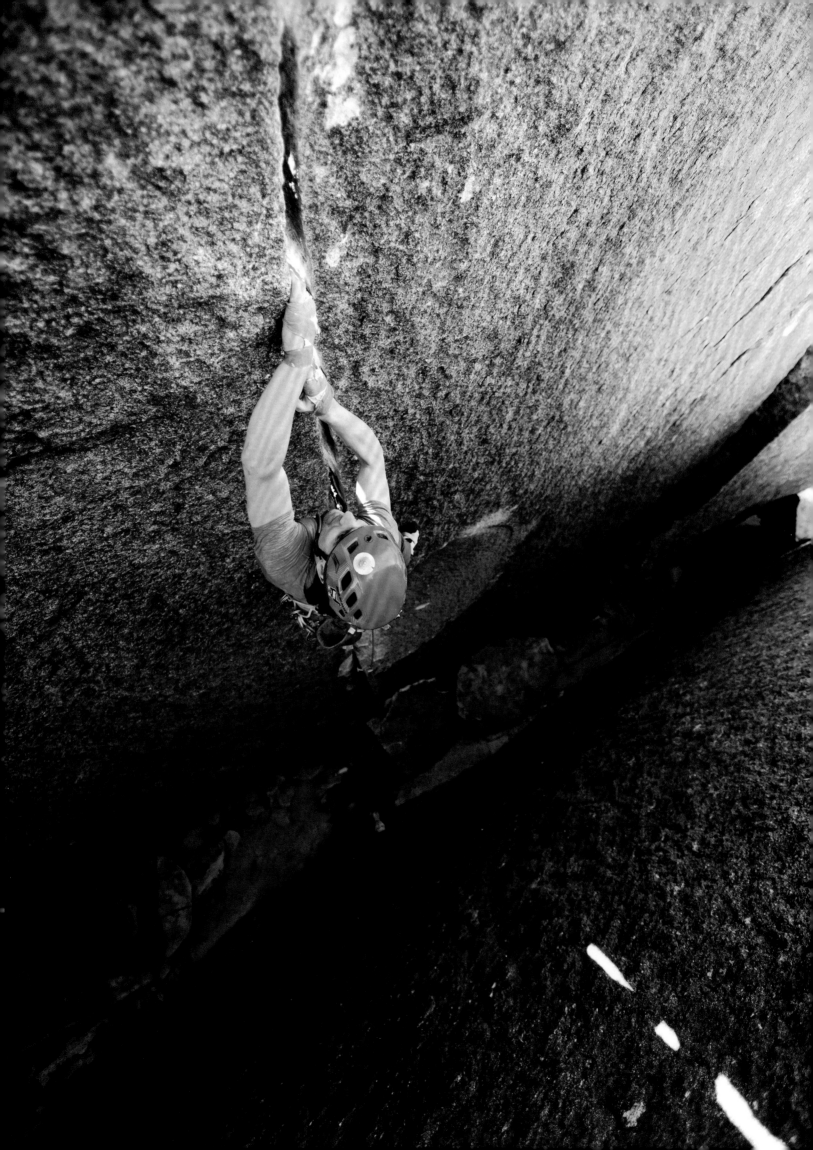

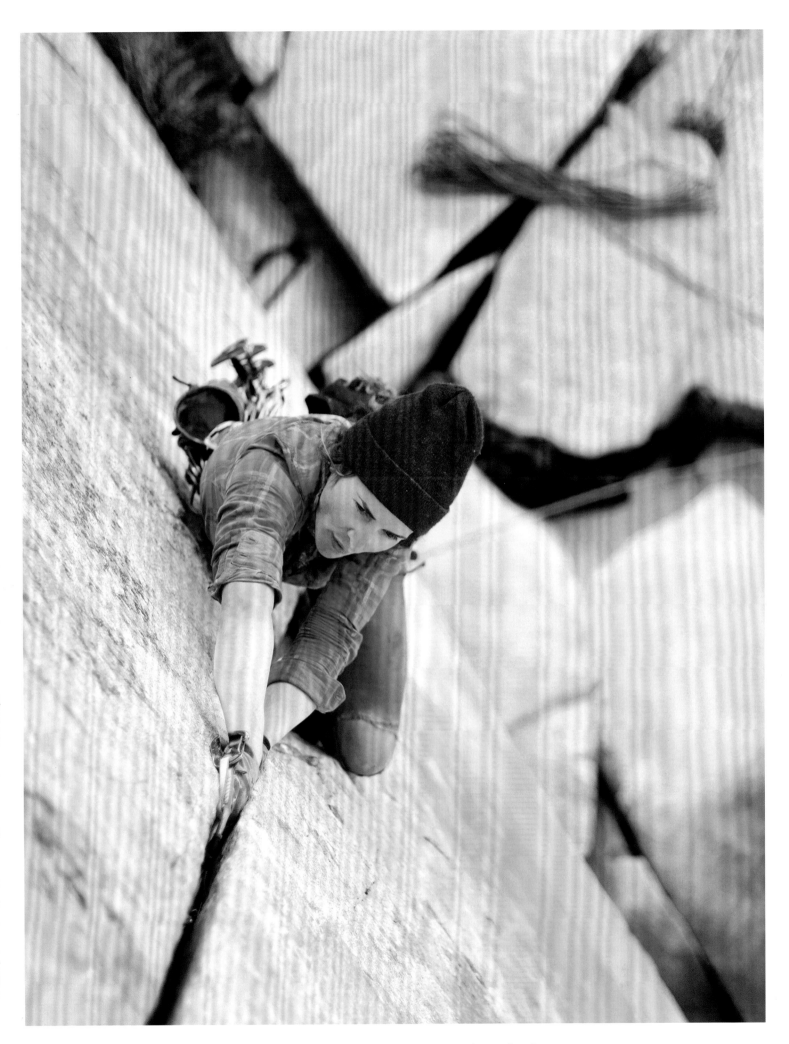

Left *Heart of Darkness* **(5.11a)**
Brooks Wenzel on the thin hands crack that bisects the entirety of Conrad Rock, an enormous block. For only 5 to 10 minutes each evening, the rays of sunset shine through the crack, creating this otherworldly effect.

Right *Wangerbanger* **(5.11c)**
Trish Matheny having no problems swimming through the thin hands crux.

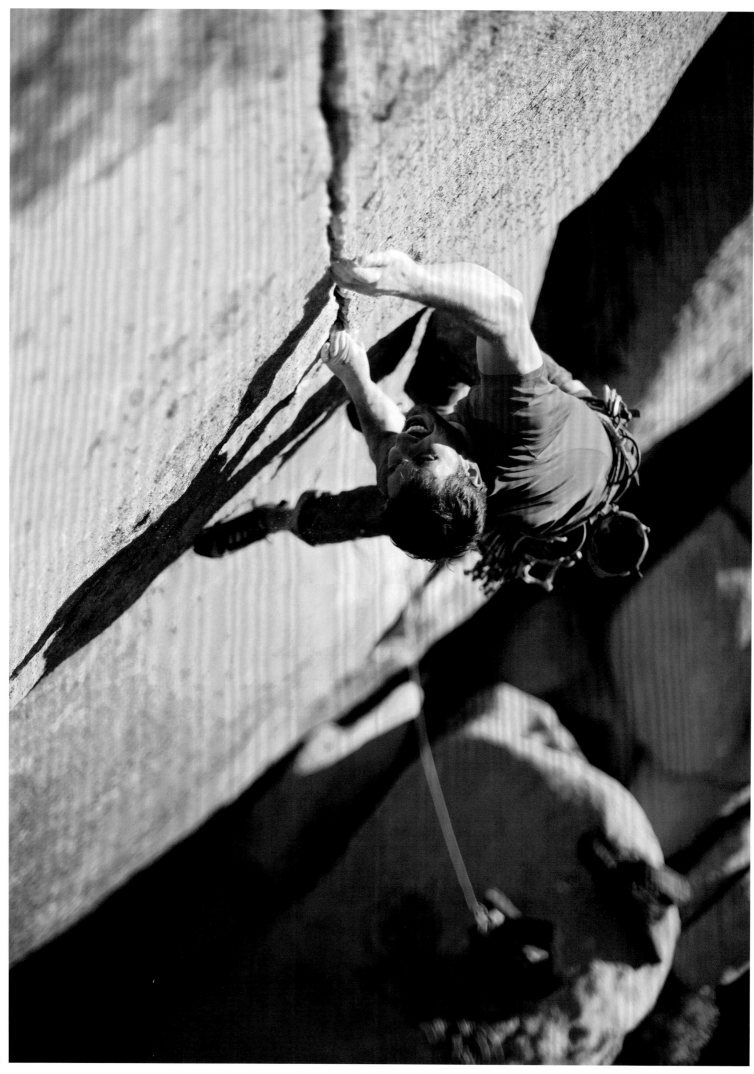

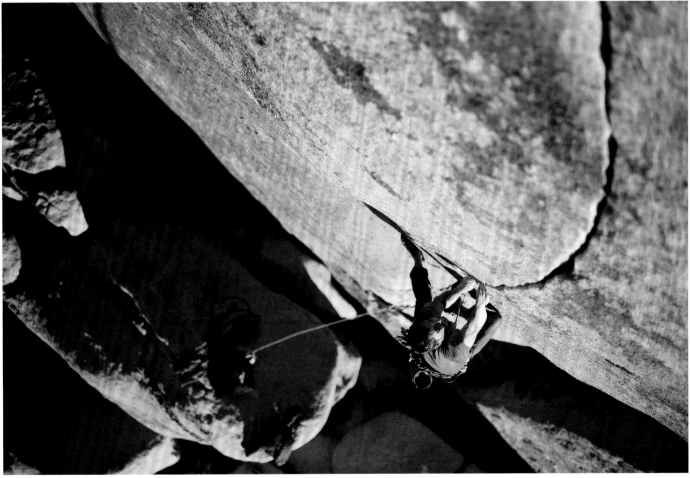

Left
Equinox (5.12c)
Chris Tomasetti giving it everything on the crux of this incredible fingercrack. The rock steepens and the footholds disappear as the crack narrows to fingertip width.

Top
The minimalist desert landscape of Joshua Tree National Park.

Bottom
Equinox (5.12c)
Alternate view of Equinox. This world-class line is etched into a giant boulder, at the top of an unlikely heap of giant boulders in the middle of the desert (p. 224–225).

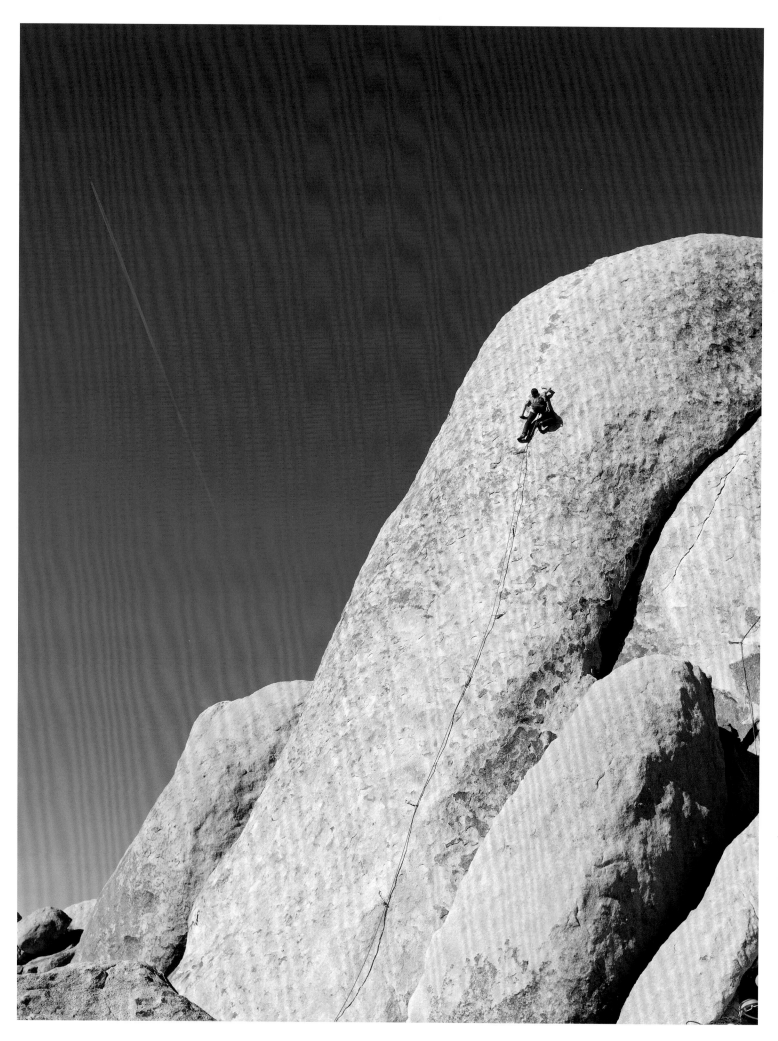

Left *Puss N'Boots* **(5.11c)**
Brooks Wenzel demonstrating the iconic hard slab climbing of Joshua Tree.
The sandpaper-like texture of J-Tree's granite offers incredible friction,
allowing for improbable ascents with no obvious holds.

Right
Joshua Trees set against granite at sunset. These surreal trees live to be
150 years old, and are currently under consideration for listing under the
Endangered Species Act, due to their vulnerability to climate change.

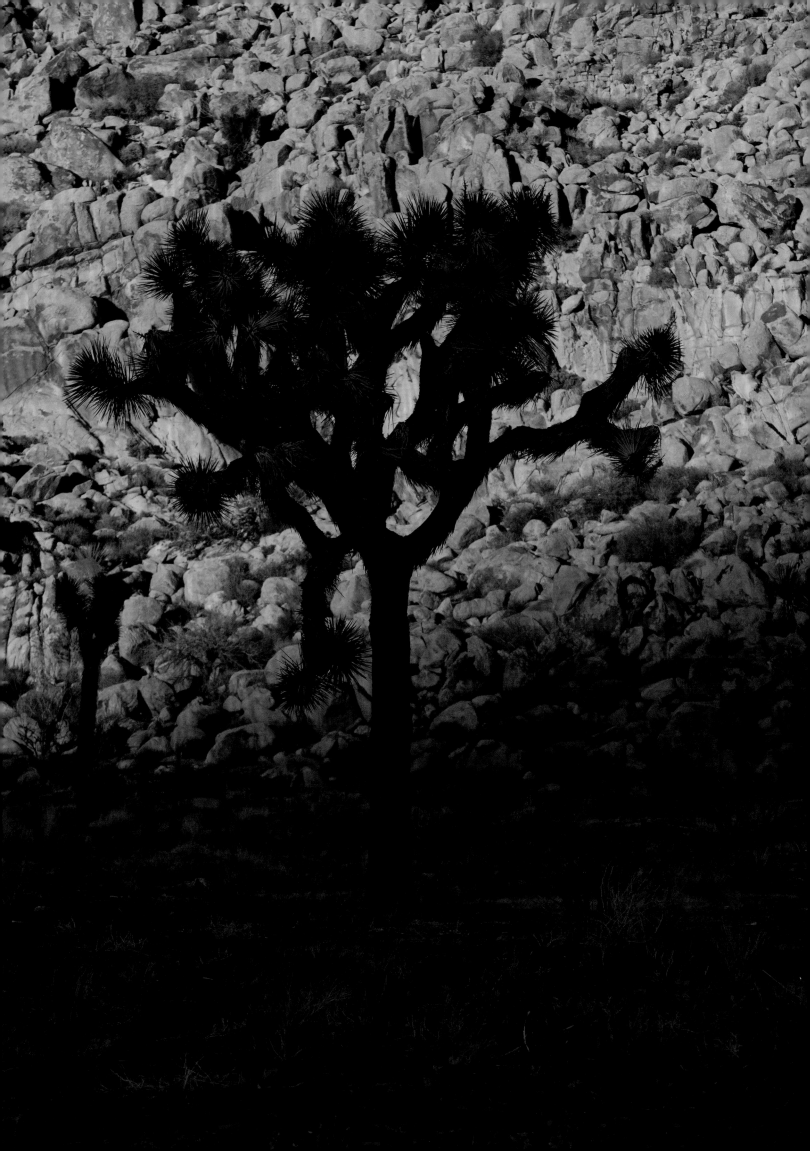

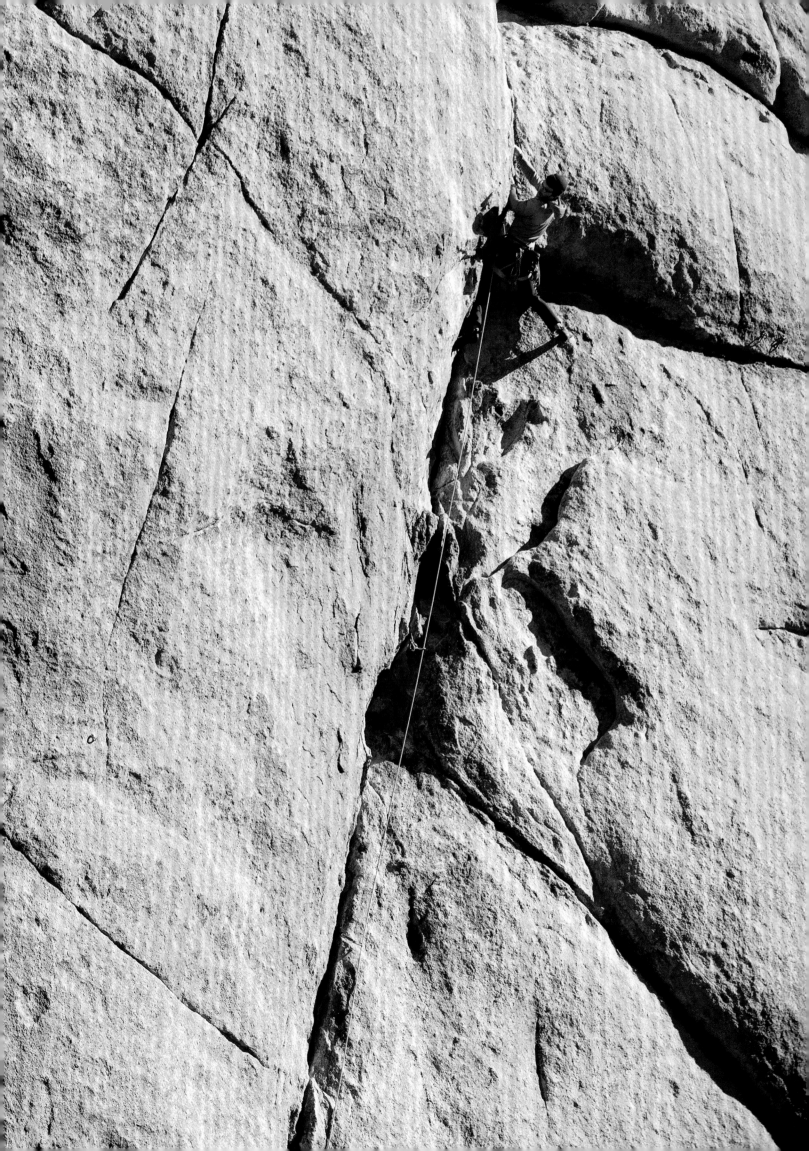

"What I love about climbing changes as I change. As I grow, my priorities and goals change and the same thing is mirrored in my climbing goals and motivation— I can always find something satisfying in the process, regardless of where I am in life or climbing strength."

–Jon Glassberg

Previous
Illusion Dweller **(5.10b)**
Jaysen Henderson about to discover the bulging crux on this terrific and lengthy line.

Right
Jesse Lynch and Jaysen Henderson rambling through the dusty desert towards Jerry's Quarry, home of *Equinox* (5.12c).

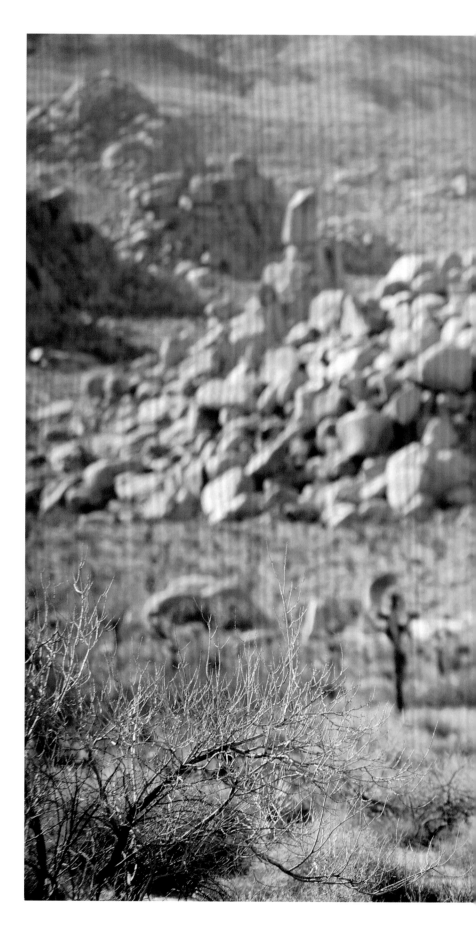

225

Bishop

California

Type of Climbing:
Bouldering, sport

Rock Type:
Granite, tuff

Climbing Style:
Highball, slopey, crimpy

Number of Climbs:
~2,500

Elevation:
4200 ft

Prime Season:
October–May

Classic Climbs:
The Hunk (V2), *Jedi Mind Tricks* (V4), *High Plains Drifter* (V7), *Soul Slinger* (V9), *Evilution Direct* (V12-13), *Southwest Arete* (5.9-), *West Face of Cardinal Pinnacle* (5.10a), *Yellow Peril* (5.10c), *O.R.G.asm* (5.11a), *Darshan* (5.12b)

Right
Saigon Direct (V9)
The whole crew gathers for Claire Bukowski's ascent of this popular Bishop highball. A mound of crashpads and a few attentive spotters are ready for action down below.

Following
Gigantor (V3)
Lance Carrera as the focal point in some serious Sierra scenery. This highball gets its crux out of the way down low, moving up to good holds at the lip.

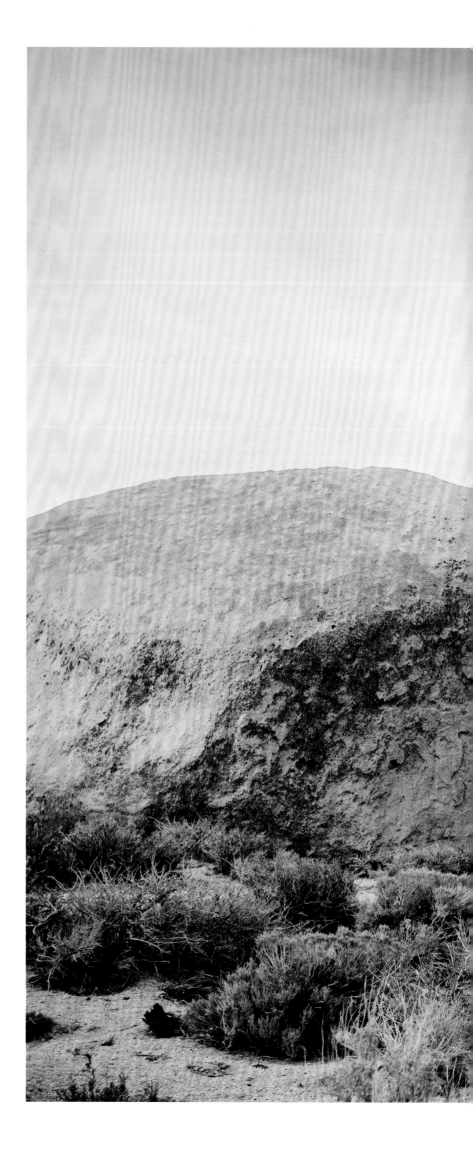

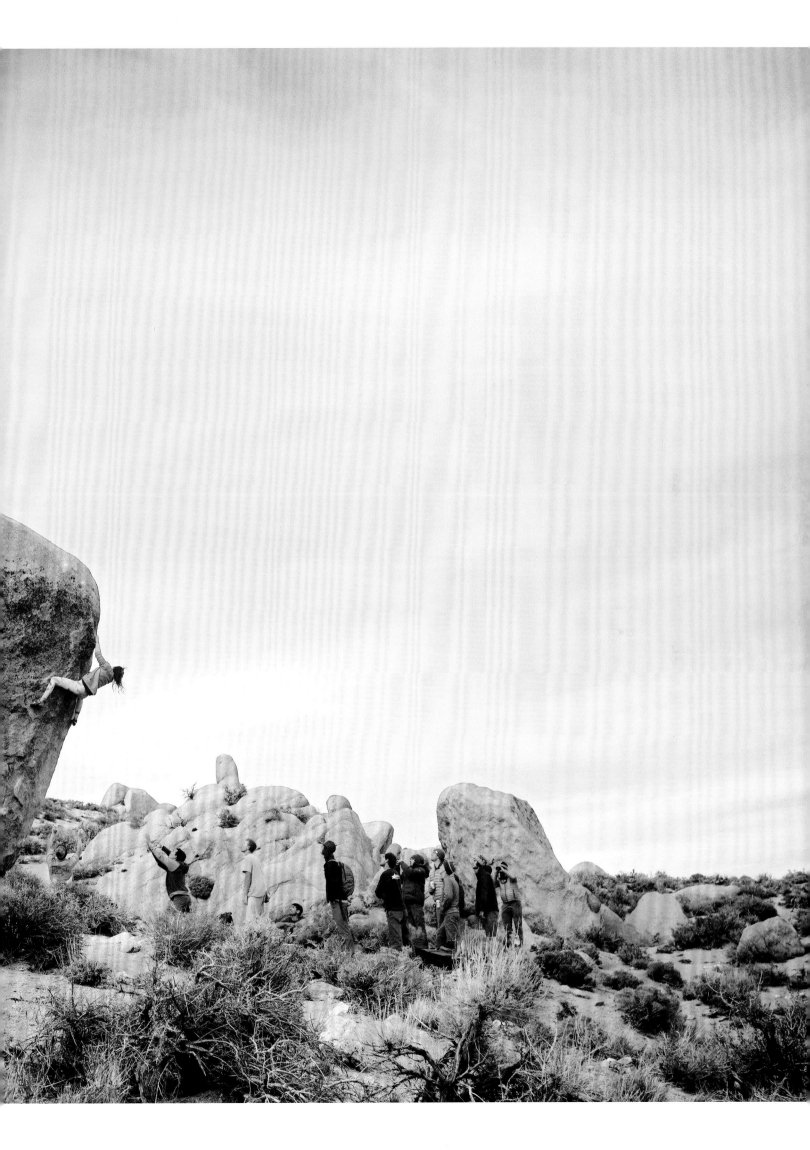

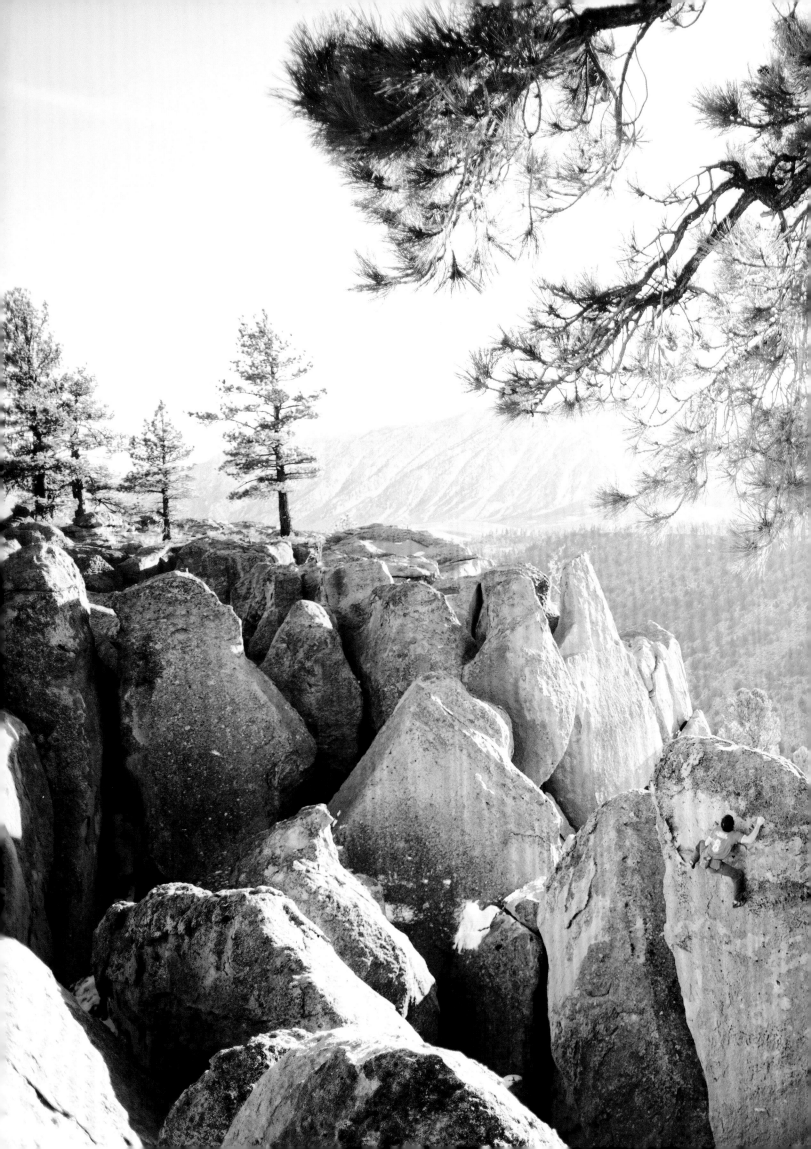

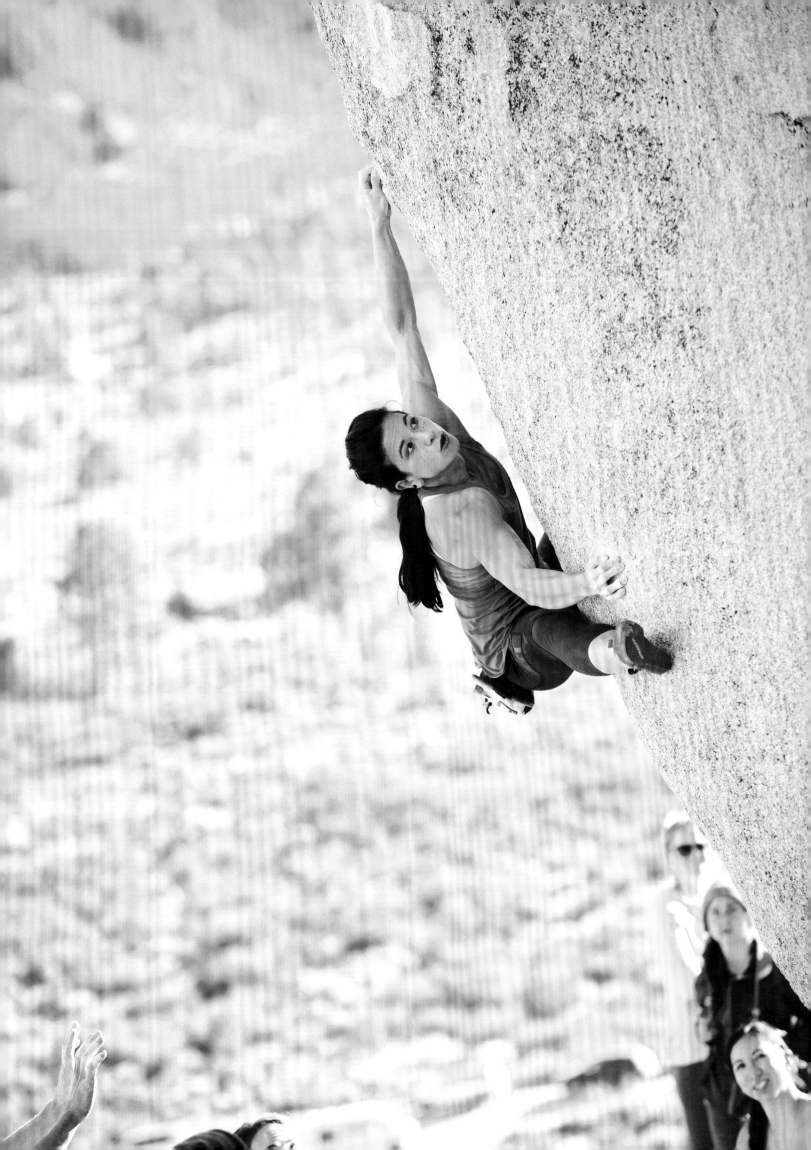

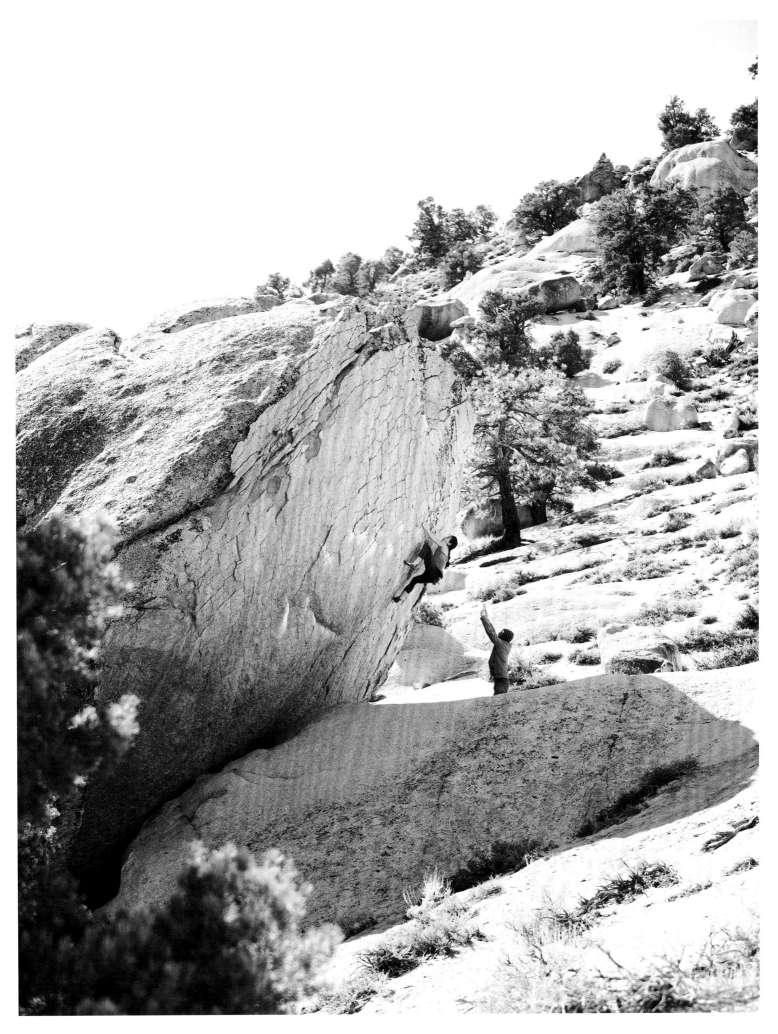

Left *Saigon Direct* **(V9)**
Nina Williams taking her turn on the same boulder. The spectators approve of
the creative use of sticky rubber on her soles.

Right *Checkerboard* **(V8)**
Nina Williams on the scaly features of another of Bishop's famous highballs.

"Climbing is somehow this thriving, flowing, conscious community that connects us in both the most populated and remote places on Earth; this, then, strengthens us when we feel most alone."

—Tiffany Hensley

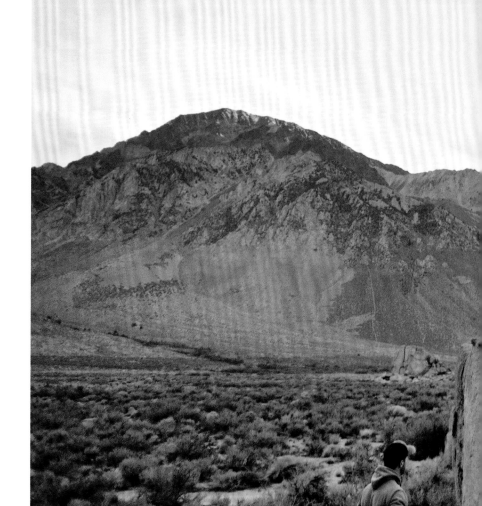

Right
Seven Spanish Angels (V6)
Nic Charron pulls of of the lip hueco to mantle the top of this fun problem.

Following
Love Stinks (5.11a)
Peter Croft warming up on a fantastically long, thin face climb.

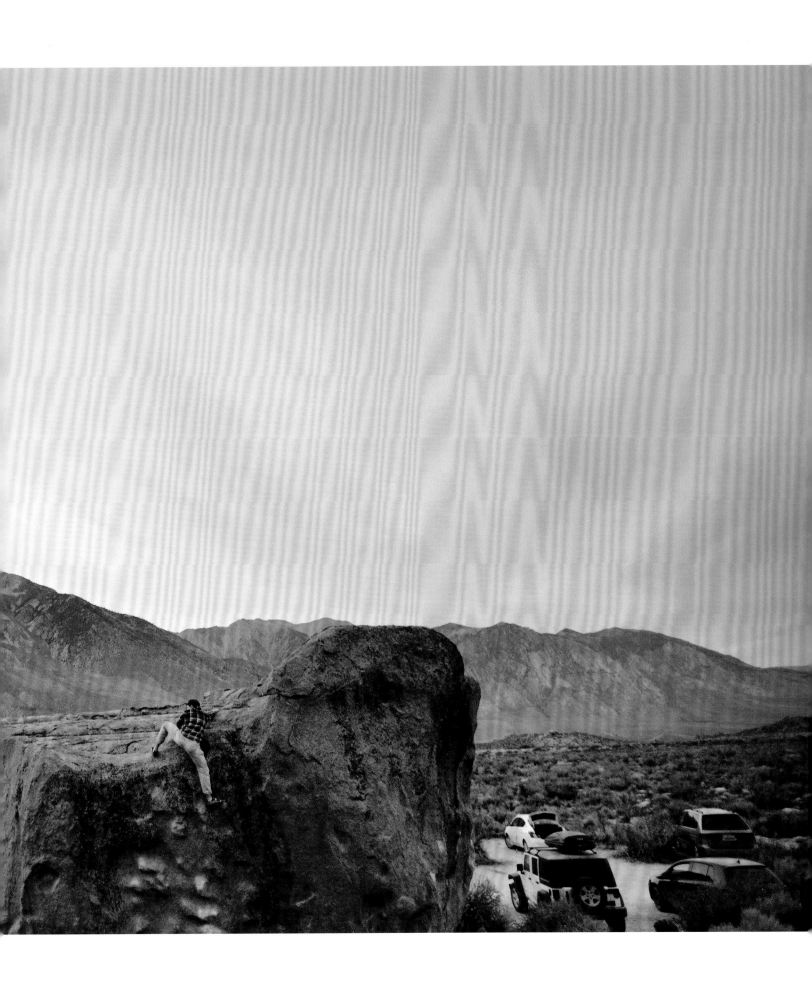

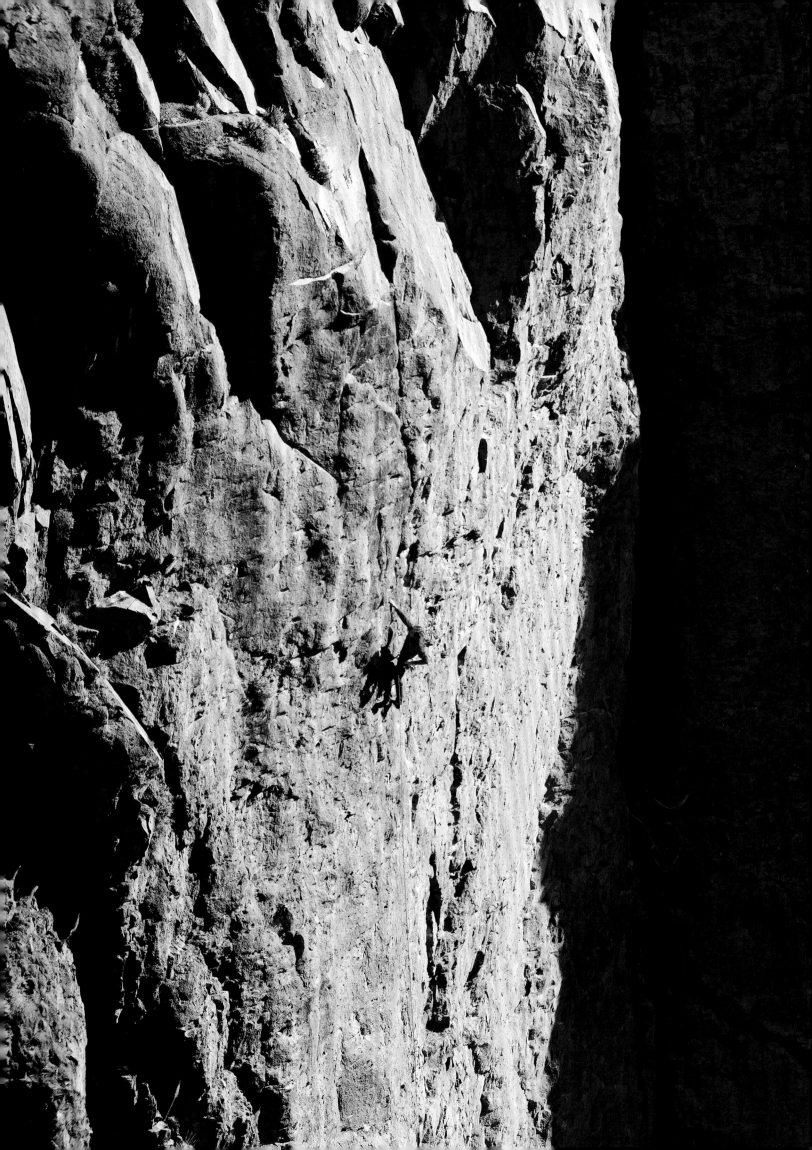

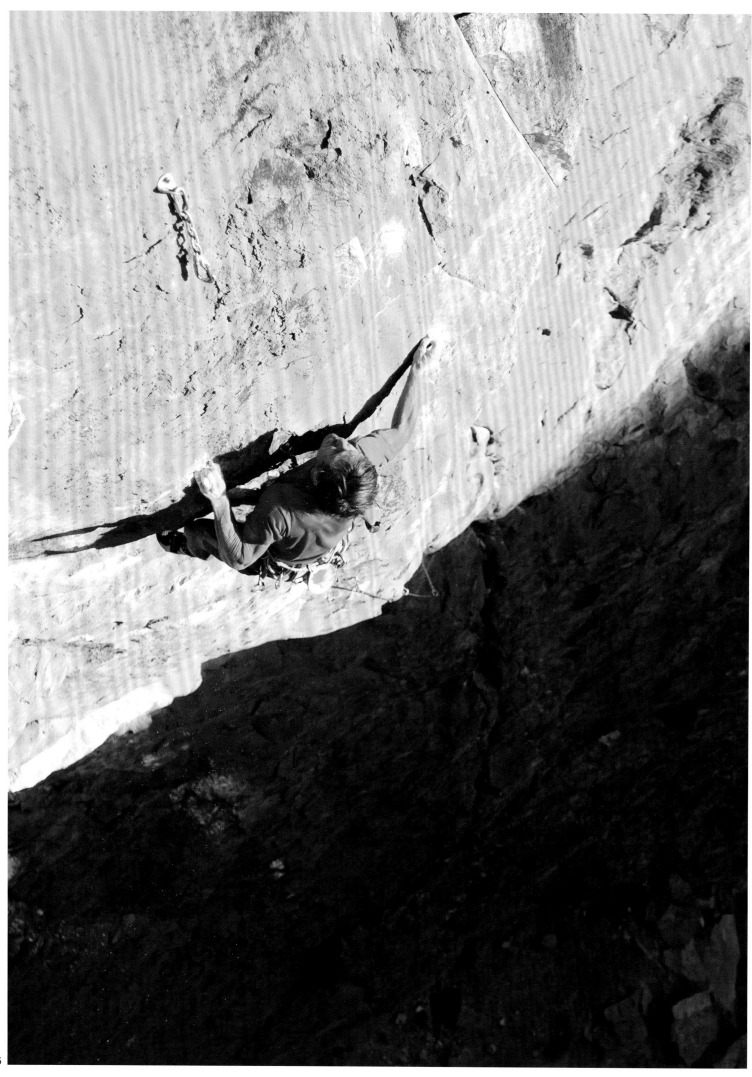

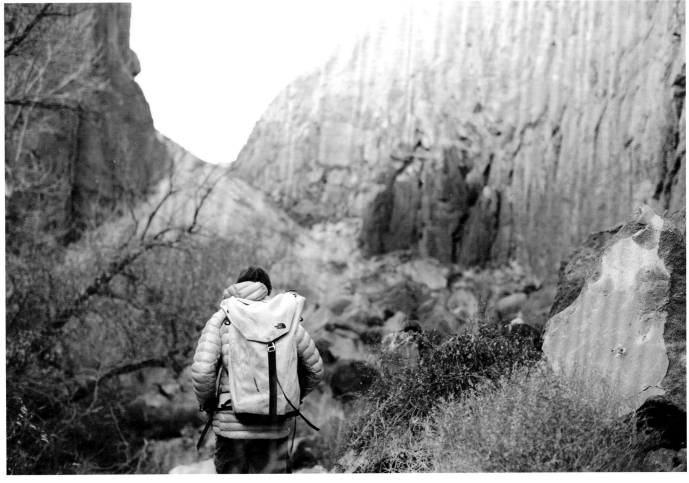

Left
Corona (5.13a/b)
Peter Croft showing us how it's done on one of his many first ascents in the Owens River Gorge. Owens is one of the sport climbing epicenters of the west coast.

Top
Black Capacitor (5.12d)
Peter Croft pulling the bulge on this link up between *Flux Capacitor* (5.12c) and *Black Hole* (5.12b).

Bottom
Peter Croft venturing into familiar territory—the central gorge at Owens.

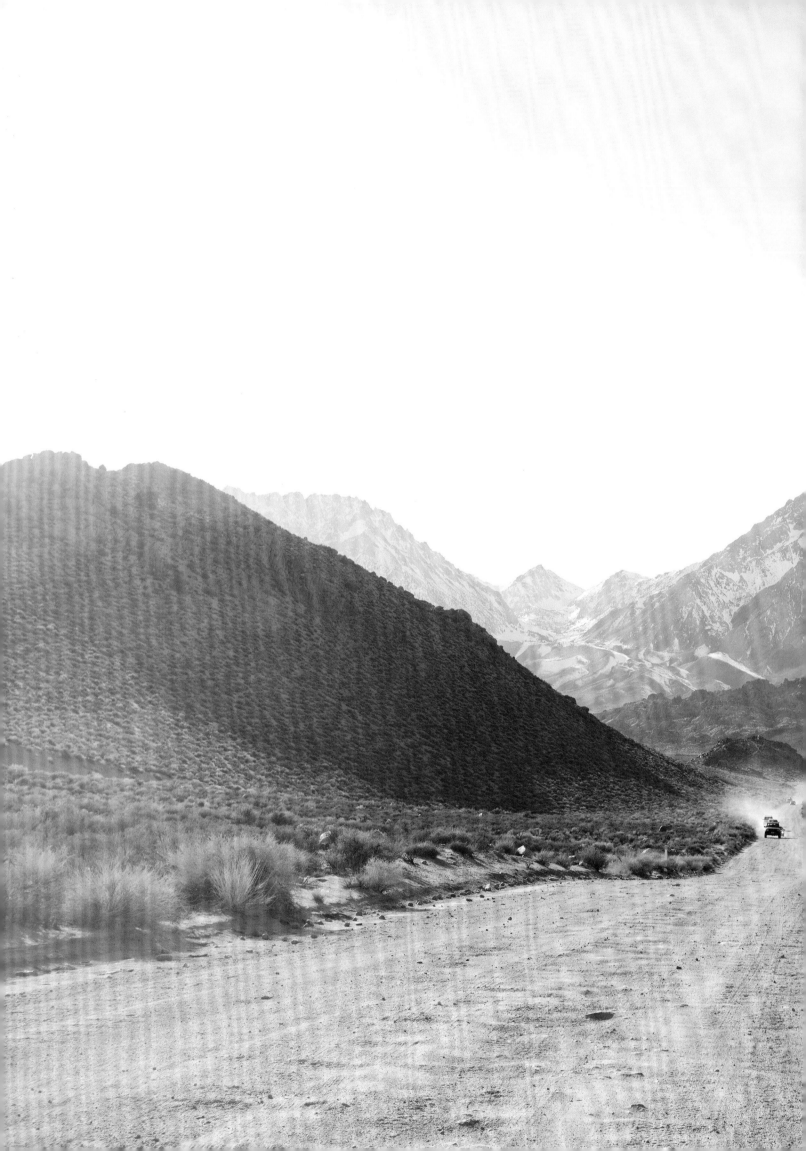

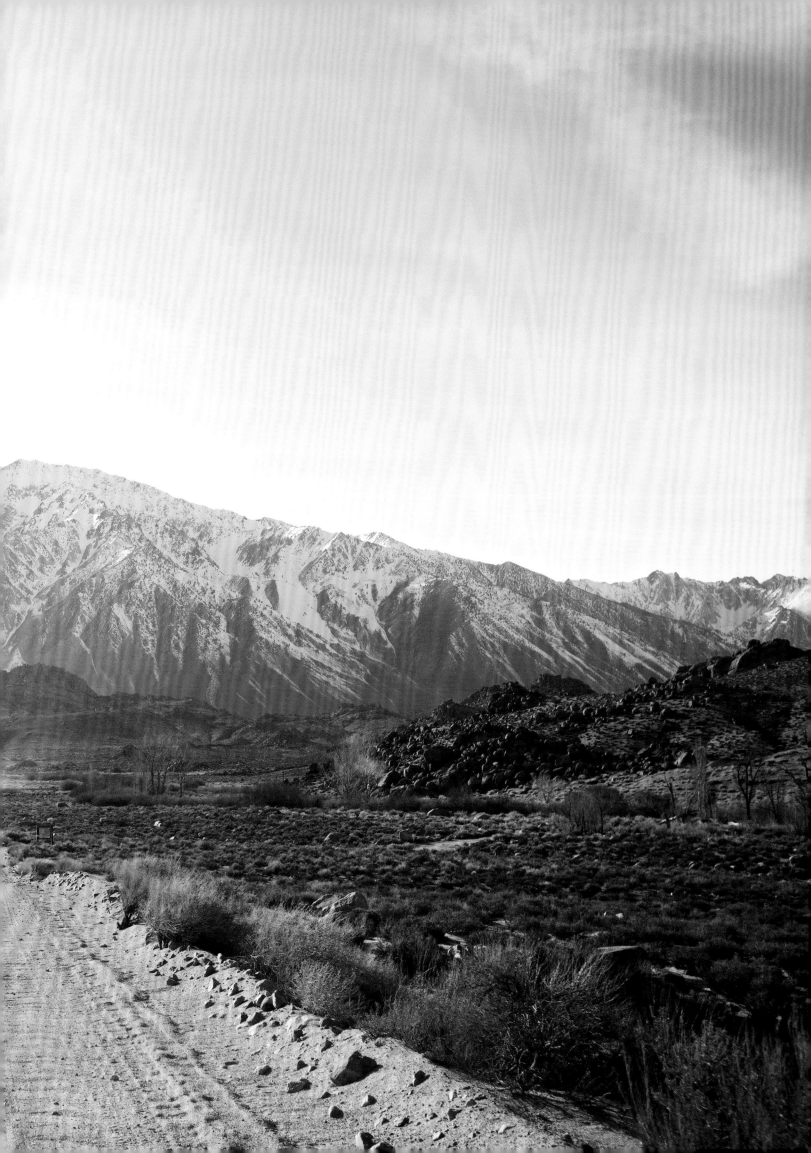

Jailhouse

California

Type of Climbing:
Sport

Rock Type:
Basalt

Climbing Style:
Steep, pumpy, slopers

Number of Climbs:
~100

Elevation:
958 ft

Prime Season:
March–April, October–January

Classic Climbs:
Cuckoo's Nest (5.11d), *Whipping Boy* (5.12b), *Iron Junkie* (5.12c), *Soap on a Rope* (5.12d), *Fugitive* (5.13a), *Jailbait* (5.13c)

Previous
A few miles down Buttermilks Road lie the Buttermilks—a phenomenal destination that draws boulderers from around the globe.

Right
***Iron Junkie* (5.12c)**
Shabana Ali wrestles with this steep foundational Jailhouse climb. Mastering the skills required for *Iron Junkie* is helpful to move on to the harder climbs at the main wall.

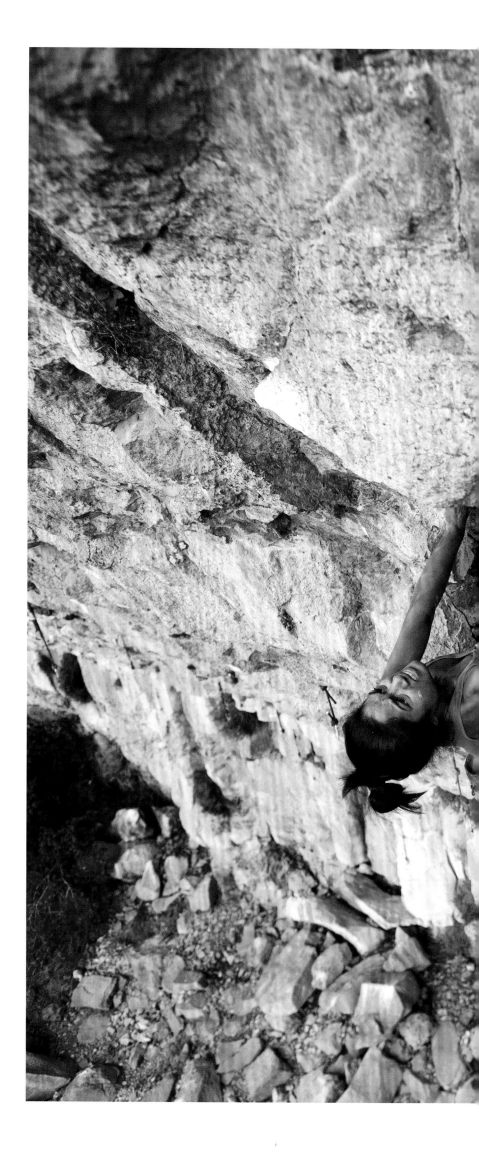

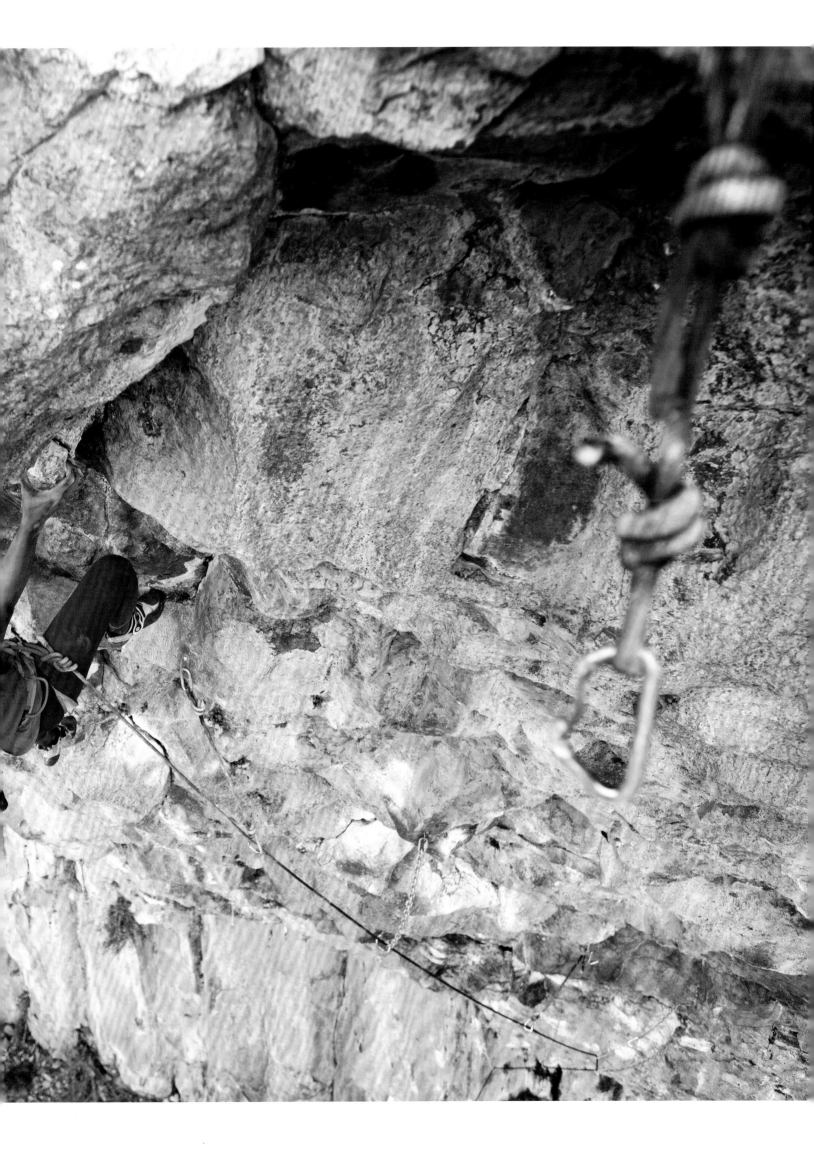

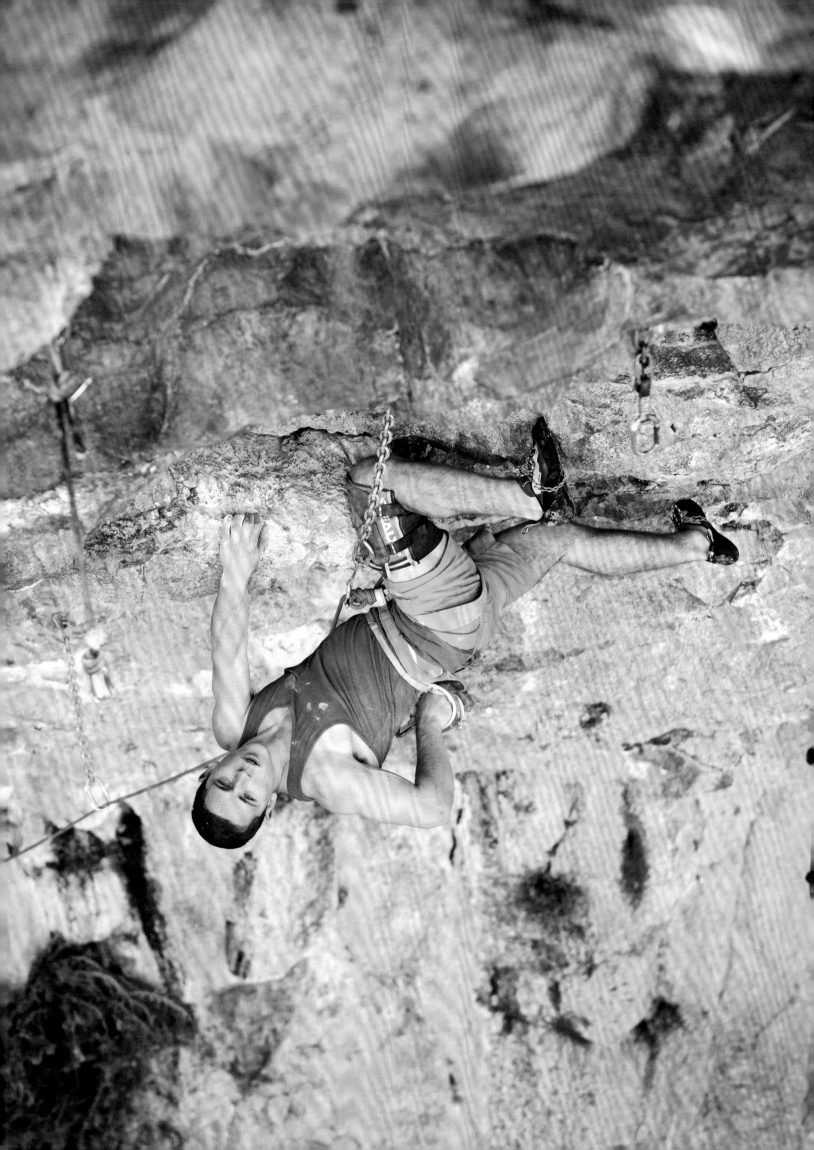

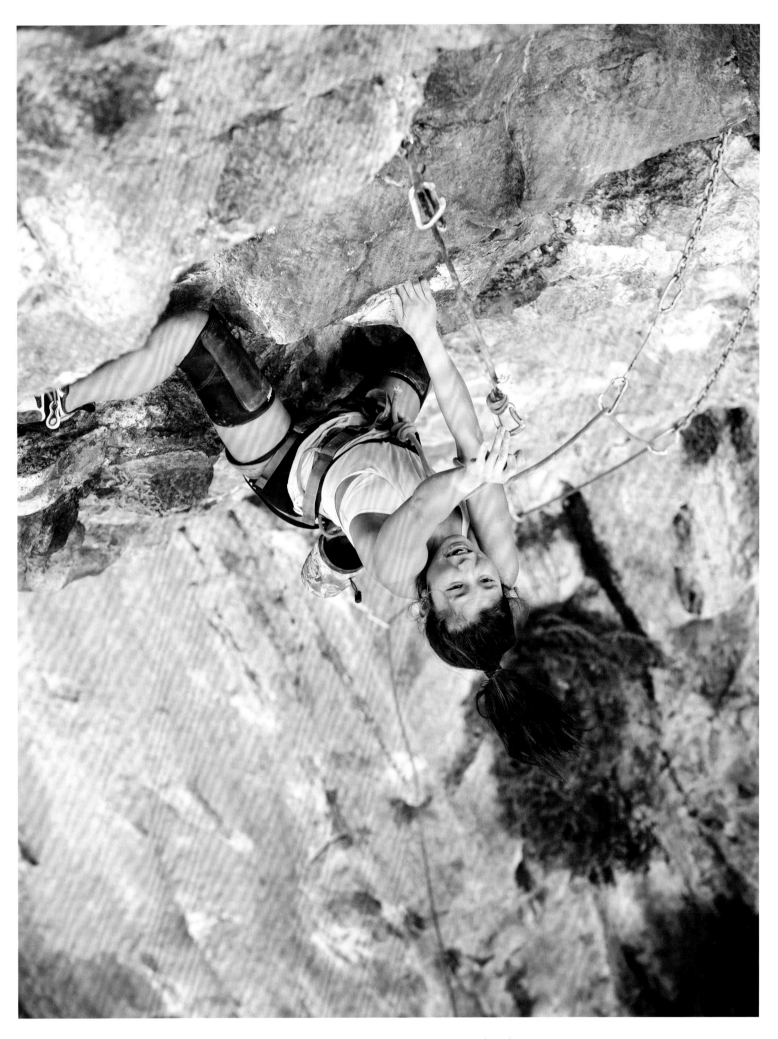

Left *Big House* **(5.14a)**
Josh Levin inverting off of a textbook kneebar on one of the more challenging Jailhouse classics.

Right *Iron Junkie* **(5.12c)**
Alana Murao making best use of Jailhouse's blocky features to find a clipping stance.

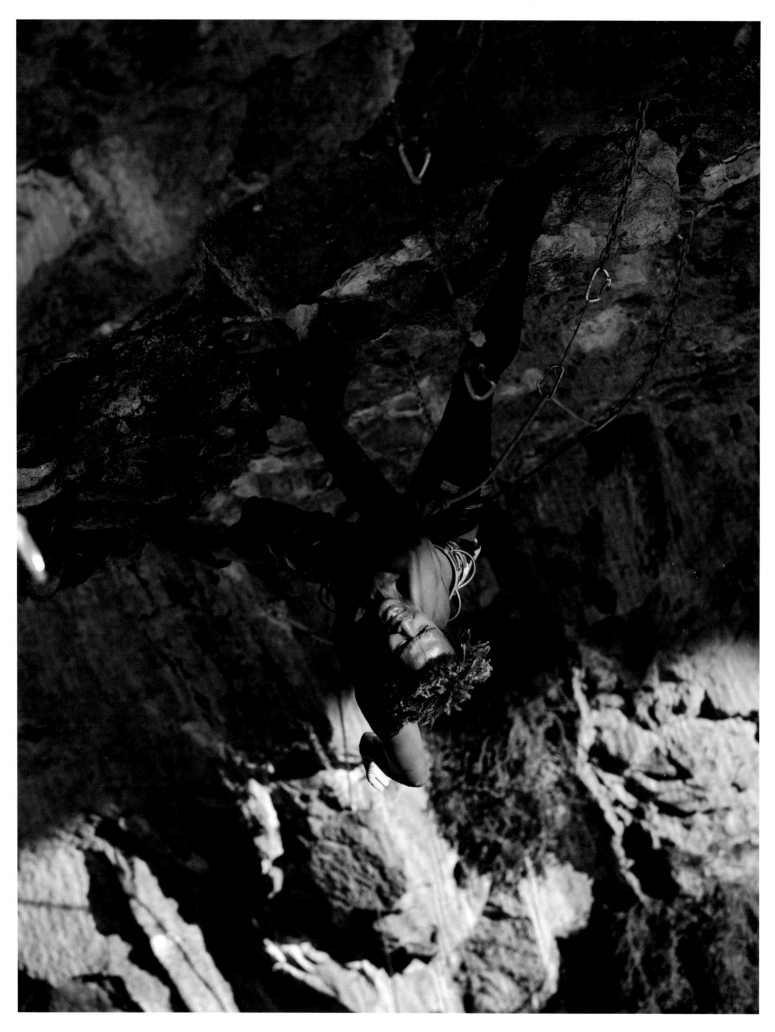

Left *Iron Junkie* (5.12c)
Joshua Enoch Williams taking a moment on a quality heel hook.

Right *Soap on a Rope* (5.12d)
Josh Levin ascending steep slopers through pockets of light.

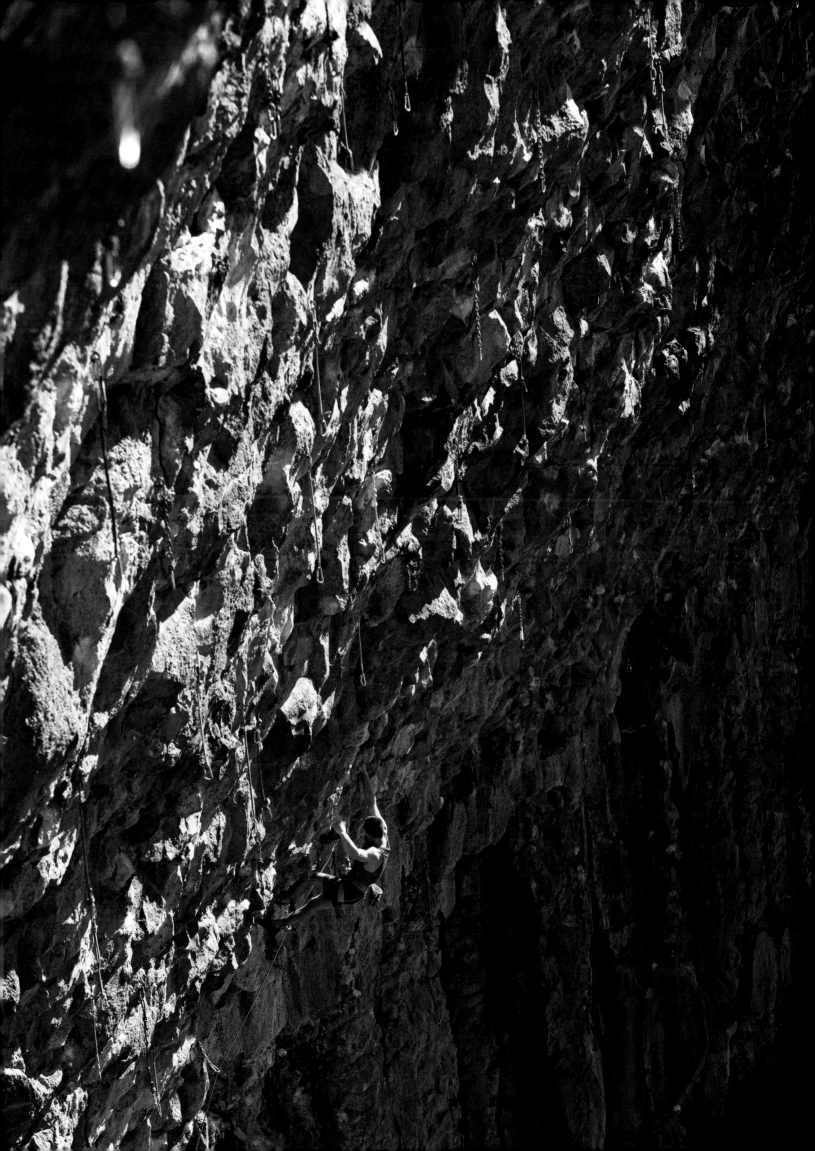

San Francisco Coast

California

Type of Climbing:
Sport, bouldering

Rock Type:
Greywacke and serpentine sandstone

Climbing Style:
Balancy, powerful, breezy

Number of Climbs:
~100

Elevation:
20 ft

Prime Season:
Year round

Classic Climbs:
Orange Buddha Arete (V7), *Sign Language* (5.11a), *Sex Porpoises* (5.12c), *Holy Mackerel* (5.13a), *Little Wing* (V7), *Surf Safari* (5.13d)

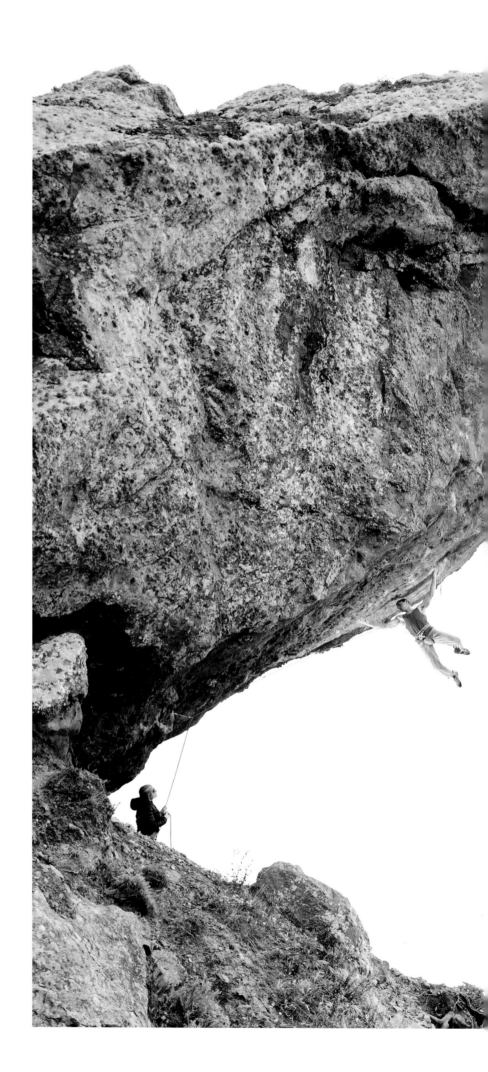

Previous
Jailhouse climbers availing themselves of the natural seating in between burns

Right
Surf Safari (5.13d)
Josh Levin on the iconic bolted line put up by Scott Frye in 1992. At the time it was one of the hardest climbs in California.

Following
Mickey's Beach Arete (5.14a)
Giovanni Traversi trying hard on one of the coveted hard classics at Mickey's. By using a manufactured pocket, the route is climbable at 5.13b.

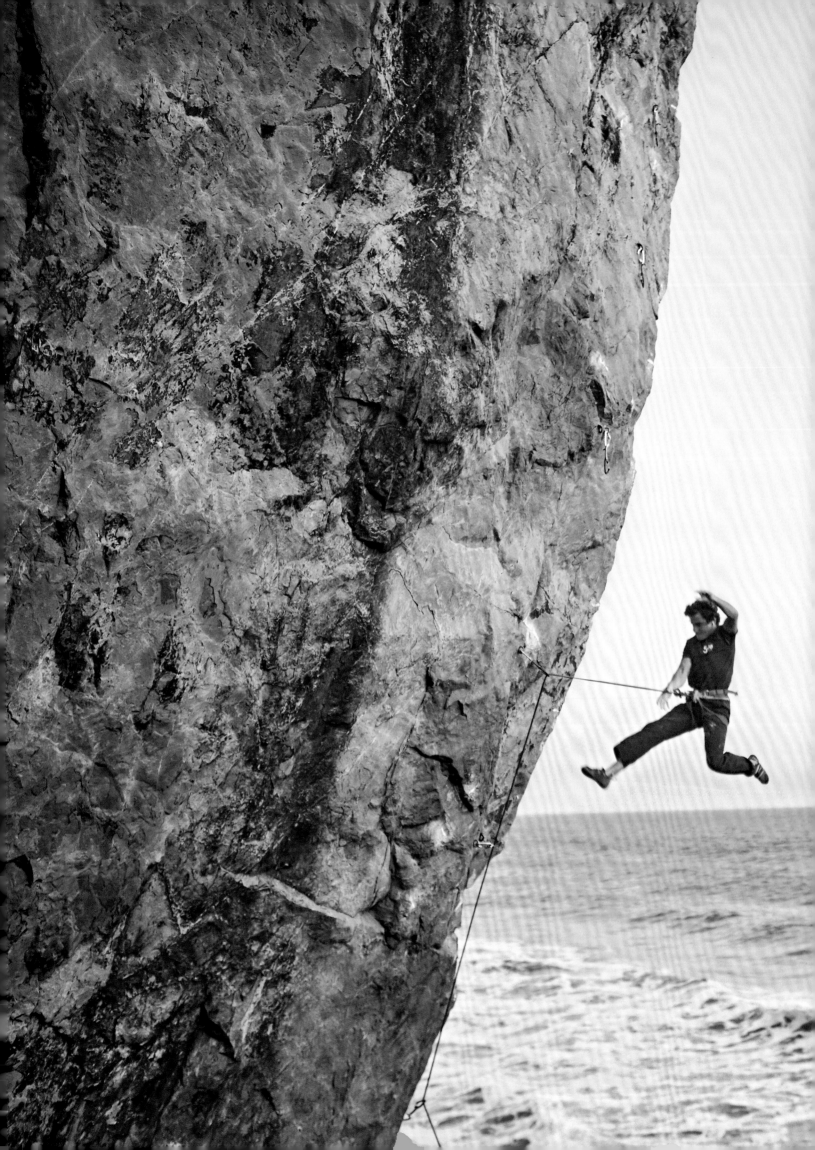

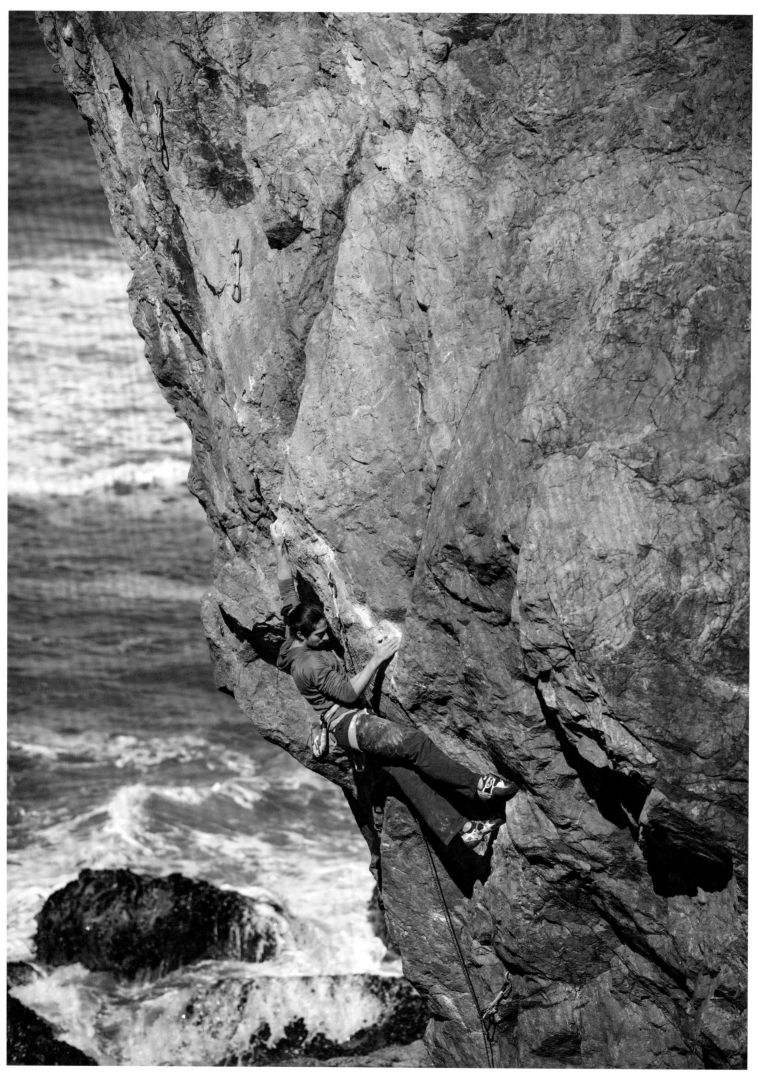

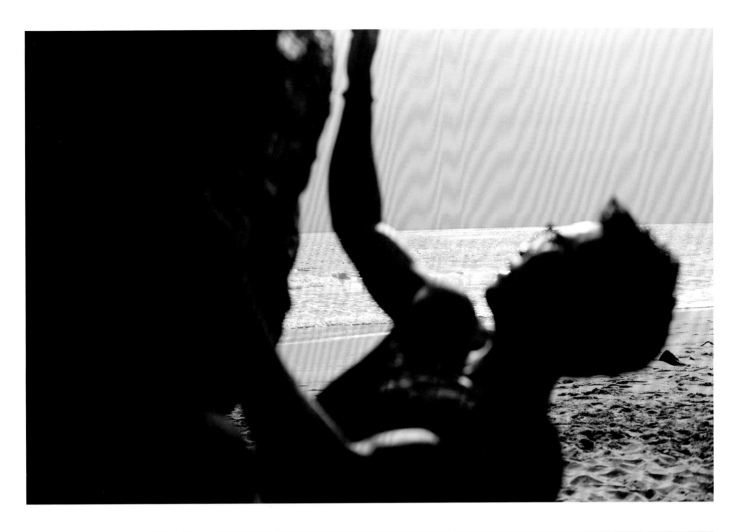

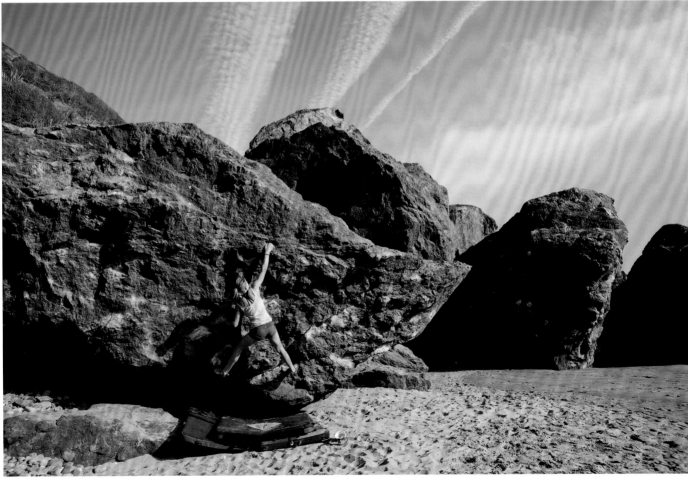

Left
Sex Porpoises (5.12c)
Amit Kapadia on a classic Jim Thornburg line at Mickey's Beach.

Top
Baseball (V3)
Davis Ngo ascending the orange Buddha Boulder, set against a Pacific panorama.

Bottom
Baseball (V3)
Sara Evenson having a full-value beach day at the Mickey's Beach boulders.

Smith Rock

Oregon

Type of Climbing:
Sport, trad

Rock Type:
Volcanic tuff

Climbing Style:
Thin, sharp, vertical

Number of Climbs:
1,500+

Elevation:
2,648 ft

Prime Season:
March–June, September–November

Classic Climbs:
Pioneer Route (5.7), *Moonshine Dihedral* (5.9), *Zebra Zion* (5.10a/b), *Moons of Pluto* (5.10d), *Toxic* (5.11b), *Dreamin'* (5.12a), *Chain Reaction* (5.12c), *Churning in the Wake* (5.13a), *To Bolt or Not to Be* (5.14a)

Right
Dreamin' (5.12a)
Jules Jimreivat working up the lower slab before the two roofs up above.

Following
Ankur Singhal about to launch into the day's next climb. Smith routes are easy to access and move between, allowing for high-volume cragging.

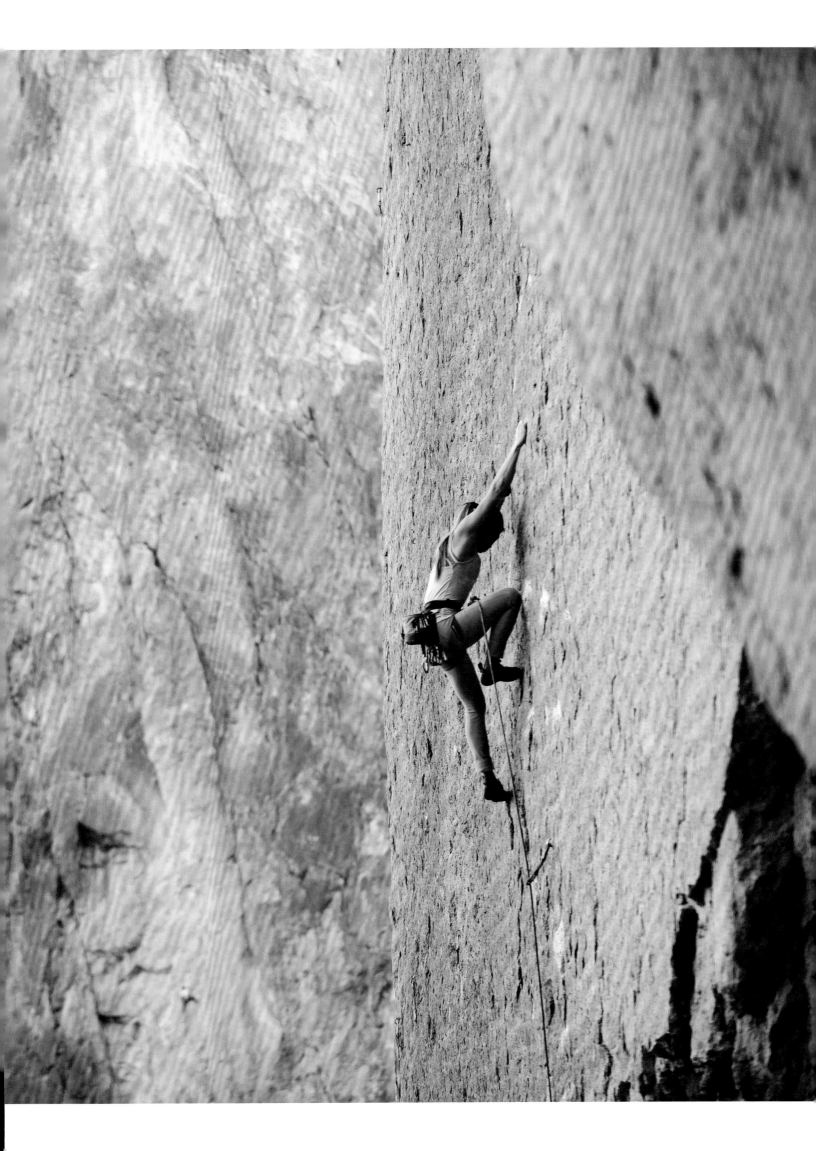

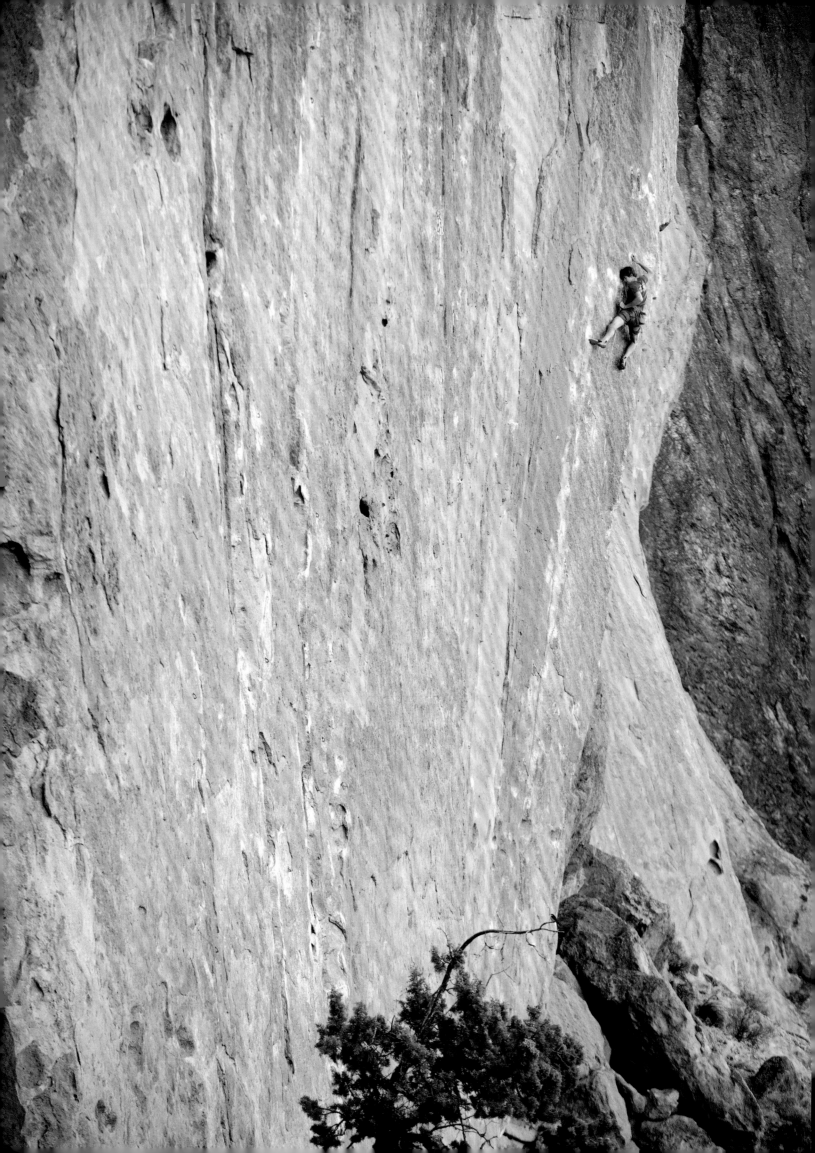

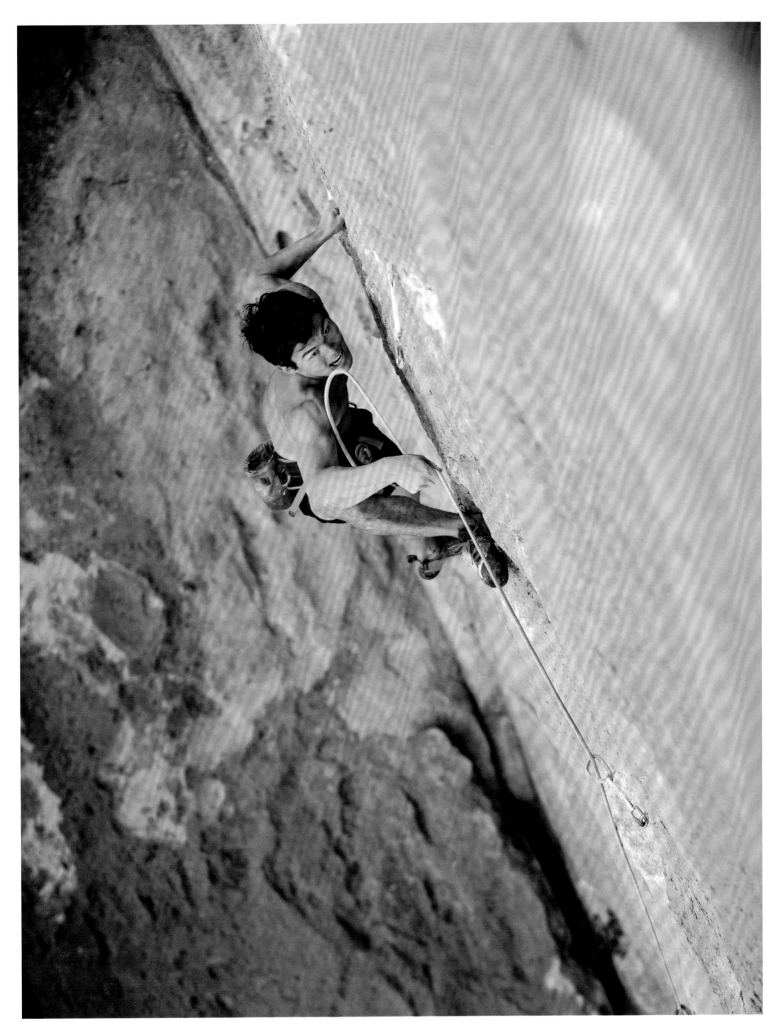

Left *Churning in the Wake* (5.13a)
Lukas Strauss-Wise executing the beta sequence on this controversial yet extremely popular route. *Churning* is for many their first 5.13, a monumental milestone for any dedicated climber.

Right *Aggro Monkey* (5.13b)
Ricky Marin getting aggro on another pumpy park classic.

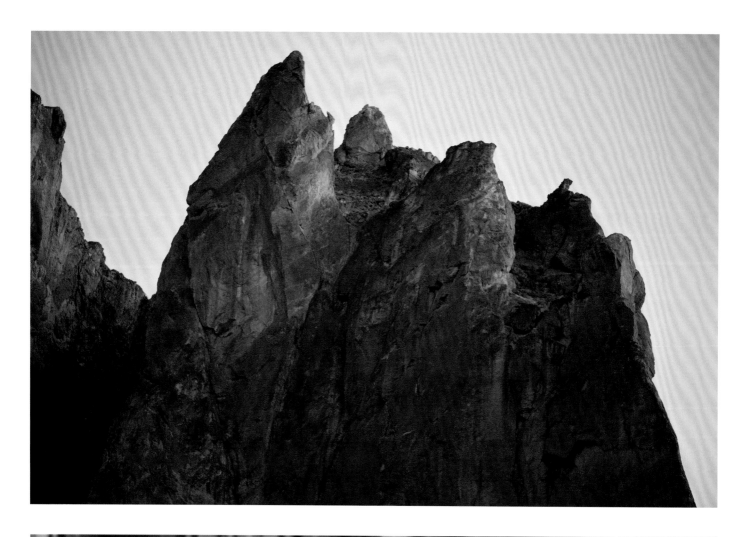

Top
The sharp, angular profile of Smith Rock.

Bottom
The Petzl Grigri and similar devices are a
popular choice for belaying on sport routes,
thanks to their assisted breaking function.

Right
Master of Puppets (5.10c)
Jules Jimreivat warming up on a lower-angle
Smith pitch.

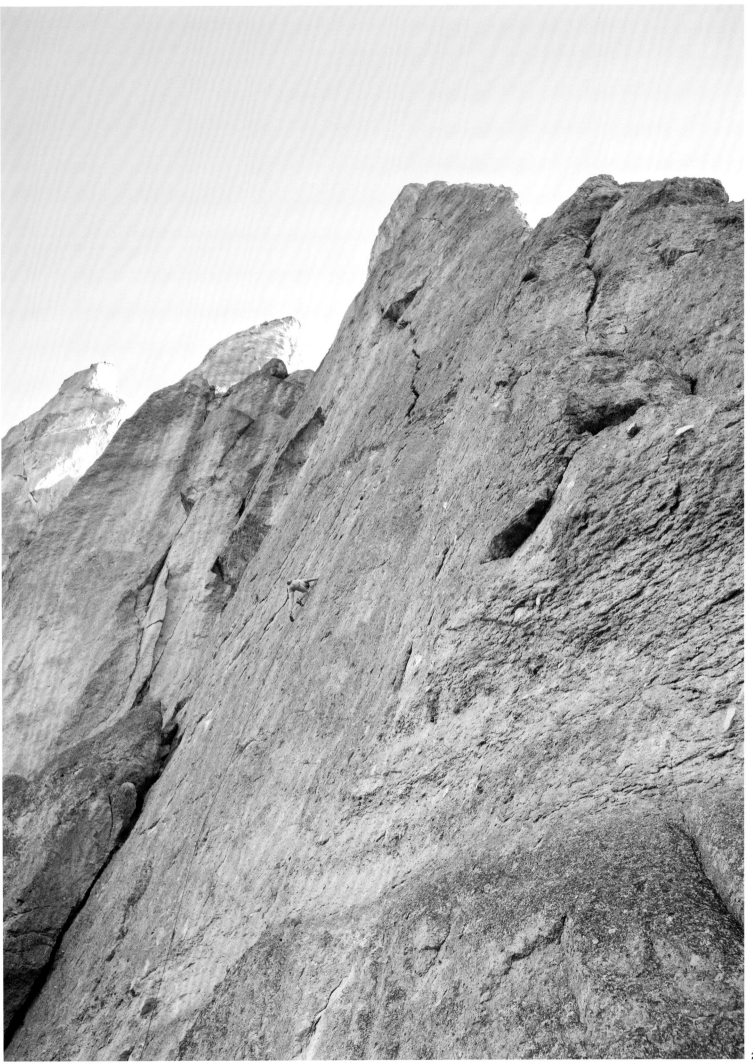

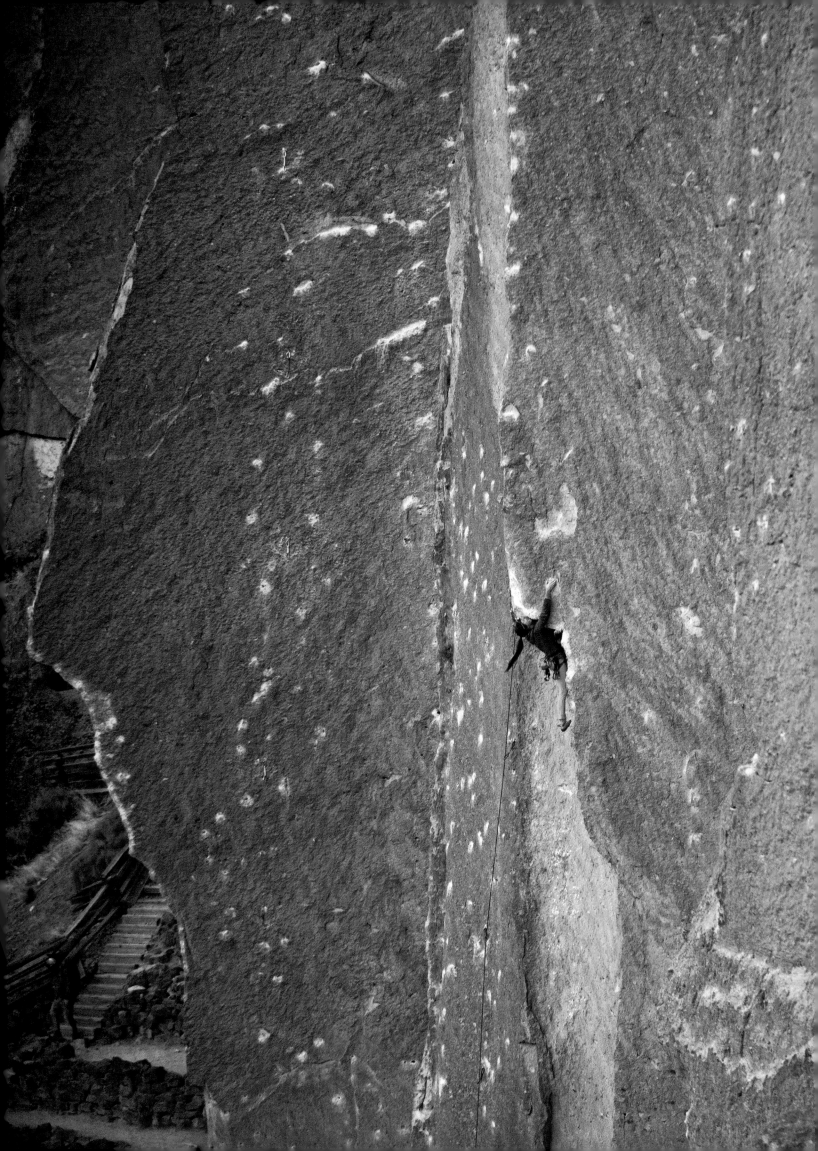

"I did not know it before I was a climber, but a fire lived inside of me. I am just tiny bones and fleshy limbs, sun-soaked skin stretched like blank canvas across a brittle frame. I am dusted with the dirt of old country roads I have driven down, of desert sand and smut. Climbing took one small ember and then burst it into flame and I realized that I am more than bones and brawn. I am the sound of coyotes howling yip yap songs across the valley. I am gritty jokes told over raging campfires. I am new light at daybreak, spilling into the canyon, its walls an ocean of red sandstone. I am strength, fierce and unyielding. Climbing did not give me strength but was a reminder that it had been there all along."

—Kathy Karlo

Previous
Last Waltz (5.12c)
Jules Jimreivat sizing up the moves around the arete on an evening burn. To the left is the iconic, chalked-up arete of Chain Reaction (5.12c).

Right
Chain Reaction (5.12c)
Lukas Strauss-Wise showing us that great climbing is built on a foundation of great falling. Without integration of this mantra, climbers would never take the chances necessary to push their limits and evolve.

Following
Spank the Monkey, (5.12a)
Lukas Strauss-Wise making his way up the exposed arete to finish the day.

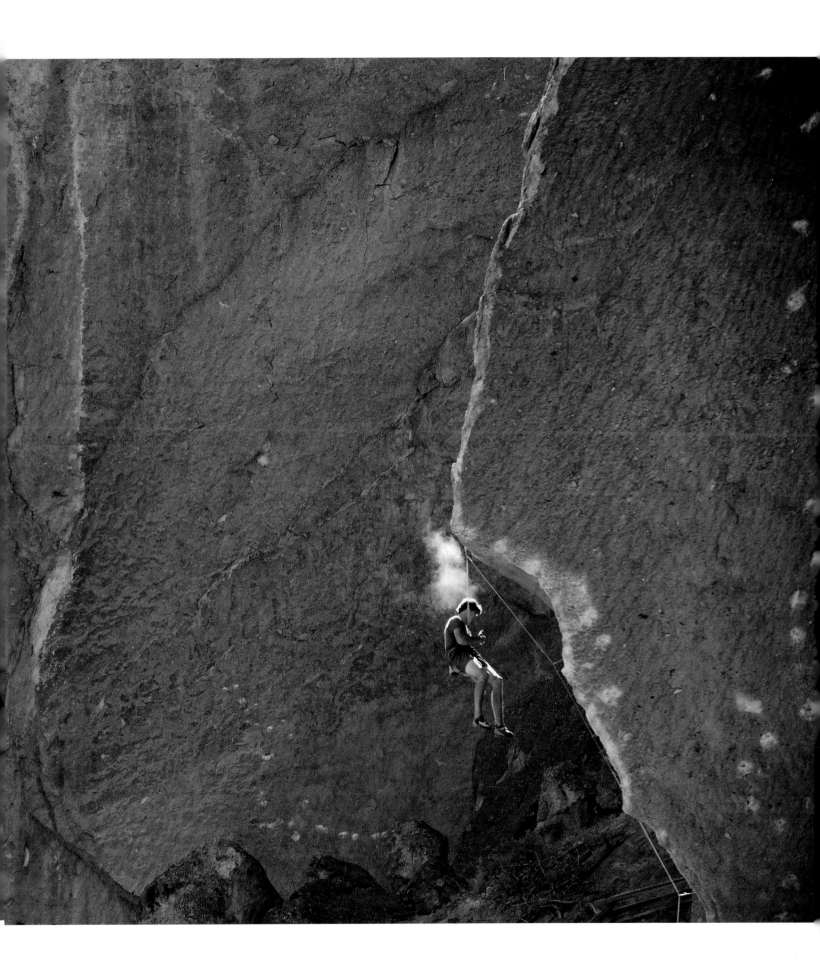

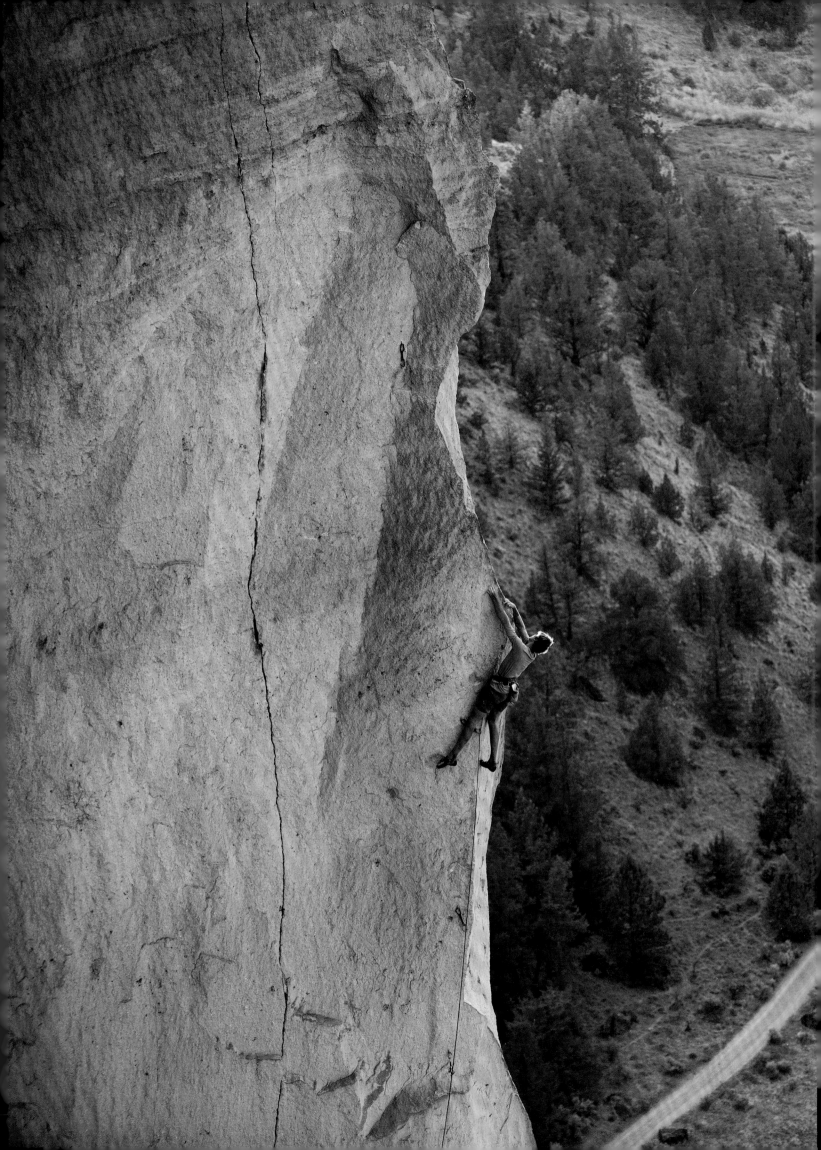

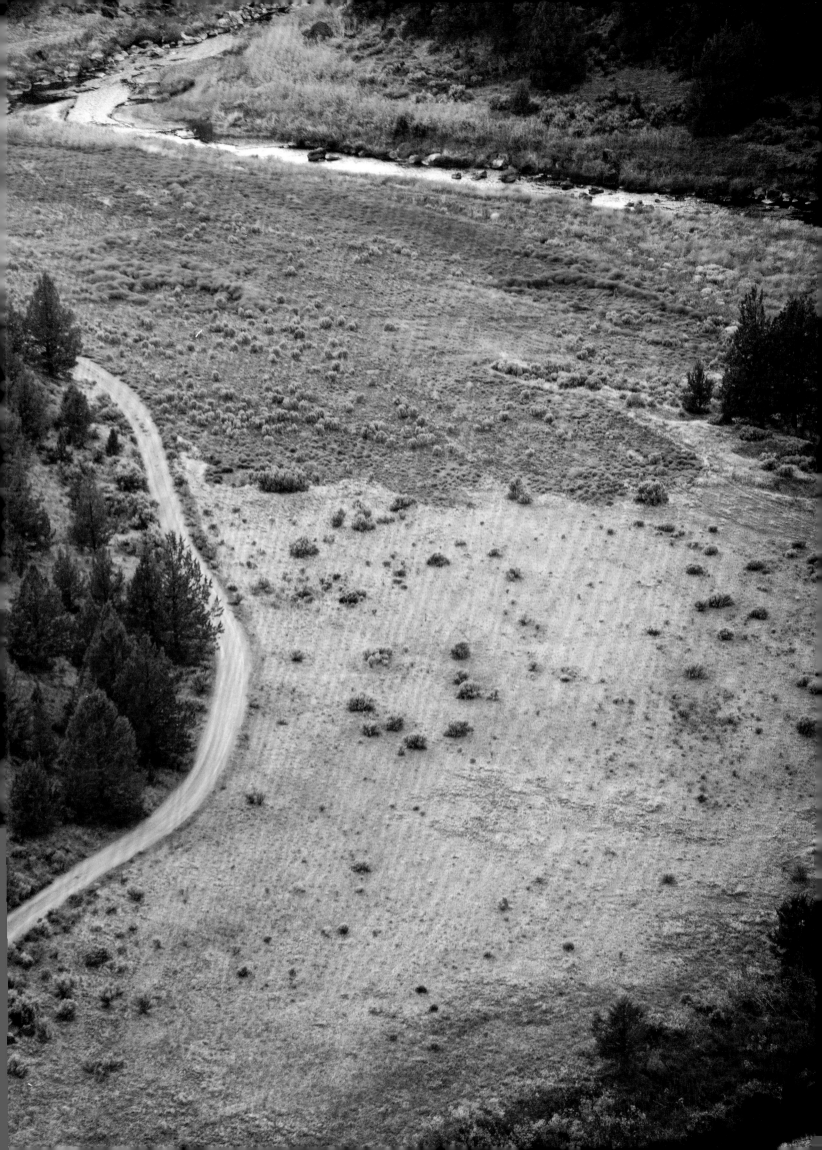

Completing four seasons of ceaseless adventure, the convoy finds solace in well-deserved rest. The road life is both invigorating and exhausting, and requires some measure of balance. The stoke that drives us eventually needs to recharge—often the motivation for a new quest arises from the down time.

We take refuge in camaraderie, and for a brief moment, enjoy mundane civilian activity. Libations pour readily, accompanied by entertaining tales of glory and defeat. The harsher aspects tend to fade and dissolve in the memory.

In the end we are left only with bright visions from the tall stone.

Left
Late afternoon light spilling across Smith's pedestrian byways.

GLOSSARY

Aid climbing - advancing up the wall by placing and then pulling on (and stepping into) specialized aid gear, as opposed to climbing the rock features themselves.

Alpine climbing - type of climbing involving high level of commitment and isolation on big mountains. This often demands snow and ice climbing as well as rock skills.

Anchor - Security point made at the top of a pitch of climbing. All climbers connect into each anchor in the case of a multi-pitch or bigwall climb.

Approach - the way leading to the base of a climb, often involving hiking and/or scrambling up boulders.

Arete - the outward corner resulting from two walls joining, as in a ridge-like corner.

ATC - a tubular belay device designed for the rope to run through, connecting to a belayer's harness to catch the fall of a climber. "ATC" is technically a specific Black Diamond brand version of a tube-style device.

Belay - to control the non-climber side of the rope so that the climber can safely hang or fall during a climb.

Bigwall - a wall that commonly takes more than one day to complete. Climbers sleep on the wall on rock ledges, or on portaledges that they carry up in the haul bag.

Bivy - to sleep, generally employing minimal sleeping gear, either somewhere in nature or up on a wall. Short for bivouac.

Bolt - permanent hardware drilled into the rock to affix bolt hangers, which are used to clip into as protection.

Bouldering - short climbs on boulders done without using ropes. Boulderers often use crash pads (specialized portable cushions) to soften their landing in case of a fall.

Cam - standard protection in trad climbing. Short for camming device. A cam most often consists of four metal lobes, spring loaded to exert outward pressure against the inside walls of cracks, where they are placed. Cams come in a wide variety of sizes to fit various cracks and fissures.

Carabiner - a metal clip with a spring-loaded gate.

Cave - a large opening in the rock, enclosed by a ceiling or roof on which the climber tends to climb upside down.

Chalk - gymnastic-style magnesium carbonate powder used to increase friction between hands and the rock.

Chimney - formation with parallel walls which are contacted simultaneously in climbing.

Choss - slang term for poor-quality rock.

Crag - a rock climbing wall or area with routes generally a few pitches or less in length.

Crimp - the smallest type of handhold; a small edge or break in the rock that can be latched by the tips of the fingers and pulled on to move upward.

Descent - The way down from the top of a climb. Can be a rappel line or a walking trail.

Dihedral - an inward corner resulting from two walls joining.

Dirtbag - distinction of honor within the climbing community. One who is without a home, living exclusively in climbing areas or on the dusty roads in between.

Dyno - a dynamic movement whereby a climber disconnects with the wall entirely and latches on to a higher hold.

Epic - a scenario during which the participants undergo tremendous challenge, generally when things go wrong, or not according to plan.

Fingerlock - stuffing fingers inside a tight constriction of rock to create a secure hold.

First ascent - the successful completion of a climb that has not been climbed before. An FFA, or "First Free Ascent" is the first successful free climb of a new route or existing aid route.

Flash - sending a climb on the first try, after having been given information about specific moves or holds.

Free climbing - advancing only by using one's hands and feet on the rock features, while placing protection that is weighted only in the event of a fall.

Free solo - climbing without use of ropes or any protective gear.

Grigri - a more complex belay device with an assisted braking feature that grabs onto the rope in case of a fall. "Grigri" is a Petzl brand product name, the generic term for which is "assisted braking belay device"

Hand jam - using one's hand in a gap, constriction, or crack to pull down on for upward progress.

Haul bag - a highly durable bag filled used to store food, water and equipment during a multi-day ascent. The bag is hauled after each pitch of climbing using pulley systems. In special cases, such bags have been dedicated entirely to hauling Cobra, a cheap, foul-tasting malt liquor popular among Yosemite dirtbags.

Highball - a particularly tall boulder problem that blurs the line between bouldering and freesoloing.

Hueco - a hollow, circular feature in the stone. Many huecos make terrific handholds; in some cases larger ones can fit a leg or even an entire body for resting.

Jug - A large, positive down-pulling hold.

Kneebar - leveraging the bottom half of the leg, from the knee to the foot, between opposing pieces of rock. This serves as a temporary relief from the arms, which often can come completely off of the wall when a secure kneebar is in effect.

Mantle - to push up onto one's palms to surmount a ledge, cliff or top of a boulder.

Monkey - one who has responded to the calling of the stone, who has been inducted into the ranks of the tribe; best distinguished by swollen veiny forearms, gritty fingernails, and general scabbing.

Nut - passive protection used in trad climbing, usually aluminum chocks or wedges designed to slot into cracks or constrictions.

Offwidth - a crack larger than a fist, necessitating special techniques of awkward, physical jamming into the crack.

Onsight - to send a route on the first try, without any "beta" (information about the climb).

Pitch - distance of climbing before the lead climber makes an anchor, either to come back to the ground, or in the case of multi-pitch, to rest before beginning the next pitch.

Pocket - a hole in the rock that accommodates one to several fingers and is used as a hold for upward progress.. A one-finger pocket is called a "mono."

Portaledge - a portable ledge made from aluminum tubing and fabric that can be set up and used for sleeping on a bigwall.

Project - either a climb that hasn't seen a free ascent, or a route that a climber is currently trying to redpoint but has not yet completed.

Pump - a swollen feeling of fatigue in the arms that builds up over the course of climbing hard moves.

Quickdraw - two carabiners joined with a "dogbone" or connecting piece of webbing. A standard piece of protection for sport climbing.

Rack - assemblage of gear one brings up the wall to place for protection in trad or alpine climbing.

Rappel - to lower oneself down the rope after completing a climb. In the case of some multi-pitch climbs, multiple rappels from anchor point to anchor point are required to return to the base.

Redpoint - Completing a route or a pitch of climbing without falling or weighting the rope.

Roof - a ceiling of rock, protruding horizontally outward from the wall for some distance.

Runout - a long distance between protection on a climb. Falling during a runout would result in a longer than usual fall.

Sandbag - to present a climb to another climber, in such a fashion that they believe it is not as hard (or scary) as it actually is.

Send - to climb a route completely without falling or taking. Can apply to a redpoint, onsight or flash.

Simul-climbing - a type of climbing during which two climbers attach a short section of rope to each other and climb simultaneously without a traditional belay. The lead climber still places protective gear while leading, and in the case of a fall they are counterbalanced by the other climber's body weight.

Slab - cliff or piece of rock that is less than vertical, often devoid of large holds and climbed by the friction between the rock and one's climbing shoes.

Sloper - a sloping hold with no positive inset part to sink the fingers into. Generally difficult to hold and requires maximizing surface area of the hand against the rock.

Sport climbing - class of climbing protected by clipping quickdraws into a series of pre-drilled bolts.

Sprinter van - climber for "house."

Stemming - climbing a dihedral or chimney by using a bridging technique, with one foot on one wall and one foot on the adjoining wall.

Take - a command given to a belayer to take in the slack and hold the rope so that the climber can weight the rope without falling.

Trad - "traditional" climbing protected by specialized pieces of removable gear carried on one's harness. As the climber ascends, they place appropriately sized protective gear to fit cracks and fissures in the rock face.

Traverse - lateral (instead of upward) movement across a rock face while climbing.

Tufa - stalactites or "ribs" that form in limestone from dripping minerals over time. Tufas can be climbed in any number of creative ways, from pinching to wrapping an arm or leg around, to bear hugging (in the larger cases).

Wag Bag - "to-go" option for harmless removal of one's own human waste from a pristine natural area. Appropriated from dog walkers.

ACKNOWLEDGMENTS

In the making of this book, I have been inspired and humbled many times over. My first thanks goes to Martynka Wawrzyniak—thank you for your passion, vision, and your relentless execution on the projects that matter. Also for your uncanny ability to magnetize just the right people, no matter who they are; it is magic to witness. François, thank you for your artistry and friendship, your care for the climbing community and your warmly snarky (French?) sense of humor. You have been incredible and egoless to work with—thank you for endless days of sacrificing comfort for this project. Jaysen Henderson, thanks for the excellent design, your clear and discerning brain, your ability to soulfully argue, and your solidarity. Andy Anderson, thanks for keeping me in check with your clear-minded edits of my texts. Let the record show, if there are any cheesy or bad jokes in the final version of this book, Andy probably warned me against them. Ostensibly this book is Martynka's vision, François' art, my conceptual frameworks, and Jaysen's design—but largely it just became a big team effort, and the whole is definitely greater than the sum of the parts.

I want to thank the climbing community for being so freaking cool, for providing support and inspiration over the years. Erik Sloan, thank you for taking me to Swan Slab on my birthday 12 years ago to introduce me to this strange activity, and for continuing to be a mentor to me every time I come back to Yosemite. I consider all the sandbagging to fall under the "inspiration" category. Jay Bachhuber, thanks for being my partner on almost every major adventure I've been on. The bonds that form on big climbing adventures are deep, especially those that endure years. I'm almost willing to overlook your "gate-out" racking style.

Special thanks to the New York City climbing community, which has been my major circle of friends/belay partners over the last decade. For a city with poor access to nature, y'all know how to get rowdy. Thank you to those of you that rallied to shoot with François for this project, I appreciate your time and efforts. Big thanks to Peter Croft for being Peter Croft, and for collaborating with us in making this book as good as it could possibly be.

Finally I'd like to thank Charles Miers and Rizzoli Publications for trusting and supporting our vision in the making of this book. You provided the opportunity and the machinery to birth and follow through with this project in a sincere, authentic way. In so many ways this book has become a gift for the climbing community, from the climbing community.

Jesse Lynch

This book wouldn't be in your hands without all these magic people:

Big, big thanks to Martynka Wawrzyniak and Jesse Lynch to have believed in my artistry and giving me the opportunity to print so many images into a single art book. I won't be able to thank you enough. A sincere thanks to Charles Miers for being so excited about the project and giving us a green light on what we envisioned to be a true portrayal of rock climbing culture. Thanks to Jaysen Henderson for his refined taste, the fabulous layout of the book, and his regimen of keeping our meetings restricted to two hours instead of a week long. To my incredible wife, Anna Porreca, for being patient with all my travels and for her support of my photography pursuits. To all those talented photographers out there that push me to be on top of my game, every day. I think it's just a constant and mutual collaboration that raises the quality of the work everyone sees. Also, special thanks to Galen Rowell, who helped spark my love for the outdoors and inspired me with his vision. To Keith Ladzinski, Jimmy Chin, Tim Kemple, Jim Thornburg, Andrew Burr—thanks to all of you that have been my main source of inspiration for so many years.

Big, gigantic thanks to all the climbers who allowed me to shoot while they were doing what they love. Thanks for going up when it wasn't the right conditions to send the project but the light was just perfect. For when your fingers were done but you did one last go to get the shot. For committing a little higher up even if you were scared. For helping me set countless static lines, and for waking up way too early in order to get that first-light magic. For offering me a spot to stay in your house instead of freezing my butt off outside in the rain. You all are, sincerely, the best. You know who you are.

To my family, I tip my hat to all of you, for your constant support, believing in me since I've started taking images. Your trust and positive energy allowed me to reach unexpected states of happiness, pride, and accomplishment. In my eyes, it is one unique precious gift.

And a last thanks to one of my dear friend, JS, who had been my best and harshest critic. You were there when I was fumbling, making my first steps in this photo world. You taught me to be as critical of my own work as you were, to raise the bar as high as I am be capable of. I apply the rule of "the sky is the limit" to my work, and it comes from you. Rest in peace.

François Lebeau